A specialist in medieval Islamic and Ottoman art and architecture, and an expert on Yezidi religion and culture, **Birgül Açıkyıldız** is Professor of the History of Art at Mardin Artuklu University. Before taking this post she was Research Fellow in the Faculty of Oriental Studies, University of Oxford, and taught in the Department of Islamic Art and Archaeology of the University of Paris I Panthéon-Sorbonne.

The minority communities of northern Iraq are under increasing and desperate threat from Islamic state jihadists. Among these minorities, the Yezidis have one of the most fascinating legacies of any tradition in the entire Middle East. Yet not just their religious and material culture but now their entire existence lies under the looming shadow of extinction. But who are the Yezidis (or 'Yazidis' as they are called in much of the Western media)? Denounced as infidels by al-Qaida in Iraq, who sanctioned their indiscriminate killing, and now seeking sanctuary from eradication by ISIS, the Yezidi community has been misunderstood and oppressed for centuries. Predominantly ethnic Kurds, and the target of 72 genocidal massacres under the Ottomans, until now they have succeeded in keeping their ancient religion alive, despite the claim that they are 'devil worshippers'.

Birgül Açıkyıldız has written the essential guide to a tradition that may soon disappear altogether from the maps of the Middle East. Without presupposing prior knowledge about Yezidism, and in an accessible and readable style, she examines the Yezidis both from a religious point of view and as a historical and social phenomenon. Expertly assessing Yezidi religion, society and culture (at the centre of which is veneration of *Tawûsî Melek*, the 'Peacock Angel' and ruler of the earth), the author reveals an intricate syncretic system of belief influenced by early Iranian faiths like Zoroastrianism and Manichaeism, Sufism and regional paganism like Mithraism. She discusses the origins of the Yezidis, the community's relations with its Middle Eastern neighbours, the most important facets of Yezidi art and architecture and the often misunderstood (and now progressively life-threatening) connections between Yezidism and the Satan/Sheitan of Christian and Muslim tradition. Richly illustrated, with accompanying maps, photographs and illustrations, this pioneering book may be the final in-depth testimonial to one of the region's most extraordinary and venerable religions.

GW00497819

The
Yezidis

The History of a
Community, Culture
and Religion

Birgül Açıkyıldız

I.B. TAURIS
LONDON · NEW YORK

New paperback edition first published in 2014 by I.B.Tauris & Co. Ltd
London ● New York
Reprinted 2014 (twice), 2015
www.ibtauris.com

First published in hardback in 2010 by I.B.Tauris & Co. Ltd

ISBN: 978 1 78453 216 1
eISBN: 978 0 85773 901 8

A full CIP record for this book is available from the British Library
A full CIP record is available from the Library of Congress

Library of Congress Catalog Card Number: available

Printed and bound by CPI Group (UK) Ltd, Croydon, CR0 4YY

Dedicated to Marlyse Lescot

Contents

Illustrations

Plate Section

Black and White Illustrations

Figures

Maps

Acknowledgements

The origins of this book lie substantially in my Ph.D. thesis completed in the Institute of Art and Archaeology at the University of Paris I Panthéon-Sorbonne in October 2006. The composition of this book has been realised with the help and advice of many people, but nobody is responsible for its errors and weakness except myself. My thanks are particularly due to Professor Alastair Northedge, who supervised the original thesis. I am grateful to Professor Jeremy Johns who supported this work with his precious criticisms and to Dr. Mamo Farhan Othman who supplied me with a great deal of information on Yezidi history and culture. I would also like to thank Prof. Dr. Asker Kartarı, Associate Professor Christine Allison and Dr. Pierre Simon for their contribution.

Acknowledgements are also due to the Barakat Trust, the National Higher Education and Research Ministry of France, and the Shivan Perwer International Cultural Foundation for their generous financial support. I would like to express my gratitude to the Kurdish Institute of Paris for its support during my doctoral studies in Paris, to the Cultural Centre of Lalish in Dohuk, Ba'shîqe and Sinjar for their assistance in my fieldwork, and to the Khalili Research Centre of Oxford University and the Department of Communication Sciences of Hacettepe University for providing me with facilities necessary for the redaction of this book.

The translation and transcription of the inscriptions were carried out by Dr. Luaï Jaff, Muhammad Hussein, and Zeinab Zaza. The latter also helped me with the translation of the Arabic sources. The translation of the Ottoman archives was made in collaboration with Yavuz Aykan. Natalia Tari, Paul Grey and Arezou Azad helped me with corrections in the English texts. Arzu Karahan helped me to give the final shape to the line drawings. I thank them greatly.

Amongst the Yezidis, my thanks go to Mîr Kamuran Beg, Khidir Dimili, Kheyrî Bozan, Suleiman Havend, Hecî Katari, Hecî Ali Suleiman, Ismail Hasan Said, Khidir

Kh. Behzani, Sozan Hajee Samw, Sagvan Mirad, Said Kasim Hason, Dexil Kasim Hason, Karina Usabian, Feqîr Tayar Keleshi, Torina Torin, Kibar, Rustem and Siyabend Hudeda for their support. Moreover, I would like to thank the people who helped me in organising transport and accommodation as well as in establishing contacts during my fieldwork. In particular, I would like to thank the many local residents who welcomed me generously as a guest and guided me during my research. These include Devrim Karaoba, Huda, Macid, and Zubeida Berwari, and Shehnaz Zebari in Dohuk, the family of Pirşeng Budak in Diyarbakır, the family of Fatma Akdoğan in Midyat and Nusaybin, family of Özcan Ayboga in Tunceli, and M. Ali Hançer and Eyüp Burç in Viranşehir, Dr. Vardan Vaskanian and Şilan Aras in Yerevan, Ibrahim Bilal, Hamide and Said Bilal in Afrin and Zekeria Mustafa in Damascus. I thank Dr. Saywan Barzani, who facilitated my trips in northern Iraq. Finally, I would like to thank my family and Marlyse Lescot, who supported me throughout this work.

Abbreviations

Journals

AJSL	American Journal of Semitic Languages and Literatures
BSOAS	Bulletin of the School of Oriental and African Studies
BSOS	Bulletin of the School of Oriental Studies
EI	The Encyclopaedia of Islam
GJ	The Geographical Journal
JA	Journal Asiatique
JAOS	Journal of the American Oriental Society
JRAS	Journal of the Royal Asiatic Society of the Great Britain and Ireland
JRCAS	Journal of the Royal Central Asian Society
JRGSL	Journal of the Royal Geographical Society of London
POC	Proche-Orient Chrétien
RMA	Revue du Monde Arabe
RMM	Revue du Monde Musulman
ROC	Revue de l'Orient Chrétien

Others

Sh.	Sheikh
W.w.	White washed
R.s.	Rubble stone

Introduction

The Yezidis are a fascinating people who form part of the rich cultural mosaic of the Middle East. They first appeared on the historical scene as an isolated community in the Kurdish mountains of northern Iraq in the twelfth century. Originally the heirs to a variety of cultural and religious beliefs, including Zoroastrianism, they became the supporters and followers of the Sufi Sheikh 'Adī. Thus, a syncretic belief system and unique religious belief system grew up. Eventually, the Yezidis acquired the label of 'devil-worshippers' for their love of the Peacock Angel.

This book aims to give a comprehensive and comprehensible introduction to Yezidi culture, religion and society. It examines Yezidism not only as a religion but also as a historical and social phenomenon. This is a fresh approach to the subject. Previous scholars focused mainly on the origins, early history and religious practices of the modern Yezidis of northern Iraq.[1] In this book, the full historical and geographic range of Yezidism is examined for the first time, not just in northern Iraq but also in Turkey, Syria and Transcaucasia. Thus, the book throws light on the origins of Yezidism and documents its historical development as part of the general history of the Kurds. It traces the changing fortunes of Yezidism and examines the role of the Yezidis in Kurdish history over time and in the different Kurdish regions.[2] The Yezidi community emerged in a small area, known as Sheikhan, and spread rapidly amongst the Kurdish tribes. However, this rapid expansion disturbed their Muslim neighbours, and from the thirteenth century onwards, Yezidis suffered repression and massacre. As a result, the Yezidis remain a small, oppressed community, but one that has stubbornly survived to this day.

This book explores what makes Yezidism a separate and unique religion. It principally focuses on the Peacock Angel (Tawûsî Melek), the main character in Yezidism, and explores his relation with the Creator and the Yezidi people. Yezidis believe in one eternal God (Xwedê) who is the creator of the universe. He is Good and

the owner of every motion and sensation on earth. He is all-forgiving and merciful. According to the Yezidi belief system, God manifests himself as a Holy Trinity in three different forms: the Peacock Angel, Sultan Êzî and Sheikh 'Adī (d. 1162). Furthermore, God has delegated his earthly powers to seven angels led by the Peacock Angel, who have responsibility for human and worldly affairs. In Yezidi belief, this angel is the mediator between God and the Yezidi people. He leads directly to God and is not in opposition but is an independent entity. At the same time, he is God's alter ego who became the same, a united inseparable. He is the manifestation of the Creator, not the Creator himself. Nevertheless, Muslim and Christian neighbours of the Yezidis in the Middle East consider the Peacock Angel as the embodiment of Satan and an evil, rebellious spirit. The devil was identified with the fallen angel, who was expelled from Paradise because of his disobedience to God. And as the Yezidis pray to God through his banners in the form of the peacock, they were considered to be worshippers of Satan ('*abadat al-sheitān*). Although Yezidis recognise this concept of evil, they do not have the same comprehension of Satan as the other religions do. In the Yezidi religious belief system, Satan is not a fallen angel but the only representative of God on earth. According to the Yezidis, Satan refused to prostrate himself in front of Adam because of his true love for God. God had ordered Satan to bow to Adam to test his honesty and his commitment. As Satan refused to bow to anyone but God, God made Satan the chief of his angels, that is, the Peacock Angel.

This book describes the Yezidi belief system and its religious practices. It analyses the personality of Sheikh 'Adī – who is considered the reformer of Yezidi religion by modern Yezidis – focusing on his written works and other Arabic sources to examine his influence on the Yezidi doctrine. It also considers a set of Yezidi myths, including those of the Creation and the Flood, and explores the originality of the Yezidi holy books, the *Mishefa Resh* (the Black Book) and the *Kitêb-i Cilwê* (the Book of the Revelation). The caste system, one of the predominant characteristics of Yezidi society, is also analysed. Membership to Yezidi castes is inherited from both parents, and it is impossible to change one's status. The Yezidis divide themselves into three main endogamous castes: sheikhs, pîrs and murîds. Sheikhs and pîrs are from the clerical caste, and the murîds (or disciples) are the commoners. The life of every Yezidi is full of ceremonies and rituals, and it is upon participation in these virtuals that their acceptance in the Yezidi community hinges. The essential rites of passage shall be described in the book, notably the cutting of hair, baptism, circumcision, 'brother of the hereafter', marriage and death, and pilgrimage rites. The information drawn from earlier written accounts is supplemented with new data which I collected through many interviews with the Yezidi men of religion, mainly in northern Iraq, where most of the Yezidis live and continue to practice their religion today.

One of the main aims of this book is to give the first full and extensive account of the most important facets of Yezidi religious and funerary architecture, in order to relate religious observances and practices to material and visual culture and their relationship

to the corresponding culture of their neighbours throughout the Middle East. This is the first attempt to study the material culture of the Yezidis. The funerary monuments and zoomorphic tombstones are described and illustrated with line drawings and photographs. This material is not found in any earlier publication that aimed to bring architectural evidence for the Yezidi religion and history. In this study the typology of Yezidi religious and funerary art and architecture is analysed and their relationship to Islamic and Christian material culture in the region is examined. Furthermore, this study explores whether it is even possible to speak of a homogeneous Yezidi architecture in the Kurdish regions of the Middle East and Transcaucasia (Iraq, Turkey, Syria and Republic of Armenia). It describes and analyses Yezidi sacred monuments in northern Iraq's three principal Yezidi settlements: Sheikhan, Sinjar and Beḥzanê/ Ba'shîqe. It also gives a general account of pilgrimage places, funerary architecture and tombstones in other Yezidi areas, such as Aragatsotn in the Republic of Armenia, the Tur 'Abdin in Turkey and the Kurd Dagh in Syria. The aim is to discuss how form, content and function sanctify a place in the Yezidi world. Among the questions that will be considered are the following: what impact did the coming of Yezidism have upon the pre-existing sacred topography of the region? What makes a building 'Yezidi' in form, function or meaning? How is the 'spirit' of Yezidism manifested visually? Is there a correlation between Yezidi art and architecture and that of Islam and Christianity? What is new and original in Yezidi material and visual culture? Special attention shall be paid to the influence of Mosul which was the artistic centre of the Atabeg Badr al-Dīn Lu'lu' (r. 1211–59) on Yezidi material culture. A typology of Yezidi places of worship is proposed and a chronology suggested on the basis of the comparative study of dated Islamic monuments. It also considers an extraordinary group of statuary tombstones in the shape of horses found in the Republic of Armenia and Turkey today, and my proposal that they should be attributed to the Yezidi community.

In this study we face two main methodological challenges. The first challenge lies in the dating of Yezidi buildings with precision. Few Yezidi monuments offer inscriptions or other written evidence for their dating. Moreover, Yezidi architecture does not exhibit period-specific architectural styles, and thus the same type of building can be found in the twelfth century as in the present. These limitations made it necessary for me to look for other clues to dating such as architectural details and building materials, and their differences from other monuments of the region in which they are found. Another dating factor has been the period in which particular saints lived and to whom a building is dedicated. However, there are uncertainties about the biographies of Yezidi saints as well. Thus, I have often had to make educated guesses as to the dating of certain buildings. In dating the structures, I also tried to consider the chronology of the Yezidi population in areas where Yezidi buildings stand. For instance, it is known that the valley of Lalish and village of Bozan in the Sheikhan area are the most ancient places inhabited by the Yezidis. However, the region of Sinjar became important principally during the period of Sheikh Sharaf al-Dīn, who died

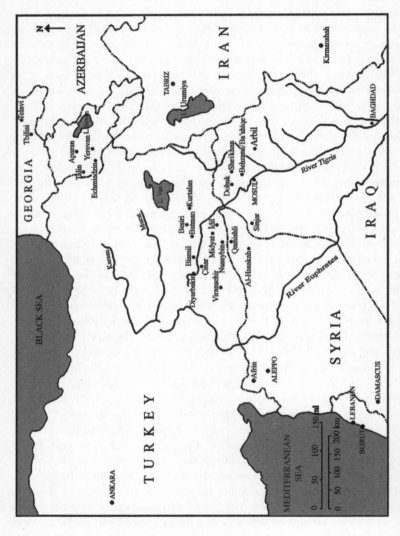

Map 1 Centres for Yezidism in the Middle East (today)

in 1256. Beḥzanê/Baˈshîqe was also populated in the thirteenth century, a time when Zangid Atabeg of Badr al-Dīn Luˈluˈ oppressed the Yezidi community.

We encounter similar lacunae in the dating evidence amongst the Yezidi zoomorphic tombstones in the Republic of Armenia. Apart from two sculptures that are dated to the mid-twentieth century, we do not have any inscriptions to help us date the other tombstones. Nevertheless, I suggest they were made between the eighteenth century and the beginning of the twentieth, given that this was a time when many Yezidis migrated to Transcaucasia. Although an early presence of Kurds in these regions is attested to the tenth-eleventh century during the Shaddadid dynasty,[3] the first known migration of Yezidis to Transcaucasia in conjunction with Muslim Kurds, did not occur until the eighteenth century.

The second difficulty is in the transcription of names. Although the Yezidis speak Kurdish, most Yezidi names are originally Arabic, and the orthography of the Arabic names does not always correspond to the way they are articulated by the Yezidis. Moreover, place names in Turkey are in Turkish. Thus, it was difficult to use a single system of transcription for Kurdish, Turkish and Arabic names, which have different transcription conventions. In general, I tried to use an adapted version of the standard transcription of Kurmanji with ˈshˈ for ˈşˈ, ˈkhˈ for ˈxˈ, ˈchˈ for ˈçˈ and ˈzhˈ for ˈjˈ, but I respected the original transcription of these letters in Turkish.

This study is mainly a result of extensive fieldwork amongst the Yezidis which I carried out in northern Iraq, Syria, Turkey and Armenia between 2002 and 2005. In this book I describe experiences with the Yezidis, my observations of their daily lives which I shared with them, and the difficulties that I faced crossing modern political borders to meet Yezidis and conduct the research upon which this book is based. I also describe the role of women in Yezidi society; relations between the Yezidis and other communities, such as the Assyro-Chaldeans and the Muslim Kurds; and the current political and social conditions of Yezidis in the countries where they live. Such a perspective allows the reader to grasp the living Yezidi culture and lifestyle, and the relationship between Yezidis and their Muslim and Christian neighbours.

Meeting the Yezidis

I decided to start my research on the Yezidis of northern Iraq, where the majority of the Yezidi community live and where the most important Yezidi religious architecture is located, so that I might finally meet the Yezidis in the flesh as it were. Indeed, with all the contradictory information I had gathered up to that point, I knew that an extraordinary adventure awaited me. However, I was also aware that I would face a number of difficulties during my fieldwork as I was going to a country which does not even exist on the maps; given the unstable political context within the entire region, it was by no means certain that I would even be able to get there. However, how I

was going to get there was an entirely different matter altogether: at the time there were no direct flights from Europe to Arbil, as there are today. It was April 2002, and war was very much in the air in Iraq. It was exactly at the time that I was planning to travel to Dohuk that a new air company, 'Medes Air', was established by the Iranian administration to fly between Düsseldorf (Germany) and Urumiya (Iran) in order to serve northern Iraq. The company also offered a trip from Urumiya to the Kurdish border by coach – I booked my ticket for their second-ever flight. The company's first flight had taken off on 7 April and on that same day Turkish newspapers severely criticised Iran by running the headline: 'Iran Establishes Airport for Terrorism'.[4] The following week it was my turn to fly on the very same flight which had been decried by the Turkish media as serving Kurdish terrorists. However, it was too late for me to change airlines as I had already organised my entire trip. I arrived at Düsseldorf Airport on the afternoon of 15 April. I was greeted by the owner of the company in his office who politely informed me that I was flying to Urumiya as the sole passenger that evening. I was furious and wanted to know why I had not been informed earlier. He replied that after the reports in the Turkish media some of their clients had cancelled their flights, but that they had wanted to go ahead with the flight anyway as a matter of principle, even if there was only one passenger. This left me speechless and at a loss as to what to do – in fact, my options were limited, indeed, non-existent. At this point it was too late to change my mind and say no, so somewhat reluctantly I agreed. I got on the plane that same evening and was greeted by an Iranian air hostess in black chadors and looked after by the entire cabin crew, who made a point of smiling knowingly at me. It was true that I had an airplane to myself, but I couldn't help feeling lost and anxious. When the flight took off, I wasn't very sure whether I would even reach my destination, or indeed, return one day to Europe in one piece. When I arrived at Urumiya Airport in the middle of the night, all the airport employees seemed shocked to see a young woman descending from a large airplane at such an unearthly hour. After the usual airport checks, I rode with four men in a taxi to northern Iraq. I was afraid of them and felt exhausted and made a point of speaking only when spoken to; in fact, they all looked as serious as I did. I was taken to various places in the city centre under the pretext of looking for documents, and it was at this point that I had the impression that I was going to be taken to a police station. However, I was told that we were ready to make our way to Haji Umran. In my long skirt and scarf, I felt disoriented and full of mixed feelings. In contrast to my silence, my four companions were quite talkative, and probably all felt strange travelling with me. This was probably their first time journeying with a woman such as me in a car in the dead of night, definitely an unusual thing to happen in Iran. We drove slowly along serpentine roads as the first light of day began to illuminate the mountains in front of us, the landscape bringing to mind a thousand eastern tales, while smugglers carrying heavy loads on their backs passed along the slopes of snow-capped mountains. Some four hours later,

at around seven o'clock in the morning, we arrived at the Iranian-Iraqi border, where I was left on the other side of the gate – standing all alone beside my suitcases. My companions drove off as I stood there wondering what would happen next. My first reaction was to take off my scarf – what freedom it was to be without it! I had just removed it when a car pulled up and took me to a makeshift office to have my passport checked. After I presented it to one of the officials – his features betrayed nothing less than shock and surprise – I was asked to sit on the floor in an adjoining room. Here was a young European-looking woman with a Turkish passport standing in front of him trying to explain that she was there to visit the Yezidis' pilgrimage centre somewhere in Dohuk, the existence of which he himself was not even aware of although it was in his own country. Added to which, my poor command of Kurdish meant that I couldn't converse with him comfortably, especially as the Sorani dialect of Kurdish predominated there, a dialect I was not at all familiar with. However, he was very kind to me. The tiring journey between Paris-Düsseldorf-Urumiya and Haji Umran had taken its toll and left me exhausted, but now I finally felt that I was in safe hands. I knew that I would be interrogated so that they might ascertain why I was there, but I did not know that they would send me to the large garrison near Rowanduz, where the Kurdish fighters were encamped. As soon as my entry into the country was registered, I left accompanied by a *Peshmerge* (Kurdish fighter) with whom I spent almost the entire day. We arrived at the camp that afternoon and I was questioned by several people. After the first interrogation, they took pity on me and let me rest in a room, where I slept for sometime sitting on a sofa and woke up as fresh as the proverbial daisy. I had lunch with the commander of the camp, who was in *mufti* and he asked me many questions about who I was and the reason for my visit to the region. However, a Turkish interpreter was brought in for the second real interrogation. It seems that I was suspected of being a security agent working for the Turkish government or a guerrilla from the PKK (Kurdistan Workers Party) who had come to join them at their main camp in Kandilli in the north, near the Turkish-Irakien border. I explained to them that I had nothing to do with Turkey or with the Kurdish guerrillas, rather I was a simple student in Paris working on the Yezidi material culture and my reason for being there was to visit the Yezidi sites, take photographs, meet Yezidi people and interview them about their religion, and I wished to reach the city of Dohuk, where some Yezidis knew of my arrival that day. I also mentioned the Kurdish Institute of Paris, a non-political but cultural Kurdish institution from which I had received support for my research. I knew that what I was saying sounded absolutely absurd to them, but finally they shook my hand with a kind smile and sent me to Aqra accompanied by the same person with whom I had come to the camp. It was time to enjoy my journey to Aqra and then be on my way to my final destination, Dohuk. When I arrived in Dohuk it was already evening and a Kurdish lady of my own age from Paris who was teaching at the University of Dohuk was waiting for me at her house and greeted me with some

good French wine. At last I could relax, and my trip from Paris to Dohuk had already become a fond memory and a story with which to regale people.

* * *

The following day, accompanied by two Kurdish journalists, Shehnaz Zebari and Khidir Dimili, I went to the sanctuary of Sheikh 'Adī, situated in the small valley of Lalish. As I approached this small village hidden in the mountains, I experienced what I can only describe as a sense of temporal and physical dislocation and tried to figure out why Sheikh 'Adī had chosen this place to retire from the world. Everything was calm, green and far removed from all that might be considered modern, and yet the sounds of war could be heard just nearby. Birdsong, the lapping of the mountain streams, the abundant green of spring, dotted with the brilliant stains of the poppies and the unique mountain sunlight playing on the conical domes made this place a scene of harmony, something very much akin to a pastoral idyll. I was dazzled by it.

In the middle of the valley, at the foot of the hill, the sanctuary seemed unprepossessing, almost humble against the evident richness of nature. We had entered the first courtyard of the complex, where my companions explained to me that it was necessary to remove one's shoes. Yezidi tradition only allows one to tread the ground of these holy places barefoot. Then, from this first courtyard one has to pass under the main gate, which leads into the actual sanctuary. For visitors, it is considered polite to kiss the threshold of the gate as well as its sides and to enter the hall of the sanctuary by stepping over the threshold without touching it; for the Yezidi themselves, however, such strictures are obligatory.

My reading of travellers' accounts written between the seventeenth and early twentieth centuries had allowed me to create a sufficiently clear image of the sanctuary, and what now stood before my eyes corresponded to it exactly. I had the impression that despite the passage of time, very little had indeed changed.

In the interior of the sanctuary, in every corner, the bustle of preparations for the New Year festival that evening was in evidence. With the setting of the sun, the pilgrims would gather in the front courtyard of the sanctuary, and in the company of the baba sheikh, the religious and the laity, women and men, reciting prayers in Kurdish, together would begin in procession to light the wicks on the paving of the courtyard. The ceremony itself is quite short, no more than ten minutes. The Yezidis believe that at this precise instant the Peacock Angel, sitting on his celestial throne, looks down kindly upon these devotions and bestows upon them his blessing. For the remainder of the night, the men and women went their separate ways and retired to different buildings in the sanctuary. Being a young Kurdish woman from Europe studying their community granted me the privilege of conversing with the male religious leaders. Seated in the main courtyard drinking tea beneath the mulberry

trees the men, who without exception were bearded, plucked at their prayer beads. These long conversations, which I regarded as reliable and which later formed part of my research, unfolded at a leisurely pace and with some simplicity on the part of my interlocutors. Although the ambience was both agreeable and sympathetic, I was rather disappointed by their responses, which appeared to me to have been prepared in advance and definitely seemed to owe much to catechism. They were quite curious and insistent on explanations about both my identity and my motivation. From this point onwards, all doors were wide open to me, and my curiosity and research continued unimpeded.

On the following day, at dawn, the faithful began to decorate the doors and arches with bouquets of poppies and eggs prepared the day before; coloured eggs were offered

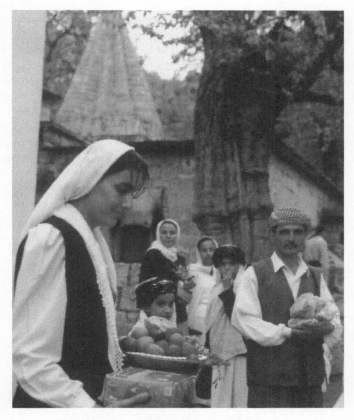

1 Offer of coloured eggs on the occasion of Serê Sal, Lalish

to the pilgrims already in the sanctuary, including myself (Pl. 1). After breakfast, the entire assembly, both men and women, gathered in the main courtyard to carry out the ritual of baptising the banner of the Peacock Angel,[5] and I had privilege to photograph this extraordinary scene.

It was not until the third day, when the ceremony was over, that I really started to work on my research. My goal was to list and catalogue the architectural components of the entire sanctuary, both symbolic and religious, as well as those of the mausoleums and other monuments in Lalish, by taking detailed photographs, which would take account of designs, measurements and drawings. I was quite disciplined in my approach to all this work, but it took place in a very informal and relaxed atmosphere amidst constant comings and goings. During this time, the pilgrims and both the religious would come to see me out of curiosity, always asking questions. I was no less curious and was not shy about asking them about their faith or even just their daily lives, and I made a point of observing them during their prayers and meals as well as during their conversations with one dignitary or another. Although a hallowed place of pilgrimage, the sanctuary of Sheikh 'Adī also served an administrative and political function in Yezidi society. The mîr (prince) welcomed high-ranking politicians as well as Muslim and Christian dignitaries. For example, on the day of the visit of Monsieur Raban, the bishop of Amadiya, I had the honour and privilege of being invited by Mîr Kamuran to join their discussion. Beneath the shade of the peristyle, with the participants sipping that inimitable Yezidi brown tea, the conversation slipped from topic to topic. Indeed, the French journalist who accompanied the bishop was very much taken with the simplicity of the whole affair. Just like their two respective communities, the friendship

2　　Boys playing with coloured eggs, Lalish

and mutual respect between these two dignitaries were evident and obviously sincere. In effect, the Yezidis, like the Assyro-Chaldeans, are a robust minority within the greater Kurdish population, the majority of whom are Sunni. As a result of their colourful and often tragic history punctuated by persecutions and various deportations, a lasting sympathy and solidarity had been created between these two minority communities. Nevertheless, even though the memory of the communal oppression which they had for generations undergone at the hands of the Muslim majority was still very fresh, it is important to make clear that these days there is, above all, a genuine will on the part of these politicians as well as the Muslim dignitaries to present the Yezidi community as an integral part of Kurdish culture and history. There is, then, a new form of respect vis-à-vis this Yezidi community, long disparaged for being akin to proto-Kurds. Besides, at the time of my stay, I saw often Muslim visitors coming to the sanctuary. To them, as to every other non-Yezidi person, the entire complex was open, with the exception of the Zemzem source, the holy of holies of the sanctuary.

At this juncture, I would like to reflect for a moment on the situation of the women within the Yezidi community. It was a matter of some regret to me that I had had very little contact with the Yezidi women, not because I was forbidden to approach them, but rather because their occupations and position within society meant that there was very little occasion for exchange or contact. In effect, they are confined to the domestic sphere: the kitchen, laundry and other such services. On the rare occasion when I did come into contact with them, I could not but notice their considerable lack of knowledge about their own religion as well as about national/international current events; indeed, the schooling of girls is almost non-existent. Their entire education is

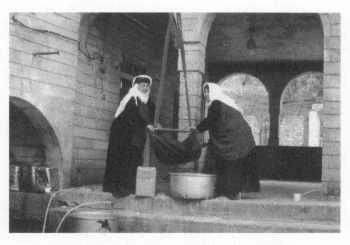

3 Kebanes, religious women, making butter, Lalish

directed towards giving the world as many children as possible (the number varies between seven and fifteen per family) and towards dedicatedly serving their husbands. Their husbands are almost systematically chosen for them by their fathers at a very young age. In addition, they can marry only within the Yezidi community and again, uniquely, only within their own caste. I had been able to record the women's situation and their difficulties from afar, and my conversations with the men had confirmed all that I had observed and inferred. However, the men that I spoke to evidently belonged to a cultivated, even academic, stratum of the population, and they did not hesitate to tell me of their dismay at having to marry women who were being coerced into marriage and who were so poorly educated. This they believed was a source of added frustration in the lives of married couples. During these conversations, they also confided in me, almost inadvertently, about the difficulties they faced in submitting to the strictures of a religion in which they had no faith. Within the context of ethnic identity, their regard for these rules is at present mostly practical as they are members of a distinct community which believes that it is threatened with extinction – pure and simple. These men confided in me their thoughts and feelings that perhaps had gone unvoiced hitherto, and certainly it was the first time in their lives that they had revealed such thoughts to a woman. However, I found myself troubled by contradictory feelings; although I had sympathy for them and could understand their frustrations, I could not stave off the feeling that I wanted them to continue to be bound by these selfsame regulations. I was ill at ease. They had made me feel guilty, as though I were complicit in some sort of conspiracy against their wives, and I asked myself what it was that made me different. They regarded me as a Yezidi woman and yet my standing in their eyes was equal to that of the men. Was this due to fact that I had come from outside their strict community, or was it my education and my status as a university researcher which granted me this privilege?

At the end of my stay I decided to visit a number of the Yezidi villages as well as towns, which were more populous. At that time, in May 2002, it wasn't possible to go to Yezidi villages situated outside the Kurdish Regional Government, and it was particularly inadvisable for foreign visitors to attempt to do so. Thus important localities that I wanted to visit, such as 'Eyn Sifni, Beḥzanê, Ba'shîqe, Bozan and Sinjar, which were to be found on the other side of this 'frontier,' were inaccessible to me; however, it was a deficiency which I made up for on my second trip to northern Iraq in May 2004.

* * *

With a new journey in July 2003, I intended to visit the Yezidis in the Republic of Armenia. Indeed, for me, this trip had all the connotations of a pilgrimage about it. I was born in Göle on the Turkish-Armenian border and grew up with many stories concerning the Yezidis and the Armenians, though I had never seen them. As a child

I always imagined them to be aliens, much talked about but never seen. In fact, my paternal great-grandfather was originally from Yerevan; he was a semi-nomad who had spent the period of transhumance with his family around Kars. The native population suffered because of the Ottoman-Russian wars and regional domination see-sawed between these two powers, most notably in the nineteenth century. Inhabitants of the area moved between Armenia and the Ottoman lands until the Turkish-Armenian frontier was stabilised in 1920 with the Gumri agreement. Moreover, the majority of the Kurdish population of Kars was Yezidi until their vast migration to Armenia at the end of the nineteenth century. According to my family, my paternal grandfather decided to settle down on the Ottoman side of the 'frontier' in the mid-nineteenth century. I suspect he was a Yezidi who had converted to Islam either by force or necessity when he chose to settle on the Muslim side of the border. However, the majority of his tribe remained in Armenia, and we have had no contact with them for some four generations. By virtue of my cultural affinity, this family 'history' had evidently played a significant role in my choice of university studies, centred as they were on the Yezidis.

The case of the Kurds of Armenia, and more particularly that of the Yezidis, merit some explanation. First of all, it is numerically a very weak community and almost exclusively of the Yezidi persuasion, because the Muslim Kurds have been mostly exiled, and occasionally, deported. The fact that Armenia remained part of the Soviet Union for almost eight decades needs to be borne in mind. This last was quite a precise political measure directed at the religious and ethnic minorities in order to bolster the identities of the non-Russian peoples of the Soviet Union exclusively through cultural events, while minimizing – indeed, even suppressing – all religious aspects. Moreover, as for those whom it was possible to divide, one from the other, either ethnically or on the basis of community as a result of religious or dialectical differences, the Roman adage 'divide and conquer' was immediately applicable. Indeed, up to the present day, the independent Armenian Republic continues to implement these selfsame measures. A good example of this can be seen in the Armenian state's encouragement of and financial support for two quite distinct radio stations: one aimed at the Yezidi Kurds and the other at the Muslim Kurds, even though these last are numerically almost non-existent in Armenia. This political will, which insists on the uniqueness of the Yezidis in relation to all of the Kurds, extends as far as the teaching of 'their' language in the public schools. However, this language (which is Kurdish) is called *Yezidiki* with the sole aim of distancing it totally from the Kurdish language, which is common to the two religious communities. Throughout my stay, during my different encounters with the Yezidis, I sadly had confirmation of the results of this approach; that is to say, many Yezidis of the Republic of Armenia regarded themselves as Yezidi rather than Kurds. Furthermore, within the entire community, I found that Yezidis in Armenia were less knowledgeable about their religion than those in Iraq. This ignorance took the form of a very evident syncretism with Christianity, to the extent that the Yezidis

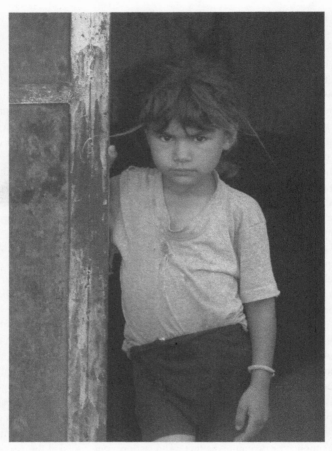

4 Yezidi girl, Hoktember, Armenia

would frequent Christian churches. It is important to clarify the differences between the Armenian and the Iraqi Yezidis: those from Armenia do not have their own place of worship, nor do they receive any educational support from the clergy. In addition, in the Yezidi dwellings, it is not uncommon to see pious images of Jesus Christ, the Virgin Mary and Zoroaster on the walls. Their funeral rites and new tombs are likewise similar in certain respects to the Armenian tradition. As to their differences with the Yezidis of northern Iraq – who do have certain gaps where their religion is concerned, but never with their Kurdish identity – those from Armenia are very often ignorant of their ethnical provenance. Their religious identity, itself at best approximate, remains

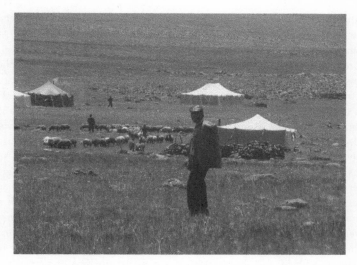

5 Nomads in transhumance, Mount Aragats (Armenia)

their sole point of identity. As to other differences, the Iraqi Yezidis are very clearly in favour of large families and politically pro-birth, whereas Armenian Yezidi families have relatively few children. This was indeed already the case during the Soviet era, but the tendency has become even more pronounced in the younger generation, who have on average two children, rarely three. Furthermore, marriage outside of the community – completely non-existent in Iraq – can be found here, although not to any great degree. The Yezidi women in Armenia also have more rights and social skills, a legacy perhaps of the communist era.

I arrived in Armenia at the very start of the month of July, during the period of transhumance. In fact, a lot of Yezidis live a semi-nomadic life for this reason as their summer pastures are situated at some considerable distance from the winter dwellings. On the day after my arrival, I went to a meeting of villagers on their annual migration in the pastures of the Aragats Mountain. I had at the time intended to remain there for at most two days in order to photograph them going about their the daily routines but, I hadn't factored in the ruggedness of the terrain or the absence of general transport, so I was more or less forced to remain there for five days in total. Nevertheless, in the end, I was quite content with my enforced sojourn as I had several very rewarding and enriching meetings with these drover families, who welcomed me warmly. I was lodged in the tent of a charming couple, Kibar and Rustem, and their little grand-daughter Armo. It would be euphemistic at best to say that their life was rustic and rough. The days were always fresh, but at nightfall, a dry cold easily penetrated the

tent. Thankfully, the traditional Kurdish covers, made of wool of sheepskin, retained the heat quite well.

Since I was a 'captive' and my photography work was at an end, I had the great pleasure of taking part in the daily domestic life of the couple who were putting me up. However, even the minor aspects of their daily routine were quite hard. At dawn, the women would rise to milk the cattle and after that prepare breakfast, which invariably consisted of cheese, yoghurt, eggs, bread and tea. Immediately after breakfast the men would leave the encampment with the cattle. The women would start the daily task of preparing butter and cheese with fresh milk. Done entirely by hand, this work is tiring and extremely time-consuming. Girls – some, such as nine-year-old Armo, very young – actively help their mothers and grand-mothers with this work. Observing them, I noted that there was already an adult-like seriousness discernible in the way they went about their work and in their appearance, as if their childhood was already at quite a remove. For the women, the evenings, too, are dominated by work; they are the first to rise in the morning and the last to go to bed at night. Almost by chance, by way of a rather banal conversation with Kibar, I discovered that she was originally of the same tribe as my 'famous' forebear. I was happy and excited at this discovery, but this simple woman was more discrete and expressed her joy far more reservedly, with what was an almost childish exuberance.

On the fifth day, at a point where I no longer believed that my departure would be any time soon, I was informed that a truck was on its way up the mountain and that later on, at about eight o' clock in the evening, it would come to get me – in fact, eight o'clock in the evening became midnight. The truck looked quite old, and one of its headlamps did not work. I was hoisted up into the back of it, where I found a dozen other passengers, all men and all drunk, the acrid smell of vodka confirming first impressions. Some were singing, others noisily discussing this or that, creating a total cacophony. At first, I was amused because they were gracious and friendly towards me, but the news that the driver was also drunk was neither reassuring nor amusing. Quite regularly, the truck would break down and everyone would get out either to push the vehicle or to give their opinion on how to fix the engine, undeterred by the fact that they hadn't got a clue what was wrong. On the steep tracks, almost in darkness, with the engine failing and the driver drunk, the truck nevertheless rolled along at some speed. Even though it is a funny anecdote, I would also like to use the occasion to talk about at what point the consumption of strong alcohol, particularly vodka, became as widespread among the Yezidis as among the Armenians. Like a lot of the other regions of the former Soviet Union, alcohol was a genuine national scourge here also.

After this somewhat hair-raising mountain adventure, the rest of my stay in Armenia, some twenty days in all, was spent visiting a large number of Yezidi villages

6 Yezidi woman with her daughter, Riya Teze (Armenia)

and an even greater number of settlements where the Yezidis lived with Armenians. My guide was an educated young Yezidi woman, Karina Usabian, from Yerevan.

In the northern part of Aragatsotn province, which is not very far from the capital of Armenia, Yerevan (although because of the mountains it seems remote), there are several Yezidi villages which in terms of authenticity are among the most interesting. It was there, at last, that I had the great good fortune to 'discover' the tombstones of the ancient Yezidi villages, which are sculptures of horses and sometimes rams. They are carved in the round and are erected only for those judged exemplary for their bravery or honesty. Alas, these days, the Yezidis have completely abandoned this style

of funerary monument which was uniquely their own. Their present cemeteries are indistinguishable from those of the Armenian Christians.

In concluding my impressions of the life of the Yezidis in Armenia, one interesting meeting perhaps best illustrates the complexity of their identity. I had arranged to meet a young Yezidi sheikh who was very cultivated, spoke several foreign languages and was a former student of Kurdish studies at the University of Moscow. He had also spent quite some time in northern Iraq, particularly in Lalish. It was there that he had received his first and only religious instruction. Unfortunately, as we talked, it became apparent to me that his recitation of dogma was very much akin to that which I had already encountered among the religious in the sanctuary at Lalish. My impression was that I was faced not with a mystic but with someone far too dogmatic. As we strolled through a vineyard which he himself had cultivated, he spoke about Yezidi ethnic identity in the same narrow-minded way. Despite his university background, he put forward some rather dubious theories: Yezidism was a nationality and not a religion, and this nation had existed since the prophet Moses. Its territory was vast, encompassing Iran, Iraq, Turkey, Syria and Afghanistan and had earlier been one country, namely the country of the Yezidis, Yezidikhane. Of course, the Kurdish people, as he saw it, had existed only for the last four centuries at most, and they were originally Yezidis who had converted to Islam.

I left Armenia and his Yezidi community with a genuine feeling of affection. They are undoubtedly a fierce, warm and hospitable people.

* * *

This time I decided to make a trip to northern Syria to meet the Yezidis of the Jazira and Kurd Dagh regions and then enter northern Iraq directly from Syria, killing two birds with one stone. It was May 2004. After a long trip from Damascus, I arrived in Qamishli and was brought up to date on the very delicate situation that existed there. In March 2004, following a rather ordinary brawl between Kurdish and Arab football supporters, the entire region had experienced particularly serious problems; the police as well as the army had intervened, and there had been several deaths and numerous arrests, resulting in a state of emergency being declared in the Kurdish region. As such, this rather banal skirmish between rival football fans had revealed the fire of discontent that smouldered there just beneath the surface. In Qamishli, a family welcome awaited me, courtesy of a Kurdish acquaintance in France. However, at the last moment, a telephone call alerted me to the arrest of a member of this family. I was advised against contacting them in case it compromised their safety and my own. Besides, all the hotels that had been recommended to me by friends living in Paris who were from the region were closed by the Syrian authorities. In addition to which, the Iraqi-Syrian frontier was also closed, and within the week would be open

only to Iraqis. It was clear that it was impossible to carry out research in the area under these conditions. Therefore, I decided to go to northern Iraq, which was my second destination of this trip. I contacted the office of the Kurdish Regional Government in order to ask for help in crossing the border. After a long conversation with the head of the office, it was clear to me that it would be risky to stay in Qamishli and riskier still to try to cross the Iraqi-Syrian frontier, and I was advised to leave Qamishli immediately. I didn't remain there another day; that afternoon I crossed the Turco-Syrian frontier and arrived in Nusaybin, where I stayed for one night; the following morning I took a bus to the Khabur gate and in the late afternoon reached Dohuk in northern Iraq, where I was welcomed by the family of the mayor of Simel, Mr. Majid Berwari, who very kindly put me up during my stay there.

Although I had encountered some difficulties at the border with the Turkish authorities, who wanted to know the reason for my trip to 'northern Iraq' and who made a point of checking my bags quite thoroughly, I must admit that it was the easiest way to cross the frontier into northern Iraq when compared with the other routes I had taken on previous occasions. On the other side of the frontier beneath the Kurdish flags and heading in a taxi in the direction of Dohuk, I took a deep breath and was delighted to be again navigating the serpentine routes of the Kurdish-speaking world. It was May 2004, almost two years to the day since my first visit to northern Iraq. This time, as an experienced traveller in the region, I was in possession of a letter from Dr. Saywan Barzani – the representative of the KDP (Kurdistan Democratic Party) in Paris – which allowed me to pass any checkpoints unmolested. If at any point the *Peshmerges* asked me for my passport, I just presented the letter instead.

The war was ruining Iraq. The Kurdish region, which was enjoying its autonomy to the full, was, however, also suffering the occasional terrorist attack at the hands of fanatical Islamists. Nevertheless, the entire region enjoyed a definite tranquillity – two years back, it had been much more difficult to travel. At the same time, the disputed province of Sinjar was reintegrated into the autonomous Kurdish region, although it continued to be very unstable as its status had still not been defined and it remained uncertain whether it would join the Kurdish region or Iraq. From a practical standpoint, therefore, my second visit to northern Iraq had been auspicious. The provinces and the villages, predominantly inhabited by the Yezidis, namely Sinjar, 'Eyn Sifni, Beḥzanê, Ba'shîqe and Bozan, which two years earlier had been inaccessible to me, were now no longer off limits.

On arrival, I was struck by the very visible changes in the appearance of the Kurdish villages. Essentially, in this very brief period, a frenzy of construction of every type had seized the country. Everywhere new buildings of every type glittered – schools, universities and even banks and residential developments had all been erected. The streets and the roads had been newly resurfaced and widened. Moreover, a considerable number of the vehicles were either 4x4s or vehicles of a similar nature. Nevertheless, in

parallel with this new, almost dazzling enrichment, the great poverty of a large part of the population was still also very much in evidence.

I had begun my research in the province of Sinjar, where somehow an feeling of constant rebellion seemed to hang in the air, a province that throughout Kurdish history had been known as a symbol of resistance. At the same time, these days, this province had a very heterogeneous population: Yezidi Kurds and Muslims as well as Sunni Arabs and Shi'ite Turkomans and finally, a minority of Assyro-Chaldeans, all lived there. During the actual conflict in Iraq, the population mix in the province of Sinjar played into the hands of all the extremist groups, who stirred up inter-ethnic and inter-religious rivalries and feuds and played upon nationalist and religious aspirations. I was continually escorted by three employees of the Yezidi association 'Centre of Lalish in Sinjar' during my research and travels in the province. When I arrived in the small town of Sinjar, the administrative centre of the province, I was astonished to see it in ruins, as if nothing had been rebuilt – indeed chaos seemed to rule, and it appeared as if the streets themselves no longer existed. Elsewhere in the Kurdish Autonomous Region, I had seen numerous women, veiled or otherwise, strolling through the streets; here, however, the town gave the impression of being nothing more than one grand barracks. The only rare female silhouettes that one could make out were those of mothers accompanied by their children, begging. The Kurdish and Arab men wore similar clothes and were indistinguishable but for the differences in the cut of their moustaches and beards.

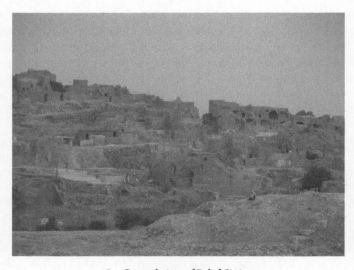

7 General view of Beled Sinjar

As for matters linguistic, the Kurmanji dialect of the Kurdish language is strongly influenced by Arabic in Sinjar. This linguistic 'Arabisation' is particularly marked amongst those living in the town; however, in the mountains and villages, the Kurdish language is quite vital and unalloyed. Equally, from a sartorial point of view, the Kurds who live in the rural heart of the province are much more traditional – the Yezidi men wear their hair in long plaits, while the women are recognisable not only by their white clothing but also by the veil, which covers their hair but never their faces. A large part of the province, though, appears to be deserted. The inhabitants of the area told me that in 1974 the Ba'athist regime had amalgamated several traditional Yezidi villages into one; now, after the destruction of the original settlements, this new artificial creation persists, expansive and lacking in any cultural or historic references. I visited two of these 'new' villages and found that, despite the recent phase of construction, they did not have access to either power or running water. In some respects, these ill-conceived and poorly constructed agglomerations seemed provisional; even though three decades had passed since their initial construction, their inhabitants still seemed ill at ease living there and appeared not to have made them their own.

In fact, one must travel quite some distance into the mountains to find Yezidis who remain faithful to the nomadic way of life, but one does so, not along roads, but rather on paths, at the edges of which Yezidi cemeteries can often be seen. Their tombs, with their square shape and ribbed conical domes, are identical to those of the region of Sheikhan and the twin districts of Beḥzanê and Ba'shîqe.

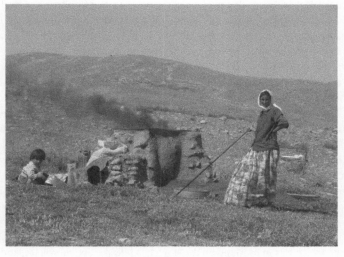

8 Nomads in the mountains of Sinjar

I insisted that my guides bring me somewhere more traditional, a place that had maintained the typical aspects of Yezidi life, and Karsi – a village we visited en route – fulfilled that wish. It was one of those rare places which had somehow escaped the folly of the Ba'athist destruction and had retained all the architectural charms and style of the traditional Yezidi way of life. What made this village even more original and interesting was the fact that it was inhabited almost exclusively by members of one great family, all belonging to the brotherhood of feqîrs. In the company of my guides I was received with honour in the 'reception' hall, where we were welcomed by a dozen religious men, all dressed in a similar fashion. Nevertheless, the first few moments of our meeting were intimidating, indeed, even vexing. None of them shook hands with me in the same way that they did with my guides, all of whom were men, and their eyes did not even meet mine. Indeed, I did not experience any introductory formalities until such time as the reason for my visit as well as the benefits which might accrue to the community from it were explained. The features of their long weather-beaten faces and the shape of their beards and moustaches left no doubt as to their kinship. Women were conspicuous by their absence, and I was acutely conscious of the honour they had accorded me. However, once the inevitable tea was being served, the conversation promptly became lively and animated. I provoked it somewhat with a rather anodyne question about why the Yezidis smoked so much. In this not very large room my hosts had been smoking their cigarettes continuously and during our conversation, taking place under a thick cloud of smoke, it had been the first thought to enter my head. Imagine my surprise when I heard them reply quite seriously and with some passion that Tawûsî Melek himself had prescribed the practice. Not for the first time, I found myself faced with people who were supposedly educated and informed when it came to religious matters, supposedly trustees, but whose explanations left me somewhat uncertain when confronted by such naiveté.

During my week-long stay in Sinjar I visited ten villages located in the mountains where the mausoleums of Yezidi saints were situated. These mausoleums had all been destroyed during the campaign of the 1970s and only recently restored by the Yezidis themselves. On each occasion, having arrived with my guides at the summit of a mountain on foot – the terrain made driving beyond a certain point impossible – in order to sketch and photograph these buildings, I was invariably disappointed by the poor quality of the restoration work, which had attempted to make each one look new.

I continued my work in the Sheikhan region in the village of Bozan. After Lalish, the most interesting village, famous for the richness and antiquity of its mausoleums and shrines was Bozan, located an hour's drive from Dohuk city, where I stayed for three days in order to photograph, draw and measure its buildings. Whitewashed mausoleums and shrines were scattered throughout the village itself as well as in its cemetery, which was to be found on the slope of a hill, skirting the village, and which encircled exactly thirty mausoleums and sacred enclosures. In addition to the classic

9 General view of the mausoleum of Sheikh Abū'l Qasim, Sinjar

mausoleums containing the remains of the dead, there were also open-air altars, where one could venerate Ḥasan al Basrī (the great eighth-century Arab Sufi), Sheikh ʿAdī as well as the archangels Jibra'īl and Israfīl or ʿEzra'īl. On the third day, I started to work on some of the mausoleums in this same village. I noted that all of the Yezidi villages contained these mausoleums, which also functioned as small 'chapels' around which the faithful gathered daily at all hours to pray.

On one particular day, totally engrossed in the work I was doing near one of the shrines, I didn't notice that a large group of observers had gathered around me, and I was startled by their murmuring; raising my head, I could not believe my eyes – a large group of men, women and children of all ages were watching me closely, squatting or sitting on the ground, while others watched from the flat roofs of the houses, quietly and respectfully exchanging comments and opinions. I was torn between a sense of amused surprise and the most awful agoraphobia. However, there was no sense of hostility and I understood perfectly well that for the majority of them, this certainly was the first time that they had seen a foreigner, dressed in such an 'exotic' manner and so interested in things which to them were utterly banal.

To the north of Mosul is the district of Beḥzanê and Ba'shîqe. Yet, it has the appearance of a town, nestled as it is in a valley at the foot of Maqlūb Mountain. Two quite distinct parts from which the district gets its name make up its population; Beḥzanê is the old part, whose traditional white and yellow houses surround the high walls, Ba'shîqe is the new part – indeed one might say modern section – with its straight

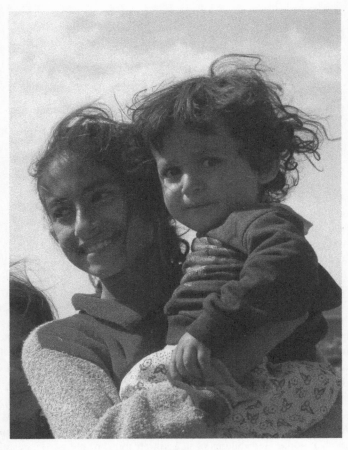

10 Yezidi children in Bozan

rectangular streets bordering the often multi-storied houses made of concrete. On the small hills, and acting very much as a buffer zone in the middle of Beḥzanê, is an area reserved exclusively for mausoleums. Here the exact same classic Yezidi design is in evidence with its typical conical domes. Unfortunately, all of them had undergone a little too much restoration. The distinctive characteristic of each mausoleum, however, is its peristyle, and these contain numerous tombs. A further distinctive characteristic of the area, unique within all of northern Iraq, is the language, as some of the Yezidi inhabitants, who are from the Tazhi tribe, speak Arabic as a mother tongue. Some of them continue to define themselves as Yezidi Kurds, but there are also those who consider themselves Arab. There are two plausible explanations for

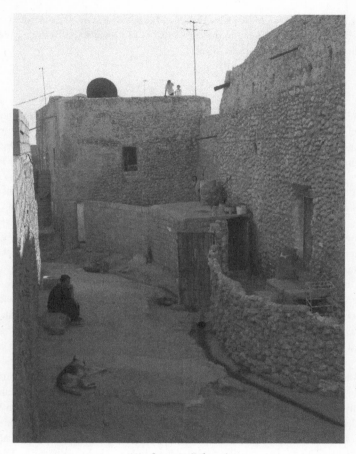

11 Street in Beḥzanê

this, which comfortably co-exist and indeed even complement each other. The first is that it is the result of a long slow process of Arabisation, and the second is that they are descendants of a main Arabo-Yezidi community, which can trace its roots to the era of Sheikh 'Adī, who was himself descended from an Arabo-Muslim community.

As to the relationships between men and women, a rather amusing anecdote will, I think, serve to highlight the point at which they become somewhat delicate and how they are regulated by quite strict customs. In this large town there were a few small places which vaguely resembled restaurants. I wanted to have something to eat in one of them with my guide from the Yezidi cultural centre of Ba'shîqe, Khidir Kh. Behzani, but he told me rather embarrassedly that women here, even those accompanied by

men, could not eat in a public place. However, I insisted, and finally, according to my guide, became the first woman in the entire history of Beḥzanê and Ba'shîqe to sit at a 'restaurant' table in their glorious town.

* * *

Towards the end of my sojourn in northern Iraq in June 2004, I learnt that the situation had improved for the Kurds in Syria, especially in the region of Kurd Dagh, which is located between Aleppo and the Turkish border. I left northern Iraq behind me by crossing back over the Turko-Iraqi frontier and travelling until I reached Kilis in Turkey, where I once again entered Syria and arrived in Aleppo.

Aleppo, like almost all ancient and cosmopolitan Middle Eastern towns also has its ethnic and religious quarters; here they are Arab, Kurdish and Armenian, and the Yezidi community evidently inhabits the Kurdish quarter. On this occasion, I had managed to secure lodgings with a Kurdish Muslim family. The Aleppo Kurds maintain not just professional but also friendly contacts with each other irrespective of religion. They have created a community which is cognisant of its own Kurdicity, while the religious element remains part of the private domain. The following morning I returned to the home of a Yezidi family and it goes without saying that the welcome was warm, but I was pleasantly surprised to see for the first time since the start of my travels men and women in a Yezidi house sitting down together and talking in a relaxed manner. The women were casually dressed and besides this the mistress of the house was rather chatty and extroverted and did not hesitate to interrupt her husband, who was not offended by her frankness. After the meal, we went towards Afrin to the north of Aleppo, on the Turkish frontier. This hilly and verdant region is almost exclusively populated by Kurds, of whom a sizeable minority is Yezidi. In Afrin I was introduced to an eminent Yezidi, Mahmud Kelesh. I had, for the first time, an exchange of ideas which went beyond the usual stereotypes. I had been taught that the rules of the caste system were less strictly adhered to here and that marriages between different castes were thus fairly frequent, something completely unthinkable among the Yezidis of Iraq. When I outlined these points to him, which were in apparent contradiction to the official hagiography of Sheikh 'Adī, who as an Arabo-Muslim was considered to be a reformer of the Yezidi religion, he answered me patiently, without showing the least surprise. He defended the traditional thesis of Yezidism, which said that Sheikh 'Adī had come from a Kurdish family from the area of Hakkari and that the family had been exiled to Lebanon following the murder by the head of the family of two Christian monks from Lalish. Here, Sheikh 'Adī had supposedly started to study Islam. With the rise of Abbasids, Sheikh 'Adī turned back to his natal place in the area of Mosul, where he established a religious school. According to my interlocutor, Sheikh 'Adī apparently went to Lalish with the specific intention of converting the members of his family

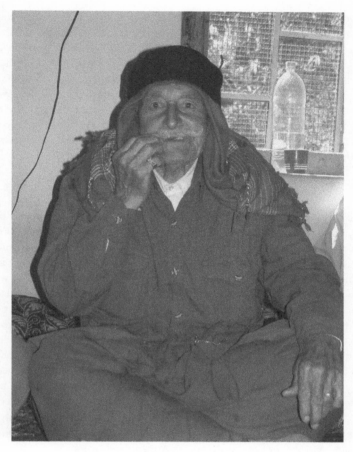

12 Old man, Afrin, Syria

who lived there to Islam. Instead of the hoped for conversion of the Yezidis, it is he himself who abjures his faith and converts, following the Miracle which gave rise to the Zemzem source.

After many similar meetings and conversations, it was abundantly clear to me that Yezidism is very much reliant on an oral tradition, which is somewhat vague as to the genesis, history and evolution of its current form.

Unfortunately, unlike the many vestiges of the Greco-Roman era (such as Ain Dara, Deir Samaan and St. Simon), the Yezidi architectural patrimony just does not exist. Nevertheless, in several villages I took the opportunity to visit some Yezidis in

their houses. Some Yezidi villages are located on ancient Roman sites, such as those in Brad. The walls of the houses as well as of their courtyards were built of these spolia materials and in some places these beautiful buildings had even been transformed into stables. I found myself wondering again and again if they knew anything at all about the rich heritage that lay all around them. Everything I saw suggested they didn't and that it concerned them only in so far as it served their immediate needs. That evening at sunset, these same ancient stone buildings took on the colour of fire, which reflected off the faces of the children who were playing in the ruins. Entranced by the colours of this magical scene and the smell of the countryside, I felt that making conversation with my guides was impossible.

* * *

Although the eastern territory of the Turkish Republic was populated mainly by the Kurds, it was very heteroclite. Until the end of the nineteenth century, thanks to the meticulous Ottoman administration, which took regular censuses of the population, it is possible to obtain a clear idea of the ethnic and religious make-up of the area – stretching back some four centuries. Apart from the Kurds, Armenians as well as Assyro-Chaldeans, Greek and Jewish minorities were also to be found in many places in this region. Yezidis, on the other hand, were never recognised as a distinct group from their Muslim neighbours, although the Ottoman archives, the local writings, as well as the accounts of western travellers testify to their considerable presence. This religious and ethnic diversity almost disappeared with the first pogroms which took place at the end of the nineteenth century and the beginning of the twentieth century, particularly as a result of the oppression that they suffered under the Hamidiye Cavalries, which, in its ferocity, swept away with it the other minorities. Important Kurdish cities such as Van, Bitlis, Doğu Beyazıt, Kars and Erzurum witnessed the exodus of not only their Armenian inhabitants but also many of their Yezidi residents at the same time and these latter settled elsewhere, particularly in Armenia and Georgia.[6]

These days, the Yezidi community of Turkey living around Urfa and Mardin is quite simply on the verge of disappearing altogether. This exodus appears inexorable and is directed especially towards European countries, particularly Germany. This mass movement of people can be attributed to a variety of causes and difficulties – political, religious and economic – and cumulatively they are potent forces for change indeed.

I chose as my first destination Diyarbakir in the Kurdish region of Turkey, where I would carry on my research in August 2005. Although I knew that no Yezidi remained in Diyarbakir, except for a few families in the small town of Çınar nearby, in order to gather any information of value about the Yezidis of the region, I hoped to meet people who had previously written about the Yezidis or were interested in Yezidism. In

addition, I wanted to visit the Diyarbakir Archaeological Museum – Diyarbakir itself is situated on the banks of the Tigris River and encircled by a citadel – to carry out a comparative study of the zoomorphic tombstones, horses and rams seen here and those of Yezidis in Armenia. En route, our coach was stopped several times by Turkish soldiers checking passengers' identity cards, and these stops became more frequent as we approached Diyarbakir. It was my first trip to the city, and I was thrilled to be there. In fact, Diyarbakir has a history. When Ottoman Sultan Selim I organised a military campaign against the Safavids in 1514, he entered into an alliance with the Kurdish chieftains against the Safavids. These chieftains accepted Sultan Selim's offer on the condition that he recognise their authority as local rulers and that, thus organised, they would come under Ottoman protection. With this agreement, all the major and minor Kurdish chiefdoms were organised under the province of Diyarbakir (Amid) in 1515; ever since then Diyarbakir has served as the Kurdish capital. Latterly, during the conflict between the Turkish army and PKK (Kurdistan Workers Party) militants, the population of the city grew dramatically as villagers left or were forced to leave their villages and settle around the city itself. As a result poverty and disorder in most parts of the city were very much in evidence. On the other hand, I observed that the municipality was making great efforts to create parks and restore ancient buildings for the use of the general population, and many traditional houses had also been transformed into cultural centres. Furthermore, some streets had been closed to vehicles and were now surrounded by book stores, art galleries and coffee shops, as was the case with Street of Art (*Sanat Sokağı*), which intellectuals and students frequented. During my interviews, I was able to confirm that there were many Kurds in Diyarbakir who wanted to convert to Yezidism.

I also visited several Yezidi villages in the Tur 'Abdin region, more precisely in the area of Viranşehir and Midyat, the majority of which have been abandoned and lie in ruins, but of late, the Muslim Kurdish population has settled in some of these areas. During my visits to this region, I was accompanied by the families of friends living in Europe. Thus, my trips were made easier. The Yezidis treated me as if I were from the community, and they were relaxed and open about talking to me.

In Viranşehir, it was quite surprising to see how the town's appearance matched its name – Viranşehir in Turkish meaning ruined city – and there was, in fact, nothing very particular about Viranşehir's planning, layout or architecture. It is a large, concrete town, located on an open plain where only the remnants of a pillar from a Byzantine Christian structure of the fourth or fifth century and some destroyed traditional houses stood. M. Ali Hançer, a French language teacher from the town, was kind enough to accompany me and show me around. The day after my arrival, we travelled to the village of Burç, which was the second biggest Yezidi village in the region. Fifteen families were still living there, and they were from the Sîpkan tribe, who make up the murîd caste in the Yezidi hierarchy. The majority of the tribe, which converted to Islam

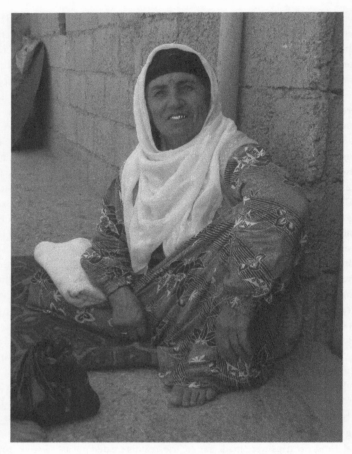

13 Woman with tattoo, Viranşehir (Turkey)

some time ago, were living in Ağrı (Ararat) and Doğu Beyazıt. We were welcomed by the headman of the village, İbrahim Agha, in his garden and served cold drinks in the shadow of the trees. While we were conversing with a group of men and women, I was attracted by the women's tattoos, which almost covered their hands and some of their face. I inquired if it was a Yezidi tradition, but they replied that it was regional. Indeed, the ethnic and religious groups in Viranşehir were continuing a tradition which was African in origin but had arrived in Viranşehir with the Arabs. However, they observed that the younger generation was less inclined to maintain it and that it did not have any religious or symbolic meaning but was rather a sign of beauty.

Afterwards, we went to visit the village of Oğlakçı, near where Sherkiyan's tribal members were living. Only five Yezidi families remained there, the rest having emigrated to Germany, and the village looked empty and abandoned as a result. I also visited the cemetery in the hope of finding some authentic materials for my research. On arrival, I was informed by a Yezidi that the tombstones belonged to the family members of the famous Derwêshê 'Êvdî – one of the national heroes of the Yezidis, famous for his tragic love for his chief's daughter, a Muslim Kurd. Songs about his story are still sung today. It was in this cemetery that I came across a number of high rectangular tombstones, and in several cases there were lion-shaped stones on the tombstones as spolia – nobody knew whether these sculptures were originally from this cemetery or had been brought from somewhere else. Unfortunately, the cemeteries which remain are the only Yezidi sites in the region and do not evince the characteristic style which one sees in Iraq and Armenia.

Midyat has a very mixed population, the majority of whom are Syriac, intermingled with Kurds, Arabs and Turks. The ancient part of the town attracts one's attention with its fine stonework houses, churches and mosques, some of these houses having been transformed into government buildings, as well as its small, narrow streets lined with artisan silver shops. Indeed, Midyat is generally recognised as one of the main centres for silver works in Turkey. With my guide, Resho, I visited a Yezidi family who unlike so many others, had remained in Midyat. An old, sad-looking woman in red welcomed us in her garden. She was not talkative but was nonetheless very hospitable and proceeded

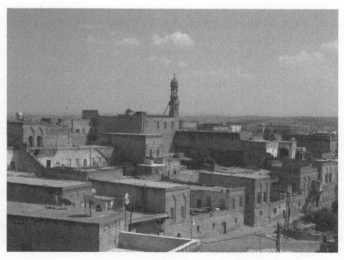

14 General view of Midyat (Turkey)

to inform me that she and her husband were the only ones who lived there as the rest of her family had emigrated to Germany – her loneliness and sense of abandonment all too sadly evident. Afterwards, we took a mini-bus, or '*dolmuş*' to the Yezidi village of Çayırlı, where we were welcomed by a Yezidi family who live in Germany but spend the summer season in their newly built, modern-looking house in the village. When we were served the famous Midyatian melons on their balcony from where we could see the steep, bare, brown hills surrounding the village, we were joined by a group of men. Most of my questions were directed at my host, who seemed to hesitant to answer even the most banal and simple questions about the Yezidis of the region. Later, when I went inside to chat with the hostess, who had not joined us, as the men were foreign, she hinted that the men who were accompanying us were the village guards or '*köy korucuları*' and advised me to be careful not to ask too many questions for my own and their safety. Village protectors are local Kurdish men who have been armed and paid by the Turkish government since 1982 in order to act against the PKK and Kurdish activists. When I rejoined my male companions, I didn't ask any more questions but rather tried to converse with them about the most inconsequential of things. When we left the village without incident, Resho and I breathed a sigh of relief. In addition, I had the chance to chat with the children of the family in the kitchen, who did not know any Turkish but spoke Kurdish and German. However, Resho, my little guide, who was only fifteen years old, was fluent in four languages, all of which are spoken in Midyat and its surrounding area: Kurdish, Turkish, Syriac and Arabic. When I asked how he had learnt so many, he replied that he spoke Kurdish with his family, Turkish at school and Arabic and Syriac with his friends from those communities. I was amused by the diversity of this small town and the tolerance of the various communities towards each other, all living side by side in apparent harmony.

My next destination was Van, which is next to Lake Van, near the Turkish-Iranian border. Van used to be inhabited by a big Yezidi population until their departure to Armenia. Any memories of the Yezidis had long since been lost as those who had lived with them throughout the chaos of the late nineteenth century were now all deceased. No Yezidis remained in Van, nor indeed was there anyone who knew anything about them. I started my work by visiting the archaeology museum, where I researched on the animal-shaped tombstones displayed in the garden. Apart from one, which was a horse, they were exclusively in the form of rams and ewes, cut from different materials and brought from various villages and towns surrounding Van. I asked whether there was any horse sculpture in situ in the region that I could visit and learnt that there was only one, located in the village of Hespê resh/Black horse (Tekindere in Turkish), the Kurdish name having been derived from the sculpture itself. However, I was advised not to go there as one of the museum's employees had almost got killed by the inhabitants of the village when he had gone to examine it. According to the museum staff, the villagers believed that there was gold inside the horse and so did not let anyone from

outside the village approach the sculpture – wisely, I abandoned the idea of going there. Instead, I went to meet the academic staff from the Archaeology and Art History department of the University of Yüzüncü Yıl, where I hoped to get some information about these zoomorphic tombstones and buildings, which had probably formerly belonged to the Yezidis. Alas, I was somewhat taken aback to discover a surprising level of ignorance and indifference on their parts in relation to the Yezidis.

As it turned out, Van was the only place where I did not have a guide to accompany me. It was not a problem to stroll alone in the city centre; nevertheless, I most certainly would have run into difficulties had I chosen to travel to nearby towns and villages by myself. However, having decided to take a ship to view the famous Armenian church of Akhtamar on a nearby island, I was lucky to procure a new guide; the captain of the ship, Captain Mustafa, volunteered to fulfil that role – I was saved. I had found that when I was accompanied by a local person, especially a male, it made my travels in the region much easier and less risky.

So, in the company of my new guide, I visited the Hoşav (Khoshāb) castle, which is situated between Van and Başkale. Originally an Urartian castle, it was rebuilt in 1643 by the Mahmudi tribe, who were originally Yezidi but had partly converted to Islam in the fifteenth century and who had been in possession of the castle until the mid-nineteenth century. On arrival, I found this splendid monument closed to visitors because of restoration work; however, we managed to gain access to it and strolled around the interior, undisturbed by crowds of tourists.

Although I had wanted to finish my travels with the city of Kars on the Turkish-Armenian frontier where the Yezidis had once also lived, I did not have the energy for it, as three weeks of constant travel at the hottest time of the year had left me drained and more than a little ill, and so I took a coach from Van to Ankara instead of Kars. However, to content myself, I bought a copy of Orhan Pamuk's *Snow* (*kar*) – whose story unfolds in Kars – to read on the long voyage to Ankara.

Geographical Location and Distribution

Today Yezidis live in northern Iraq, Turkey, Syria, Iran, the Republic of Armenia and Georgia as well as in Europe and the United States. They live principally in northern Iraq in Sheikhan, Sinjar and Beḥzanê/Ba'shîqe as well as in the villages located around the city of Dohuk. There are 57,000 inhabitants in the region of Sheikhan; 50,000 in Dohuk and 15,000 around Tel Kef; 300,000 Yezidis live in the province of Sinjar, forming 60 per cent of the whole population. Muslim Kurds (20 per cent), Arabs (12 per cent), Turkomans (6 per cent) and Christians (2 per cent) compose the rest of the inhabitants. Furthermore, there are 30,000 inhabitants in Beḥzanê/Ba'shîqe and 51,000 in the north of this twin town[7]; 15,000 Yezidis live in two big Iraqi cities, Mosul and Baghdad. The total estimated Yezidi population in Iraq is 518,000 (Map 1). The second big zone of

the Yezidi population, about 60,000 individuals, is in Transcaucasia, especially in the Republic of Armenia, Georgia and some frontier regions of Azerbaijan.[8] In Armenia, the majority live around Aragats Mountain and on the plain of Ararat. The villages which are purely Yezidi are located in the cities of Aragat, Talin, Aparan and Ashtarak in the region of Aragatsotn, as well as in Echmiadzin and Hoktember in the region of Armavir. A small group of Yezidis live in the capital city of Yerevan (Map 7). In Georgia, they live in Tbilisi and Telavi. According to the census of 2000, there are only 423 individuals who remained in Turkey,[9] a group which was very important in the past but the majority of them quitted their homeland and moved to European countries because of the political and economical conditions as well as religious repression (Map 5). Today the estimated Yezidi population in Syria is 15,000 (Map 6).[10] The Yezidis of Iran, because of repression by Iranian Shi'ite authorities, do not declare openly that they are Yezidi. To our knowledge, the majority of them live around Kirmanshah. The majority of Yezidis living in Europe are located in Germany, numbering around 25,000. They live especially around the federal cantons of Niedersachsen and Nordrhein-Westfahlen, and have a strong presence in Oldenburg, Hanover and Bielefeld.[11] There is a smaller Yezidi community in Holland, Denmark, Sweden, Belgium, France, Switzerland and the United Kingdom as well as in the United States, Canada and Australia. However, because of the lack of a census, it is almost impossible to give an exact number for the Yezidi population in the world. Nevertheless, their estimated number across the world is around 600,000–620,000, about 2 per cent of the total Kurdish population. The Yezidis speak northern Kurdish dialect, the Kurmanji, with the exception of some inhabitants of Behzanê/Ba'shîqe, who speak Arabic but utilise Kurdish as the language of prayer.

1

Origins, History and Development

The religion of the Yezidis was transmitted orally, and its characteristic elements derive from its oral character. Myths, folk legends and hymns memorised by the men of religion or qewwals have been transmitted from generation to generation since time immemorial. Although some sacred texts were first published at the beginning of the twentieth century,[12] and although some Arabic[13] and Syriac[14] sources refer to events at the time when the Yezidi community first emerged, almost nothing is recorded about the history and beliefs of the first Yezidis. Thus, their origins are still uncertain and scholars have various and contradictory theories about the roots of the Yezidi religion.

Yezidis define themselves as Êzîd, Êzî or Izid. This may derive from *Yazad, Yazd* or *Yazdān* in Middle Persian and Kurdish, meaning (یزدان) *Yazdān* 'God' or (ایزد) *Izid/ Izad* 'Angel' in New Persian. The verbal root *Yaz-* means 'to worship, to honour, to venerate' and becomes the noun *Yazata*, 'a being worthy of worship' or 'a holy being' or 'a being worthy of sacrifice'.[15]

Some scholars have thought that the Yezidis derive their name from the Zoroastrian city of Yazd in Iran, where fire is still worshipped, a reference to 'Ahura Mazdā/Ohrmazd', the principle of Good in opposition to 'Angra Mainyu/Ahriman', the principle of Evil.[16] Moreover, a current popular etymology derives the term *Yazdan* from *ez da*, meaning 'I was created' in Kurdish.

Many Yezidis believe that Yezidism is the most ancient Middle Eastern religion, one whose origins are lost in antiquity. They believe that the entire Kurdish population was once Yezidi, until repression and massacres forced them to convert to Islam, so

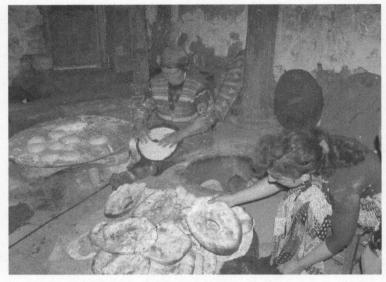

15 Women making bread, Derik, Aparan (Armenia)

that only a small number resisted and remained faithful to their original religion, Yezidism.

Arabic speakers, however, derive the word *Yezidi* from the name of the Umayyad caliph Yazid ibn Mu'āwiya. Some western scholars support this theory.[17] Yazid, who reigned in 680–83, is associated with the murder of the Prophet's grandson Hussein ibn 'Ali in 680 and also with the sack of Medina, where he is said to have killed eighty Companions of the Prophet. He is, therefore, little appreciated by Sunnis and detested by Shi'ites. It is suggested that Yezidis took his name in order to protect themselves from persecution by Muslims by claiming to be the descendants of a noble family.[18] Some scholars[19] assert that the name of Yazid was given by orthodox Muslims to renegade tribes as a sign of reproach, and it is also said that the Yezidis are *murtaddūn* – apostates, infidels or renegades – because they first accepted Islam and afterwards renounced it.

Some western writers have suggested that the Yezidis were the followers of the Kharijite Yazid ibn 'Unaysah, who were attracted by Sheikh 'Adī's reputation and took him as their religious chief.[20] Alternatively, the Yezidis were said to derive their name from Jabir b. Yazid al-Ju'fi (d. 128/745), a Shi'ite scholar from Kufa, also known as Abū Sabrah Yazid, who played a crucial role in the Arab conquests of Iraq during the reign of 'Umar and who probably settled in northern Iraq.[21]

Some Yezidis called themselves Dāsinī or Dāsin, a name derived from a Kurdish dynasty of the Hakkari region; today they are entirely Yezidi. According to one eastern Christian tradition, Dāsenī or Dāsaniyat is the name of one of the churches of the East (Nestorian) dioceses, a church which disappeared when the Yezidis first appeared. Another Christian tradition suggests that the Yezidis were originally Christian but were reduced to their present condition at the beginning of the twentieth century by ignorance.[22] It may be that the eastern Christians came to this conclusion because, like them, Yezidis practise baptism and consume wine and other alcoholic drinks. In order to support their claims, local people of the Church of the East assert that Sheikh 'Adī was Addaï, the legendary Christian Apostle of Mesopotamia. This idea may correspond to the tradition that the sanctuary of Sheikh 'Adī at Lalish was originally a monastery.[23]

Yezidis in Mesopotamia and Anatolia

The *Kitāb al-Ansāb*[24] of 'Abd al-Karīm al-Sam'ānī (d. 563/1167), a contemporary of Sheikh 'Adī, is the earliest source to mention a community called al-Yazīdiyya in the region of Ḥulwān[25] in northern Mosul in the twelfth century.

> ... A large group of them whom I met in Iraq in the mountains of Ḥulwān and in the vicinity of al-Yazid. They lead an ascetic life in the villages of those mountains. They live on *al-hāl*.[26] Rarely do they associate with other people. They believe in Yazid ibn Mu'āwiya and that he was righteous. I saw a group of them also in the mosque of al-Marj. I heard that al-Ḥasan ibn Bandār al-Bardajūdī, a learned man who had travelled widely, visited them once in Sinjar and went into a mosque of theirs. One of the Yazidis asked him 'What do you think of Yazid?' 'What would I say (but good) of a man who was mentioned several times in God's book where it is said "he increases unto people as he pleases" and God increases the righteousness of those who have found the right path', said I. They showed great generosity toward me and gave me plenty of food. There is another group, a Khārijite one, also called Yazīdīyah. They are the followers of Yazid ibn 'Unaissa, who, as it is said, preceded Nāfi being at the head of the first Mahkamah ...

Furthermore, in 1324 Abū Firās 'Abd Allāh ibn Shibl described Yezidis as lovers of Yazid in his manuscript *Al-Radd 'Alā al-Rāfidah wa'l-Zaidiyyeh.*[27]

> A righteous group of the Sunnis who live in the Furāt (Euphrates) district ... had visited me and informed me that various misleading innovations had been introduced in their district such as those who adhered to the Rafiḍa and to the Zaidiyyeh. Another sect adopted the idea of the ignorant Adawite Yezidis

and each of the latter two sects stand in the extreme in their opposition to this one ... These Yezidis were misled by Satan who whispered to them that they must love Yazid, to such an extent that they say we are justified in killing and taking the property of whoever does not love Yazid, and that to pray under the leadership of an imam is a forbidden act; so they ceased to join Friday prayer, but most deviant one of them was Ḥasan bin 'Adī ... I had argued with them about their false claim of the love of Yazid.

This would suggest that a movement known as the Yazīdiyya, whose followers supported the Umayyad cause and sympathised with Yazid ibn Mu'āwiya, already existed in the Kurdish mountains before Sheikh 'Adī.

The last Umayyad ruler, Marwan II (744–50), was half-Kurdish[28] and ruled the region of Jazirat ibn 'Omar. After the fall of the dynasty, some of its descendants remained in the Kurdish mountains and were welcomed by the Kurds, who had an excessive devotion for this dynasty.[29] The Sufi sheikhs 'Uqayl al-Manbijī and Abū'l-Wafā al-Ḥulwānī, whom Kreyenbroek identifies as descendants of the Umayyads, came from this region and four centuries later formed the mystical religious movement that attracted Sheikh 'Adī.[30]

There were also local tribes who continued to practise pre-Islamic Iranian religions in the same region at the same time. Gregorius Bar Hebraeus (d. 1286) gives a description of the Taïrahite Kurds and their beliefs in his *Chronicon Syriacum*.[31]

In the year of 602 of the Arabs (18 August 1205–8 August 1206), the race of those Kurds who are in the Mountain of Maddaï (near Ḥulwān) and who are called Taïrahites came down from the mountains and caused much destruction in those lands (near Mosul). The Persian troops united against them and killed many of them. Taïrahites did not follow Islam but persisted in their original idolatry and the religion of Zoroaster.[32] Besides, there was mortal enmity between them and the Muslims.

The same source differentiates Yezidis from Muslim followers of Sheikh 'Adī.[33]

... When, in the beginning of November, Yezidis on the way from Zozan passed by 'Adī, the son of their emîr, with rich presents and gifts, 'Adī rewarded with food and drink and every kind of festivity. These people liked to drink excessively. They numbered about 650 tents, not counting the men of 'Adī, who were Muslims, and the Taïrahite Kurds who numbered more than 1,000 tents.

The Shafi'i scholar Ibn Kathīr (1301–73) mentions the presence of a people called Tirhiye, who were Magians, in the territories where the Yezidis live today. According

to him, the new generation had forgotten their ancient religion, Magism, and begun to accept another religion, a hybrid with Islam.[34]

The 'Adī mentioned by Bar Hebraeus was the descendant of Sheikh 'Adī, a learned Muslim intellectual of the twelfth century who studied with many famous mystics in Baghdad. Amongst them were 'Uqayl al-Manbijī and Abū'l Wafā al-Ḥulwānī who, as we have seen earlier, came from the Kurdish region. This connection may explain why Sheikh 'Adī left Baghdad in the early twelfth century and established his own *zāwiya* (convent of dervishes) at Lalish. On their arrival, the 'Adawis found a peasant community, whose beliefs may have been a mixture of ancient Iranian beliefs, such as Zoroastrianism, and veneration for Yazid ibn Mu'āwiya, and who were in need of a saviour. With time, the Miracles and the ascetic lifestyle of Sheikh 'Adī and his disciples established the reputation and status of his order. Just as the 'Adawis influenced the local peasantry, so did their heterodox beliefs and practices little by little impregnate the doctrine and teaching of Sheikh 'Adī. After the death of Sheikh 'Adī in 557/1162, his tomb became a place of pilgrimage for both Muslims and non-Muslims. His descendants continued to venerate him and turned the *qibla* towards Lalish, away from Mecca.[35] Continuing syncretism between Sufi Islam and ancient Iranian religions developed into a kind of synthesis of belief which definitively distanced the religion of Sheikh 'Adī's followers from orthodox Islam. This process of transformation and affirmation seems to have lasted for some three centuries, from the death of Sheikh 'Adī (1162) until the fifteenth century, when Yezidism is first represented as a religion distinctly different from Islam.

The question is why were the members of the 'Adawiyya order influenced by local Kurdish practices and attitudes. According to scholars,[36] several factors explain this development: the dominant influence exercised on the community at Lalish by a significant number of Kurdish adherents of an older faith; the isolation of the remote Lalish valley, which cut off the 'Adawiyya community from the teaching centres of orthodox Islam; and the tendency of Sufi orders to emphasise the experiential, emotional side of religion rather than dogma.

However, according to a Yezidi tradition, when Sheikh 'Adī arrived in the region, there was a group of local people called Shamsani, from whom the current Sheikhly family of Shamsanis traces its descent and who were originally Manichaeans[37] and worshippers of the sun.[38] They were attracted by Sheikh 'Adī's (d. 1162) influential personality and his mystical ideas, which were in tune with their own beliefs. Thus, they developed mutual co-operation and defended against their common enemy, the Abbasids.[39] The disciples of Sheikh 'Adī, 'Adawis, were practising Islam, while Shamsanis were practising their own Iranian religions; the two sects, however, allied with each other politically and, because of Sheikh 'Adī's diplomatic approach, united peacefully. With time, the Shamsanis' practices began to penetrate into those of the

16 Sheikh effectuating a fire ritual, Bozan

'Adawis as they accepted Sheikh 'Adī's teaching. Shamsanis gradually became powerful to the extent that Sheikh 'Adī nominated their leader as his assistant, granting him the status of sheikh al-wezir (minister sheikh). In this way, he would balance both communities' interests.[40] The sheikh al-wezir still represents the Shamsani family in the Yezidi hierarchy and is a deputy (*mendûb*) to the mîr in Sinjar.[41]

Sheikh 'Adī had no children and, before he died, appointed as his successor his brother's son, Abī 'l-Barakāt b. Ṣakhr, who had come to join the 'Adawis from Beit-Fār and had settled at Lalish with his uncle. After the death of Sheikh 'Adī, Abī 'l-Barakāt was chosen as sheikh of the order and directed the 'Adawis for a long time. He died at an advanced age. He was a pious Muslim who followed the path of Sheikh 'Adī, opposed innovations and excesses and gathered many new disciples around him.[42]

Abī 'l-Barakāt b. Ṣakhr was succeeded by his son, 'Adī b. Abī 'l-Barakāt (hereafter Adī II), who is mentioned in the Syriac account, written by the mid-fifteenth-century Nestorian monk Ramisho', as the leader who seized the Christian monastery of Mar-Yuḥanan and Isho' Sabran in 1219 and massacred all its monks.[43] Christian monks went to the Mongols in Iran to complain and have their monastery restored. 'Adī II was subsequently captured, judged and executed in November 1221 in Maraghā in Iran by Tuman, the nephew of Gengis Khan. 'Adī II had accused Taïrahite Kurds of the occupation and destruction of the monastery[44] but was nevertheless condemned to death by the emîr.[45]

Sheikh Ḥasan, the son of 'Adī II, is the second most important figure in 'Adawi history after Sheikh 'Adī. His full name is al-Ḥasan b. 'Adī b. Abī 'l-Barakāt b. Ṣakhr b. Musāfir Shams al-Dīn Abū Muḥammad. He is also known as Tāj al-'Ārifīn (Crown of Gnostics) and is identified in modern Yezidism with the Arab Sufi al-Ḥasan al-Basrī. He is remembered in Arabic sources[46] as an intelligent, ambitious and enthusiastic man who became the spiritual chief as well as military and political leader of the 'Adawis. He was the author of the Kitāb al-Jilwa li-Arbāb al-Khalwa,[47] a mystical treatise following the ideas of Sheikh 'Adī that he wrote while he was in seclusion for six years.[48] During the reign of Sheikh Ḥasan, the 'Adawis attracted many new disciples and developed militarily. They were soldiers of Saladin's army in Syria and Egypt. For instance, the very well-known Yezidi Sheikh Mand Pasha was at the service of the Ayyubids in Aleppo region in Syria as the emîr of the Kurds.[49] Yezidism expanded notably in Kurdish tribal milieu from the thirteenth century. This quick expansion disturbed their Muslim neighbours and Yezidism became to be seen as a threat. Especially Yezidis of the era of Sheikh Ḥasan were a threat for the Atabeg of Mosul, Badr al-Dīn Lu'lu' (r.1211–59), who governed Mosul after the Zangid Nur al-Dīn's family.

The Zangids were a Turkoman dynasty who ruled the Jazira and Syria between 1127 and 1251. Nur al-Dīn, the most famous descendant of this dynasty, captured the Jazira and established suzerainty over Mosul in 1170. At the same time, Saladin, the Kurd, invaded Syria and captured Damascus. By 1183, Ayyubids invaded all of the Zangid territory except Mosul. Although Saladin besieged Mosul in 1182 and 1185, he was unsuccessful. In 1211, Mas'ud II became Atabeg of Mosul and Badr al-Dīn Lu'lu', the son of an Armenian slave and a Shi'ite, was chosen to serve as regent. After the death of last Zangid in 1233, Lu'lu' was recognised as the new ruler of Mosul by the

Abbassid Caliph.[50] Lu'lu' ruled mainly Mosul, Sinjar and Jazira and managed to gain the right to rule over the Kurdish forts; by the end of 1221, most of Kurdish territories had accepted his authority. Nevertheless, the Yezidis were politically opposed to the authority of Lu'lu'; they often revolted against him and refused to pay taxes. The Yezidis especially took advantage of the rivalry between Zangids and Ayyubids and used Ayyubids' attacks in the Jazira to occupy Sinjar from the Mosuli Zangids.[51] Thus, fearing a Kurdish revolt under the reign of the ambitious Yezidi leader Sheikh Ḥasan, Lu'lu' sent his army against the Yezidis, killed and imprisoned many Kurds and had Sheikh 'Adī's bones disinterred and burned.[52] Sheikh Ḥasan was arrested, imprisoned in Mosul and decapitated in 1254.[53] An Arabic chronicle attributed to al-Fūtī[54] describes this conflict and calls the followers of Sheikh Ḥasan 'Adawi Kurds (*Akrād 'Adawiyya*).

Although it is commonly accepted that it was during the time of Sheikh Ḥasan that Yezidism began to diverge from orthodox Islam, and the influence of local Kurdish elements on the doctrines of the 'Adawiyya order increased, there is no evidence in the Arabic sources that explains, of how and why this could have happened under a strict Muslim reign. For instance, the Hanbali scholar Ibn Taymiyya, who lived during the Mongol invasions, composed a treatise about the 'Adawis in which he criticizes Sheikh Ḥasan and describes him as an orthodox Muslim.

> They also reported that Ḥasan b. 'Adī was a saint, for such and such a reason... At the time of Sheikh Ḥasan, they added to their belief in Yazid many further errors, in poetry and prose. They devoted to Sheikh 'Adī and to Yazid an excessive veneration, incompatible with the doctrine of the great Sheikh 'Adī. In fact the teaching of the latter was orthodox and did not admit any of these innovations.[55]

However, the answer can be found in the narratives of modern Yezidis. According to the Yezidis, Sheikh Ḥasan was an orthodox Muslim. Unlike Sheikh 'Adī, who allowed Shamsanis to practise their own non-Muslim beliefs, Sheikh Ḥasan interfered in their practices and tried to impose the Islamic beliefs of 'Adawis on them during his reign. His interference caused an internal conflict in the community that was settled by Sheikh Mand Pasha, who had come from Syria. Sheikh Mand, an influential Yezidi figure, was originally from the Bahdinan region of northern Iraq but was appointed emîr of the Kurds of the Aleppo region by the Ayyubids.[56] With the intervention of Sheikh Mand, the matter of the faith was reorganised, and there was a reconciliation between Shamsanis and Adanis. Shamsanis made up the Kurdish bloc of the original settlers of the region, whereas Adanis constituted the Muslim Arab block, successors of Sheikh Ḥasan. The Adanis were allowed to follow their Islamic religion, and the rest of the community had the right to continue to practice their own local religion.

In fact, these were Shamsanis who gained control over the social and religious life of the Yezidis during the Sheikh Ḥasan era, and their ancient Iranian practices became dominant and diverged definitively from Islam. The Islam practiced by the Adanis gradually diminished under the political and social pressure of the Shamsanis. The Shamsani element was also fortified by the support of the new prince family Qatanis, who took the power after Sheikh Ḥasan's death.[57] Thereafter, the 'Adawis of northern Iraq increasingly gravitated towards Yezidism as we know it today, moving further and further away from the 'Adawis of Damascus and Egypt, who were under the influence of Islam. It is still believed by the Adanis who are the descendants of Sheikh Ḥasan that the Shamsanis helped Badr al-Dīn Lu'lu' to kill Sheikh Ḥasan and collaborated with the Qatanis to end Adanis's political leadership.[58]

The son of Sheikh Ḥasan, Sheikh Sharaf al-Dīn Muḥammad (1215–57), succeeded his father after his death. Sheikh Sharaf al-Dīn allied with the Seljukid prince 'Izz al-Dīn Kaikaus II against the Mongols and was appointed a general of an army of Kurds and Turkomans. As a reward for his collaboration, he was given the city of Ḥiṣn Ziyad (Harput). He stayed there with his army until the Mongols arrived after which there was a terrible battle. Sharaf al-Dīn left Harput to get help from Sultan 'Izz al-Dīn, but the pursuing soldiers of the general Angurc-Nowin caught and killed him in a place called Kammah, above the Jazira, in 655/1257–58.[59] According to Yezidi tradition, Sheikh Sharaf al-Dīn is the one who converted people in Sinjar province to the Yezidi faith. Therefore, his position in this region is comparable to that of Sheikh 'Adī. Thus, it is not by accident that his mausoleum, built in 1274, is the most popular building in the region, visited regularly by Yezidi pilgrims.

In 657/1258, the grandson of Genghis Khan, Hulagu Khan, who sacked Baghdad and ended the rule of the Abbasids, arrived in Mosul but did not harm its population because the son of Badr al-Dīn Lu'lu', Saleh, had made an agreement to fight at the service of the Mongols.[60] However, Hulagu Khan, remembering the Yezidi chief's collaboration with the Turks, invaded Hakkari when passing through Mosul with his army and massacred its Yezidi habitants. Subsequently, he also destroyed the Yezidi settlement of Sinjar in 660/1261–62.[61]

Sheikh Zeyn al-Dīn, the son of Sheikh Sharaf al-Dīn, was chosen as his successor and the leader of the 'Adawis, but he relinquished his rights to his uncle, Fakhr al-Dīn (who had married a Mongol woman and had good relations with the Mongol leaders), and then departed for Syria. Fakhr al-Dīn, the new leader of the Yezidi community, had to face an uprising by his brother, Shams al-Dīn. But Shams al-Dīn lost and had to escape with his troops to Syria in 1275, where a large Yezidi community lived. The Yezidis of Syria and Egypt were without doubt the soldiers of Saladin. In 1276, for unknown reasons, Fakhr al-Dīn also ran away to Egypt. When he returned to his homeland in 1281, the Mongols condemned him to death because of his escape.[62]

17 Nomad girls, Sinjar

Meanwhile, Zeyn al-Dīn was supported by the 'Adawiyya order and led a flamboyant life in Syria. He settled in Damascus, where he received the title of emîr and lived the life of a king. Later, he moved to his ancestral village of Beit-Fār. Towards the end of his life, he repented for his sins and went to Cairo, where he founded a Sufi centre known as Jami' al-Qadiriyya or Jami' Sidi 'Ulay[63] (in the Qarafa). He died in 697/1297 and was buried in his *zāwiya*.[64]

His sons, 'Izz al-Dīn Amîran and 'Aladin 'Ali, remained in Syria. 'Izz al-Dīn, who inherited the title of emîr and lived first in Damascus and then in Shafad, became famous among the 'Adawis of Syria. Later, however, he abandoned the leadership and withdrew to Mezze near Damascus where he gathered many Kurdish followers around him. His plan to revolt against the Mamluk Sultan Nasir Muḥammad (1309–41) was discovered. Thereafter, on the order of Sultan Nasir, 'Izz al-Dīn was captured in Damascus by Tengiz al-Husami, the governor of Damascus. He died in prison in 731/1330–31.[65] At the same time, the members of the 'Adawiyya order in the Qarafa in Egypt were also seized.

By the fourteenth century, Yezidism reached as far east as Suleimania and as far west as Antioch (Antakya). The region between Diyarbakir and Siirt belonged to the Yezidis, and Sinjar was already one of their strongholds. The early emîrs of the Jazira region were themselves members of the 'Adawiyya (Map 2). Yezidism even became the official religion of the semi-independent principality of Jazira.[66] The Kurdish tribes of Huveydel, Shures and Niywednivan in the Judi region; Bohti, Mahmudi and Dunbeli from Bohtan; Reshan, Shiqaqi, Suhani, Chelki and Sherawi of Sason; and the Khaliti of Bitlis were all Yezidis.[67]

During the eight decades following the death of 'Izz al-Dīn, nothing is known of the 'Adawiyya community of northern Iraq. It seems that some members continued to hold emirate and provincial governor posts in Damascus and Egypt, enjoying their 'Adawi followers' support and veneration of as a mystical order before finally disappearing from history. The 'Adawis of northern Iraq, however, took a path leading away from Sufism and survived under different names, such as al-Ṣuḥbatiyya (the Companions), Dasinis, Yezidis and the like.

As their political strength grew in the early fifteenth century, and they came to constitute a threat to the rulers of the region, the Muslims became crueller towards the disciples of Sheikh 'Adī, whom they considered to be apostates and worshippers of Yazid.[68] Compulsory conversion to Islam and the massacre of those who resisted became common. Arab, Persian and especially Ottoman authorities organised true pogroms against the Yezidis, and even Muslim Kurds joined in the persecution. One of the most bloody massacres occurred at the beginning of the fifteenth century. In 1414, the tribal leader Jalal al-Dīn Muḥammad ibn 'Izz al-Dīn Yusuf al-Ḥulwānī declared holy war against the Yezidis and persuaded local leaders to raise forces in order to invade Sheikhan, the centre of the Yezidi community. The emîr of the Jazira region, 'Izz al-Dīn al-Bohti, together with Emîr Tawakkul of Sherānīs, Emîr Shams al-Dīn Muḥammad al-Jurdhaqili and the emîr of Ḥiṣn Kayfā, participated in this massacre. They assembled many of the Sindi Kurds, invaded the mountains of Hakkari, killed numerous followers of Sheikh 'Adī and imprisoned the rest. They sealed their victory by ransacking the grave of Sheikh 'Adī. However, his followers rebuilt his tomb and stayed there in accordance with their custom.[69] Despite such massacres and persecution, the Yezidis spread to every corner of the Kurdish regions.

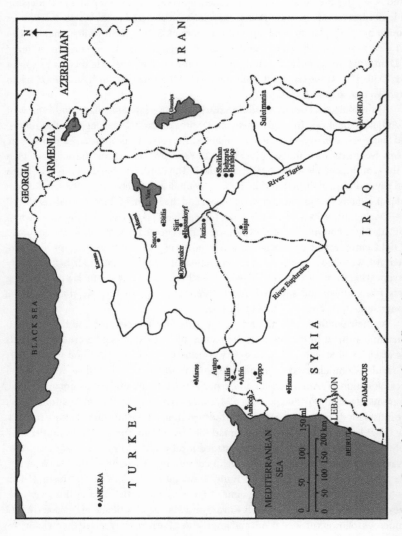

Map 2 Centres for Yezidism in the Middle East (Fourteenth Century)

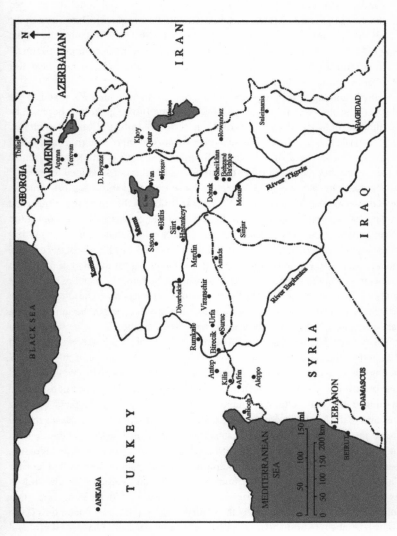

Map 3 Centres for Yezidism in the Middle East (Sixteenth Century)

Unlike in the thirteenth and fourteenth centuries, when they were united and powerful, from the fifteenth century onwards the Yezidis survived as small tribal groups and as local authorities who made alliances with their neighbours and changed them according to their own interests. Some Yezidi tribes allied with Qara Yusuf of the Black Sheep Turkomans (1375–1468). Others allied with Uzun Hasan of the White Sheep (1378–1508) against Tamerlane, as did many other Kurdish emîrs at this time.[70] Some important chiefs of Yezidi tribes were forcibly converted to Islam, and the power of the Yezidis declined (Map 3).

In the beginning of the sixteenth century, because their homelands straddled the border between the Persian Safavids and the Ottoman Turks, the Yezidis began to be drawn into the conflict between the two rival empires for control of the Kurdish territories. In 1501, Isma'il Shah of Safavids conquered Diyarbakir and all of eastern Anatolia, and then in 1502, he occupied Mosul. The Shah imprisoned most of the Kurdish princes of these regions, but the Yezidi tribes of Dunbeli and Mahmudi submitted to Isma'il.[71] However, the Ottomans sought to forge an alliance with the various Kurdish emirates to defend their eastern borders against Safavid expansion, as the Shi'ite state threatened to expand into central Anatolia, where the considerable Qizilbash ('Alevi) population were supporters of the Persian Shah Isma'il. The Ottoman Sultan Selim I (the Grim) sent his advisor Idris-i Bidlisi (d. 1520–21), an influential Kurd at the service of the Ottoman court, who was imprisoned by Shah Isma'il during his invasion of the region in the beginning of the sixteenth century, to organise the Kurdish chieftains against the Safavids. In return for recognition by the Sultan and the protection of the Ottoman state, the chieftains gave him their allegiance.[72] Thus, the Kurdish chieftains became part of a larger and stronger political structure, underwritten by the Ottomans. After the defeat of the Safavids at the battle of Çaldıran (1514), the province of Diyarbakir was established (1515), and all the Kurdish chiefdoms were united under the control of this province, including Ḥiṣn Kayfā, Urfa, Mardin, Jazira, Mosul and Sinjar, where the Yezidis formed the majority. Important Yezidi chieftains were also appointed to significant positions in the administration of the Ottoman Empire. Sultan Selim I appointed the Yezidi chief 'Izz al-Dīn emîr of the Kurds, governing Aleppo. He retained this post until his death and did not leave any successor behind him.[73] Later, Melik Muḥammad Beg, one of descendants of the emîr of Ḥiṣn Kayfā, was charged with governing the Kurds as their emîr. Moreover, several Yezidi tribes were given major administrative and political responsibilities over the lands that were occupied by the Ottomans. Sharaf Khan Bidlisī, the Muslim emîr of Bitlis and author of the earliest chronicle of Kurdish history,[74] identifies six important Kurdish tribes as Yezidi in the sixteenth century: Dasinis (Hakkari), Mahmudis (Lake Urumiya), Dunbelis (Khoshāb/Hoşav), Khalitis (around Batman), Bicianes (Silvan) and Bakhtis.[75] Bidlisī criticises them as follows:

> They believe falsely that Sheikh 'Adī has taken upon himself their duties to
> fast and to pray, and that on the day of resurrection they will be carried to

heaven without being exposed to any punishment or any reproach. These Kurds have sworn hatred and the most implacable enmity against the virtuous sages of Islam.[76]

The three most important Yezidi tribes in the fifteenth and sixteenth centuries mentioned by Sharaf Khan Bitlisī were the Dasinis, Mahmudis and Dunbelis. The Dasinis, who were originally from the region of Sheikhan, occupied the region northeast of Mosul and south-west of Amadiya in northern Iraq. The Dasini tribe have remained Yezidi to this day. They also held the fortress of Dohuk for some time in the beginning of the sixteenth century and were allied with the Ottoman Sultan Suleiman, the Magnificent. At the same time, the territories of Arbil and Kerkuk were governed by Shi'ite Kurds allied to Shah Isma'il. After capturing Baghdad, Suleiman executed the Shi'ite emîr of Arbil and Kerkuk and appointed in his place a Yezidi, Hussein Beg Dasini, to govern Sorani fiefdom. However, a cousin of the Soran emîrs managed to re-seize Arbil from Hussein Beg and defeated him by killing his 500 men. Thereafter, Hussein Beg was summoned to the Ottoman court and murdered.[77]

Another important Yezidi tribe, the Mahmudis, came originally from Jazira but moved to the Van region in the fifteenth century, when they were given the fortresses of Ashūt and Khoshāb by the Black Sheep Turkomans as a gift for their loyalty.[78] The emîrs of Mahmudi tribe governed Khoshāb for generations. They changed their alliance frequently. For instance, when Emîr 'Iwaz Beg of the Mahmudi tribe was imprisoned in the citadel of Van for having disagreed with the governor of Van, Urkmez Sultan, who was there at the service of Shah Isma'il to defend this region, 'Iwaz Beg asked the help of Sharaf Khan, the emîr of Bitlis who fought against Urkmez Beg to release Emîr 'Iwaz Beg. After his liberation, 'Iwaz Beg governed 'Albaq and Khoshāb for Shah Tahmasp.[79] However, his son Hussein Quli Beg received the possession of the canton of Karcigān and became its Sanjak Begi under the reign of the Ottoman Sultan Suleiman who was later discharged from this post and left for Diyarbakir where he died. When the Ottoman Sultan Suleiman invaded Azerbaijan in order to subdue Iran in 1548–49, Haçane Beg, the second son of 'Iwaz Beg, joined his forces and was later awarded an important post at court and accorded the principality of Khoshāb. His tribe was also granted many villages in Armenia and Azerbaijan, such as Maku and Ordubad in Nakhchivan.[80] He remained loyal to the Ottomans until his death.[81] He was a skilful diplomat and protector of his tribe. Haçane was killed by the Persians in 993/1585 in Sa'īd-abād near Tabriz. His tomb is located in the madrasa he built in Khoshāb. He had three sons, 'Iwaz Beg, Sher Beg and Sheikhy Beg. He gave Khoshāb and the Mahmudi principality to his son Sher Beg, who exercised a strong influence over his people and whose pious personality and strength as a leader were instrumental in influencing his people. Sher Beg, an adherent to the mysticism of the Sufis, became a pious Muslim and banished Yezidi beliefs from his tribe. He fasted, prayed and went on pilgrimages to

Mecca.[82] Nevertheless, some Mahmudis continued to adhere to their ancient faith; this is recorded in an Ottoman 'History of Van' which reveals that Mahmudis from Khoshāb and Abaga were still Yezidi in 1127/1715.[83]

The Dunbelis (Dumbeli/Dimili) were also originally from the Jazira region, and their prince, Isa Beg, also converted to Islam. However, a group of them preserved their own Yezidi faith. One of his descendants, Sheikh Ahmed Beg, was given authority by Uzun Hasan of the White Sheep Turkomans and was granted the fortress of Baq and part of Hakkari in 1457.[84] His son, Hecî Beg, received the principality of Khoy from the Persian Shah Tahmasp and was charged with the protection of the border of Van and the defence of other parts of the frontier against the Ottomans. The Mahmudi and Dunbeli tribes also fought each other over purely tribal interests, allying now with

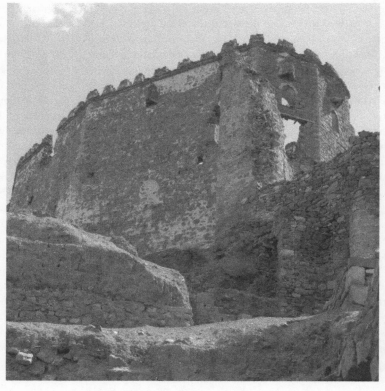

18　　Castle of Khoshāb (Hoşav), Van (by Zeinab Zaza)

the Ottomans, now with the Safavids. Because of their double dealing, the Mahmudi Emîre Beg was executed by the Ottoman Suleiman in 1535,[85] and Dunbeli Ahmed Beg was put to the sword by the Safavid Shah Tahmasp.[86]

While the Yezidi tribes were allying with Ottomans and Safavids to survive in the various Kurdish regions, Sheikhan and Sinjar continued to develop as the two main Yezidi strongholds. As a result from the seventeenth century, they were periodically raided by the Ottoman governors of Mosul, Baghdad and Diyarbakir and were also attacked by the semi-autonomous Kurdish principality of Amadiya. The main pretext for these attacks was to convert the Yezidis to Islam; however, the Yezidis were also seen as brigands who harmed the Muslim inhabitants,[87] refused to serve in the Ottoman army[88] and evaded paying tax.[89] For instance, in 1050/1640–41, Ahmed Pasha, the governor of Diyarbakir sent his army against the Yezidis of Sinjar who had pillaged the villages around Mardin. In 1057/1647–48, the Yezidi mîr Mîrza Beg demanded that the Ottomans make him governor of Mosul; when they refused, he rebelled. The governor of Van, Shemsi Pasha, who had been sent to fight against Mîrza Beg, captured and killed him.[90]

At about the same time, many Carmelite, Franciscan and Jesuit missionaries attempted to convert the Yezidis of Sinjar and the Kurd Dagh (north-western Syria) to Christianity, but they were not successful.[91] Two well-known missionaries who during the second half of the seventeenth century spent much time among the Yezidi communities of Anatolia, Syria and Iraq were Père Jean-Baptiste de Saint-Aignon and Père Justinien de Neuvy-sur-Loire.

The eighteenth century saw many bloody expeditions against the Yezidis. In 1127/1715, the Vali of Baghdad attacked and massacred many of the Yezidis of Sinjar and entrusted the government of Sinjar to the Tayy Bedouin. The Persian Nadir Shah invaded Mosul in 1743; the local people, including the Yezidis, resisted. Nadir Shah's army killed many Yezidis and captured their leader.[92]

Mosul had a separate provincial status from 1726 to 1834 and was governed by the members of the Jalili family, which was originally Christian but converted to Islam in 1726. Thereafter, under Ottoman rule, the government sought to extend and consolidate its authority over the district of Mosul, including the two main Yezidi areas of Sheikhan and Sinjar. Nonetheless, the Yezidi inhabitants of northern Sinjar remained in revolt and did not permit the Ottoman governors access. Thus, they suffered frequent military expeditions and persecutions by the local Ottoman governors. In 1770–71, Bedagh Beg, the mîr of Sheikhan, revolted against Isma'il Pasha, the prince of Amadiya, who was the leader of a Sunni Kurdish principality guarding the eastern Ottoman frontier, but Beg was captured and executed.[93] The same year, the governor of Van, Murtaza Pasha, attacked the Yezidi tribes of Abaga district, capturing the Khoshâb (Hoşav) castle.[94] In 1785, 'Abd al-Baqi Pasha, the governor of Mosul, attacked

the Yezidi Dannedi tribe but he, along with most of his troops, was killed. In 1794, Suleiman Pasha of Baghdad raided Sinjar, kidnapped sixty women and raided cattle of the Yezidis.[95]

From the nineteenth century, the Yezidis attracted many travellers[96] and missionaries[97]; thanks to their records and to the Ottoman archives,[98] we are better informed about the Yezidi communities.

Ottoman governors continued raiding Sinjar in the nineteenth century too. Very well-known are their raids of 1803 and 1809 that were carried out by 'Ali Pasha and Suleiman Pasha, the governors of Baghdad.[99] In the beginning of the nineteenth century, Mirza Agha, the chief of a Yezidi autonomous unit, struggled against other Kurdish chieftains and Ottoman authorities.[100] During the chaos that gripped Iraq in the nineteenth century, the Kurds of Rowanduz, who were enemies of the Yezidis, gained Arbil and Altun Köprü and established an independent state; they were recognised by the new Ottoman governor of Baghdad, who overthrew the Mamluk regime and assumed direct control over Iraq in 1831. At this time, in 1832, the Kurds of Rowanduz raided the plains of Mosul belonging to the Kurdish principality of Amadiya under the pretext that the murder of the Muslim Kurdish chieftain 'Ali Agha by Mîr 'Ali Beg of the Yezidis had not been avenged because the prince of Amadiya had not allowed 'Ali Agha's tribe to do so. Whereupon an eminent Kurdish mullah, a relation of 'Ali Agha, appealed to a Kurdish chief, Kor Muḥammad, for help. The latter, being a strict Sunni Muslim, responded rapidly and advanced to the east of Mosul into the principality of Amadiya to fight with Mîr 'Ali Beg and force him to convert to Islam. Mîr 'Ali Beg refused and was captured, but he was later released. Kor Muḥammad killed many Yezidis as well as Christians and Jews.[101]

In the same year, Bedir Khan Beg, the Kurdish prince of Bohtan, invaded Sheikhan. Although the Yezidis resisted, their mîr, 'Ali Beg, was arrested and condemned to death. Sheikhan was sacked by the Bedir Khan Beg's men who murdered Sheikhan's inhabitants. Some managed to escape to Sinjar, the rest were slaughtered by Muslim Kurds.[102] These attacks strained relations between the Yezidi and Sunni Kurds.

From the second half of the nineteenth century, the Ottoman Empire became more centralised and began to see the various ethnic and religious communities and rural separatism as a threat to the state's unity and stability. During the Tanzimat reforms (1839–76), the Ottomans attempted to counter the rise of the separatist movements and to gain the loyalty of certain ethnic and religious groups in order to maintain public security and implement tax collection. The Yezidis were a distinct ethnic and religious community and were not recognised as a People of the Book protected under Islamic rule. Their legal status was not defined by the Ottoman administration, and they were placed on the lowest rung of Ottoman society. In 1849, the Ottomans wanted to impose military service on the Yezidis. Since they were not recognised as a

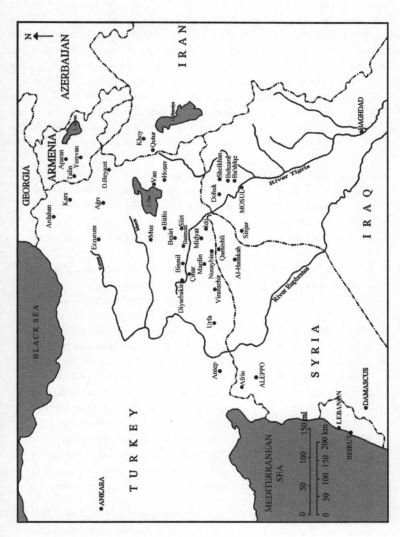

Map 4 Centres for Yezidism in the Middle East (Nineteenth Century)

non-Muslim religious group, they had to receive the same treatment as Muslims. Only the People of the Book, such as Christians and Jews, were exempted from conscription on payment of a tax (*bedel-i askeri*). Only after the English ambassador Stratford Canning persuaded the administration to adopt reforms tolerating non-Muslim communities, did the Yezidis obtain a *firman* from Istanbul exempting them from conscription.[103] However, this privilege was annulled by the governor of Baghdad, Midhat Pasha, in 1872. The same year, Sultan Abdulaziz sent one of his marshals, Tahir Beg, from Istanbul to Mosul to raise 15,000 soldiers among the Yezidis of northern Iraq. Whereupon the Yezidis petitioned the Ottoman court to be allowed to pay the *bedel-i askeri* like the Christians and Jews. The petition consisted of 14 articles and explained why the Yezidis could not serve in the Ottoman army. It was written in three languages: Ottoman Turkish, French and Arabic. The following is the full text of the petition:[104]

(0) It is impossible for Yezidis to serve in the army.

(1) Every Yezidi must visit the image of Tawûsî Melek three times a year, in April, September and November of the Julian calendar. If they fail to do so they become unbelievers.

(2) Every member of the sect must visit the shrine of Sheikh 'Adî at least once a year, from 15 to 20 September.

(3) At sunrise every member of the sect must go to a place where he can see the rising sun, and where there are no Muslims, Christians or Jews.

(4) Every Yezidi must kiss the hand of his 'brother of the hereafter', who is the servant of the *mehdî*, and the hand of his sheikh of his pîr every day.

(5) When Muslims pray in the morning, they say, 'I take refuge in God, etc'. If a Yezidi should hear this he must kill the person who says it, and kill himself.

(6) When a Yezidi dies, his 'brother of the hereafter', or his sheikh or pîr, or one of the qewwals, must be with him and say, 'Oh servant of Tawûsî Melek – great is his dignity – you must die in the religion of him who is worshipped by us, Tawûsî Melek – great is his dignity – and not die in any other religion. And if anyone of the religion of Islam or the religion of the Christians or the religion of the Jews or of religions other than that of the Tawûsî Melek come to you and speak to you, do not think that they are right and do not believe them. And if you regard as true, or believe in any other religion than that of him who is worshipped by us, Tawûsî Melek – great is his dignity – then you shall die an unbeliever'.

(7) We have a thing called the 'blessing of Sheikh 'Adî', namely earth from his tomb. Every Yezidi must carry some of this in his pocket, and eat some of it every morning. If this earth is not found upon him when he dies, he dies an unbeliever.

(8) A Yezidi, if he wishes to fast, must do so at home, not elsewhere. Every day of the fast he must go to the house of his sheikh of pîr in the morning to begin his fast, and to break his fast he must return there to drink two or three glasses of the holy wine of the sheikh or pîr. If he fails to do this his fast is not acceptable.

(9) If a Yezid travels abroad and stays there for at least a year, when he returns home his wife is unlawful for him and none of us may give him a wife.

(10) Just as each Yezidi has a 'brother of the hereafter', he also has a 'sister of the hereafter'. If a Yezidi has a new shirt made, his 'sister of the hereafter' must make the opening at the neck with her own hands.

(11) If a Yezidi has a new shirt made, he must dip it in the holy water of the shrine of Sheikh 'Adī before putting it on.

(12) We may not wear dark blue clothes, or comb our hair with the comb of a Muslim, Christian or Jew, or shave with a razor which any other man has used, unless the razor is washed in the holy water of the shrine of Sheikh 'Adī.

(13) A Yezidi may not enter a closet, or go into a public bath, or eat with the spoon of a Muslim; nor may he drink from the cup of a Muslim or of one who belongs to one of the other religions.

(14) The Yezidis do not eat fish, gourds, bamiyye,[105] beans, cabbage and lettuce, nor may they live in a place where lettuce etc., are grown.

This petition was signed by the prince of the Yezidis, Mîr Hussein, the spiritual chief Sheikh Nassir and fifteen Yezidi headmen of the Sheikhan region and submitted to Rauf Pasha in 1873. This text was the first written source which speaks of the principal doctrines of the Yezidi religion. This petition was successful; the Yezidis were granted exemption from conscription in 1875.[106]

In the 1870s, Sufuq Agha from the Yezidi tribe of Musqara was appointed by the Ottomans principal sheikh of Sinjar to act as an intermediary between the local Ottoman administration and the Sinjari tribesmen for the purpose of tax collection. The choice of a leader from the Musqara was significant because this tribe included an important number of Muslim tribal sections. The advisor of Sufuq Agha was a certain Hamu Shiru of the Feqira tribe. On the death of Sufuq Agha in 1890, Hamu Shiru proclaimed himself to be the paramount chief of Sinjar without the assent of the local Ottoman authorities, became a strong opponent of Ottoman and Muslim presence in Sinjar and played an important role in the politics of the region until his death in 1933.[107]

In 1885, the Ottomans again placed the Yezidis on the same conscription basis as Muslims. This new regulation also offered a short-term military service in addition to a payment of 50 Turkish pounds. This regulation was applied to the Yezidi communities

of Aleppo, Diyarbakir and Van without any trouble. However, it was almost impossible to enforce in the province of Sinjar, where the Yezidis were forced to become Muslim by the Ottoman officials.[108]

In 1890,[109] the Ottoman general 'Omar Wahbi Pasha of Mosul was sent to Sheikhan in order to collect unpaid tax from the Yezidis and to give the mîr of Sheikhan, 'Ali Beg, an ultimatum—the Yezidi faithful must choose between death and conversion to Islam. When 'Ali Beg refused, 'Omar Wahbi Pasha invaded both Sheikhan and Sinjar and massacred the inhabitants.[110] Many Yezidis converted to Islam to escape death, including Mîrza Beg and his brother Badi Beg, who were subsequently rewarded with the title of pasha and given a salary by the Ottomans.[111] The sanctuary of Sheikh 'Adī, the centre of the Yezidi faith, was converted into an Islamic school, or madrasa,[112] which remained in Ottoman hands for twelve years. Beḥzanê and Ba'shîqe were also sacked, and many Yezidi shrines were destroyed. 'Ali Beg was imprisoned in Kastamonu, in north-western Anatolia. Contrary to Ottoman expectations, this persecution stimulated a widespread religious revival in Sinjar, where Hamu Shiru and his followers became the focus of anti-Muslim resistance.[113] Hamu Shiru was followed by two other temporal leaders from two powerful Sinjari tribes, Haskan and Qiran. That such temporal leaders or *aghas*, alongside the men of religion, should take responsibility for the community was a new departure for Yezidi society.

In 1891, the Ottoman sultan Abdülhamid II created his own personal army, the Hamidiye Cavalry, drawn from selected Sunni Kurdish tribes and modelled on the Russian Cossacks.[114] The main duty of the Hamidiye Cavalry was to guard the empire's eastern frontier against Russian incursions, to keep the Armenian population of the empire's eastern provinces in check. As Kurds were mostly Sunni Muslim, the Ottomans allied with them through Pan-Islamic ideas and tried to educate and integrate them into the wider Ottoman society by sending the sons of important Kurdish chiefs to schools established in Istanbul and in the Kurdish cities.[115] After the Balkan crises and the Treaty of Berlin (1875–78) in which the Ottoman Empire lost a significant part of its population and territory, Abdülhamid II sought to prevent further defections of other ethnic groups from the empire. As in previous wars between the Ottoman Empire and Russia, some Kurdish tribes inside Ottoman territory were supporters of the Czar. Thus he would keep the Kurdish tribes under his authority and reduce the threat of Kurdish-Armenian co-operation.[116] Ibrahim Pasha, chief of the Milli tribe,[117] was given command of the Hamidiye regiments. A Yezidi chieftain, Hussein Qinjo, converted to Islam in the Tur 'Abdin region and joined the Hamidiye with his tribesmen. Later, he became Ibrahim Pasha's right-hand man.[118]

Hundreds of Yezidi villages in the Serhat region,[119] the upper Tigris and Euphrates valleys, the Mosul plain and Sheikhan were attacked by the Hamidiya. Almost all the Yezidi population of Kars, Ardahan, Doğu Beyazıt, Van, Bitlis, Siirt and Antep

fled with the Armenians towards Transcaucasia to escape from these attacks in 1895 and 1915.[120] Many high religious ranks had to convert to Islam or flee to Sinjar from Sheikhan to escape death.[121]

At the end of the nineteenth century, the Ottoman Pasha in Mosul was replaced by a new governor, Aziz Pasha, who brought peace to Sinjar and allowed the Yezidis to practise their religion. Those Yezidi leaders who had been converted to Islam by force resumed their old faith; The exiled 'Ali Beg was allowed to return to Sheikhan in 1898 and, after his brother's death, became the mîr of the Yezidi community.[122]

Women also had an important impact upon the Yezidi community. Mayan Khatun (1874–1957), the daughter of Abdi Beg, wife of Mîr 'Ali Beg and mother of Mîr Said Beg, is remembered as a strong personality who possessed diplomatic skills. After the murder of her husband by the Muslim tribe of Doski Kurds in 1913, she took power and ruled the Yezidis as regent for her young son, Said Beg. During the First World War, her prudence protected the Yezidis of Iraq from calamity, and she led the community in throwing off the Ottoman yoke. Mayan Khatun founded a religious school to teach the Yezidi faith in Beḥzanê.[123]

In 1915, the Ottomans initiated widespread persecution of the non-Muslim communities living in Karadağ, Rumkale, Mardin, Nusaybin and the Jazira. A big number of the Yezidi populations from Karadağ and Rumkale thus fled; they were joined the Yezidi population in northern Syria and Iraq. Moreover, Armenian Christians and Christians from churches in the east fled to Sinjar province to seek the protection of the Yezidi community.[124] Hamu Shiru encouraged Christian settlement in the region and refused to surrender Christian refugees to the Ottoman authorities. This provoked the last Ottoman occupation of Sinjar in 1918.[125] In the same year, Great Britain invited every minority in the province of Mosul to say whether it wished to be governed by the Arabs or the British. The *Vilayets* of Diyarbakir and Mosul, including all the Yezidi chiefs, expressed a desire to be British subjects, refusing to be ruled by Arabs. Hamu, who was pro-British, was immediately appointed as the head of Sinjar by the British military government prior to the British occupation of Mosul in early 1919. He was put in charge of administration and public security and retained his title until the end of the British mandate.[126] However, although the Yezidis were in the majority in Sinjar, few were able to read and write because of the strict prohibition of education and learning enforced by the Yezidi religious hierarchy, and so most administrative officials were chosen from Christian communities.[127]

The state of Iraq was established in 1921 under British supervision. After the dismemberment of the Ottoman Empire (1922), new countries were created. The Republic of Turkey was established in 1923. With the treaties of Lausanne (1923) and Ankara (1926) the frontiers of Turkey with Iraq and Syria were established and Iraq's title to the province of Mosul was recognised by a treaty of 1926. The frontier between

19 Yezidi girls in Bozan

Iraq and Syria was established in 1933. The ancestral homeland of the Yezidis was now divided by the borders of four separate states – Iraq, Turkey, Iran and Syria. In this way, Yezidi communities' communication with Sheikhan, the centre of the faith, and with each other was cut. Qewwals, who are the missionaries of the Yezidi faith amongst the Yezidi people and who collect donations, were not allowed to cross the borders to visit the Yezidi communities. Thus, the Yezidi religion developed in different ways in these countries.

From the 1920s, many Kurdish tribesmen started to rebel against these new states. The most famous revolts were those of Sheikh Mahmud Barzanji (1919–23) and Sheikh Ahmad of Barzan (1931–37), who claimed independence from Iraq.[128] Against Turkey were the rebellions of Koçgiri (1920), of Sheikh Said Piran (1920–25), of Sheikh Abdurrahman of Ararat (1927–30) and of Dersim (1937).[129] Although they were principally inspired by Pan-Kurdish ideas, these rebellions were for the most part exclusively Muslim. Similarly, the educated Kurdish nobles who had served in the Ottoman administration and the Kurdish intellectuals of Iraq who gave shape to Kurdish nationalism were also Muslim. In 1929, six Kurdish deputies in the Iraqi parliament submitted a memorandum to the League of Nations arguing that an independent Kurdish government should be established over a territory, which included Dohuk, Aqra, Zibar, Amadiya and Zakho. However, none of this appealed to the majority of Iraqi Yezidis, whose aspirations did not match those of the Muslim Kurds. Moreover,

neither Sinjar nor Sheikhan was included in the putative independent Kurdish state until 1931. It was only in the 1960s that Kurdish nationalists realised the importance of obtaining the support of the Yezidis. Nevertheless, Pan-Kurdism found favour among some Yezidi tribal leaders, such as Hajo Agha of the Heverkani tribe, who rebelled against the Turkish government in the Tur 'Abdin in 1926 with followers drawn from not just the Yezidi community but also from other Kurdish tribal groups.[130] He became a member of the Kurdish nationalist organisation *Khoybun* (independence), which was created in Beirut in 1927 by Kurdish intellectuals and activists who were former Ottoman officers and tribal leaders.[131] Through Hajo Agha's activities, Kurdish nationalist propaganda arrived in Sinjar, where he maintained contact with Isma'il Beg Chol.[132]

After the establishment of the Republic of Turkey in 1923, it became state policy to create a homogeneous socio-political system by assimilating non-Christian ethnic communities. The Kurds, most of whom were Muslim, were the first to be affected by this policy.[133] The Kurdish language was banned from schools and from the administration, and Kurds were deprived of all right to express their own culture.[134] The Yezidis, a minority within a minority, were doubly disadvantaged: to Turkish officialdom, the Yezidis were either Muslims or non-believers. However, the Iraqi government recognised Kurdish cultural specificity in 1931 and accepted Kurdish as the language of the administrations, courts and instruction in the north of Iraq, where Kurds were living in majority. This linguistic unity prompted Yezidis to enter as a large Kurdish community in Iraq. However, the lack of a standardisation of the Kurdish dialect led to confusion among the Kurds and hindered the functioning of this law, because the majority of the Kurds Iraqi were Sorani speakers while the Yezidis and a small group of Bahdinan region's inhabitants were Kurmanji speakers. Furthermore, in the Bahdinan region, the education was not in Kurmanji but in Arabic.

The mîr's family has exerted religious control on the Yezidi community of Sheikhan and Sinjar. However, since the conversion of Mîr Mîrza to Islam in 1892, the prestige of the mîr family had weakened, and the interference of the Ottoman authority on the prince family had increased. Some Sinjari tribal chiefs, such as Hamu Shiru and Sheikh Khidir, who were willing to execute religious reforms by transforming the nature of the Yezid emîrate and by taking part in Yezidi religious affairs, challenged the authority of Sheikhan. With their help in the 1930s, widespread anti-mîr demonstrations occurred among the inhabitants of Sinjar. However, the rights of the princely family were strengthened with the 'Sheikhan Memorial', a document written and signed by the baba sheikh and the heads of other religious orders of Sheikhan, which was declared at a conference in Mosul in 1931. The Sheikhan Memorial was about the fundamental rules observed by the Yezidis; it cited that the mîr cannot be dismissed or removed except by natural death. In this way, the mîr family consolidated their position in the community. At the same time, the relationship between the princely family of Sheikhan

and the tribal leaders of Sinjar was strained for several reasons. Sinjari leaders preferred to act with the British authorities while Sheikhani prince family and religious groups preferred to agree with the current political authorities, such as Ottomans or Arabs. However, after the death of Isma'il Beg (1933) and Hamu Shiru (1933), Mayan Khatun's authority over Sinjar was enhanced. The marriage of Wansa, daughter of Isma'il Beg, to Mîr Said Beg also strengthened the relationship between these two families. However, in 1937, Isma'il Beg's son Yezid Khan Beg's claim to become the ruler of Sinjar spoiled the relationship between these two princely families.[135] In order to protect her brother, Wansa attempted to kill her husband. She shot and wounded her husband and ran away to Mosul and thence to Baghdad and Aleppo. After this incident, she was cast off from the Yezidi community; she later converted to Islam, married an Arab husband and still lives in Cairo.

After the death of Mîr Said in 1944, Tahsin Beg, his thirteen-year-old son by Xoxê Khatun, was chosen to carry the title of mîr under the regency of Mayan Khatun.[136]

The Kurdish Autonomous Region was established in 1970 over the governorates of Arbil, Dohuk and Suleimania.[137] However, Yezidi homelands remained outside this territory. Almost all Yezidi areas were subjected to the Arabisation that was carried out by the Ba'ath regime in the years 1965, 1973–75, 1986–89. They were forced to leave their own villages and live in the collective villages ('mujamma'at') which were mostly located close to their natal lands.[138] With this policy, the Ba'athist regime tried to suppress Yezidi independence and make them dependant on the government. The Yezidi villages were either destroyed or repopulated by the Arabs.[139] Furthermore, the Iraqi government tried to distance the Yezidis from the larger Kurdish community by declaring them to be Arab descendants of the Umayyad Caliph Yazid ibn Mu'âwiya. However, only a few Yezidis joined the Ba'ath party.[140] From 1974, because of the autonomy law of the Kurdish regions, the Kurds were able to teach Kurdish in schools, but in areas where Arabisation was strong, such as the Yezidi stronghold of Sinjar, Kurdish was prohibited like other minority languages, such as Aramaic and Turkish.[141] Some Yezidis also lost their lives during the Anfal campaign of 1986–89 (culminating in 1988) in which the Kurdish civilians were targeted by the Iraqi regime.[142]

Following the Persian Gulf War in 1991, the Kurds revolted. After the fight between Iraqi forces and Kurdish troops, the Iraqi government withdrew from the Kurdish region in October 1991, which gained de facto independence to be ruled by the Kurds outside the control of Baghdad.[143] After the creation of the Kurdish Regional Government in northern Iraq, the partition of Kurdish territories into the Kurdish Regional Autonomous zone and Iraq (under the control of Saddam Hussein) divided the Yezidi community into two parts. Approximately 90 per cent of the Yezidis lived outside the Kurdish safe haven. The whole region of Sinjar and much of Sheikhan, including its principal towns, 'Eyn Sifni, Beḥzanê and Ba'shîqe, remained under Iraqi government control. Only Lalish, Ba'adrê and Dere Bûn as well as the collective villages

of Khanek, Memê Shivan and Shari'a were within the Kurdish Autonomous Region. For this reason, although Mîr Tahsin Beg, who lived in 'Eyn Sifni, was the prince of all the Yezidi community, there was a sub-ruler for the Kurdish side of the autonomous region for twelve years, until 2003. Kheyri Beg was chosen to rule this latter region until his death in 1997, and then Mîr Kamuran Beg, the nephew and son-in-law of Mîr Tahsin Beg, who lives in Ba'adrê, took over the leadership of the Yezidi community.

Following the establishment of the Kurdish Autonomous Region in 1992, the Yezidis of northern Iraq had a more or less peaceful life for the first time in their history. Yezidis began to integrate into the wider Kurdish society with the support of both major Kurdish parties, KDP (Kurdistan Democratic Party) and PUK (Patriotic Union of Kurdistan), who gave them symbolic importance as adherents of the original Kurdish religion. It is mostly KDP, which controls most of the Yezidi areas in Iraq, which supports the Yezidis. For instance, the Lalish Cultural Centre was founded in 1993 in Dohuk. In 2003, two other branches of the same cultural centre were created in Ba'shîqe and Sinjar, and the salaries of the employees of these cultural centres, as well as all of men of religion who actively participate in the Yezidi religious life, are paid by the KDP. Yezidis were encouraged to publish several magazines and journals retracing their history, culture and religion. The Yezidi religion is taught in the schools. The community restores ancient Yezidi monuments and builds new ones. Nevertheless, many Yezidis are displeased with the current Kurdish rule as they believe that the Kurdish parties recognise the Yezidis only to further their own political interests. Some Yezidis of Sinjar even demand that the Yezidi identity be recognised as religiously and ethnically separate from that of the rest of the Kurds.[144]

Although the Yezidis, like other Kurds of Iraq, supported the coalition forces' attempt to overthrow Saddam's regime in 2003, they feel that they are not rewarded as much as Muslims of the region with development of their villages and improvement of their social conditions. Moreover, contrary to what they had hoped for, such as security and religious recognition, they have continued to be subject of attacks. Especially in the chaotic situation in Iraq since 2004, the Yezidis living outside of the Kurdish Autonomous Region have had to face attacks from fanatic Muslims, as did Yezidi leaders such as Mîr Tahsin Beg (in September 2004), former minister of civil society of Iraq Pîr Mamo F. Othman (in July 2005), the mayor of Sinjar Dexil Kasim Hason (in June 2004) and other representatives. Among these attacks the most horrific took place on the 14 August 2007 when two Yezidi villages, Gir Uzeir (Qahtaniya) and Siba Sheikh Khidir (Jazira), in the Sinjar region were razed by four track bombs, killing around 500 inhabitants and wounding many.[145] The province of Sinjar is not protected by the Kurdish army as it is outside of the Kurdish Autonomous Region. Currently, Sinjar does not have a clearly defined status in Iraq. Despite its Yezidi population, which is in the majority, it is not under the control of the Kurdish Regional Government, and a referendum will decide whether its inhabitants will join the Kurdish Regional

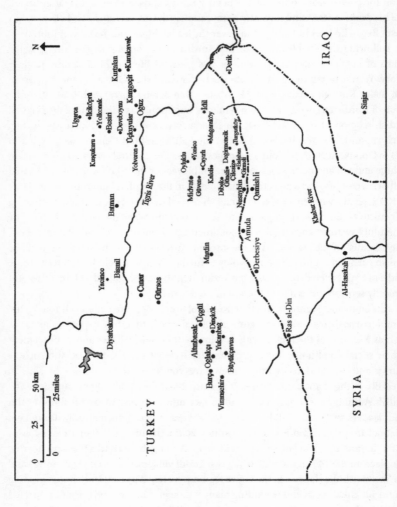

Map 5 Yezidi villages in Turkey

Government or the Iraqi Government. Due to this unclear situation and its unprotected location, Sinjar is vulnerable to Islamist attacks. For al-Qaeda activists, who act under the banner of *jihad* against the infidels, the Yezidis are the worst infidels, because they are not only non-Muslims but also Devil-worshippers. Thus, fearing attacks, the Yezidis have since 2003 stopped celebrating their annual feasts. Unemployment, religious discrimination and killings, kidnappings and intimidation are all part of the Yezidis' daily life in the new Iraq as well.

The Yezidis living in Turkey during and after the second half of the twentieth century gradually left for European countries, particularly Germany. In the 1980s, there were 60,000 Yezidis in Beşiri, Kurtalan, Bismil, Midyat, İdil, Cizre, Nusaybin, Viranşehir, Suruç and Bozova; these places are presently almost empty (Map 5). This massive departure was provoked by political, religious and economic difficulties. Today, there are only a handful of Yezidis remaining in the villages around Midyat, Viranşehir, Nusaybin, Bismil, Çınar and Beşiri.

Yezidis in Syria

The Yezidis live in two regions in northern Syria: (1) the Kurd Dagh (Kurdish mountain) around the city of Afrin and Jebel Sim'ān and (2) the Jazira, where Qamishli and al-Hasakah are the main towns. These two regions are around four kilometres apart, and their histories are different.

The majority of the Yezidi villages in the Kurd Dagh are situated between the Turkish border and Jebel Sim'ān (Map 6). These villages are entirely Yezidi or a mixture of Yezidi and Muslim Kurds.[146] In fact, they are the southern extremity of the Kurdish community of Turkey.[147] According to Bar Habraeus in his *Chronicon Ecclesiasticum*, the Yezidis who were deported from Persia settled in Syria in the thirteenth century.[148] The author associates them with Manichaeans. Moreover, the presence of the Yezidis in this area is talked about by Sharaf Khan Bidlisī.[149] According to him, a Kurdish emîr known as Mand, originally from Bahdinan region of northern Iraq and a descendant of Shams al-Dīn, was in the service of the Ayyubids and possessed the castle of Kousseir in Antioch, where the population was Yezidi. Sheikh Mand was also the ruler of the Muslim and Yezidi Kurds of the valley of Afrin and Kilis.[150] Sharaf Khan also informs us that Yezidis existed in a larger area between Hama and Marash, whose sheikhs were against Mand's rule. Yezidis managed to survive, particularly in Afrin and Jebel Sim'ān, which were situated far away from big centres and crowded roads; their desert, dead cities and remote location made them the ideal place for this isolated population, which lived there for a long time without drawing the attention of communities hostile to them.[151]

In the mid-thirteenth century, when Mamluks replaced the Ayyubids, the Kurdish princes of Kilis refused to recognise the Mamluks, who revolted. Thus, the relations

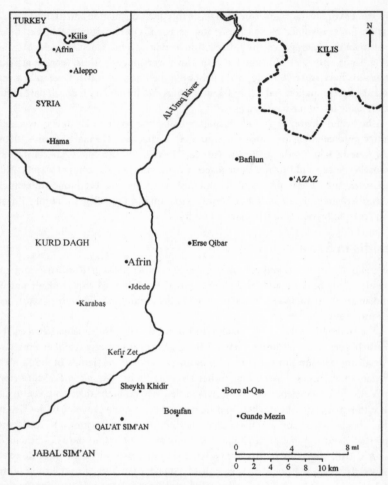

Map 6 Yezidi villages in the Kurd Dagh region, Syria

between the Kurdish principalities and the Mamluks has always been strained. Towards 1500, the original emîrs of Kilis were dismissed by the Mamluks, and a Yezidi chief, Sheikh 'Izz al-Dîn, was appointed as the emîr of the Kurds.[152] He maintained his post even when Syria was conquered by Ottoman Sultan Selim I in 1516.[153] When 'Izz al-Dîn died, he did not leave any successors. Melik Muḥammad Beg, a descendant of the principality of Ḥiṣn Kayfâ, was appointed for the principality of the Kurds.[154]

From the seventeenth century, Yezidis of Syria began to be attested by European missionaries who established their missions and colonies in Aleppo and by travellers who visited Afrin via Aleppo. Father Paul Perdrizet was one of the missionaries who visited Afrin and met Yezidi chiefs. He informs us about the existence of fifteen Yezidi villages around Rumkale on the Euphrates in the north.[155]

Although the Yezidis of this region never suffered violence on a scale comparable to the persecution their co-religionists in Sinjar and Sheikhan endured, they were under pressure from Muslims. In 1850, they suffered at the hands of local authorities who gave them the choice to either convert to Islam or be sent to Yemen to fight.[156] Over the last two centuries, many Yezidi villages had been pressured to convert to Islam. The other reason for the conversion was mixed marriage. Even today, the Yezidi population of Syria does not respect the strict ban on marriage with non-Yezidis and among the different castes, a ban which is one of the principal rules of the religion.

The Yezidis of the Jazira region of Syria live mostly in the villages around Derik, Qamishli, Amuda, Derbasiye and Ras al-Din as well as around Lake Khatun in al-Hasakah (Map 5). Because of a lack of historical sources, it is difficult to date the presence of the Yezidis in this region. However, it can be assumed that their presence in this area dates as far back as the Yezidi presence in Sinjar and Turkish Jazira, that is, to the twelfth century. These three areas, cut off from each other by the modern Turkish-Syrian-Iraqi borders, originally formed a single region which had historically parallel development until their separation in the 1930s. The Yezidis were probably living in this area as a part of the semi-nomadic Kurdish population. The German anthropologist Carsten Niebuhr visited the area in 1764 and drew a map of the population of the region indicating the presence of some Kurdish tribes.[157] One of these tribal groups is the Milli confederation, which also includes Yezidi members. Especially in the nineteenth century, the region became a settlement for the Kurdish community including the Yezidis who had abandoned their pastoralism and embraced farming. The area also received immigrants from the Kurdish regions of Turkey in the beginning of the twentieth century. A considerable migration of the Kurdish population in the area took place after the revolt of Sheikh Said in 1925[158] and some Kurdish tribes – Muslim and Yezidi – fled from Turkish repression during the pacification of the Kurdish tribes in 1925–28.[159] The second migration took place in the 1930s, when Yezidi tribesmen of Sinjar moved to the Syrian Jazira to avoid conscription in Iraq.[160] However, most of these tribesmen returned to Sinjar in the early 1940s, a time when Christian communities, such as Armenians, Chaldeans, Syrians and orthodox Greeks, also moved into this area to seek refuge. Thus, it became an ethnically and religiously mixed area with a non-Arab character.

In 1938, the Kurds of Jazira demanded full self-government from France, and the following year Kurdish Jazira was detached from Syria and came under direct French control.[161] The French authorities recruited disproportionate numbers of

Muslim and Yezidi Kurds as well as Christians into the police and military. In 1956, however, a succession of Arab nationalist regimes came to power in Damascus and began suppressing the Kurdish minority. Anti-Kurdish repression grew harsher in 1961. The following year, the government carried out a special census in Jazira and revoked the citizenship of some 200,000 Kurds who could not prove that they had resided in the country since 1945.[162] Today, there are an estimated 5,000 Yezidis among 160,000 Kurds in Syria who are classified as non-citizen foreigners (*ajanib*) on their identity cards.

Yezidis in Transcaucasia

The presence of the Kurds in Transcaucasia[163] goes back to the late tenth century when two Kurdish dynasties of Shaddadids[164] (951–1199) and Rawwadids (955–1227) ruled throughout the region. The principality of Shaddadid, established in Dvin (Yerevan), eventually ruled the other major cities of Barda, Ganja (Gyandzha) and Ani, while the Rawwadids (955–1227) ruled Azerbaijan centring on the cities of Tabriz, Maraghā and Sahand.[165]

During the Mongol invasion in the thirteenth century, Kurdish tribes moved into Armenia, specifically, in the south of the Karabakh region. Hecî Beg of the Dunbeli tribe, who were Yezidi, received the principality of Khoy from Shah Tahmasp in the fifteenth century for his collaboration against the Ottomans.[166] Shah Abbas I (1587–1629) moved many mixed religious Kurdish tribes from Iran to Azerbaijan to fortify the borders of the Safavid Empire.[167]

Today, much of the Yezidi population in the Republic of Armenia is concentrated around Mount Aragats. In the eighteenth century, when Mîr Choban Agha of Hasanli tribe brought his tribe from the province of Van, he settled in this area.[168] In 1770, the Georgian King Irakli II established contact with the Yezidis. In a letter he sent to the Yezidi leader Choban Agha through the intermediary of the Assyrian archbishop Isaya, he proposed a coalition with other non-Muslim communities of the region, such as Armenians and Assyrians, against the Ottomans. Mîr Choban Agha accepted his proposal on the condition that the King give him the ancestral fortress of Khoshâb[169] in which he could gather the entire the Yezidi community of the region. In the eighteenth century, the area between Karabakh and Zangezur in Azerbaijan was also populated by the Kurds.[170] During this period the Kurdish population, mostly Shi'ite Muslims, became the dominant community of the region around Lachin, Kelbajar and Qubadli which eventually unified as the Kurdish Autonomous Province, which was known as 'Red Kurdistan' from 1923–29.[171]

During the nineteenth century, wars between the Ottoman Empire and Russia (1828–29, 1853–56, 1877–78) as well as the Kurdish revolts against the Ottomans forced the Kurdish population, both Muslims and Yezidis, to move towards the czarist

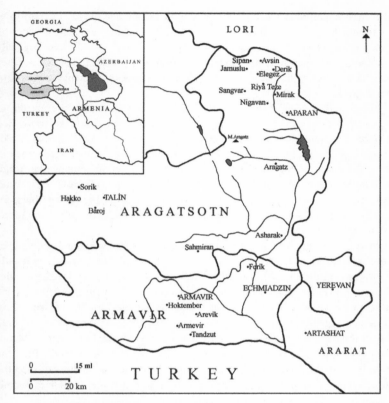

Map 7 Yezidi villages in the Republic of Armenia

Russian lands for safety.[172] They were welcomed by the Russian authorities, who probably considered their presence a potentially useful tool in future conflicts between Russia and the Ottomans. During the 1828–29 war, the Yezidi chief of Hasanli tribe of the southern slope of Mount Ararat allied with the Russians, and after the war he was permitted to move with his tribesmen and flocks to Yerevan province. In the second half of the nineteenth century, Yezidis were already living in the villages of Mîrak, Kurabogaz, Derik, Chobanmaz, Avshin, Camushlu and Korubulax in the northern Aragatsotn region[173] and in the Sardarabad district on the left bank of Aras River in Armenia.[174] Haxthausen also describes the Yezidis in his travel account as semi-nomadic people who in summer wander around the Ararat Mountain and in winter settle in the Armenian villages.[175] By the end of the nineteenth century, according to Russian census of 1897, approximately 100,000 Yezidi and Muslim Kurds were living in the southern Caucasia.[176]

A mass migration occurred in the area in the second half of the nineteenth and early twentieth century, when the Yezidis were persecuted by the Ottoman army, the Hamidiye Cavalry and the pan-Islamic Kurdish forces.[177] These Yezidis were originally from Kars, Van, Surmeli, Doğu Beyazıt, Erzurum and Iranian border areas. They joined the Yezidis who had already been living in the villages of Armenia, and some of them migrated to Georgia.

The Yezidis of Sheikhan maintained their relationship with the Yezidis of Transcaucasia through the religious messengers, the qewwals, who regularly visited the Yezidi communities in the area to collect alms as well as to keep alive the Yezidi faith amongst the faithful who were now so far from the religious centre. Nevertheless, during the chaos of the nineteenth century, the connections among the Yezidi communities of Sheikhan and Transcaucasia weakened, despite the visits of the Yezidi qewwals of Sheikhan. In the beginning of the twentieth century, Isma'il Beg Chol from Sinjar visited the Yezidis of Transcaucasia to unite them under the protection of the Armenian Church.

In 1918, the Ottomans made a brief war against the Yerevan Republic, captured Gumri and advanced north of Aragats, where the population was predominantly Yezidi. Many Yezidis were killed, and their villages ransacked.[178] Cenghir Agha, a Yezidi military commander, fought alongside Armenians against the Turks in 1918–20; the war became a symbol of the long-lasting friendship between Yezidis and Armenians, who fought together in many Armenian defence battles. With the treaty of 1921 between Russians and Ottomans, Gumri was given to Russia, but whole of Mount of Ararat and the towns of Iğdır and Surmeli remained in Turkish hands. Thus, the Yezidis living in the Surmeli district were moved by the Russians and resettled on the southern slope of Mount Aragats where once Muslims Kurds and Turks lived a semi-nomadic life rearing cattle and cultivating crops.[179]

In the 1920s the Yezidi collective farms were established in Armenia. Yezidi peasants began to live under the communist regime. The dream of Isma'il Beg Chol to establish Yezidi schools in Armenia was realised by the Communist authorities in Yerevan rather than the Armenian Church. However, religious men, sheikhs and pîrs suffered because of the abolition of religious tithes and the termination of contact with Sheikhan until 1977. In the Soviet census of 1926, the Yezidi and Muslim Kurds were listed separately, but in the 1930s, the Yezidis lost their distinctive-ethnic-group status and were henceforth recognised as Kurds, until 1989.

As a result of Stalin's policy of ethnic cleansing under the pretext of separatism and collaboration with the Germans, in 1937, thousands of Kurds of Azerbaijan and Armenia were deported by the Soviet authorities to various resettlements largely in Central Asia (Kazakhstan, Kyrgyzstan, Tajikistan and Uzbekistan) and Siberia, and in 1944, many Kurds in Georgia were similarly resettled.[180] Although most Yezidis in Armenia could

20 Men, Hoktember (Armenia)

continue to stay there, some were deported. For instance, the commandant Cenghir Agha was exiled in Saratov, where he died. However, in the late 1930s and after World War II, many Yezidis of Armenia moved to Georgia and elsewhere in the Soviet Union, creating a powerful community in the city of Novosibirsk.[181] In the 1950s and 1960s, Yezidis continued to migrate to the big Georgian cities, especially Tbilisi and Telavi, to

find work and a better life. Most of the Yezidis of Georgia still have family in Armenia. Thus the relationship between the Yezidi communities of these two countries is still strong. Although the date of their immigration is unclear, there are many Yezidis in the Ukraine, Crimea and Saint Petersburg who are originally from Armenia.

Yezidis in Armenia and Georgia enjoyed some cultural rights during the Soviet regime. Kurdish language and literature were taught in the Latin alphabet in the schools of Kurdish villages. The Kurdish newspaper *Riya Teze* was published in Yerevan every two weeks from 1930 to 1937, and from 1955 until post-Soviet economic difficulties forced the editorial team to reduce the frequency of publication. Since 1956, Radio Yerevan has broadcast daily in Kurdish, attracting a very wide audience even outside Armenia, that is, throughout the Kurdish regions in Turkey. The Kurds of Armenia are intellectually and culturally well organised especially in the capital city of Yerevan.

In 1988–94, during the Nagorno-Karabakh war between the Republic of Armenia and Azerbaijan, Kurdish communities came under pressure from both sides. A population of 85,000 Kurds was displaced from the predominantly Kurdish areas of Lachin and Kelbajar by Armenian and Karabakh forces. From 1989, the vast majority of Muslim Kurds left Armenia as a result of the Nagorno-Karabakh war, heading for Russia, Central Asia and various parts of Azerbaijan. Only the Yezidis were allowed to remain in Armenia, where they are once again recognised as a national group, separate from the Kurds. Their language was named Yezidiki. Thus, Yezidis of Armenia have become politically divided since the collapse of the former Soviet Union. Some affirm loyalty to the Armenian Republic by refusing their Kurdish identity while others claim their Yezidi Kurdish identity. The Yezidi National Movement identifies Yezidis as a separate ethnic group from the Kurds. Also, there is a growing struggle for Kurdish political rights among the Yezidis. Many of them have become supporters of pan-Kurdish independence struggles.

2

Religious Belief System

God, Angels and the Trinity

God (*Xwedê*)

Yezidis believe in one eternal God named *Xwedê*[182] who is the creator of the universe. All-forgiving and merciful, he is Good and the owner of every motion and sensation on the earth. Nevertheless, he is not active and has delegated his power to the seven angels (the Heptad of seven holy beings), or seven mysterious *heft sir*, who assist him.[183] He appointed the Peacock Angel, Tawûsî Melek, to take care of worldly affairs and human fortune; God is interested only in heavenly affairs. It is very rare for the Yezidis to address *Xwedê* directly in their prayers. In Yezidism, *Xwedê* has a transcendental character, and he is perceived only through activities of the Holy Trinity, the divine and semi-divine creatures that are intermediaries between God and the Yezidi people. Thus it is believed that God manifests himself in three different forms: (1) a bird, Tawûsî Melek, the Peacock Angel who is the main representative of God; (2) a young man, Sultan Êzî; and (3) an old man, Sheikh ʿAdī, a historical personality and the reformer of the Yezidi religion.[184] It can be said that the existence of this Holy Trinity in the Yezidi doctrine relegates *Xwedê* to the background, providing him with an implicit character. However, the monotheism of the Yezidis and the roles of the Holy Trinity can be seen in the hymn of the Symbol of Faith, *Şehda Dînî*:[185]

> Şehda dînê min êk ellah,
>
> ...
>
> Siltan Şêxadî pedşê mine,
>
> ...

Siltan Êzî pedşê mine,

...

Tawûsî Melek şehde û êmanêd mine,

...

Heke xudê kir Êzdîne,
Ser navê Siltan Êzîne.
El-ḥemd lillah em bi ol û terîqêd xwe di-razîne.

The testimony of my faith is One God,
Sultan Sheikh 'Adī is my king,
Sultan Êzî (Yezid) is my king,
Tawûsî Melek is (the object of) my declaration and my faith.
God willing, we are Yezidis
Followers of the name of Sultan Êzîd.
God be praised, we are content with our religion and our community.

Angels

According to sacred Yezidi book, the Black Scripture (*Mishefa Resh*) God began to create the world by creating a white pearl. Then he created a bird, Anfar, and placed the pearl upon its back to remain there for 40,000 years. After that, he created seven angels, the Heptad of holy beings, and made 'Azazîl, who is Tawûsî Melek, to direct worldly affairs.[186] According to the Yezidi religious tradition, Tawûsî Melek and his six companions are responsible for determining the destiny of the following year, which they do during the festival of the Assembly (*Cejna Jema'iyye*) in the autumn, between 23 and 30 September, in Lalish. Thus, these seven angels are highly regarded and respected in Yezidi culture.

Yezidis believe that angels come to the earth periodically to bring new rules to nations. Every 1,000 years, one of the seven angels comes, revealing holy texts and rules to the Yezidi community. When he finishes his mission, he goes back up to heaven. It is also believed that some of the angels transformed themselves into humans and left descendants in the world.[187] The sheikh families are believed to be descended from this angelic blood. Moreover, the Yezidis believe in the transmigration of souls and use the metaphor of a change of garment to describe the process of *kiras gehorin* (changing the shirt). Thus, it is believed that the seven angels have successive manifestations in human form. The most recent manifestations of this Divine Essence were the members of Sheikh 'Adī's family, who were his early successors, as well as the members of the Shamsani sheikhs. These sheikhs in turn represent a *khas/mêr* (man)[188] through which Yezidis approach God.[189] Thus, these *khas/mêr* figures are objects of devotion seen in the mausolea and shrines which constitute the main Yezidi sacred buildings and are regarded as symbols of the Yezidi religion.

Moreover, Tawûsî Melek ('Azazîl) and six other individuals of high spiritual rank are shown to be incarnations of the seven holy beings in *Mishefa Resh*, namely, Sheikh

Ḥasan is Darda'îl, Sheikh Abū Bekir is Jibra'îl, Sheikh Shams al-Dīn is Israfîl, Sheikh Fakhr al-Dīn is Nura'îl, Sajadīn is 'Ezra'îl, and Sheikh Nasr al-Dīn is Shemna'îl.[190] Four of these figures, Shams al-Dīn, Fakhr al-Dīn, Sajadīn and Nasr al-Dīn, also make up the 'four mysteries' who are believed to be sons of Êzdîna Mîr, eponyms of the lineage of the Shamsani sheikhs.[191] Three Yezidi angels commune with and have the same duties as the archangels in Judaism, Christianity and Islam. Jibra'îl bears the word of God to the Prophets and believers; 'Ezra'îl is the archangel of death; Israfîl stands in the presence of God and announces his messages by blowing the trumpet.

The Peacock Angel (*Tawûsî Melek*)

Tawûsî Melek is the most important character in the Yezidi pantheon. He is the leader of the Yezidi Holy Trinity and dominates all the divinities.

In Yezidi belief, Tawûsî Melek is the mediator angel between God and the Yezidi people who leads directly to God, who is independent but not in opposition to God. At the same time, he is God's alter ego, united with him, whole and inseparable. He is the manifestation of the creator, but not the creator itself. He is the enlightening of mankind. Thus, Yezidis pray to God through his banners in the form of a peacock.[192] The Hymn of Tawûsî Melek, *Qewlê Tawûsî Melek*,[193] clearly indicates Tawûsî Melek's place in the belief system of his followers.

> ...
> Ya rebbî tu melekê melikê cîhanî
> Ya rebbî tu melekê melikê kerîmî
> Tu melekê 'erşê 'ezîmî
> Ya rebbî ji 'enzel da her tuyî qedîmî
>
> Tu tam û kam û ray
> Ya rebbî her tu xuday
> Her tu hay
> Û her tuyî layîqî medḥ û senay.
> ...
>
> Oh my Lord, you are the angel who is the king of the world,
> Oh my Lord, you are the angel who is a generous king,
> You are the angel of the awesome Throne.
> Oh my Lord, from pre-eternity you have always been the ancient one.
>
> You are the taste, happiness and insight,
> Oh my Lord, you are forever God,
> You are forever aware,
> And you are forever worthy of praise and homage.
> ...

In *Mishefa Resh* Tawûsî Melek is identified with ʿAzazîl. God creates an angel and gives him the name of ʿAzazîl that is Tawûsî Melek, who is the leader of all angels.[194] Moreover, the Book of the Revelation, *Kitêb-i Cilwê*, exalts Tawûsî Melek as the symbol of the Yezidi religion.[195]

It is probably not by accident that an angel, or *djin*, called ʿAzazîl and later named Iblis, also exists in the Muslim tradition. He was young and grew up among the angels and became learned in their knowledge; thus he assumed governance over them and became their chief until the infamous event happened between him and Adam. 'When we said unto the angels, Worship ye Adam and [all] worshipped except Iblis, [who] was [one] of the *djin*'.[196]

The veneration that the Yezidis show to Tawûsî Melek, the Peacock Angel, has earned them the name 'Devil-worshippers', 'Abadat al-Sheitān. It was principally Muslims and Christians from the Middle East who considered Tawûsî Melek to be the embodiment of Satan, the evil, rebellious spirit, and the devil; occidental travellers of nineteenth and early twentieth century helped to disseminate this opinion. As a result, the Yezidis became a subject of interest for many writers and researchers during the twentieth century, and understanding the role of Tawûsî Melek in the Yezidi cult kept many of them busy.

The image of the peacock is associated with the Middle Eastern deity Tammuz found in Mesopotamian iconography; because of this association and the resemblance of the name Tammuz to Tawûs, it has been argued that Tawûsî Melek is the God of fertility, Dumuzi/Tammuz, the son of Enki/Ea and the lover of the goddess Inanna/Ishtar.[197] Moreover, as this prominent angel is equated with Satan, some scholars find Iranian dualism in Yezidism, and some consider Tawûsî Melek to be the Evil Principle, Angra Mainyu/Ahriman, who opposes Ahura Mazdā/Ohrmazd, the Good Principle.[198] Ahura Mazdā is the light and life and all that is true and good and in the ethical world, law, order and truth, whereas Angra Mainyu symbolises darkness, filth, death and all that is evil, lawless and deceitful in the world. However, this dualism does not exist in the Yezidi cult as Satan is not considered Evil and in opposition to God. Nevertheless, it is evident in the Old Iranian beliefs that Angra Mainyu, the Evil Principle, creates the peacock in order to prove that he is able to create good things as well.[199] Therefore, it has been argued that this link between the devil and the peacock in Zoroastrian tradition may have influenced Yezidism through the Shamsanis, who were practising ancient Iranian religions in which the veneration of angels was one of the main characteristics, and the importance of Tawûsî Melek in the Yezidi cult may have been strengthened particularly by the teaching of Sufi Sheikh ʿAdī concerning the devil in the twelfth century.[200] It is possible to believe that Sufi Sheikh ʿAdī continued the tradition of the redemption of Satan in his teaching, which was promoted by famous Sufi leaders from the ninth century.

The ambiguous figure of Tawûsî Melek is largely regarded as an incarnation of evil and equivalent to Satan in the ancient Near Eastern cultures. Notably, he was identified

with the fallen angel, who was expelled from Paradise because of his disobedience to God. However, although the Yezidis acknowledge the concept of Evil, they do not have the same understanding of Satan in their cult as other religions. Thus, they refuse to call Tawûsî Melek Satan and are forbidden to pronounce the word Satan, something which is regarded as a sin. Tawûsî Melek appears in the Book of the Revelation and says 'O, people, who observe my injunctions, reject such sayings and teachings as they are not from me. Mention not my name or my attributes, as strangers do, lest you be guilty of sin, for you have no knowledge thereof'.[201] Thus, in Yezidi religious belief, Satan is not a fallen angel, but the most beautiful and powerful angel and the only representative of God on earth. In Yezidi belief, Satan refused to prostrate himself in front of Adam because of his true love for God. God ordered Satan to bow to Adam to test his honesty and his commitment. As Satan refused to bow to no one but God, he made Satan as the chief of his angels. Satan with his behaviour showed his fidelity and emphasised the eminence of his Creator. Nevertheless, in another Yezidi tradition, Satan appears as a fallen and redeemed angel. After having been cursed and fallen, Satan regretted his not bowing in front of Adam and cried for 7,000 years, filled seven jars with his tears and extinguished the fires of Hell with them. Thereupon, God forgave and redeemed him. He regained his fame and was thereafter considered to be the source of goodness.[202] Consequently, Satan is not a source of malice for the Yezidis.

The Fall of Adam and Eve and their expulsion from Paradise has also been an important subject for Islamic Mystics over the centuries, who discussed Satan and presented him as a redeemed, even holy, figure. Sufis asked themselves how to reconcile the inflicted punishment of Iblis with the doctrine of predestination, as it is believed in mystic doctrines that God himself desired that 'Azazîl should disobey him and become Iblis. The Fall of Adam was essentially desired by God. Thus, 'Azazîl is the executor of God's will, ready for self-sacrifice and tragically in love.[203]

This tradition, reconciliation of the punishment of Iblis, starts with Sufi Sahl al-Tustarī (818–96). According to him, Satan is his friend and his master. Ahmad al-Ghazālī (d. 1126), who was a friend of Sheikh 'Adī and a great influence on the latter's teachings, described Satan as 'the Lord of Monotheists'[204] and states, 'One who will not learn to worship One God from Iblis is a heretic and infidel. He was ordered to worship someone other than his Lord and he refused to do so'.[205] Al-Ḥallaj (855–922), who was crucified because of his orthodox ideas, believed that Satan disobeyed God's order to bow down to Adam because of his love for God.[206] Thus, his disobedience must be understood as laudable. Farīd-ūd-Dīn 'Attar in his *Mantiq at-ţayr* considers Satan to be a monotheist and a lover of the Way of Truth, carrying God's curse joyfully, as a mantle of honour.[207] Apart from these Sufis, Muhyi'al-Dīn ibn al-'Arabī (1165–1240); Kutb al-Dīn Bakhtiyar Kākī (thirteenth century); 'Abd al-Karim al-Djīlī (1365–1428, a descendant of 'Abd al-Qādir al-Jīlānī), who also supported the idea of rehabilitating Iblis, and many other Sufis also refused to curse Satan and tried to promote him to his

holy place. According to one Jewish tradition,[208] Satan[209] is not a representative of evil, but a messenger of God. A sub-group of Ahl-e Ḥaqq[210] also believe that Satan is not evil and the guardian of the Hell but the Lord of this world. Nevertheless, the Yezidis have an interesting interpretation of the association of Tawûsî Melek with Satan. According to a Yezidi legend, one day Prophet Muḥammad rose to Paradise, where he found God, Tawûsî Melek and other angels at a meeting. Muḥammad wanted to meddle in the conversation, but Tawûsî Melek pointed out that Muḥammad, the simple mortal, should not be at the meeting. He asked Muḥammad to withdraw, but the Prophet replied rudely. Becoming angry, Tawûsî Melek took him and threw him to the Earth. Thereafter, Muḥammad called this angel Satan.

Another Yezidi legend shows Tawûsî Melek as a fallen angel and the leader of the Yezidi people.

A little star fell from heaven, said an ancient Yezidi legend, and hid in the depth of the then still dark earth. In that little star a bright beam of the nocturnal sun illumination paradise fell on earth, and the earth became light, clear and warm; a particle of endless light illuminated it, enflamed life in it, gave it strength, reason and breath. That beam, that particle of endless light, was the great and glorious Tawûsî Melek; through love for the dark earth he exchanged the realm of endless light – the blue sky fooled with the sunbeams and thirty three thousands stars, along with endless light Tawûsî Melek lost the grace of the height of the Throne whereupon he had ruled the stars, the sun and the moon. The great and the incomparable, it took him (Tawûsî Melek) a long time to fly down, with no place to stay and rest; there was not a star, or moon or sun to lend him support. Loyal to the will of the Most High, they drove away the fallen spirit, being afraid to anger the one who cast Tawûsî Melek down. Only earth did not deny shelter to the exile, accepting him with open arms. Having fallen on the green earth covered with sweet-smelling flowers, the incomparable Tawûsî Melek lay motionless: battered, sick, dejected, he was alone in the world, for all disdained him ... Even people whom he loved so much, to whom he brought the bright hope and blazing fire, were so mean that they did not want to alleviate the heavy sufferings of the exile. Passing by and seeing him helpless, they jeered at him, beat him with sticks, spat in his face and cursed the one to whom they owed their life and their senses. All those insults were patiently born by Tawûsî Melek in silence; he believed and hoped that a spark of the better light that had been brought by him would not be extinguished even among cruel and corrupt people, and the bright hope did not deceive Tawûsî Melek.

There came about kind people, pure in heart, which had preserved the un-extinguished spark of endless light galling on earth as a bright star

21 Banner of Tawûsî Melek (Peacock Angel), Lalish

of heaven; they recognised and welcomed Tawûsî Melek, fearing not what other people would say or in what way Allah would view their kind deed. Gathering around the fallen angel, they washed his body with the water of pure springs, sprinkled him with the incense of the colourful mountain flowers, covered him with the best ferments woven by the hands of their beautiful daughters. Tawûsî Melek then revived and woke up for the new life on earth; he raised his hands to heaven, as if to bid farewell to him, and the Everlasting rolled thrice in the roaring storm.

The Creator of the world, the source of grace and limitless love, condemned not the kind people for what they did for the miserable Tawûsî Melek, and showed his blessing with the sign of the rainbow. And the poor people of the mountains received that sky-sign as the command of the Most High never to abandon the downcast and rejected Tawûsî Melek in distress or affliction. Those people were the Yezidis; until now they go after Tawûsî Melek, hated and cursed by the whole world ... [211]

Beside the identification with Satan, Tawûsî Melek is also depicted as a peacock, which makes him more mysterious. Why do the Yezidis represent Satan in the form of the peacock, and what is the relation between the Peacock and Satan that they should be thus identified?

The peacock is the symbol of immortality, rebirth and the unification of opposites. It is a natal bird of India. It was known in Mesopotamia by the late eighth century BC[212] and was associated with the Mesopotamian deity Tammuz.[213] In Persian iconography, the peacock is usually depicted in pairs on either side of the tree of life and represents the duality of human nature. The depiction of the peacock is known in the Sasanian buildings. For instance, on the stucco plaque which covers the inner walls of the Palace of Shapur at Ctesiphon (c. 250 AD, Iraq) is a beautiful carving of the beribonned peacock in a medaillon.[214] The peacock is a fairly common motif on Sasanian seals and has mostly aesthetic significance.[215] The image of the peacock also frequently appeared in the Christian world, and as its tail covered with eye feathers resembles the wings of cherubs, it was used widely for its symbolism. Roman coins bear the peacock depictions from the first century AD.[216] The image of a pair of peacocks in on either side of a fountain face to face while they drink the sacred water in the Garden of Eden appears frequently in Byzantine Christian art.[217] As the peacock was regarded as the symbol of the immortality of the soul, it was depicted on the sarcophagus or on the altars as a relief,[218] on the ground or panel mosaics and on the walls as a fresco. A beautiful fourth-century fresco depicting peacocks in pairs is found on the internal wall of the Elbeyli Hypogeum in Iznik. A similar peacock panel mosaic is found on the vault of the fifth-century AD Roman church at Beligna.[219] Similar examples are also found in Medieaval Armenian art. These are mostly in pairs on either side of a vase

or sometimes as a single pair carved on the walls of Armenian churches,[220] depicted on katchkars in low relief or in miniature.[221] In Muslim tradition,[222] the peacock is extremely popular and is represented especially on funerary architecture,[223] textiles, metal works and ceramics of early and medieval Islamic periods.[224] In the Ottoman period, the peacock is the bird of Paradise and is depicted principally with Adam, Eve and the serpent in their expulsion from Paradise.[225]

According to Muslim tradition, it was the peacock that helped Satan to enter Paradise and seduce Adam and Eve into eating the forbidden fruit. Therefore, the peacock is identified with Satan. According to this story, Satan presents himself to the peacock as an angel and asks him to help him enter Paradise. In return, he promises to teach the peacock three magic formulas granting three different boons: eternal youth, prevention of illness and eternal access to Paradise. The peacock sends Satan to the serpent to get help entering Paradise in order to deceive Adam into eating the prohibited wheat. Thus they are all expelled from Paradise.[226]

In another Muslim tradition, which pre-dates the Fall of Adam and Eve from Paradise, Satan was called the peacock of the angels, *Tawūs al-Malaïka*, because of his beauty which surpassed that of other angels, just as the beauty of the peacock surpasses that of all other birds. According to Ḥasan al-Basrī (642–728), a famous Muslim preacher of the Umayyad Period, who is also highly respected by the Yezidis and is identified with the Yezidi saint Sheikh Ḥasan (third successor of Sheikh 'Adī), Iblis, who was a *djin*, governed the lowest heaven and the earth and was called *Tawūs al-Malaïka*. When *djins*, on earth rebelled, God sent a troop of angels who drove them to the islands and mountains; and since Iblis was delighted with pride and refused to bow in front of Adam, God transformed him into Satan (*Sheitān*).[227]

Despite its fame, the peacock was qualified with inauspicious events as there is contradiction between its colourful feathers and its ugly feet and dreadful voice, which symbolised the darker side of the human being. Although the peacock is very proud of its divine beauty, it is very unhappy with its lean ugly legs. Thus, it suffers. For instance, Farīd-ūd-Dīn 'Attar, a medieval Persian Sufi poet, describes the peacock as follows: 'Everybody praises *Tawus* [peacock] for his beauty, but he is ashamed of his ugly legs'.[228] Moreover, the poet Nizāmī writes, 'Do not judge a peacock by the colour of its feathers and the manner of its flight, for like the cat he too has an ugly cry'.[229]

The representation of Satan in the image of peacock is also seen in other heterodox religious communities of the Middle East such as the Mandeans, Takhtadjis[230] and Druzes.[231] Although the Yezidis are not the only or the first to give a primordial place to Satan in their cult, with time, Tawûsî Melek became the most obvious and clear symbol of the dissociation of Yezidism from other religions. This symbol grew notably over time, and it was depicted on brass banners, called *sanjak*, when Yezidi heterodoxy became clearly defined in opposition to the Muslim establishment. This re-adaptation of a pre-Islamic cult, developed with the teaching of Sufi Sheikh 'Adī coincided with

22 Baptism of the banner of Tawûsî Melek, Lalish

the persecution and forced conversion that the majority of Muslims undertook vis-à-vis the Yezidi minority, who, henceforth, were considered as apostates. Yezidis were people without book as they did not hesitate to represent the image of the Peacock Angel on banners in their places of worship. The banner of Tawûsî Melek is omnipresent during the ceremonies and rituals which take place in the Lalish valley. Besides, when the religious singers, qewwals, go to Yezidi places to inform people of the religious rules as well as to collect donations for the needs of the community, especially for the mîr family, they pray and recite hymns in front of these statues. However, Yezidis categorically reject the idea that these images are idols and regard them simply as symbols. According to them, these statues are used during their rituals and ceremonies in order to make the faith more tangible. The statues were originally seven in number and used to represent the seven Yezidi provinces in the past. These provinces were Sheikhan, Sinjar, Aleppo, Khatta (around Mardin), Zozan (Şırnak and Batman), Haweri (Jazira) and Transcaucasia (Kars, Van, Yerevan and Tbilisi)[232]; today there exist only three, which belong to the Sheikhan, Sinjar and Aleppo provinces. According to the Yezidis, the other banners were stolen during the last century.

The image of the peacock is also depicted on the triangular pediment of the main gate of the Sanctuary of Sheikh ʿAdī in Lalish where there is a representation of a black snake as well. It is evident that the trio of Satan, the peacock and the serpent has a central role in Yezidi belief (Pl. 23).

23 Portal of the sanctuary of Sheikh 'Adī, Derîyê Kapî, Lalish

Sultan Êzi

Sultan Êzi is the second crucial figure, appearing sometimes as God and sometimes as an angel, and many legends are attributed to him in Yezidi mythology. Sultan Êzî is one of the Yezidi Holy Trinity. He is sometimes identified with Tawûsî Melek as well.

Although it is difficult to historically identify Sultan Êzî, from whom the Yezidi community derives its name, there are several opinions concerning him. These appraisals are based mainly on legends. For instance, according to a Yezidi legend that was related to me during my field research, Êzî, Êzda is the child of Shehîd b. Jerr an a houri. It was Tawûsî Melek who arranged this marriage and the Yezidis are the descendants of this child.[233]

Nevertheless, some scholars find an association between Êzî and the ʿUmayyad caliph Yazid ibn Muʿawiya (680–83).[234] Moreover, this association is made by medieval historians such as ʿAbd al-Karīm al-Samʿānī (d. 563/1167) and Ibn Taymiyya (1263–1328). Al-Samʿānī in his work *Kitāb al-Ansāb*[235] talks about a group of people living in northern Iraq who believe in Yazid ibn Muʿawiya and that he was righteous. Ibn Taymiyya also discusses the correlation between the worship of Yazid and that of ʿAdī's family.

> At the time of Sheikh Ḥasan, they added to the belief in Yazid much of other errors in words and prose. They dedicated to Sheikh ʿAdī and Yazid an excessive veneration, incompatible with the doctrines of grand Sheikh ʿAdī.[236]

Moreover, although modern Yezidis deny any kind of relationship between Islam and caliph Yazid ibn Muʿawiya, Sheikh ʿAdī is said to have described Yazid as 'an *imam* and the son of an *imam*, who battled the infidels' and to have declared that anyone who cursed him should be spurned.[237] Furthermore, the description of the angel Êzîd in a Yezidi legend also reveals a connection between the Yezidis and Muʿawiya.

> Muʿawiya [the first caliph of the Umayyads] was the Prophet Muḥammad's servant. Once the Prophet Muḥammad asked Muʿawiya to shave his head. Muʿawiya shaved his head in a hurry which caused Muḥammad's head to bleed. Fearing that the blood would fall on the ground, he licked it, thinking it was sacred. Muḥammad became upset and said to him: what have you done? You are going to create a nation that would oppose my nation. Muʿawiya then vowed not to marry that he might not have offspring, the source of a nation which would oppose that of Muḥammad. After a while, Muʿawiya was stung by a scorpion which poisoned his face and body. He was advised to marry in order to cure his illness resulting from the scorpion poison. He decided to marry an old woman who could not beget children and so he married a woman who was eighty years old, Mahūsa. She, however, became like a young woman after the wedding night and gave birth to Êzîd.[238]

Sheikh ʿAdī

For the Yezidis, Sheikh ʿAdī is sometimes a historical as well as a religious and mystical person whose spirit has survived the centuries. He was born in Beit-Fār in the provinces

of Baalbek in Lebanon as an Arab from the Kuraysh tribe of Umayyad origin. His complete name is 'Adī b. Musāfir b. Isma'il b. Musa b. Marwan b. al-Hakim (or al-Ḥasan) b. Marwan. Although his birthday is unknown, according to Arabic sources, he died in 557/1162–63 when he was 90 years old. Thus, 1073 can be suggested as his year of birth. Sheikh 'Adī's birth is described in Yezidi legends, and it is widely believed that 'Adī's future as a Sufi was pre-determined by events concerning his father. According to a legend, 'Adī's father, Musāfir b. Isma'il, went to a forest and remained there for forty years. Once, in his dreams, he was told to go back home and copulate with his wife because from this copulation a friend of God would be born whose fame would spread in the east and the west.

Historically, Sheikh 'Adī is well documented by a number of distinguished medieval historians and geographers. For instance, Yāqūt al-Ḥamawī (1179–1229); in his *Mu'jam al-Buldān* (Geographical Dictionary);[239] Ibn al-'Athir (1160–1233) in *al-Kāmil fi al-Tarīkh* (The Complete History);[240] Ibn Khallikān (1211–82) in *Wafiyāt al-A'yān wa-Anba' Abna' al-Zamān* (The Obituaries of Eminent Men);[241] Ibn Taymiyya (1263–1328); 'Al-Risāla al-'adawīyya' in *Majmū' al-Rasā'il al-Kubra* (A Great Compilation of Message);[242] Al-Hafiz al-Dhahabī (d. 1347) *Siyar al-Alam al-Nubala* (The Lives of Noble Figures)[243] and Ibn Kathīr (1301–73) in *Al-Bidaya wa al-Nihaya* (The Beginning and the End).[244]

'Adī received his first religious education in Beit-Fār. His father, even with his Sufi tendencies, was also known as a good Muslim. At an early age, he moved to Baghdad, the centre of culture, education and politics of the Muslim world, where he met famous Sufi mystics of the time and studied with them: 'Abd al-Qādir al-Jīlānī, the founder of Qadiriyya order, the two Ghazālī brothers and Abū'l-Najīb 'Abd al-Qāhir al-Shuhrawardī.[245] He also won respect for his good manners. Then, he received a Sufi education from Abū'l-Khayr Hammād al-Dabbās, 'Uqayl al-Manbijī and Abū'l Wafā' al-Ḥulwānī. He went twice to Mecca on pilgrimage, once, in 1116, with al-Jīlānī,[246] from whom he received help when he withdrew to the Kurdish mountains, where al-Jīlanī already had many supporters among the Kurds. Al-Jīlanī appreciated Sheikh 'Adī's diligence and noted that, 'if one could attain the gift of prophecy through striving, Sheikh 'Adī b. Musāfir would certainly have attained it'.[247]

While Sheikh 'Adī was in Baghdad, he wrote several treatises and *qaṣīdas* which give some idea as to his religious and philosophical ideas but are generally not very innovative; they simply follow the rules of Islam. It is important to note here also that there is absolutely no evidence of Yezidi doctrine in his works that we are aware of today. Thus, as I discussed in the previous chapter, Yezidism took its current form after Sheikh 'Adī's death. His works about his teaching number four, and all are currently in the Berlin Library. They are collected in a manuscript under the code of We 1743, folios 29^b–43^a. This manuscript was copied by a certain Muḥammad b. Ahmad al-'Adawī in 915/1509.[248]

In his work *I'tiqād Ahl es-Sunna wa I dhamā'a* (Dogma of the People of the Sunna), Sheikh 'Adī talks about the unit of God and the means by which we can arrive at the knowledge of this truth. These are two, the first is provided by the study of tradition (*sam'*), the second, by reason ('*aql*). 'Adī then describes the attributes of the divinity, insisting particularly on his supremacy, from which an important conclusion is drawn: it is God who created Satan and evil. He quotes passages of the Qur'an and the *ḥadīth* to support his theory. He also justifies it by the following reasoning: 'another proof is that, if evil existed independently of the will of God, God would be impotent, but an impotent being cannot be God'. The second part of the work is devoted to the study of the faith, a virtue that 'Adī defines in these terms: 'The faith is at the same time word, work and intention; it is increased by obedience and decreased by disobedience'. Moreover, according to him, Muslims must be guided only by the Qur'an and the *sunna,* having as examples the lives and experiences of the four caliphs Abū Bekir, 'Omar, 'Othman and 'Ali. Thus, it is obvious that 'Adī is attached to *sunna,* which is respectful to the Prophet Muḥammad's education and his four successors. However, Sheikh 'Adī opposes Shi'ites but not 'Ali.

His *Kitāb Fīhi Dikr Adāb en-Nafs* (Book of How to Train Soul Beautifully) contains the *dhikr* of good intellectual education. This book shows Sheikh 'Adī as the founder of a *tarīqa,* a mystical order similar to Bektashis. He advices his disciples by giving the example of *derviches* and says to his disciples, 'You should know that saints did not become saints by eating, drinking, sleeping, striking and beating, but that they rose until their state thanks to their religious zeal and their austere practices. The one who perishes for the love of God becomes a dress of honour for the Divinity and who comes closer to God by annihilating his own life, God gives him this life'.[249]

His *Waṣāyā Ash-Sheikh 'Adī b. Musāfir ilā'l-Khalifa* (Sheikh 'Adī b. Musāfir's Admonition to Caliph) is about counsels of piety and humility. This text advises Muslims to have contempt for the worldly life and to follow the way of faith, being wary of unlawful innovations.

And finally, *Waṣāyā li-murīdihi Ash-Sheikh Qā'id wa-li- sā'ir al-Murīdīn* (Recommendations to His Disciple, Sheikh Qā'id and His Other Disciples) is an apologia for Sufism and the ascetic life. On the basis of Quranic verses, 'Adī orders his disciples to stand up against this world, conquer their passions and abandon all which is agreeable in this world, and he teaches his disciples how to follow the Sufi life.[250]

Sheikh 'Adī also wrote the eulogy [*qaṣīda*] 'The Hymn of Sheikh 'Adī', found in the British Library. 'Adī begins with a self-proclamation: he is the bearer of the Truth and the creator of everything by the will of God. He finishes with his self-identification as God.

...

And I am the ruling power preceding all that exists.

And I am he who speaks a true saying.

And I am the just judge, and the ruler of the earth.

And I am he whom men worship in my glory,
Coming to me and kissing my feet.

...

And I am Adi Es-Shami [of Damascus], the son of Musāfir.
Verily the All-Merciful has assigned unto me names,
The heavenly throne, and the seat, and the seven [heavens] and the earth.
In the secret of my knowledge there is no God but me.[251]

...

Sheikh 'Adī was influenced by the ideas of various Sufis such as al-Ghazālī, al-Jīlānī, al-Ḥasan al-Basrī, al-Ḥallaj, Qeḍib al-Ban and Fakhr al-Dīn Tabaristanī al-Gaydī, who are still venerated by modern Yezidis and also identified with Yezidi angels.[252]

Afterwards, becoming himself an appreciated and much sought after spiritual master, who was a Shafi'i,[253] he gathered a certain number of disciples and retired with them to the Kurdish mountains at the beginning of the twelfth century, before the year 505/1111.[254] There were probably several reasons that he chose this region. First, the peaceful idyllic environment of the Kurdish mountains perfectly suited his desire for solitude and enabled him to avoid the learned people of Baghdad, who envied or disliked him, especially since he had given up normative Islamic theology and turned to Sufism. It is believed that he had visited this region when he was living in Baghdad and had established contacts with the local people as well as with the Kurds living in and around Baghdad.[255] Second, he was warmly welcomed by the Kurdish population, who were a sizeable community of supporters of the Umayyad dynasty, as well as by the region's influential Kurdish Sufi masters, who had a local network and were in contact with Sheikh 'Adī.[256] Sheikh 'Adī was a descendant of Marwan II, who was born to a Kurdish mother. Before ascending the throne (740–50), Marwan II had ruled over the Kurdish regions, Armenia and Azerbaijan, where he was widely supported by the Kurdish population. When this dynasty collapsed, some Umayyad descendants remained, settling among the Kurds, and some of them became ascetics. In this way, from the twelfth century, Kurdish regions became the supporters of the Umayyad cause both politically and religiously. So, Sheikh 'Adī was an Arab from the Umayyad dynasty with Kurdish blood running in his veins. Finally, Sheikh 'Adī might have intented to propagate Islam amongst the Kurds in the Hakkari region by following the example of al-Ḥallaj (858–922), one of the earliest Sufis from Persia whose father was of Kurdish descent, who was executed by the Abbasids because of his extreme mystic ideas, one of which was his defence of Iblis, Satan.[257]

Sheikh 'Adī founded the 'Adawiyya order with the help of his disciples who came with him from Baghdad and the Kurdish Sufi masters of the region. Moreover, he founded a zāwiya at Lalish for himself and his disciples in order that they might be able to follow the contemplative life. His ascetic life and miracles attracted Kurds

in large numbers, Muslim and non-Muslim, and he became a figure of authority in the region. Furthermore, he met at Lalish the four sons of Êzdîna Mîr, from whom the current Shamsani lineage comes.[258] According to the Yezidis, Êzdîna Mîr's sons practised Iranian religions and created an influential group in the region. Because of the diplomatic skills of Sheikh 'Adī, his disciples, the 'Adawis and the Shamsanis were politically reunited for the purposes of self-defence in their fight against the Abbasid Muslim state.[259] Over time, they influenced each other's beliefs.

Sheikh 'Adī had power over his disciples due to his strict application of his doctrines: his self-tortures, fasting and miracles. It was believed that he had control over the snakes and the wild animals. He could read the thoughts of his interlocutors and make water appear from arid ground, turning it fertile. One day, by placing his hand on the chest of his servant, he enabled him to recite the Qur'an by heart. He could cause visions among his disciples and reveal in a mirror the face of the absent people. He returned sight to blind men. He would become invisible at will and could shorten distances. He communicated with the dead. He knew magic words to open doors. He reversed the course of rivers.[260]

Sheikh 'Adī, the master of the 'Adawis and the leader of many Muslim and non-Muslim communities of the Hakkari region, to whom many miracles were attributed, died in Lalish in 557/1162–63 and was buried in his zāwiya. Afterwards, his tomb became one of the main places of devotion for the inhabitants of the region and over time, the centre of pilgrimage for the Yezidis. It was called the sanctuary of Sheikh 'Adī or Perisgaha Lalish (Lalish Temple in Kurdish).

Yezidi Mythology

Yezidi mythology consists of the creation of the cosmos and universe, the creation of Tawûsî Melek and other angels, the creation of human beings and the Yezidi race, and the Flood. Although Yezidi traditions of the creation of cosmos and the Flood are similar to those found in other Middle Eastern religious texts, Yezidis enrich their own legends in their two sacred books, *Mishefa Resh* and *Kitêb-i Cilwê*.

The Creation of the Cosmos and the Universe

The creation myth begins with the creation of the white pearl and a bird named Anfar. The pearl is placed upon the back of the bird for 40,000 years. Then God creates seven days and an angel for each day. On the first day, Sunday, he creates an angel named 'Azazîl, which is Tawûsî Melek, the chief of all. On Monday, he creates Darda'îl, who is Sheikh Ḥasan. On Tuesday, he creates Israfîl, who is Sheikh Shams. On Wednesday, he creates Jibra'îl (Gabriel), who is Sheikh Abū Bekir. On Thursday, he creates 'Ezra'îl, who is Sajadīn. On Friday, he creates the angel Shemna'îl, who is Nasr al-Dīn. On Saturday, he creates the angel Nura'îl, who is Fakhr al-Dīn. Afterwards, he creates the

form of the seven heavens, the earth, the sun, and the moon. He creates mankind, animals, birds, and beasts, places them in the folds of his mantle and arises from the Pearl accompanied by the angels. Then he lets out a loud cry and forthwith the Pearl falls asunder into four pieces. Water gushes out and becomes the sea. He creates Jibra'īl (Gabriel) in the form of a bird and commits to his hands the deposition of the four corners. Then he creates a ship and resides therein for 30,000 years, after which he comes out and dwells in Lalish. He cries out in the world, and the sea coagulates, and the world becomes earth. Then he commands Gabriel to the two pieces of the White Pearl, one of which he places under the earth, while the other stays in the Gate of Heaven. Then he places in them the sun and the moon; he creates the stars from their fragments and suspends them in heaven ornaments. He also creates fruit-bearing trees and plants on the earth, and likewise the mountains, to embellish the earth. He creates the Throne over the Carpet.[261]

The Creation of Human Beings

After the creation of the world, God assembles his angels and announces to them that he will create Adam and Eve, and thus human beings, and from them two shall arise, out of the loins of Adam, Shehīd b. Jerr (son of the Jar); from him shall arise a single people on the earth, the people of 'Azazīl, that is, Tawūsî Melek, and these will be the Yezidi people. Then he will send Sheikh 'Adī b. Musāfir from the land of Syria, and he shall come and dwell in Lalish. Then, the Lord descends to the holy land and commands Gabriel (another name for Tawūsî Melek) to take earth from the four corners of the world: earth, air, fire and water to create man. He makes the man with earth and endows it with a soul by his power. Then he commands Gabriel to place Adam in Paradise, where he might eat the fruit of every green herb; it is only wheat that should not eat. Adam stays in Paradise for a hundred years, after which Tawūsî Melek asks God, 'In what way should Adam increase and multiply, and where is his offspring?' God says to him, 'I passed you the arrangement of this matter'. Then Tawūsî Melek comes and says to Adam, 'Have you eaten of the wheat?' He answers, 'No, for God forbade it to me'. Tawūsî Melek says, 'If you eat of it, all shall go better with thee.' But, after Adam has eaten, his belly swells up, and Tawūsî Melek expels him h from Paradise, leaving him there while he ascends into heaven. Adam suffers from the distension of his belly, because there is no way to relieve it. But God sends a bird, which comes and helps Adam by making an outlet for it, and he is relieved. And Gabriel stays away for a hundred years, during which Adam remains sad and weeps. Then, God commands Gabriel to come and create Eve for Adam. Then, Gabriel creates Eve from under Adam's left arm-pit.[262]

After the creation of Eve, Tawūsî Melek asks Adam and Eve to generate a people who will respect him. They watch animals that propagate by mating but Adam and

Eve have a quarrel on the subject of procreation. Eve claims that all their children will be generated from her, whereas Adam asserts that it is the father who gives life to his children. Each one puts the fruit of their concupiscence in a jar, sealing the openings and burying them. After nine months, they open the jars. In Adam's jar they see a beautiful boy called Shehîd b. Jerr, from whom the Yezidi race draws its origin. But when they open Eve's jar, they see worms, foul and sordid. Then, God creates breasts to feed his children during their first two years; since that time man has had breasts. After that, Adam knows Eve, and she gives birth to two twin children, male and female, from whom are born the Jews, Christians and Muslims.[263]

In another creation myth, Eve exists before Adam and Tawûsî Melek plays a role in the generation of human beings. According to this legend, God creates the earth and the near and far skies. Therein he places the bull and fish. Tawûsî Melek says to God 'There is no human on this earth'. God replies, 'Go for a walk by the universe!' Tawûsî Melek goes and walks on the universe and sees a woman. He comes back towards God and says, 'I have seen a woman!', and adds, 'This woman without a man is useless!' God creates a man with the name of Adam. God makes his body with clay and introduces a soul into his body. While Adam is asleep, Eve goes to him but does not wake him up, and then leaves. Adam wakes up and sees the traces of human steps. He follows them, sees Eve and takes her as his wife. Then, God places forty boys and forty girls in Eve's belly. Tawûsî Melek asks, 'How do we marry them?' God replies, 'Those on the right side should pass to left side and those on the left pass to the right side', and they make the world prosperous.[264]

The Flood

Yezidis believe that the Flood occurred not once, but twice. While the first Flood ravaged the children of Adam and Eve, the second one directed its rage at the Yezidi people. Some time after the first Flood, which was survived by Noah, came the second Flood, which befell only the Yezidis; Na'umi (king of peace), a noble person, survives.[265]

Because of the contempt of the Yezidi people had for the marriage of Adam and Eve as the origin of the Yezidi race, they became the victims of the second Flood. The ark sails to the village of 'Eyn Sifni[266] in northern Mosul, where it is lifted up and carried by the waters to the top of Mount Sinjar.[267] There, it violently hits the rocks and is pierced. But a serpent appears and plugs the hole by curling up against it. The ship resumes sailing and comes to rest on the Mount of Judi.[268] However, the race of serpents multiplies and becomes harmful to humans.

Holy Books

It is acknowledged that Yezidis possess two holy books, the *Mishefa Resh* (the Black Book) and the *Kitêb-i Cilwê* (the Book of the Revelation). Both are rather short

manuscripts. At least nine copies exist in several European and Turkish libraries.[269] They contain almost the same contents and also include an Arabic text entitled 'History of the Yezidis in Mosul and its Environs' and a Syriac treatise 'Extract from the History of the Yezidis'. Some of these collections also include the Yezidis' 1872 petition serving in to the Ottoman authorities explaining the rules of their religion in order to be exempted from the Ottoman army.

There is absolutely no evidence of when these manuscripts were originally written. Their existence was unknown until the end of the nineteenth century. However, according to a letter that Shammas Jeremiah Shamir, a dealer in books and manuscripts, wrote to Alpheus Andrus in 1892, the *Kitêb-i Cilwê* would have been written in 558/1162–63 by Sheikh Fakhr al-Dīn, the secretary of Sheikh 'Adī, as dictated by Sheikh 'Adī, and conserved in Ba'shîqe by Mollah Haydar.[270] Whereas the *Mishefa Resh* would have been written by a certain Ḥasan al-Basrī in 743/1342–43 and conserved by Sheikh 'Ali in Qasr 'Izz al-Dīn, a village east of the Tigris.[271] This information is largely shared by the Yezidis of northern Iraq today. Nevertheless, the first authentic document written by a certain Sheikh 'Abd Allah er Ratabkī (d. 1746–47) mentions a book called *cilwe* in the eighteenth century in which he declares the Yezidis as unfaithful and denigrates them.

> Adultery is lawful in their eyes, if it is committed with the assent (of the husband). The person who asserts this has told me that he has seen it written in a book called *cilwe*, which they attribute to Sheikh 'Adī.[272]

Moreover, Forbes[273] confirms the existence of the *Mishefa Resh* in 1838. He had heard of the *Mishefa Resh* containing Yezidis' laws and precepts, and he was told that Sheikh 'Adī was its author; but the book has never been seen by anyone. In addition, without any evidence, their existence in the past was confirmed by religious men I met during my visit to Sheikhan and Ba'shîqe.

Then, suddenly, several copies of these closely guarded holy books began to appear in the late nineteenth century. The first known copy of these manuscripts was made in 1874 by Ishak of Bartella, a Christian priest (Syrian Catholic) who lived for a long time with the Yezidis in Ba'shîqe. It was written in Syriac and contained texts of the *Kitêb-i Cilwê*, the *Mishefa Resh* and information about the history and customs of the Yezidis.[274] It was kept in the library of the monastery of Rabban Hormuzd at Alqosh. It is believed that this manuscript was derived from a religious training manual used by Mollah Haydar for the instruction of qewwals in Ba'shîqe.[275] Later, in 1889, Gabriel Jeremiah (son of Jeremiah Shamir) copied the first Arabic text, which was probably derived from the Syriac version found at the Monastery of Rabban Hormuzd, where Gabriel Jeremiah's father, Shammas Jeremiah Shamir, was a monk. This Arabic text was obtained by Wallis Budge, a British Museum official from Jeremiah Shamir. It is entitled *The History of the Yezidis in Mosul and Its Environs* and is composed of nine

folios. It describes Yezidi beliefs, rites, customs and traditions and makes up the text of the 1872 petition and the texts of two Yezidi holy books. The same year, another version of these texts was copied, under the title *Extract from the History of the Yezidis*, by a certain Abdul Aziz, a Jacobite priest at Mosul who lived in Ba'shîqe. However, unlike Budge's manuscript, it was written in the Karshuni script used by Syrians when writing Arabic. This version is now to be found in the Bibliothèque Nationale in Paris (BN Syr. MS 306). A similar copy of MS 306, also copied by Abdul Aziz, was acquired by Oswald Parry in Mosul in 1892 and sold to the Bibliothèque Nationale in Paris (BN Syr. MS 324). This manuscript was translated by orientalist E. G. Brown and published by Parry in 1895.[276] It was the first full translation of the Arabic text. Then, Isya Joseph published the texts that he had obtained from Daud Es-Sa'igh, a Syrian Catholic citizen of Mosul, with an English translation in 1909.[277] Moreover, in 1904, Père Anastase Marie, a Carmelite from Baghdad, met in Sinjar librarian Hammu who had made a copy in Kurdish for him. These manuscripts consisted of eight pages of the *Kitêb-i Cilwê* and fourteen pages of the *Mishefa Resh*. This Kurdish version was published in 1911 by Père Anastase Marie.[278]

According to scholars, these two scripts probably existed not as written text[279] but in the Yezidi oral tradition. They were likely written down at the end of the nineteenth century when Western travellers, missionaries and scholars began to take an interest in the Yezidi religion and were looking for ancient manuscripts for trade purposes.[280] It is commonly believed that these texts were written by non-Yezidis. For instance, according to Mingana, their author was someone who wrote in Arabic but thought in Syriac, so it was probably Jeremiah Shamir.[281] However, the text of the manuscripts represents the Yezidi beliefs that are taught to Yezidi religious singers, qewwals and other religious men as part of their training. It contains essential teachings of the Yezidi faith practised by the Yezidis according to their oral tradition, which passed from father to son. Thus, these texts represent a genuine tradition.

The text of the *Kitêb-i Cilwê* (the Book of the Revelation) declaims the sovereignty and supremacy of Tawûsî Melek and is divided into five short chapters plus an introduction.[282] In the first chapter, Tawûsî Melek appears as God and reveals his qualities, his operations and his exigencies. Chapters two and three describe the omnipotence of God. Chapter four contains a warning to outsiders and gives them instructions to follow his doctrine. Finally, chapter five is a short and contains advice to the faithful.

The text of the *Mishefa Resh* (the Black Book) records the acts of God in the third person and is not divided into chapters. The first half gives an account of the Creation myth starting with the creation of the Pearl and the angel, Tawûsî Melek. Then it gives an account of the Fall from Paradise wherein Tawûsî Melek encourages Adam to eat the forbidden fruit, that is, wheat, and God creates Eve from under Adam's left arm-pit. It is followed by a statement of the names of ancient Yezidi kings, a list of food taboos and certain prohibitions concerning the use of verbs which sound like *Sheitān* (Satan).

Religious Hierarchy

There is a caste system in Yezidi society. Caste membership is inherited from both parents, and it is absolutely impossible to change one's status. Yezidis divide themselves into three endogamous major castes: Sheikhs, pîrs and murîds. Sheikhs and pîrs form the clerical caste, and the murîds are the general public.

According to the Yezidis, a religious relationship was created by Sheikh 'Adī to bind the members of the religion from different ethnic and tribal origins and to preserve tribal balance and the political interests of the sheikhly groups. These were transformed into a caste system over time.

The sheikh caste is divided into three groups: Qatanis, Shamsanis and Adanis; these groups are subdivided into branches and sub-branches. These three groups of sheikhs have particular tribal origins, and inter-group marriages are not allowed in order to preserve the purity of blood in each group. According to Yezidi tradition, Shamsanis are the descendants of four sons of Êzdîna Mîr, who make up the Kurdish block. The Adanis descend from Sheikh Ḥasan, and the Qatanis have a special link with Sheikh 'Adī, a Muslim Arab. Each of these groups is represented by a religious figure: the Qatanis are represented by the mîr (prince); the Shamsanis by the baba sheikh (spiritual leader), and the Adanis by the pesh imam (the authority on ceremonies). The latter was the only Yezidi group that had the right to read and write, activities which were banned for the rest of the community until the beginning of the twentieth century. The two most powerful sheikhly groups, the Shamsanis and the Adanis, are sheikhs and disciples of each other. In this way, they are both superior and inferior to each other, though Qatanis can only be disciples to the Adanis; they are not allowed to be sheikhs to other sheikhs but can take the position of mirebbî.

The function of the sheikhs is to educate their faithful about religion and to teach the moral precepts. Every Yezidi has to have a sheikh; he is a kind of godfather to his disciples. Sheikhs have to participate in the religious rites of their disciples, such as those of birth, marriage and death. They are responsible for the organisation of the festivities in the sanctuary of Sheikh 'Adī and for the direction of the hymns. Every disciple has to pay the sheikh an amount of money annually as a mark of respect and obedience to him. Those who live near the sanctuary receive pilgrims and offer them small balls of dust called *berat*. During the religious festivities, sheikhs are distinguished by their white turbans surrounded by a black belt as well as by a cloth coloured red, yellow or orange thrown casually over the shoulders. Nowadays, however, most sheikhs dress in a fairly ordinary way.

The highest level in the Yezidi hierarchy belongs to the mîr of Sheikhan and the members of his family. The mîr, who is a secular leader and also a 'defender of the faith', and his family are given equal status, comes from the Qatani sheikh family. The responsibility of the mîr is hereditary, and it is the eldest son who inherits this

responsibility. He functions as an intermediary between local Yezidi groups, the local Muslim communities and the representatives of the Christian clergy. His spiritual and temporal power is unlimited and considered to be delegated to him by Sheikh 'Adī and the representative of the Peacock Angel on the earth. For this reason, he is considered holy. The income of the mîr comes from the donations of seven *sanjaks*, offerings made to the sanctuary of Sheikh 'Adī and the mausoleum of Sheikh Shams in Lalish. The mîr

24 Mîr Tahsin Beg, 'Eyn Sifni

and his family live in 'Eyn Sifni in the region of Sheikhan. The members of his family are allowed marry only within the family. He has to always wear the headgear, the *kullik*, which must be made of wool and black or white in colour. It can be washed only by a feqîr, a feqraya or a baba chawush. He also dresses in a special tunic for which the feqîr is responsible.

The mîr has 'legislative' spiritual power, but 'executive' spiritual power belongs to the baba sheikh (father sheikh), who is the religious head of the whole community. The baba sheikh has to come from the family of Fakhr al-Dīn of the Shamsani lineage. The title of the baba sheikh passes from father to son; however, the nomination is made officially by the mîr. The baba sheikh leads a pious, abstemious and austere life. He has to fast for at least eighty days per year, and he is not allowed to consume alcohol. His seat is in the inner courtyard of the sanctuary of Sheikh 'Adī. His presence is indispensable to the conducting of ceremonies and rituals that take place there. During the ceremonies, he is assisted by the pesh imam or his representative and the baba gawan. The baba sheikh and his family live off the donations obtained from his murîds for performing ceremonies of baptism, marriage and burial. Although he lives in 'Eyn Sifn, he must be buried in his particular graveyard in Bozan village. His dress distinguishes him from others: a permanent white turban, a large belt in black fabric and, during ceremonies, the glows.

The pesh imam (chief imam) represents the Adanis branch of the sheikhly families, who are separate from the rest of the community because of their Islamic beliefs. He has to be a descendant of Sheikh Ḥasan and has the authority to celebrate marriages

25 Men of religion: Baba sheikh, baba chawush, sheikhs at Lalish

and to arrange the bride price. He also presides over specific semi-Islamic religious occasions, such as Laylat al-Qadr. He is appointed by the mîr and receives offerings from the Yezidi community under the name of al-Ḥasan al-Basrī. He has to be present with the baba sheikh at every religious occasion.

The pîrs are the second branch of the clerical caste; they have the same function and spiritual stature of the sheikhs but are politically less important. Every Yezidi has to have a pîr just as they must have a sheikh. It is believed that pîrs are of Kurdish origin and existed prior to Sheikh 'Adī. Pîrs are divided into four principal branches and forty clans, and their chief is Ḥasan Maman, originally the prince of Harir Mountain, who joined the 'Adawis at Lalish at the time of Sheikh 'Adī. Descendants of Ḥasan Maman are considered the most elevated of all Yezidi pîrs. As it is a rule that a senior pîr must not marry a disciple pîr, they are not allowed to marry other members of pîr families. Pîrs, like mystics, are by virtue of their withdrawal from the world and as a result of their meditation, considered capable of healing with supernatural power. The ceremonial dress of pîrs is a white turban with a black feather.

Within the religious caste there are also sub-groups, each standing for an office-holder's position. These are sheikh al-wezir, baba gawan, baba chawush, feqrayas, kebanes, feqîrs, qewwals, kocheks, mijêwirs, ferrashes, mirebbîs, and hostas.

The sheikh al-wezir (minister sheikh) is the representative of the family of Sheikh Shams and the guardian of the mausoleum of Sheikh Shams at Lalish. He represents the old political status of the Shamsani family. It is believed that this title was given to Sheikh Shams by Sheikh 'Adī to appoint him as his personal assistant to reconcile Shamsanis with his mystical order, 'Adawiyya.

The baba gawan is a descendant of the Shamsani family from the branch of Sheikh Amadīn. He participates in the rituals during religious festivities and weddings. He is the spiritual adviser to baba sheikh who assists him on every religious occasion and accompanies him on all his visits to the Yezidi areas. He is responsible for all custodians and servants in the sanctuary of Sheikh 'Adī at Lalish.

The baba chawush is the custodian of the sanctuary of Sheikh 'Adī and the servant of the baba sheikh. He lives in the sanctuary and has feqrayas under his order. As the guardian of the holiest place of the Yezidis, he has to be pure and celibate and to devote himself to this place. He is a descendant of the pîr family and has to be appointed by the mîr. He wears a white tunic with a black belt.

The feqrayas are virginal women in the service of the sanctuary of Sheikh 'Adī. They live there permanently, having renounced the world and devoted themselves to asceticism and self-denial. Their main duties are to clean the shrine to light the oil wicks in the niches of the sanctuary, and to cook for those clergy and other notables visiting the sanctuary during the feasts. They receive offerings from pilgrims. They are clothed in long dresses of white wool and cover their heads with white cotton turbans. They wear a sacred cord around the waist, which is the distinctive sign of the Order. Their superior is called kebane

26 Pesh imam, Lalish

and is chosen from among the most deserving of the feqrayas. She has the privilege of taking care of the mausoleum of the Sheikh 'Adī and kneads sacred balls of dust, *berat*, in the sanctuary. Every evening, she scorches incense in front of the sarcophagus of Sheikh 'Adī and other saints in the sanctuary. Kebane has the right to marry.

There is a confraternity group of pious and virtuous men, the feqîrs, who are obliged to set a good example of piety, virtue and abstinence. They have to fast and refrain from drinking and smoking. They are not permitted to shave their beards and moustaches. Although they may come from different castes, over time they have become a hereditary group, and the initiation is undergone exclusively by the members of the Sheikh Abū Bekir, Sheikh Ibrahim Khatni, Pîr 'Omer Khalê and Dinadi (murîd) families. The superior of the confraternity is called the metbekhchî, or serderî, of the sanctuary of Sheikh 'Adī and is elected from among the members of the confraternity. Among their religious tasks is to keep sacred books and ceremonial banners. They depend on alms for their survival. Their costume is distinctive: a black tunic (*khirqa*) made of rough wool and hemmed with a red belt of plaited cord (*qemberbest*). Their tunic is considered by the Yezidis to be an exact copy of that of Sheikh 'Adī. Thus, it is specifically venerated. They have to wear a cord of black and red around the neck under their costume (called the *mehek* or *meftûl*) even when they sleep.

The qewwals are the religious musicians who are under the control of the mîr. Although their position is not hereditary, they come exclusively from two tribes, the Dimili-speaking Kurmanji and the Arabic-speaking Tazhi in Beḥzanê and Ba'shîqe.

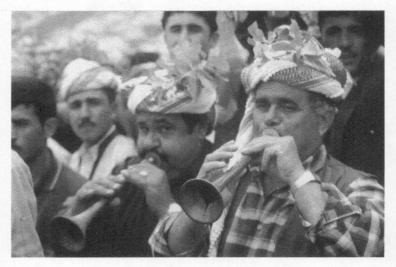

27 Musicians during a celebration, Dohuk

They receive strict religious instruction during their childhood and adolescence in order to become qewwal. They are called the 'knowledge by heart'. With their sacred instruments, the tambourine *def,* tambour and flute as well as the banners of Tawûsî Melek *tâwusgerrân,* they go on missions throughout Kurdish regions to revive the Yezidi faith and recite the sacred hymns (*qewls*). They collect donations intended for the mîr. It is the Adani sheikhs who are responsible for educating the qewwals.

The kocheks are a sub-group of the religious caste. They are considered to be servants of Sheikh ʿAdī under the authority of baba sheikh. They can come from all castes. The function of the kochek is not inherited, and there is no initiation. These are people who have the innate talent of clairvoyance. They are credited with having powers of prediction and being healers and miracle makers. It is believed that the kocheks can communicate with the invisible world through their dreams and trances. For this reason, the families of the deceased call a kochek to learn the destiny of the departed. The kochek enters into a trance, and when he comes out of it, he tells the family what he saw. Kocheks do not receive alms. During principal religious festivities, they welcome pilgrims in the sanctuary of Sheikh ʿAdī. They have to fast for a long time. One of their functions is to participate in a seven-day event known as 'The Road of the Qewwals'. They have to cut trees in the mountains and bring them to the sanctuary. They receive an axe and a cord for this work, items which symbolise the holiness of this task. Their clothes are black with one cord around the waist and another around the neck.

28 Author with mijêwir of the mausoleum of Sheikh Shams in Bozan

The mijêwirs are numerous and live in almost every Yezidi location. They are appointed to look after and protect the Yezidi sacred shrines called *khas*, of which there is one in each Yezidi village. The mijêwir comes from a pîr or sheikh family and subsists on donations and alms. He lights the oil lamps in the shrines every Wednesday and Friday evening.

The ferrashes are tasked with lighting lamps in the sanctuary of Sheikh 'Adī and the mausoleums located at Lalish. This rite starts two hours before sunset. Moreover, during principal festivals, the ferrashes carry a vase full of oil in the middle of which a big wick burns and lead the pilgrims. This is the holy lantern of Sheikh 'Adī. Ferrashes collect alms.

Mirebbî signifies the 'master' in the Yezidi society; every Yezidi has to have a mirebbî from the sheikh family of Qatanis. A hosta is a religious teacher. Sheikh 'Adī had a group of pupils to whom he taught his teachings and theories. Over time, this group of students became hostas, instructors of the Yezidi religion. Their function is to teach the principles and rules of the religion to the Yezidi people. Hostas can come from any caste.

Murîd signifies someone who is not from a priestly caste, layman/disciple. They constitute the majority of the population who have to pay tax (*resmeh*) or *ferz*, donations and foodstuffs to the mîr and their brothers of the hereafter, the sheikh and pîr. They are endogamous, but marriage is not restricted within the group.

3

Religious Practices, Observances and Rituals

Haircut, Baptism, Circumcision, Brother of the Hereafter, Marriage, Death

Every Yezidi participates in various rituals and ceremonies in order to be accepted as members of the Yezidi community. These ceremonies represent new stages in the life of the faithful. The most important are the rite of haircut (*biska pora*); baptism (*mor kirin*); circumcision (*sinet*); brother (or sister) of the hereafter (*birayê axretê*); wedding (*dawet*) and funeral (*mirin*). These ceremonies show that life is perceived by the Yezidis as a process.

The *biska pora* concerns only boys and is also accepted as a kind of baptism. Parents do not have the right to cut their sons' hair before this rite. In former times, *biska pora* was performed on the fortieth day after the birth of the child, but modern Yezidis do it when the boy is six months or one year old. The ceremony consists of cutting off a piece of the child's forelock by his brother of the hereafter, who is a sheikh or a pîr. This simple ritual signifies that the boy becomes a Yezidi. After the rite, gifts and donation are made to the child's sheikh or pîr, who preserves the forelock. Sometimes it is kept by the child's family.

The ceremony of baptism, or *mor kirin*, is performed only in the baptistery of Kanîya Spî at Lalish, and it shows many similarities to Christian baptism. Either a sheikh or a pîr who is officiating at Lalish as a mijêwir, or 'guardian', performs the ceremony in the presence of only the child's parents. The Mijêwir takes the water from

the pool in the Kanîya Spî and sprinkles it three times on the head of the child while reciting incantations in Kurdish: 'Ho, hola, Êzî Siltan. *Tu buyî berxê Êzî, serekê riya Êzî*' (Ho, hola, Prince Êzî. You have become the lamb of Êzî, the chief of the faith Êzî). They then declare the child to be a servant of Êzî. After the baptism rite, the parents of the child offer money and presents to the mijêwir. Ideally, *mor kirin* should be done when the child is still quite young, but if this is not possible, it may be done at any stage during a person's life. Children who cannot come to Lalish are often baptised with water from the Kanîya Spî brought by qewwals, the religious singers, who visit Yezidi locations at various times of the year. However, the practice is more widely observed by the Yezidis of northern Iraq, who are nearer to Lalish, than by those from Turkey, Armenia and Syria.

Male children are circumcised twenty days after their baptism. The parents of the child choose a godfather *(kerîf)* for this occasion. There are some obligations attached to the *kerîf* relationship between the two families. It creates a brotherhood of blood between the child and his *kerîf*, and the families may not intermarry for seven generations. Thus, the *kerîf* is usually chosen from a group with whom intermarriage would be impossible, such as from a different caste or from a Muslim family. Most of the time, the godfather is chosen from among the Kurdish Muslims in order to strengthen relationships with the Muslim community. The rite of circumcision is performed at home, and it is celebrated with a feast and dancing. Yezidis of Armenia no longer practise this rite since they live in a Christian milieu. But just before they bury their male deceased, circumcision is performed because of the belief that a Yezidi who dies uncircumcised, an infidel and will be punished after death during his transmigration or on the day of Judgement.

Every Yezidi has to have two brothers (or sisters) of the hereafter – one a sheikh, and the other a pîr. A man can choose his brother of the hereafter only among male sheikhs and pîrs, whereas for a woman there is no restriction. However, women get their husband's brother (or sister) of the hereafter when they get married. The brother (or sister) of the hereafter is a kind of guardian angel who protects and assists his/her protégé throughout his/her life during big events such as the haircut rite, baptism, circumcision, marriage and death. Each Yezidi has to pay an amount of money or offer presents to his/her brother (sister) of the hereafter on every occasion as a sign of gratitude.

Yezidis generally marry young, on average at fifteen years of age. Marriages are usually arranged between the fathers of the young couple. The family of the future groom has to pay a bride price *next* to the family of the bride. The bride price depends on the beauty of the bride and the social rank of her family in their tribe. When the parents of the couple have agreed upon a bride price, the agreement is written down by a religious man, usually a sheikh from the family of Adani, who is responsible for this task and for the celebration of the marriage. The sheikh blesses the couple and gives

some *berat*[283] to the bride. Then he himself receives gifts from the young couple and their families. Sometimes the bride price can be met by a future arranged marriage. An exchange for the sister of the future groom to the brother of the future bride is promised, which is called *berdel*. Nowadays, although the practice of bride price is less restrictive, it continues.

On the day before the wedding, the bride is prepared for her henna night, *sheva desthineyê*. She takes a hot bath, dresses up and then arrives at the room where the guests are. Her hands and the bridesmaids' hands are painted with henna. All participants spend the night together dancing to popular songs. The following day, the bride is dressed in a wedding dress, a red veil and a red girdle on her belly, which is fastened to her belly by her sister of the hereafter. The marriage ceremony begins with the escorting of the bride from her father's house to that of the groom. If the wedding is held in a village, the bride is taken in a procession to the groom's house, where she breaks a jar sweetmeats against the threshold of her new home. A sheep is sacrificed by the door. As for the groom, he is accompanied by his brother of the hereafter during the wedding. Dances are held and food is distributed to the guests. Nowadays, Yezidis who live in cities usually hold wedding parties in wedding halls. In theory, after the wedding day, the bride must remain in seclusion for seven days before leaving her room.

29 People at a ceremony of marriage, Sinjar

The Yezidis observe endogenous marriage. Polygamous marriage is observed, particularly by the religious caste, but it is not preferred and not very welcome in the community. There are many rules and prohibitions concerning marriage. Marriage with a non-Yezidi, Muslim or Christian, is prohibited in order to keep the religion clean. Nevertheless, the interdiction is more restrictive towards Muslims, even Kurdish Muslims. If a Yezidi marries a non-Yezidi, as conversion to Yezidism is not possible exist, he/she converts automatically to the religion of the outsider and is excommunicated by the family and the tribe. Moreover, within the community, even marriage between different casts is forbidden. It is also forbidden to marry during the month of April. However, religious and nobles are allowed to marry during this month. The only justification for this interdiction is that the Yezidis consider this month to be sacred, when all of nature and the animals awake. For the Yezidis it is the beginning of the year as they celebrate the New Year on the first Wednesday of April. Divorce is not permitted except in the case of the infidelity.

Death for the Yezidis means the separation of the soul from the body, the end of the life forever and the rebirth of the soul in another body. The Yezidis believe in reincarnation as well as in the existence of Paradise and Hell. After Judgement Day, the soul reappears in a new body and does not remember its previous life. Therefore, it is not responsible for its former offences; due to its intelligence, it is able to establish a new life on earth.

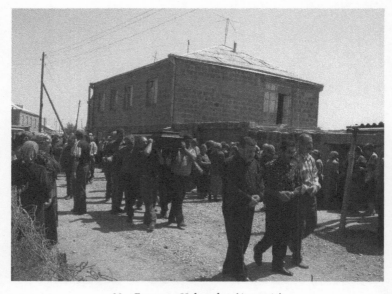

30 Funerary, Hoktember (Armenia)

Yezidi funerary ceremonies vary slightly according to different regions. However, there are some practises that every Yezidi has to observe. The deceased has to be assisted by his/her brother of the hereafter during the last three days. After the corpse is washed by his sheikh or pîr, the body is put in a white shroud (*kifin*) which is knotted at the head and then put into a sarcophagus. A small handful of blessed soil (*berat*) from the sanctuary of Sheikh 'Adī is put in the mouth of the cadaver. The procession the way to the cemetery is silent except for the religious men who chant hymns at the front of the group. If the deceased is a child or a teenager, the sounds of the qewwal's tambourine and flute may accompany the ritual. The sarcophagus is put in a hole prepared earlier in the cemetery. The head of the deceased is placed facing east. Women mourn by crying, pulling out their hair and beating their chests. People visit other tombs in the cemetery. The same day, a big meal is offered to people.

After the funeral, at nightfall, the family of the deceased asks a kochek, who is a religious visionary to consult the Heavens regarding the destiny of the deceased. The kochek concentrates silently and starts to tremble and writhe in pain, entering a trance. Then he describes his vision. If the deceased was a sinner, the kochek sees the soul of the deceased enter the body of a dog, a donkey, a pig and so on. The family offers an appropriate sacrifice to obtain forgiveness. On the other hand, if the kochek says, 'Stop crying, I have seen him. He entered the body of a person from our people', everybody calms down, and the family of deceased feels reassured. A big meal is offered by the family after three days. For a period of one week the house of the deceased is visited by the brother of the hereafter, who consoles the family by singing hymns (*qewl*) and by saying good things about the deceased. Finally, on the fortieth day, an ox is sacrificed on the tomb and the meat is distributed to the passers-by as alms.

Prayer

Yezidis pray individually; daily prayer is not a compulsory practise, and it is not a sign of being a 'good Yezidi'. However, especially pious and old people pray regularly. Kissing holy places and the hands of religious figures, offering gifts to religious men and sacrificing animals are all signs of respect and of being a good and faithful Yezidi, but there is no tradition of public prayer or worship in the Yezidi religion, any temples in which they gather to pray together and perform their liturgies. Followers are allowed to pray anywhere and in any manner they wish. Today there is no standard daily prayer – it varies according to person and place. Although there is disagreement on the daily devotions, most Yezidis pray three times a day: at sunrise, in the morning and at sunset. They pray by turning their face towards the sun. There are two prayer. The first is the following: After rituals washing one's hands and face, one turns towards the sun by opening one's hands and conducting the prayer. A religious person kisses his tunic at the end of his prayer; whereas the murîd kisses a wall. Alternatively, after

washing one's hands and face, one crosses one's arms at waist level, right hand over the left hand. This is always a standing prayer, and it is finished by kissing the right hand. There are no prepared daily prayers. Everybody is free to pray however he or she wants. However, the Yezidis usually address their prayer to Tawûsî Melek or to Sheikh Shams (the divinity of the sun). However, prayers which are done in public are mostly attributed to Sheikh 'Adī and are at the same time the poems of praise.

The communal prayer is as follows:

> Ô Sheikh Shams, protect us against misfortune and adversity!
> Lord, be beneficial for your nation!
> Lord, protect our children!
> Lord, protect our flocks!
> Lord, our testimony is the name of Tawûsî Melek![284]

Wednesdays and Fridays are holy days for the Yezidi community. On Wednesdays, the faithful gather to visit the sanctuary of Sheikh 'Adī or other places at Lalish and in other Yezidi villages. During these visits, holy places are kissed, donations are made and animals are sacrificed. It is also common for pilgrims to bring food with them and to have picnics around the shrines.

Fasting

Yezidis fast three days per year in December, during the feast of the Sun, *Cejna Rojiyen Êzî*, but this is not obligatory and it is observed less and less among the younger generation. The majority of those who do fast are old and pious people. These three days are in commemoration of Êzî. Yezidis believe that God recommended people to fast for three days, saying '*se roj*' in Kurdish, but Muslims misunderstood it as '*si roj*', meaning thirty days. However, baba sheikh, feqîrs, kocheks and feqrayas fast forty days during the summer and forty days during the winter.

Pilgrimage

Yezidi places of pilgrimage vary: a mausoleum or a shrine dedicated to a saint, the house of a sheikh or a pîr, a tree, a bush, a grotto or even a rock and a spring. The Yezidis of the Republic of Armenia consider a trio of the spring, bush and rock , located in the mountains, as a main place of pilgrimage (*ziyaret*) where animals are sacrificed and vows are made. The houses of the sheikhs and pîrs are also regarded as highly sacred pilgrimage sites. However, the entire Yezidi community, scattered in various countries, turns towards the valley of Lalish, located in northern Iraq. This is where the main pilgrimage centre, the sanctuary of Sheikh 'Adī, is found. This valley is, on the whole, a reflection of the mystic, social and political life of Yezidism. It is considered

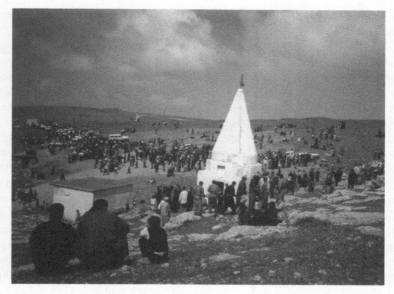

31 Pilgrimage at the mausoleum of Pîr Afat, Dere Bûn

to be a semi-divine place where God also lives, and it is believed that it came down in one piece from Heaven.[285] Thus, it is a central place of importance for the Yezidi community and the Spiritual Assembly, *Meclisî Ruhanî*, must make all important decisions there. It is also called the 'Site of Truth'.[286] If possible, Yezidis make at least one pilgrimage to Lalish during their lives, and those living in the region must attend the Feast of the Assembly *(Cejna Jema'iyye)* in autumn, which is the annual pilgrimage of the Yezidi calendar.

This annual pilgrimage takes place mainly in the sanctuary of Sheikh 'Adî from 23 to 30 of September. Yezidis coming from everywhere to participate in this event gather in Lalish. Each family or tribe has its own accommodation in Lalish, where they stay during this festival.

According to Yezidi tradition, Tawûsî Melek and other members of the Heptad meet during these seven days on behalf of God to take decisions on important events for the following year.[287] Thus, it is believed that the Yezidi faithful celebrate this occasion at Lalish at the feet of these heavenly figures in the presence of the mîr (prince) and the baba sheikh (pope). This is also the time to return the banners of Tawûsî Melek to Lalish, when the qewwals submit the gifts to the prince and the religious that they collected from the Yezidi communities during their parade in various Yezidi areas. During the seven days, the non-baptised are baptised and

animals are sacrificed; food is distributed to the visitors, and sacred and popular dances are held everywhere.

On the first day of *Cejna Jema'iyye*, the crowd of pilgrims, who are dressed in festive clothes, arrives at the Bridge of Silat at Lalish. Here, the profane life ends and the sacred life is said to start. The pilgrims take their shoes off, wash their hands in the stream under the bridge and cross the bridge three times, carrying torches and saying, 'The Silat Bridge, on one side is Hell, on the other side Paradise' (*Pira Silate, aliyek doje, êk cennete*).[288] Then, they walk towards the upper side of the valley of Lalish, chanting hymns. The mîr and most of the religious participate in this procession, the baba sheikh, the pesh imam, the baba gawan, the baba chawush, sheikhs, pîrs, feqîrs and feqrayas. They reach the forecourt of the sanctuary of Sheikh 'Adī in solemn procession and walk three times around the forecourt before entering the inner-courtyard, where they kiss the frame of the portal, the Derîya Kapî, and take their places around the torch of five branches. At the same time, pilgrims access the loggias of the sanctuary but do not enter the court. Then, the religious perform a dance, the *sama*, in the inner-courtyard. This is called the evening dance, and it is repeated every evening after sunset for each of the seven days. A group of sheikhs dressed in white and feqîrs, dressed in brown garments of coarse cloth and wearing black turbans, perform the *sama* to the music of qewwals clothed in black and white. The qewwals play their sacred instruments, the tambourine *def* and flute, around the sacred torch in the middle of the courtyard. The head of the feqîrs, who is dressed in a black fur cape and conical hat, leads the group. They recite all hymns *qewls* together.

On the second and third day, the previous evening's ceremonies are repeated. At nightfall, the religious and the pilgrims light torches on the walls and burn oil wicks in the niches of the sacred places everywhere in Lalish. Pilgrims in the valley sing and dance to popular Kurdish songs.

On the fourth day, the ceremony of *Parî Suwar Kirin* is performed with multicoloured cloths from the sanctuary of Sheikh 'Adī. Baba chawush and other religious collect the clothes, which cover the sarcophagus and pillars in the sanctuary, and take them to the baptistery of Kanîya Spî located on the opposite side of the sanctuary. Then, serderî of the Kanîya Spî, who comes only from a pîr family, baptises them in the water of the Kanîya Spî with prayers. Finally, they return the clothes to the sanctuary and put them in their place.

The fifth day is dedicated to the ceremony of *Qabax* – the sacrifice of a bull. The bull is taken to Lalish. A group of men take the bull on three tours around the mountain of 'Erafat arriving in front of the mausoleum of Sheikh Shams, where a basin, named the *gaykujî*, is located. At the same time, large masses of Yezidis gather in the valley as the qewwals play their songs. The animal is sacrificed and a special meal (*simat*) is made and distributed to the pilgrims. Religious dances are performed on this occasion.

32 Dancing pilgrims, Sina

On the sixth day, a ceremony called the *Berê Shibak or* 'Rug of Netting' is carried out to commemorate Sheikh 'Adī. Yezidis believe that when Sheikh 'Adī died, his body was transported on a stretcher (from which this ceremony takes its name). This object is also known as the *takht*, meaning bed or couch. It is a kind of bier with cords tied to four bars, which makes a rectangular shape. The Barqayî tribe, whom the Yezidis believe came with Sheikh Adī from Damascus, keep the stretcher in Beḥzanê during the year. It is brought out once a year only for this occasion and the ceremony of *Berê Shibak* is performed by the family who protects it.

The Bargayî carry this object in a multicoloured case to *Berê Silat* near the Bridge of Silat in the lower part of Lalish. A group of religious such as the baba sheikh, feqîrs and qewwals meet them at this point, having arrived from the sanctuary of Sheikh 'Adī in a solemn procession accompanied by the music of flutes and tambourines. Then, together they return to the sanctuary with the stretcher in the case and transport it to the assembly hall, where they take the pieces of the stretcher out and assemble it for the following day. The same day, a sheep is sacrificed and the meal is offered to the mîr and the baba sheikh.

On the last day of *Cejna Jema'iyye,* the stretcher is taken to the basin (*Hevza Kelokê*) located in the inner courtyard of the sanctuary by the religious to the music of the qewwals. Water is taken from this basin and poured on the stretcher and prayers recited. After this ritual, it is put into its place in the sanctuary and then retaken to Beḥzanê by the Bargayîs. Dances and songs continue, but gradually the pilgrims leave Lalish.

Festivals and Ceremonies

Yezidi ceremonies and festivities are numerous. The four main religious festivities are closely linked to nature and to the solar calendar which have their origins in seasonal Iranian celebrations, whereas others follow the Islamic lunar calendar that is related to Islamic observances. Later, there are the feasts of Khidr Ilyas, Khidr Nebî, Ida Isa, Ramadan, Sheva Berat (Laylat al-Qadr) and 'Erafat (Id al-Hecīya Id al-Kurbān). The former festivities have ancient Iranian religious features and each one is celebrated in a different season. They are known as the New Year (*Serê Sal*) in the spring, the Forty Days of Summer (*Chilê Havinê*), the Festival of the Assembly in the autumn (*Cejna Jema'iyye*) and Beginning of the Forty Days of Winter (*Serê Chil Zivistanê*).

The New Year (*Serê Sal*) is celebrated on the first Wednesday of April. It is also known as the Feast of Tawûsî Melek, the Feast of Melik al-Zen and the Red Wednesday (*Charshemiya Sor*).[289] People generally celebrate this feast quietly in their homes: animals are sacrificed, houses are decorated with spring flowers, eggs are coloured, special bread of *sawuk* is cooked, and at night fires are lit in front of the houses and in the niches of the sacred places. On the other hand, a small assembly from the religious caste performs rituals in the sanctuary of Sheikh 'Adī in Lalish.

According to Yezidi popular belief, God created the world in an egg shape in stone. In the beginning, the earth was covered by ice. God sent the Peacock Angel to break the ice to make the earth habitable for Adam and Eve. After breaking the ice, the Peacock Angel decorated the earth with flowers and plants. Thus, *Serê Sal* symbolises the day when the Peacock Angel broke the ice and brought spring to the earth. For this reason, on this day, Yezidis crack coloured eggs and adorn their holy places with them as well as with red poppies.

This celebration is also linked with nature. Yezidi farmers bake special bread called *sawuk* and cook eggs and on the day of *Serê Sal* go to the field where they eat the eggs and leave the eggshells and bread crumbs scattered on the ground for the earth's fertility.

The ceremony preparations start on a Tuesday evening in the sanctuary of Sheikh 'Adī; red poppies are prepared to adorn the sanctuary, and eggs are coloured which will be offered to pilgrims as a sign of welcome as well as used to decorate holy places. Sheep and lambs are also sacrificed. After nightfall, the entire congregation led by baba sheikh meets in the inner courtyard of the sanctuary. Oil wicks are lit on the paving of the courtyard while litanies are recited, and there is a procession from the principal entrance of the sanctuary to the small rectangular shrine opposite the entrance. The ceremony lasts a few minutes. When the ceremony is over, men and women leave each other for the different corners of the sanctuary for the rest of the night. The congregation spends the night in the accommodation prepared for pilgrims.

Next morning, the day of the *Serê Sal*, people wake up early. Women start to decorate all the holy places located in the valley of Lalish with the prepared bunches

of red poppies and coloured eggs. Clay is made with the water of Zemzem to attach bunches of flowers and eggs together on the façades of sacred buildings.

The congregation gathers again, this time in the inner-courtyard of the sanctuary. Another ceremony is carried out: a metallic basin, full of the holy water of Zemzem, is put in the middle of the courtyard. In the harmony of prayers being said by the baba sheikh, the baba chawush, the baba gawan, the pesh imam, a feqîr takes out the banner of the Tawûsî Melek from its multicoloured case. Every piece of the banner (five pieces) is plunged in the water and baptised by each religious man to the accompaniment of the incantations. Gradually, the banner is raised on a platform, and prayers are said in front of the banner, with hands open at waist level. Each pilgrim proceeds to the front of the banner, makes vows and then kisses the hands of the religious, giving them donations. When the banner is put back into its case, the ceremony ends.[290]

After *Serê Sal*, various other festivities are celebrated in the different locations; this is known as *oglama* or *tawwâf*.[291] During the months of April and May, celebrations are held in villages located in the region of Sheikhan and the twin districts of Beḥzanê and Ba'shîqe. The ceremonies of Sinjar are performed from June. For this occasion, every Wednesday, pilgrims gather in a village to visit the mausoleum attributed to a Yezidi saint, which is located far from the habitation area of the village, on a hill or a mountain next to a cavern and spring. Pilgrims offer alms to a mijêwir, who is responsible for caring for the mausoleum. These ceremonies are always followed by popular dances and animal sacrifices.

Oglamayê Karajal is one of the ceremonies performed by the habitants of the village of Sina, located in the region of Sheikhan. In the early morning, pilgrims dress in festive clothes and in groups, climb the mountain near the village where the rains of the mausoleum of their saint is located. At the top of the mountain, they gather around the mausoleum and kiss its walls and doors, each person in succession, and perform prayers. At the same time, pilgrims dance the *govend* to the sounds of drum and pipe in front of the mausoleum. After spending some hours on the top of the mountain, they begin to descend holding branches of the plants collected around the mausoleum and then gather in a small valley on the outskirts of the mountain where the men perform dances and fire their rifles in the air. Afterwards, they walk towards the village of Sina singing popular songs and join other groups coming from the village. One of these is a group of elderly women in traditional dress carrying burned fragrances in frying pans. Then, pilgrims meet in public space within the village and continue to dance. In the afternoon, a group of men go to the mijêwir's house to offer donations to him and then receive *simat*, the special food made by the family of the mijêwir. Towards the evening, people start to leave the ceremony and go to visit each other or retire to their own houses.

The Forty Days of Summer (*Chilê Havinê*) is celebrated in the sanctuary and other Yezidi holy buildings in the valley of Lalish from 18 to 21 July, and all Yezidis may

attend. These three days of celebration end the forty-day fast kept by the religious—the baba sheikh, the baba chawush, feqîrs, feqrayas and kocheks. Accompanied by a large group of Yezidis, the religious come to the sanctuary of Sheikh 'Adī three days before the end of the forty-day period to complete their fast. It is believed that Sheikh 'Adī fasted for forty days in both summer and winter. Thus, *Chilê Havinê* is also known as the Feast of Sheikh 'Adī. On this occasion, a bull is sacrificed in honour of Sheikh Shams, the divinity of the sun, in front of the mausoleum that is attributed to him. Neophytes are baptised in the baptistery of Kanîya Spî. A sacred dance, *sama,* takes place in front of the sanctuary of Sheikh 'Adī and the baptistery of Kanîya Spî. In the sacred buildings of Lalish, the mijêwirs prepare *simat* and distribute it to the pilgrims.

The Festival of the Assembly (*Cejna Jema'iyye*) is the main annual pilgrimage and takes place from 23 to 30 September for a period of seven days. This is when all the Yezidis, coming from everywhere, meet in their holiest place. This celebration was described earlier (see pp. 104–108).

The Forty Days of Winter (Serê *Chil Zivistanê*) is the second forty-day fast of the religious, which takes place from 13 December to 20 January. These three days of fast are called *Cejna Rojiyen Êzî,* the feast of Ezi's fast, and all Yezidis are invited to join in.

There are some other observations, too, during this forty-day fast period. *Bêlinde,* the Feast of the Dead, is also celebrated in January. It is believed that this is the day of Sheikh 'Adī's manifestation on earth. For this occasion, each family bakes a loaf of

33 Pilgrims effectuating a ritual with burned fragrances, Sina

bread, *sawuk*, with a raisin or date hidden in it; the fruit is believed to bring good luck to the person who eats it. Another celebration is called *Gurka Gay*, 'Flame of the Bull'. It is believed that this is the moment in January when farmers finish ploughing their fields and return home with their animals; their wives light fires to welcome them and distribute food to their neighbours and children.

Khidr Ilyas is celebrated on the first Thursday of February. Khidr Ilyas is the saint of life, water, health and healing and is regarded as a kind of Santa Claus. The Yezidis believe that he visits their houses and grants all the wishes of the Yezidi faithful. A festive meal (*cherxus*) of boiled wheat is prepared in every Yezidi house and offered to people. Another dish, called *pexun,* is made and put in bowls to offer to Khidr Ilyas. It is believed that Khidr Ilyas visits the faithful on this day and that when he comes home, he partakes of this meal. Men named Khidr and Ilyas as well as the religious fast during the three days for the occasion.

The festivity of **Khidr Nebî** is celebrated on the first Friday of February principally by the Yezidis of the Republic of Armenia and Georgia. Khidr Nebî is considered to be the God of love who fulfils love-related vows. On this occasion, Yezidis fast for three days, during which time they are not allowed to take a shower or clean the floor of their houses.

The Yezidis celebrate a feast called **Ramadan.** According to a Yezidi tradition, at the time of Badr al-Dīn Lu'lu' (r. 1211–59), a Yezidi ancestor known as Sheikh Khal Shamsan was imprisoned during the month of Ramadan and released two days before the Muslim festivity of 'Ayd al-Fitr. Sheikh 'Adī II (d. 1221) was so happy about this that he ordered a celebration in his honour, and the Yezidis have celebrated Ramadan ever since.[292]

The Yezidis celebrate **Sheva Berat,** which was originally a Muslim feast called Laylat al-Qadr. Muslims celebrate this feast on the 15th Sha'ban, that is, the eighth month of the Islamic lunar calendar. However, it is said that Yezidis celebrate Sheva Berat a few days later. Yezidis, particularly the members of the Adani lineage, meet in the sanctuary of Sheikh 'Adī. During the night the pesh imam conducts a ceremony called *Salat*[293] and people recite hymns (*qewls*), including the Qadr chapter of the Qur'ān.

> Would that you knew what the Night of Qadr is like,
> better is the night of Qadr than a thousand months.
> On that night the angels and Spirit,
> by their Lord's leave come down with His decrees.
> That night is peace, till break of dawn.[294]

The Feast of 'Erafat was also originally a Muslim feast, although it was celebrated two days before the Id al-Kabīr (the Feast of Sacrifice). Sheikhs, qewwals and kocheks

come to the sanctuary of Sheikh 'Adī and stay there for a few days before the feast of 'Erafat. On the morning of the day of the feast, the religious climb to the top of the 'Erafat Mountain and these stay for some time. Then, as the sun sets, they run down the mountain towards the sanctuary of Sheikh 'Adī. They wash their hands and faces with the holy water of Zemzem. After that, they visit all the holy places in the valley of Lalish by singing hymns and kissing the doors and thresholds. For this occasion, a special tart (*harîsa*) made of meat and crushed grain is baked overnight in the oven and is eaten after the visit to these holy places. Afterwards, they greet each other and leave the valley.

Taboos

Yezidism contains various restrictive and ritualised taboos that affect everyday life. Some of them are esteemed even today, such as exogamy or disrespecting the religious. These taboos are respected by most modern Yezidis because they go to the heart of Yezidi identity rather than being matters of religious observation.

The purity of the four elements, Earth, Air, Fire and Water, is protected by a number of taboos against spitting on earth, water, or fire. Fire is not allowed to be put out with water, but only with earth. Water must be drunk with respect; a Yezidi is not allowed to gargle. These prohibitions may reflect the seven Zoroastrian elements of creation. At Lalish, interdictions are especially varied. It is forbidden to cut trees; no refuse may be dropped in the valley; even the use of shoes by pilgrims is unwelcome. Too much contact with non-Yezidis is considered to be polluting. It is forbidden to

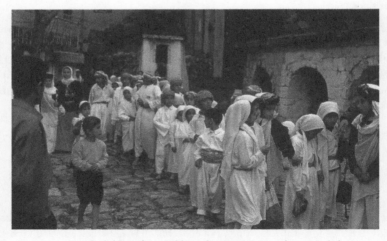

34 Yezidi children from Ba'shiqe during New Year feast at Lalish

enter a mosque or to use the utensils of Muslims. Certain words are also the subject of taboo, such as *Sheitān*, which derives from the Muslim accusation that Yezidis worship the devil in the image of Tawûsî Melek. Verbs dealing with cursing or stoning – *sh* – are not pronounced. Until very recently, Yezidis were prohibited from reading and writing, and only sheikhs of the Adani lineage group had these rights. There are also certain alimentary interdictions relating to pork, fish, cockerel and gazelle as well as to various vegetables including lettuce, okra, cauliflower, cabbage and pumpkin. The colour blue cannot be worn. According to the Yezidis, the word *shin* has two significations in the Kurdish language: the first designates the colour blue and the second means despair, mourning and death. Over time, these two significations have become indistinct. Therefore, wearing the colour blue is forbidden, especially during religious ceremonies, as it is also the colour of the peacock's plume and the sky. Given that blue was regarded as a 'heavenly' colour, the prohibition becomes a little clearer, especially where the more worldly members of the community are concerned. In addition, Yezidi clergy are not allowed to shave their beards. Also, marriages are not permitted in April; during this sacred month, the celebration of marriage is, in fact, impossible.

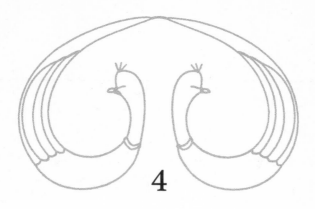

4

Material Culture

Homeland, Landscape, Sacred Places

Yezidism originated in a mountainous area where its people were protected by its heights and caverns. Considered holy by the Yezidis this area is divided into two distinctive regions, Sheikhan and Sinjar, as well as other less important areas. Today, almost all the Yezidi clergy and the great majority of the Yezidi population can still be found in these regions. Although it is still possible to find some Yezidi communities scattered outside this area, it is here that the Yezidis were best able to safeguard their customs and traditions. It is here, too, that the Yezidis have been able to preserve and develop the architectural distinctiveness of their religious buildings, which constitute the main places of worship for the Yezidi faithful. These buildings are dedicated to the first disciples of Sheikh ʿAdī, such as the members of the Shamsani, and to pîr families, such as Ḥasan Maman, Memê Resh and Cerwan, as well as the early religious chiefs of the community who were descendants of Sheikh ʿAdī (the members of Adani family) and some important Sufi mystics who influenced Sheikh ʿAdī's teaching, namely, ʿAbd al-Qādir al-Jīlānī, al-Ḥallaj and Qeḍib al-Ban (Qadî Bilban).

Sheikhan is the administrative and spiritual centre and is also the most ancient homeland for the Yezidi community. It is located between Dohuk and Mosul in northern Iraq, and it houses the most important Yezidi villages, including Lalish, ʿEyn Sifni, Bozan and Baʾadrê (Map 8). The central lieu of Yezidism is the valley of Lalish. Regarded as a holy place, it has mountains on three sides where springs and streams run through its various corners, irrigating many kinds of trees and bushes. As the

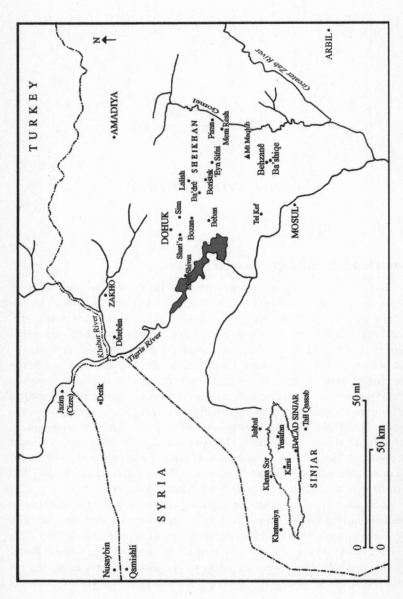

Map 8 Yezidi regions and villages in northern Iraq

countryside and the architecture are both considered integral to the sacred environment in the Yezidi religion, each stone, plant and building has a sacred meaning in this valley for Yezidi pilgrims. Thus, cutting trees and stepping on the ground wearing shoes are banned. Yezidis take their shoes off when they arrive in the valley out of respect for nature. Pilgrims take quantities of berries, leaves and fruit from the trees of the valley with them when they leave, as they are believed to be sacred and having power to cure illnesses.[295] Even the Mounts of Hezret, 'Erafat[296] and Meshet, which encircle the valley, are regarded as sacred and have roles during ritual and ceremonies. In the Yezidi popular belief, the mountain is the neighbour of the sky, where God resides, and the meeting point of the earth and the sky. In particular, Lalish houses the sanctuary of Sheikh 'Adī, which is the focal point of Yezidism. Moreover, the modest appearance of many mausoleums, shrines, caves, the baptistery of Kanîya Spî, caravanserai of Khana Êzî (Pl. 35) and the bridge of Silat (Pl. 36) is in harmony with the wilderness around the village. This bridge, built of stone which is located on a small stream that runs into the valley from the north, is considered the demarcation line between the profane and the sacred; it has symbolic meaning for the faithful who perform several ceremonies on it during pilgrimage. Pilgrims wash their hands and faces in the stream here on their way to the upper part of the valley, where most of buildings are located. In addition, more modern and small-scaled dwellings designed for use by the pilgrims are scattered on the lower slopes of the mountains. The principal pilgrimage centre, the sanctuary of

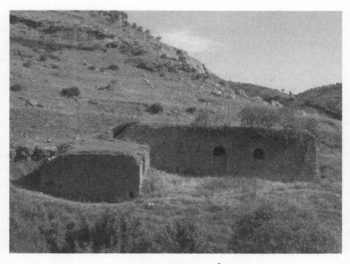

35 Caravansérai of Khana Êzî, Lalish

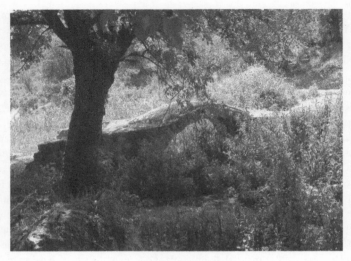

36 Bridge of Silat, Lalish

Sheikh 'Adī, occupies the centre of the valley and is surrounded on three sides by other buildings. The mausoleum of Sheikh Mushelleh on the western side of the sanctuary, is said to guard it (Pl. 37). A narrow road separates the two buildings. The baptistery of Kanîya Spî is situated in the south-west of the sanctuary and to its west are the mausoleums of Êzdîna Mîr and Sheikh Shams (Map 9). The latter is attributed to Sheikh Shams, the divinity of the sun. The Yezidis believe that the first rays of the sun fall on the conical fluted dome of the mausoleum of Sheikh Shams. In order to ensure this solar peculiarity, the mausolum in question, which is considered to be particularly sacred, was built in this place. Several celebrative rituals are performed in honour of the divinity of the sun, and a bull sacrifice takes place once a year in autumn during the ceremony of *Cejna Jema'iyye*. The Yezidi faithful turn towards the sun when they pray. In addition to these buildings, there are many others in Lalish. These edifices give the impression of belonging to a single complex, developed around the sanctuary and spreading into a hilly area. Each building in Lalish has a religious meaning for Yezidi pilgrims and has a part to play during the seasonal Yezidi ceremonies and rituals. Over time, as rituals took place there, Lalish became the *qibla* of the Yezidi faithful for their devotions. In fact, apart from a group of religious people who are responsible for the upkeep of the sacred buildings and who greet devotees, there is no permanent habitation in this valley as pilgrims reside here only during religious festivals. According to the Yezidis, God alone lives in this idyllic place.

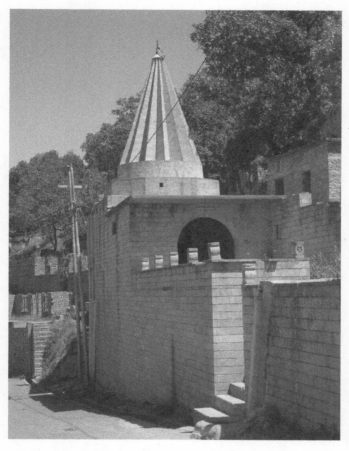

37 General view of the mausoleum of Sheikh Mushelleh, Lalish

'Eyn Sifni is the biggest village in Sheikhan, it is traditionally alleged that the Flood started here. The Yezidi prince Mîr Tahsin Beg and the pope baba sheikh live with their families here. Two well-known mausoleums are visited by the Yezidi faithful in this village. The mausoleum of Sheikh 'Ali Shamsê is located on the top of a hill and dominates the village (Pl. 38), whereas the mausoleum of Sheikh Ḥantūsh is situated in the countryside, isolated from the village (Fig. 1). Another important village in this region is Bozan, which is considered to be the first seat of Sheikh 'Adī who lived here before Lalish became the centre of his order. It is also called as *Lalisha Piçuk*, small

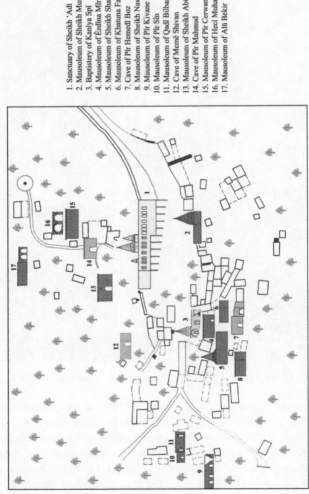

1. Sanctuary of Sheikh 'Adi
2. Mausoleum of Sheikh Mushelleh
3. Baptistery of Kaniya Spi
4. Mausoleum of Êzdîna Mîr
5. Mausoleum of Sheikh Shams
6. Mausoleum of Khatuna Fakhran
7. Cave of Pîr Hemedî Boz
8. Mausoleum of Sheikh Nasr al-Dīn
9. Mausoleum of Pîr Kivane Rut
10. Mausoleum of Pîr Sîn
11. Mausoleum of Qadî Bilban
12. Cave of Memê Shivan
13. Mausoleum of Sheikh Abû Bekir
14. Cave of Pîr Mahmud
15. Mausoleum of Pîr Cerwan
16. Mausoleum of Heci Muhammad
17. Mausoleum of Alû Bekir

Map 9 Yezidi buildings at Lalish, based on the map of Suleiman Havend

38 View towards the mausoleum of Sheikh 'Ali Shamsê, 'Eyn Sifni

Lalish. It houses many important mausoleums (*khas/mêr*), fire shrines (*nîshan*) and sacred stones (*kevir*). The most important building in the village is the mausoleum of Sheikh Shams. It is located next to a grotto and presents a rectangular plan, formed by two units. In particular, the cemetery of Bozan, located on a hilly area to the south-west of the village, is important for the number and variety of its mausoleums and shrines, around which tombstones are located. It is a closed area surrounded by low walls. There is an ancient water cistern situated between the cemetery and the village that it still collects water (Pl. 39). Round in shape, it is surrounded by small whitewashed shrines and is considered a sacred place. Finally, Ba'adrê is the village where most of the members of mîr family reside. It owns the traditional castle of the prince's family. This is a ruined castle located on the top of a hill; it was built in 1825 by Mîr 'Ali Beg (Pl. 40).

The important Yezidi settlement, Sinjar, located on the Iraqi-Syrian border in the middle of the Jazira plateau (Map 10). It is a mountainous area and the settled plains

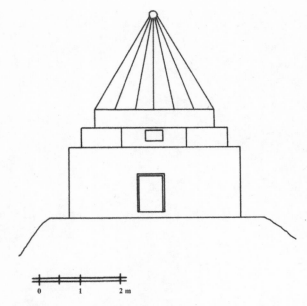

Fig. 1 Façade of the mausoleum of Sheikh Ḥantūsh, 'Eyn Sifni

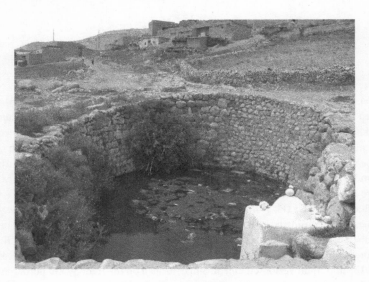

39 Ancient cistern, Bozan

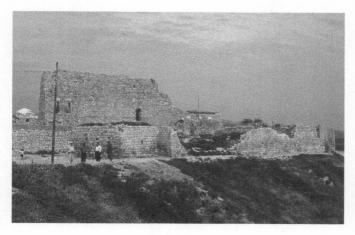

40 Castle of Mîr 'Ali, Ba'adrê

are delimited to north and the east where the majority of Yezidi villages are located. According to al-Sam'ānī, Yezidis were living in Sinjar in the beginning of the twelfth century.[297] However, before the Yezidi population became dominant in Sinjar, it was home to Christian communities.[298] It was in the middle of thirteenth century that Sinjar became important for Yezidi immigrants. Its mountainous features offered an ideal shelter to the Yezidi community fled Sheikhan after Badr al-Dīn Lu'lu' the Atabeg of Mosul, began to massacre the Yezidis. His hostile attitude towards the Yezidis is very well documented.[299] Fearing a Kurdish rebellion against him, Badr al-Dīn Lu'lu' assassinated Sheikh Ḥasan in 1254 and killed his supporters.[300] Some oral traditions and the importance of the shrine of Sheikh Sharaf al-Dīn Muḥammad (d. 1256) as a local pilgrimage centre where faithful go to worship in big numbers indicate the diffusion of Yezidism in the Sinjar region during his time. However, Sinjar welcomed new arrivals and became the main stronghold of the Yezidi faith, notably from the seventeenth century, when Ottoman authorities started to organise expeditions to Sheikhan. Sinjari Yezidis are known for their resistance against the Ottomans in refusing for centuries both conscription and taxes.

Almost all Yezidi funerary buildings are located in rather isolated areas and remote countryside, mostly on the summit of a mountain, totally cut off from modern world in the Sinjar province. According to popular belief, God created the mount of Sinjar with a mausoleum on each of its peaks so that the mount would maintain its balance.[301] The location of Yezidi buildings in these remote places can be explained by two factors: the need for security and the ascetic lifestyle of early Yezidi saints. Alas, most Yezidi villages were destroyed by the Ba'athist regime in the 1970s, and

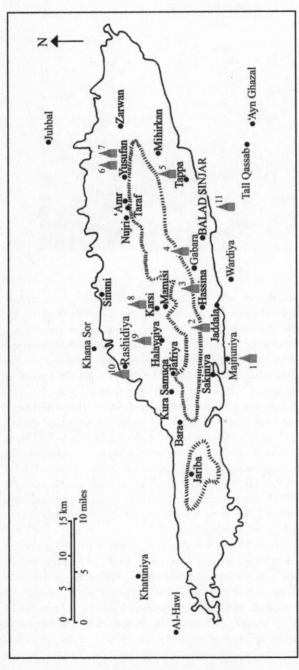

N

Juhbal

Zarwan

Mihirkan

7
6
Yusufan
'Amr
Nujri
Taraf

5
Tappa

BALAD SINJAR

11

Sinuni

8
Karsi
Mamisi

4
Gabara

Hassina

Tall Qassab

Wardiya

'Ayn Ghazal

Khana Sor

9
Rashidiya
Halaygiya
'Afriya

3

2
Jaddala

Kura Samuqa

Sakiniya

Bara

Majnuniya

1

Khatuniya

10

Jariba

Al-Hawl

0 5 10 15 km
0 5 10 miles

JABAL SINJAR

1- Mausoleum of Abd al-Qadir al-Jilani
2- Mausoleum of Sheikh Mand Pasha
3- Mausoleum of Hajali
4- Mausoleum of Sheikh Hasan

5- Mausoleum of Memê Resh
6- Mausoleum of Sheikh Shams
7- Mausoleum of Sheikh Barakat
8- Mausoleum of Abū'l Qasim

9- Mausoleum of Khatuma Fakhran
10- Mausoleum of Sheikh Sharaf al-Din
11- Mausoleum of Sheikh Amadin

Map 10 Map of Jabal Sinjar, based on the map in Fuccaro 1999, p. xiv

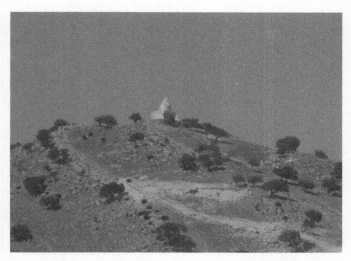

41 Mausoleum of Sheikh 'Amadīn on the summit of Galê Bîrîn

their inhabitants now live in collective villages (*mujammaàt*) on the plain of Beled Sinjar; only their saints' mausoleums remain in the mountain villages. However, Yezidi pilgrims return to these buildings regularly during festivals to take care of them.

Behzanê and Ba'shîqe on the outskirts of the Maqlūb Mountain form the third settlement of the Yezidi community, which lies on a plain between Mosul and Sheikhan (Map 11). Behzanê is the ancient part, where many old buildings are located, while Ba'shîqe has a modern appearance and contains mostly new edifices. Geographically different from the mountainous, hilly Sheikhan and Sinjar, this town is a major gateway between the mountainous Kurdish heartland and the flat deserts of the Arab world. Although there are no historical sources that confirm this, it seems that though Behzanê and Ba'shîqe was already known to the Yezidis in the twelfth century it became their homeland only in the thirteenth century, when the Yezidi population fled from the Sheikhan region. The fact that the majority of the mausoleums located here are attributed to the members of the second generation of the Shamsani family, who lived in the second half of the twelfth century corroborates our argument.

In Yezidi architecture, the concept of space expressed itself in isolated individual buildings. Although they were built for public use, they were separated from the places of habitation. Even in Behzanê and Ba'shîqe, where the majority of Yezidi sacred buildings are located in the centre of the town, they are mostly built on the top of a hill, away from public spaces (Pl. 42), they are without exception encircled by a high-walled courtyard. Yezidi sacred buildings manifest themselves entirely in mausoleums in this

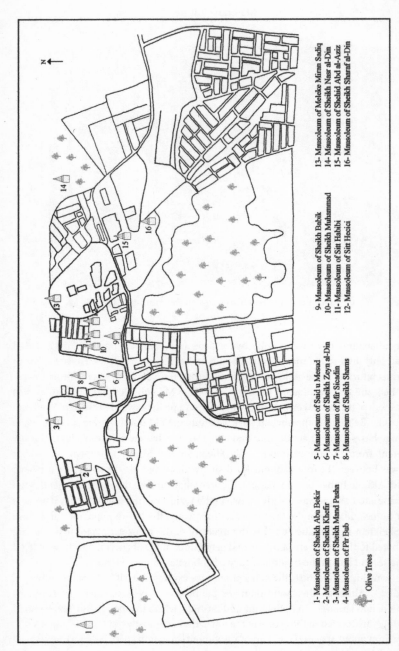

N ←

1- Mausoleum of Sheikh Abu Bekir
2- Mausoleum of Sheikh Khefir
3- Mausoleum of Sheikh Mand Pasha
4- Mausoleum of Pîr Bub

5- Mausoleum of Said u Mesud
6- Mausoleum of Sheikh Zeyn al-Din
7- Mausoleum of Mîr Sicadin
8- Mausoleum of Sheikh Shams

9- Mausoleum of Sheikh Babik
10- Mausoleum of Sheikh Muhammad
11- Mausoleum of Sitt Habibi
12- Mausoleum of Sitt Hecici

13- Mausoleum of Meleke Mîran Sadiq
14- Mausoleum of Sheikh Nasr al-Din
15- Mausoleum of Shehid Abd al-Aziz
16- Mausoleum of Sheikh Sharaf al-Din

🌳 Olive Trees

Map 11 Map of Beḥzanê/Baʿshiqe, based on the map found in the Baʿshiqe Town Council

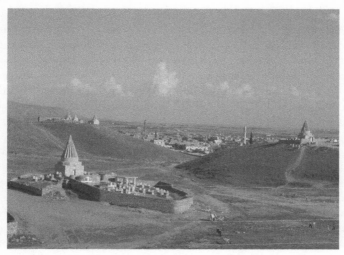

42 Mausoleums at Beḥzanê/Baʻshîqe

town. Except for the mausoleum of Pîr Bûb, who was a friend of Sheikh ʻAdī,[302] all the mausoleums are attributed to the members of the sheikh caste, particularly from the Shamsani lineage. According to the Yezidi tradition, pîrs are forbidden from entering this town.

One of the particularities of Beḥzanê and Baʻshîqe is that all qewwals, the religious singers and the keepers of the ancient knowledge of Yezidism, reside only here. Another is that the mother tongue of an important section of the Yezidi population, the Tazhi tribe, is Arabic (they use Kurdish only in prayers and hymns) – a dialect of Arabic which is close to the dialect of Lebanon. Thus it is supposed that the ancestors of these people come from Baalbek with Sheikh ʻAdī.

Situated near to the Turkish border alongside the Tigris River, Dohuk province houses Kabartu, Mem Shivan, Khanek, Dere Bûn and Shariʻa villages. The Yezidis here live without mixing with other populations. Each village possesses its own venerated mausoleums. The mausoleum of Pîr Afat, located next to a cavern with a spring in Dere Bûn, attracts many pilgrims during spring celebrations in April (Pl. 31). It is attributed to Saint Afat, who is associated with floods and storms. In the 1970s, inhabitants of seven Yezidi mountain villages located in southern Dohuk were moved and gathered in a new collective village called Shariʻa. Today the city of Dohuk attracts many Yezidis especially because of the opportunities for work.

Yezidis in Syria are historically and geographically separated in two areas: the Jazira and Kurd Dagh (Kurdish Mountain). Bafilûn, ʻErshê Qîbar, Cidêdê, Karabash, Kefi Zêt,

Borc al-Qas, Bosufan and Gundê Mezin are the main Yezidi villages in the Kurd Dagh region. There are several shrines visited by local Yezidi pilgrims. Like Muslim mausoleums in their neighbourhood, Yezidi shrines in Syria are generally square in shape and have rounded domes. Some of them are dedicated to well-known Yezidi saints and some to saints unknown to Yezidi communities outside Syria.[303] Chêl Khanê, situated near the village of 'Ershê Qîbar, is the most visited place of pilgrimage in the region. It is dedicated to forty angels of Sheikh Fakhr al-Dîn, who was the father of Sheikh Mand Pasha, the emîr of the Kurds in this area in the late twentieth century. It is a natural cavern, visited in spring by Yezidis and Muslims alike, where animals are sacrificed.[304] Another important pilgrimage place is Sheikh Helîf Helîfê Sheikh 'Adî, located in the village of Basûta. It is a domed square mausoleum, stone which is visited by ill and sterile women.

Yezidi locations in eastern Anatolia are in the Jazira, the Tur 'Abdin and Serhat regions. In the fourteenth century, Yezidism was the official religion of the principality of Jazira.[305] Most powerful Kurdish tribes of this region were Yezidis who converted to Islam over time, such as the Mahmudi and Dimili tribes, who moved out of this region in the fifteenth century towards Van and Khoy. Another important province for Yezidi population was Serhat, which includes the cities of Kars, Erzurum, Ağrı (Ararat), Muş, Bitlis and Van. Almost the entire Yezidi population in this area left the Ottoman territory at the turn of the twentieth century because of thir inoppression by the Ottoman army and some Kurdish chieftains, and settled in the Republic of Armenia and Georgia.[306] Only a small group from the Yezidi community remained

43 Village of Çayırlı, Viranşehir, Turkey

in the Jazira and the Tur 'Abdin regions which had been important in the past; the majority of them also emigrated to European countries.

Some Yezidi zoomorphic tombstones in the form of horses survived in this region, although their heads are missing. Most of them are in the archaeology museums that we are going to talk about later. Furthermore, Lescot mentions the existence of two sanctuaries (Kêkê 'Ezîz and Sheikh Mand) in Rumkale in the region of Karadağ which were destroyed around 1925.[307] Moreover, other pilgrimage places – ziyarets – are found in Midyat. Very well-known are Merava Sheikh 'Adī in the village of Güven (Bacin) and Meri Harab in Çayırlı (Kefnaz). Merava Sheikh 'Adī is the main pilgrimage place of the region, and all the Yezidis gather there for the occasion of Serê Sal, Yezidi New Year's Day in April.[308] Ceremonies continue for a week. Rituals here are similar to those in other Yezidi locations: when the pilgrims arrive in the ziyaret, they take off their shoes and kiss the door of the building to show respect. Animals are sacrificed, meals are cooked and eaten, and prayers are made during these days. In addition, the ziyaret is visited by Yezidi faithful on Wednesdays. Another place of pilgrimage is Meri Harab in the region, which is visited by the Yezidis in May. However, apart from these places there are no architectural remains; hence, it is almost impossible to talk about the Yezidi material culture in the Kurdish regions of Turkey. The Yezidis lived in a vast area between Kars and Viransehir until the beginning of the twentieth century. It seems impossible to believe that the Yezidis of this area did not produce any place of worship or, at least, burial monuments to commemorate their ancestries. Were the Yezidi buildings destroyed by the authorities or by their Muslim neighbours after the Yezidis' massive exodus to the Transcaucasia at the end of nineteenth century? Or were they adapted and appropriated by Muslim communities? The answers is likely both. They were either destroyed or converted to Muslim monuments and over time their origin has been forgotten.

The Yezidis are a minority community in Armenia too, but here they are among Oriental Christians. Moreover, the Yezidis, like their Armenian neighbours, lived for almost eight decades under a political and social system which aimed to suppress and weaken religious acts. The Armenians had a structured church system served by numerous clergy, which allowed them to better resist the Soviets; this was not the case with the Yezidis. The transmission of the faith among the Yezidis was made orally within each family.

There is no place in Armenia for a cult; there are instead informal places of prayer which became sacred for various reasons in the regions where the Yezidis live, for example, the ruins of an ancient church of the tenth–eleventh century in the middle of the village of Derik in Aragatsotn region. On these ruins, which Yezidis call ocak (hearth), several rites and ceremonies as well as prayers take place, with a big connotation of Christian syncretism. In fact, the Christians do not come here anymore, and the Yezidis have appropriated the place. The syncretism of their religious

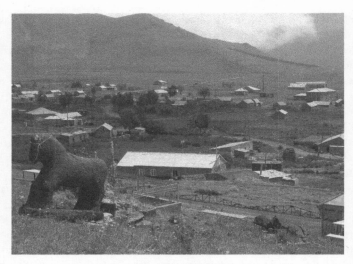

44 View of the village of Derik, Armenia

practices in other places extends to attending church next to Christian faithfuls and
lighting candles. There are places of worship proper to the Yezidis, but they are not the
architectural complexes that we imagine. They are simply places in nature (*ziyaret*)
which are considered sacred by the Yezidi faithful. In particular, the Yezidi cemeteries
in Armenia take a predominant place in Yezidi culture. Each ancient part of Yezidi
cemeteries possesses tombstones in the form of an animal. These are mostly horse-
shaped tombstones that we are going to talk about later.

Places of Worship

According to the Arabic source *Kitāb al-Ansāb*[309] of 'Abd al-Karīm al-Sam'ānī
(d. 563/1167), a contemporary of Sheikh 'Adī, the Yezidis of the twelfth century had
a mosque in Sinjar, where the author met a group of them. However, there is no
architectural evidence to confirm this information, because modern Yezidis do not
possess mosques or any other kind of worship place that are like temples in which
they conduct their liturgies. Moreover, the Yezidis do not have a tradition of public
prayer or worship. However, the Yezidis gather four times a year to perform their
annual ceremonies, which take place in the sanctuary of Sheikh Adī, the mausoleum of
Sheikh Shams, the baptistery of Kanîya Spî and other buildings in the valley of Lalish.
Some local ceremonies are also carried out at the mausoleum of Sheikh Muḥammad
in Beḥzanê and the mausoleum of Sheikh Sharaf al-Dīn in Sinjar. During these

ceremonies, the Yezidi faithful are not asked to fulfil any definite and strict obligations; however, the following communal practices are observed: women, men and children assemble in festive clothes. Sacred places are visited in a group or individually; animals are sacrificed to honour saints and martyrs; donations are made to the men of religion; meals are cooked and distributed to the pilgrims; religious dances (*sama*) are performed by the religious men to the accompaniment of the qewwals' sacred music[310] and popular dances are performed by pilgrims.

The lack of a communal place of worship probably compelled the Yezidis to compensate for this absence by constructing other kinds of buildings, such as sanctuaries, mausoleums and shrines. These buildings, dedicated to Yezidi saints, are an important part of the cultural environment of the Yezidi areas and constitute material signs of the general Yezidi belief system.

Furthermore, the Yezidis have sacred places where human and divine spaces are said to meet. These are mainly rocks next to holy spring, where rituals of animal sacrifice take place and offerings made. These sacred places are spread throughout Yezidi villages in the Kurdish regions of Mesopotamia, Anatolia and Armenia. Most holy springs and streams are close to sacred trees or plants, generally the olive, fig or mulberry trees from which votive rags are hung. Yezidis venerate especially the mulberry tree as it is thought to have sacred qualities and is regarded as having the power to cure disease. Olive trees yield oil, which is used during the rituals to burn the oil wicks in the valley of Lalish. They are stored in jars in the chamber of Sheikh Abū Bekir in the sanctuary of Sheikh 'Adī and are also considered to be sacred.

There are also stones located in the cemeteries and around shrines; locally known as *kevir*, these are also considered sacred and believed to contain the essence of the God. However, they are not objects of devotion but instruments of spiritual action. A votive wick saturated in olive oil is lighted on these stones to obtain something. Some mausoleums at Lalish are built above these stones, such as those of Sheikh Abū Bekir, Alū Bekir, Pîr Cerwan, and Khatuna Fakhran. These stones leave their functional place to the column of wish (*stûna mîraza*) in the Sinjar region. Almost every mausoleum possesses a column which can be considered as a built stone where the oil wicks are lighted and wishes are made. Mausoleums of Sheikh Amadīn, Sheikh Sharaf al-Dīn, Memê Resh, Khatuna Fakhran in Sinjar are examples of this particularity.

The Sanctuary

There is only one sanctuary in the Yezidi architecture, namely, the sanctuary dedicated to Sheikh 'Adī, the founder and master of the 'Adawiyya order. The present sanctuary was created around his tomb and became the principal centre of pilgrimage. This monument is also known as *Perisgaha Lalish*. The Temple of Lalish and its twin spires are considered by the Yezidis to be their *qibla*, as mentioned in the hymn of the 'Declaration of Faith'.[311]

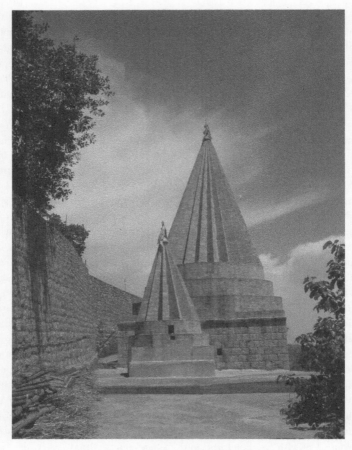

45 Conic domes of the sanctuary of Sheikh 'Adī, Lalish

Salutations to the holy men, to Lalish and to Maqlūb
Our point of orientation on this earth are the Twin Spires.
The Yezidi nation turns towards Sheikh 'Adī,
In the worship of prostration.

Şilavêd mêra Lilaşê Meqlûbî
Berî meye cotêd qûba li wî 'erdî
'Erdê Êzîdixane ser dikêşîne ber Şexadî
'Ebadetê sûcûdehê.

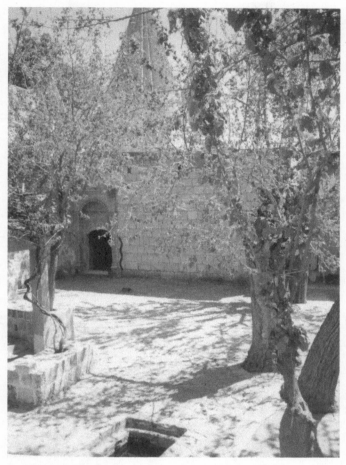

46 Inner courtyard of the sanctuary of Sheikh 'Adī, Lalish

The sanctuary of Sheikh 'Adī is a large complex of buildings of different periods, functions and dimensions. Irregular in shape, it is oriented east-west (Fig. 2). There may be two reasons for this: (1) the narrowness of the east-west valley makes this orientation most suitable from an architectural point of view and (2) during prayers and ceremonies, the Yezidis turn to face the sun as it rises or sets.

The sanctuary occupies the centre of the upper part of the valley of Lalish in the Sheikhan region and is surrounded by other buildings on three sides (Map 9). It covers an area of approximately 4,500 square metres (including the forecourt) and

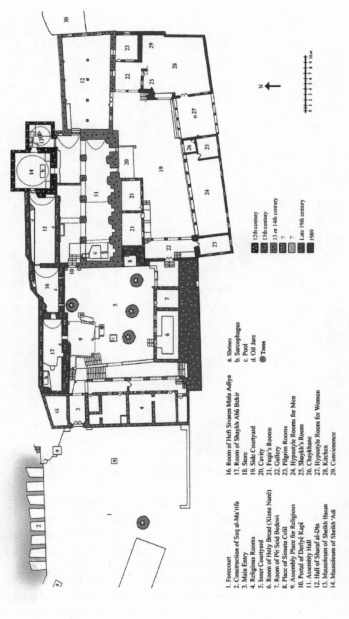

1. Forecourt
2. Construction of Suq al-Ma'rifa
3. Main Entry
4. Religious Rooms
5. Inner Courtyard
6. Room of Holy Bread (Xizna Nanê)
7. Room of Pîr Seîd Bedewi
8. Place of Simata Celil
9. Assembly Place for Religious
10. Portal of Derîyê Kapî
11. Assembly Hall
12. Hall of Sharaf al-Dîn
13. Mausoleum of Sheikh Hasan
14. Mausoleum of Sheikh 'Adî

16. Room of Heft Sivaten Mala Adîya
17. Room of Shaykh Abû Bekîr
18. Store
19. Side Courtyard
20. Cavity
21. Feqîr's Rooms
22. Gallery
23. Pilgrim Rooms
24. Hypostyle Rooms for Men
25. Shaykh's Room
26. Chaykhane
27. Hypostyle Room for Women
28. Kitchen
29. Convenience

a. Shrines
b. Sarcophagus
c. Pool
d. Oil Jars
● Trees

12th century
13th century
13 or 14th century
?
?
Late 19th century
1980

Fig. 2 Sanctuary of Sheikh 'Adî, plan of the ground floor, Lalish

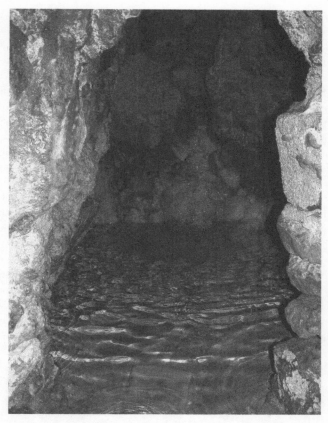

47 Source Zemzem at the basement of the sanctuary of Sheikh ʿAdī, Lalish

is delineated by three outer walls and, to the north, a rocky crag. The main entrance is on the western side, with a secondary entrance to the south and, to the east, a third entrance. The sanctuary is built on uneven ground, so the buildings are at various levels and are linked by stairs or sloping corridors. The whole complex may be divided into two distinct parts: one religious and the other secular. The religious area comprises both interior and exterior courtyards and contains the mausoleums of Sheikh ʿAdī and Sheikh Ḥasan, the assembly hall, the hall of Sharaf al-Dīn, and the rooms of Hesin Dina, Heft Sivaran Mala Adīya and Sheikh Abū Bekir. In the basement of the complex, together with the stables and stores, is the place of penitence (*Chilekhane*) and the grotto where the spring of Zemzem[312] is located. The

secular buildings occupy the south-east part of the complex and serve the needs of the pilgrims and the religious officers who live in the sanctuary. Rooms for these officials and the pilgrims, the kitchen and the hypostyle chambers, where men and women meet separately following their pilgrimage are arranged around a courtyard in this secular space.

The forecourt lies to the west of the complex. To the north of the forecourt is a series of low, vaulted structures, called Suq al-Ma'rifa, which were once used as a marketplace during the season of pilgrimage[313] but which today have no specific function, although at the times of pilgrimage they are used for the fire ritual (Pl. 48). It consists of eight barrel-vaults built against a rock, each opening to the south and all of different sizes.[314]

The outer wall of the sanctuary is formed by the eastern side of this courtyard, through which opens the principal entrance. The large entrance or Derîyê Mîr[315] is situated at the north end of the outer wall and serves as the main gateway. It is a semi-circular arch on engaged pillars, crowned by a simple entablature. The tympanum contains a symmetrical composition in low relief consisting of two elliptical panels bearing Arabic inscriptions giving the names of people who restored it.

In the north-east corner of the inner courtyard, the Derîyê Kapî'[316] leads to the assembly hall (Pl. 23). Above this door is a semi-circular arch on engaged supports, crowned by a triangular pediment. The capitals of the two fluted columns are decorated with acanthus leaves in low relief. The architrave is carved with Corinthian acanthus leaves aligned with palmettes, and the archivolt is decorated by a row of aligned

48 Suq al-Ma'rifa in outer courtyard of the sanctuary of Sheikh 'Adī, Lalish

palmettes. The triangular pediment bears a carving in low relief showing two peacocks arranged heraldically and facing each other, each with a small lion in front of it[317] and a smaller bird, possibly another peacock, on its back.[318]

The assembly hall lies at the centre of the complex and is comparable to the *Samakhane* in which Sufis perform their rituals in the *zāwiyas* of Anatolia. Rectangular in shape, it is oriented east-west. A row of five pillars running lengthwise along the centre of the room divides it into two almost equal sections, each covered with a pointed vault (Pl. 49). On the south wall, six deep niches are visible.[319] They begin at ground level with right-angled bases and are capped with pointed arches; in the centre of each is a smaller recess. Two niches at the east end of the wall pierce through it and serve as windows opening to the south. Small niches for holding votive wicks are present in every Yezidi building. In this case, however, the shape of the niches is not suited to that function. Indeed, they look more like *miḥrābs* but, if so, why would there be six large niches in such a relatively small building? Perhaps they serve only to add an interesting architectural feature to the internal walls.

The hall of Sharaf al-Dīn has the same ground plan as the assembly hall but is smaller and slightly lower. Four pillars divide it longitudinally into halves. The ceiling is now flat but, following Bachmann's plan,[320] it originally had a pointed vault.

The pilgrim gains access to the mausoleum of Sheikh Ḥasan through a door in the north-east corner of the assembly hall. In the centre of the room, a door leads to a narrow staircase which descends to Zemzem and Chilekhane. A door in the west

49 Interior of the assembly hall of the sanctuary of Sheikh ʿAdī, Lalish

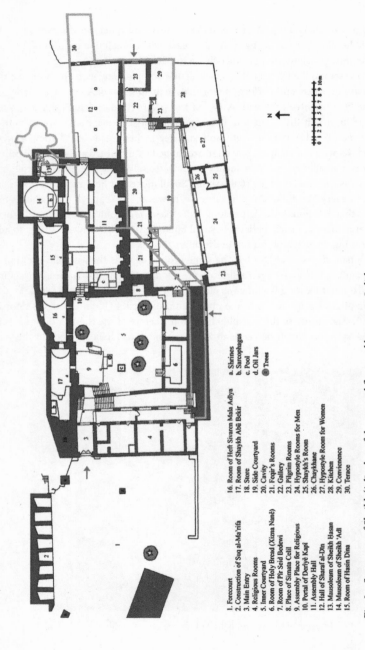

1. Forecourt
2. Construction of Suq al-Ma'rifa
3. Main Entry
4. Religious Rooms
5. Inner Courtyard
6. Room of Holy Bread (Xizna Nane)
7. Room of Pîr Seîd Bedewî
8. Place of Simata Cetil
9. Assembly Place for Religious
10. Portal of Deriyê Kapî
11. Assembly Hall
12. Hall of Sharaf al-Dîn
13. Mausoleum of Sheikh Hasan
14. Mausoleum of Sheikh 'Adî
15. Room of Hasin Dina

16. Room of Heft Sivaren Mala Adîya
17. Room of Shaykh Abû Bekir
18. Store
19. Side Courtyard
20. Cavity
21. Feqîr's Rooms
22. Gallery
23. Pilgrim Rooms
24. Hypostyle Rooms for Men
25. Shaykh's Room
26. Chaykhane
27. Hypostyle Room for Women
28. Kitchen
29. Convienence
30. Terace

a. Shrines
b. Sarcophagus
c. Pool
d. Oil Jars
● Trees

Fig. 3 Sanctuary of Sheikh 'Adî, plan of the ground floor and basement, Lalish

wall leads to the mausoleum of Sheikh 'Adī. This is also square. In the centre of its
southern wall, an unglazed 'window' opens out to the assembly hall. In front of this
window, wrapped in multicoloured cloths, is the sarcophagus[321] of Sheikh 'Adī. Both
mausoleums have the polyhedral fluted conical domes, covered in fine, deep ribbing
that is characteristic of Yezidi architecture (Pl. 50).

From the mausoleum of Sheikh 'Adī, the pilgrim can reach a succession of three
barrel-vaulted rectangular rooms aligned in an east-west direction. This is where the
ceremonial oil used for the lamps of the sanctuary is stored in jars and barrels standing
against the north and south walls. In the west end of the third room, where the
sarcophagus of Sheikh Abū Bekir[322] is located the floor is slightly raised. It is covered
by a black cloth, unlike the other sarcophagus in the sanctuary.

The south-east wing of the complex is the secular part of the sanctuary and
the animated centre of its daily life. It is composed of buildings arranged around
the side courtyard, which is irregular in shape and oriented east-west. Most of the
accommodations for the clergy and pilgrims are here. At its eastern end are several
rooms for pilgrims; opposite these there is a staircase leading to the first floor, where
most of the living accommodations are found, including sleeping and living quarters,
bathrooms, and the like. Beneath the staircase is a hearth used for preparing food for
the pilgrims. The southern end of the courtyard is defined by two hypostyle rooms,
one for men and one for women, where they congregate and eat after their pilgrimage.
The kitchen lies at the eastern end of this range.

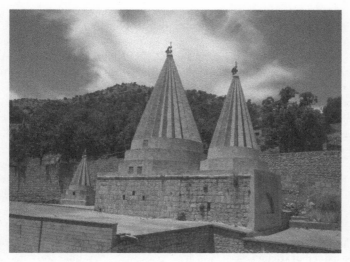

50 Three conic domes of the sanctuary of Sheikh 'Adī, Lalish

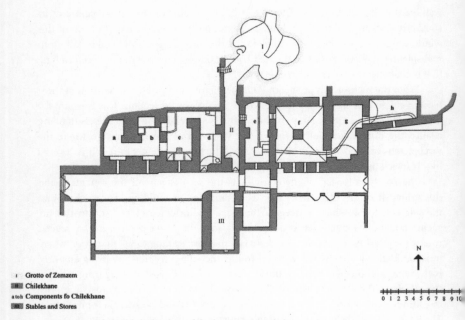

i Grotto of Zemzem
▓ Chilekhane
a to h Components fo Chilekhane
▓ Stables and Stores

Fig. 4 Sanctuary of Sheikh ʿAdī, plan of the basement, Lalish

The spring of the Zemzem lies in the basement of the complex (Fig. 4). To reach it one must take either the narrow staircase leading down from the mausoleum of Sheikh Ḥasan or the corridor that runs to the Chilekhane. On the northern side of the corridor, at an intersection, rises the spring of Zemzem. It emerges in the middle of the room and then runs along on the surface for a distance of 3.5 metres before disappearing underground, only to gush up once more in one of the rectangular rooms on a lower level. The source of Zemzem is the holiest place for the Yezidis, who believe that the water of Zemzem has magical and medicinal properties par excellence. It cures, restores and assures eternal life. Therefore, this water is not accessible to non-Yezidis.

In the basement, the Chilekhane[323] lies to the south of the spring of Zemzem beneath the eastern part of the sanctuary, underlying a large part of the assembly hall, the whole of the hall of Sharaf al-Dīn and a terrace situated in the east of the complex. This part of the complex is inaccessible to pilgrims. The Chilekhane presents a complicated arrangement of eight aligned units, which are divided by a corridor into two wings with four units on each side. The units are oriented north-south, except for one located at the extreme east end which runs east-west. These units are barrel-vaulted except for one room, which has cross-vaulting. In the south-east corner of Room d, is

an earthenware jar in which the *berats* are put. *Berats* are small balls formed from the earth of the sanctuary mixed with the water of Zemzem. They are considered sacred and are distributed to pilgrims during ceremonies and festivals. They are believed to bring good fortune to the possessor and to protect him from the evil eye.

A corridor runs in front of the south wall of the Chilekhane. A large door at its eastern end opens onto the exterior of the sanctuary and is used solely by religious officials. To the west a second door connects to another subterranean corridor leading to the side courtyard and other parts of the sanctuary. A series of rooms of different dimensions and orientations delimit the corridor to the south. These are used today for storage and stabling.

The complex is built of quarried stone. The façade of the meeting room facing the inner courtyard and the walls of the mausoleums of Sheikh 'Adī and Sheikh Ḥasan above the roof of the complex are lined with cut stone. The three conical domes with multiple, fine, deep ribs are constructed of unhewn stone embedded in a soft gypsum mortar called *juṣṣ*.

Today, the sanctuary is simple and undecorated, except for the geometric, vegetal, and zoomorphic motifs sculpted in low relief on marble and plasterwork around the two doorways located on the western façade of the outer wall and in the assembly hall. On the west wall of the assembly hall, facing the inner courtyard, there are some carved symbols which seem to be those described in written accounts and depicted in drawings and photographs of the late nineteenth and early twentieth centuries.[324] The most striking depiction is a large serpent[325] painted in black and placed vertically next to the portal, it appears to have been part of the original door while other symbols, including a horizontal serpent, three hooked sticks, a torch or a mace, and an object resembling a skimmer,[326] may be spolia from earlier structures. The same may be true of a pair of birds on a block above the portal, other unidentified carvings including a defaced stone[327] and two illegible inscriptions.

There are different opinions as to the origins of the sanctuary of Sheikh 'Adī: did the Yezidis construct the complex *ex novo*, or was exist did a building already?

According to a legend common to both the Christian and the Yezidi communities throughout the region, the sanctuary was originally a Nestorian church. Two Syriac manuscripts refer to the monastery of Mar-Yuḥanan and Isho' Sabran,[328] which some modern scholars claim became the sanctuary of Sheikh 'Adī.

The first manuscript was written in 1451 AD. by Ramisho', a monk from the monastery of Beith-Abe; it was recopied in 1588 and 1880[329] and translated into French by Joseph Tfinkdji.[330] In the manuscript, Ramisho' addressed himself to a certain Rabban Joseph, a monk in the monastery of Mar-Michael of Tarrel, and sought to convey the manner in which 'Adī, son of Musāfir the Kurd, had occupied and then seized the monastery of Mar-Yuḥanan and Isho' Sabran in 1219. He tells of several successive events in 'Adī's family during this period and also speaks of the relationship

between 'Adī and the monks and priests in the monastery in question. According to the source, 'Adī became powerful, pillaged the monastery and massacred all its monks; he then installed himself and his large family there, became the master and established it as his residence.[331] According to the same source, the monastery was, in fact, situated above the village of 'Eyn-Sifni, to the east of the Gomal River, three hours from the village of Hinis.

The second manuscript is a poetic hymn that was composed in honour of Rabban Hormuzd by a Nestorian bishop of Arbil, Isho'yahb Bar Mqadam, who lived in the fifteenth century. This manuscript, entitled 'Ouarda', was discovered at Karamles. It, too, talks about the monastery of Mar-Yuḥanan and Isho' Sabran and of its occupation by 'Adī.[332]

Although both these sources report that the monastery of Mar-Yuḥanan and Isho' Sabran was pillaged and seized by a certain 'Adī, son of Musāfir the Kurd, who made it the property of his family, they do not demonstrate that the monastery subsequently became the sanctuary of Sheikh 'Adī. Indeed, the fact that they refer explicitly, not to Sheikh 'Adī, the founder of the 'Adawiyya, who died in 1162, but to another 'Adī, who was active in 1219 (presumably 'Adī II who was executed by the Mongols in 1221)[333] seems to rule out this possibility. It may be significant that the manuscripts stress merely that the monastery became the seat of 'Adī's family[334] and do not suggest that it became a religious sanctuary. Nor does the description of the location of the monastery correspond to the location of the sanctuary of Sheikh 'Adī. Furthermore, scholars consider these sources to be a forgeries.[335] According to Kreyenbroek, the account of this event derives from an account cited by Bar Hebraeus (d. 1286) who described the seizure of another monastery by a man called Michael in 1256–57.[336]

However, most authorities argue that the sanctuary was originally a church, citing the plan of the central area, called the 'assembly hall', which is rectangular, oriented east-west and divided into two parts longitudinally by five pillars. According to Berezin,[337] this part of the complex was formerly a Byzantine church, as were the mosques in Diyarbakir, Mosul and Derbend that were converted from churches. He assumes that the two longitudinal divisions of the assembly hall correspond to two of the three aisles of a Byzantine basilica, and that the missing third aisle lay either to the north or to the south of the present building. When the basilica was transformed into a Yezidi temple, he argues, the eastern end, where the altar would have been, was transformed, and one of the side aisles destroyed. The isolated location of the sanctuary, he argues further, corresponds exactly to what one would expect in a Christian monastery.

In the same way, Bachmann, who has studied the churches and mosques of Armenia and Mesopotamia, found a relationship between the 'assembly hall' part of the complex and the Eastern churches, and he concludes that it is connected to an ancient Nestorian church or even a monastery. At the end of a large meeting room, a small door with two steps leads to the Holy of Holies, the tomb found on a raised

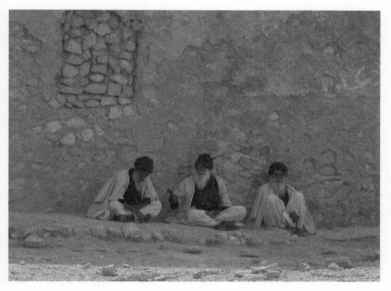

1 Feqîrs in the shadow of the wall, Karsi, Sinjar, northern Iraq

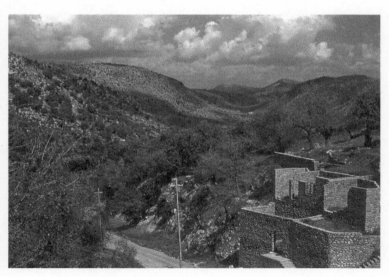

2 General view of the valley of Lalish, northern Iraq

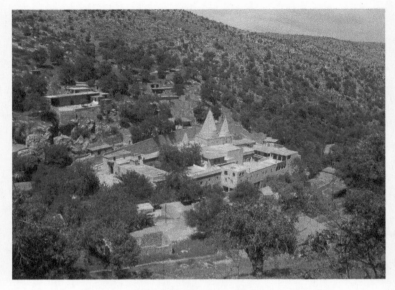

3 Sanctuary of Sheikh 'Adī with its surroundings at Lalish

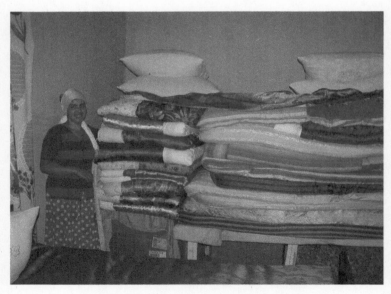

4 Yezidi woman in her guest room, Baroj, Talin (Armenia)

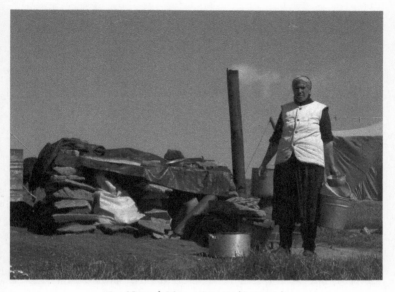

5 Nomad, Mount Aragats (Armenia)

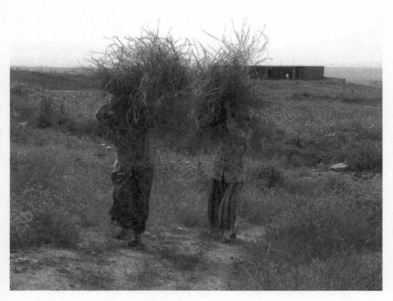

6 Yezidi women in the field, Bozan

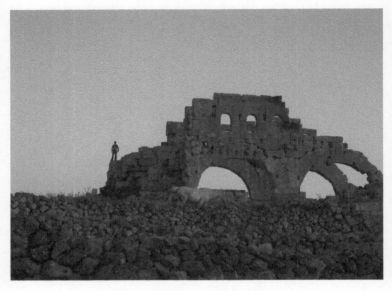

7 Ruins of Byzantine era church in Brad, Aleppo (Syria)

8 Children playing in the ruins, Brad, Aleppo (Syria)

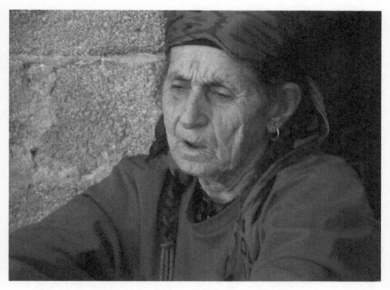

9 Woman in red, Midyat (Turkey)

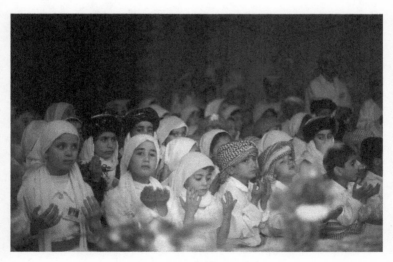

10 Praying children, Lalish

11 Working in the field, Avshin (Armenia)

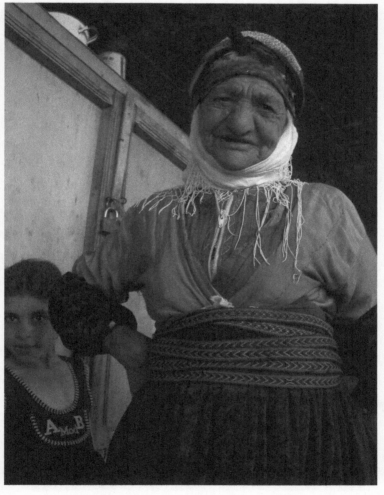

12 Old lady in traditional clothes, Hoktember (Armenia)

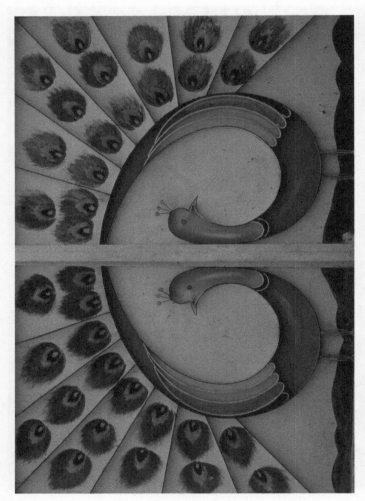

13 Image of the peacocks, garden door of the house of Mîr Kamuran, Bàadrê

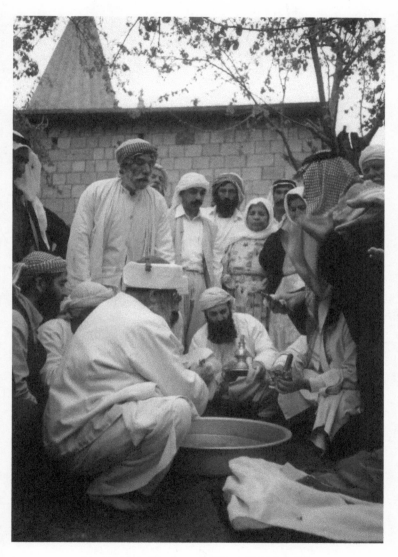

14 Baptism of the banner of Tawûsî Melek, Lalish

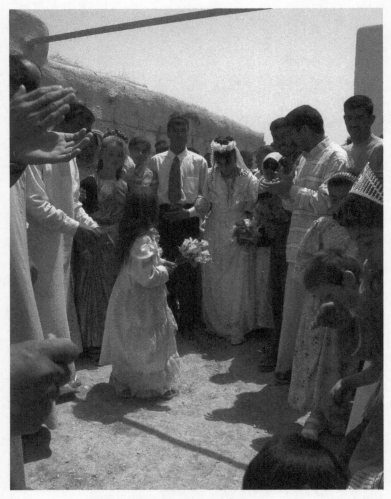

15 Ceremony of marriage, Sinjar

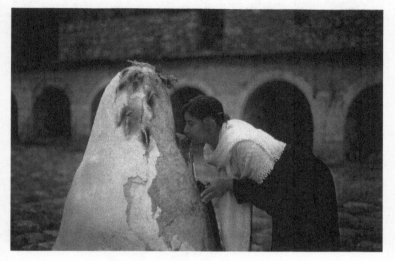

16 Woman kissing the shrine, Lalish

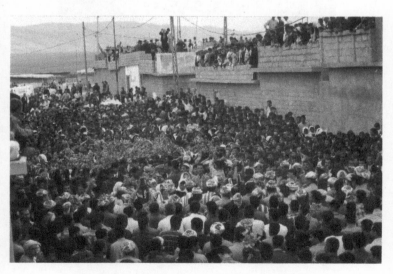

17 Pilgrims during the tawwāf of Karajal, Dohuk

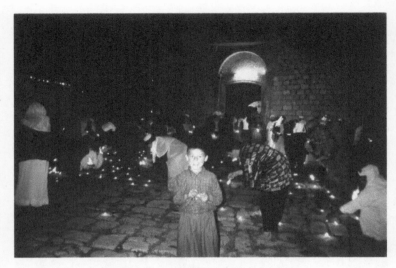

18 Ceremony of Serê Sal, Lalish

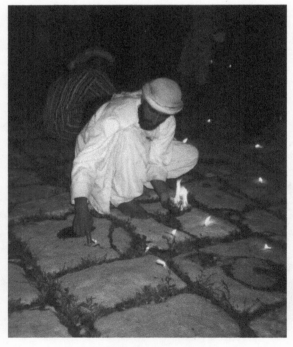

19 Pilgrim lighting oil wicks, Lalish

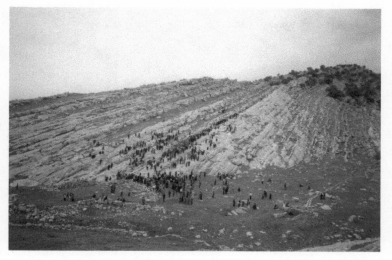

20 Pilgrims climbing on the mountain to visit the Karajal shrine, Dohuk

21 Pilgrims on the top of mountain, dancing around the shrine, Dohuk

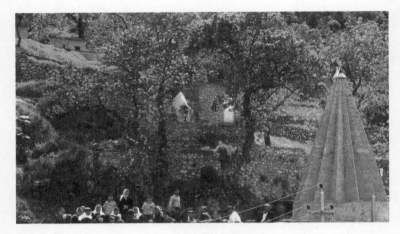

22 Pilgrims at Lalish

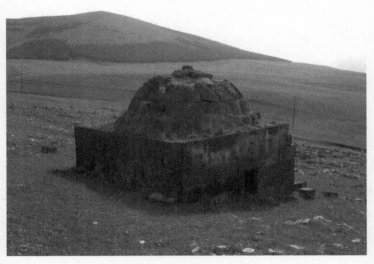

23 General view of the anonym mausoleum, Elegez, Aparan (Armenia)

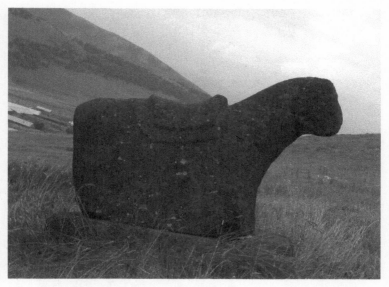

24 Horse-shaped tombstone, type III, Elegez, Aparan (Armenia)

25 Shrine at the mausoleum of Sheikh Abū'l Qasim, Sinjar

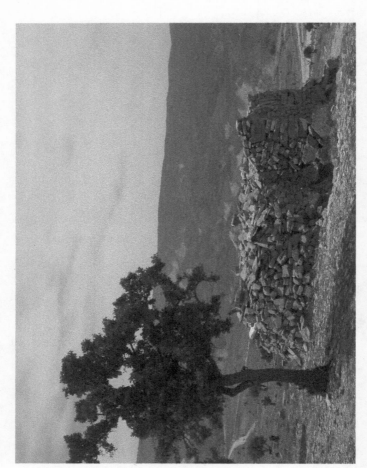

26 Shrine of Abde Sheikh 'Adī, Sinjar

platform. To the left of this is a small passageway which is accessible from two rooms. To the right are different vaulted rooms; these are lower and aligned. In one of these vaulted spaces there is a further tomb. According to Bachmann, these four elements – the 'assembly hall', the 'Holy of Holies', the 'linkage room' and the 'vaulted tomb room' – correspond to the principle elements of various small Nestorian mountain churches in northern Mesopotamia.[338]

Fiey,[339] a leading authority on the Christian communities of Iraq, however, believes that the sanctuary was originally a mosque and that the longitudinal construction, with a door at the extreme, end is typical of Kurdish mountain mosques such as the one at Bamarni near to Amadiya. The three niches which are found in the south wall, are, he says, three *miḥrābs*.[340] The faithful who turn to face these *miḥrābs* have their backs to the tomb, which is consistent with the precept that no tomb should stand between the worshipper at prayer and the *qibla*. For him, the presence of the streams and the basins found in the sanctuary is explained by the Islamic ritual of ablution.

Demeersaman[341], in his book entitled, *Nouveau Regard sur la Voie Spirituelle d'ʿAbd al-Qâdir al Jilânî et sa Tradition* discusses a *zāwiya* built for Sheikh ʿAdī by a companion of Sheikh ʿAbd al-Qādir al-Jīlānī who was a former follower of the Tāʾifa al-ʿAdawiyya order founded by Rābiʿa al-ʿAdawiyya (714–810) in Basra; for this reason, he believes that the sanctuary began as a *zāwiya* of the Qadiriyya order.[342]

While it is possible that a Nestorian church may once have stood on the spot now occupied by the sanctuary of Sheikh ʿAdī, no architectural trace remains to confirm that thesis. It is difficult to imagine that the assembly hall and adjoining structures could ever have been a church; had it been so, it would be necessary to imagine that the mausoleums of Sheikh ʿAdī and Sheikh Ḥasan had originally been side chapels, and no examples of a Christian structure of that form exist in the region. Moreover, the putative church would have had only two naves, presumably with the two mausoleums to the north. Finally, the courtyard would lie to the west of the putative church, whereas in Eastern churches, the courtyard normally lies to the north or south of the church.[343]

The best explanation for the complex and irregular plan of the sanctuary seems to be, not that it was transformed from a pre-existing Christian church, rather that it grew gradually, as various elements were added in different architectural periods. In this way, what began as no more than a *zāwiya* comprising small areas for the master, Sheikh ʿAdī, and his disciples, in which they dedicated themselves to prayer and other religious activities – the Chilekhane as it is today – grew organically as the tradition of pilgrimage developed.

Arab sources report the construction of a *zāwiya* in the Hakkari region by Sheikh ʿAdī. Al-Hafiz al-Dhahabī in his *Siyar al-Alam al-Nubala'* mentions that Sheikh ʿAdī isolated himself at Jebel Hakkar and built a *zāwiya*.[344] According to Ibn Kathīr,[345] Sheikh ʿAdī, the sheikh of the ʿAdawiyya community, went into isolation in the mountains of Hakkari and established a *zāwiya*. The inhabitants of the region believed in him and

worshipped him to an exaggerated degree. According to Ibn Khallikān,[346] Sheikh 'Adī was buried in his *zāwiya*.

Inscriptions on some of the buildings give the names of various Yezidi leaders who, at different times, undertook the restoration of parts of the complex, but no inscription is known that would help to date the original foundation of the sanctuary more precisely.

Nevertheless, it is very probable, as the variety of different materials and construction styles suggest, that the building is the product of several phases of construction and modification. The grotto of the spring of Zemzem may well have existed prior to the arrival of Sheikh 'Adī and have been used in the religious practices of other communities such as Zoroastrians, Mithreans or Christians because the spring itself may well have long been considered to have mystical properties. Moreover, Mithraic temples (Mithraea), which were built underground or often located in natural caves and the most sacred places of worship for members of the Mithraic cult[347] have been found at many locations of the Roman Empire; these were the places where Roman soldiers worshipped.[348] Thus, it is possible to find a link between the grotto of the spring of Zemzem and Mithraeas and their probable influence on Yezidi religion.[349] It is known that Sheikh 'Adī withdrew to the site with his disciples around 505/1111,[350] and it is possible to surmise that the components of the Chilekhane (*zāwiya*) belong to the early period of the complex and were constructed close to the grotto where a spring emerged – the spring which acquired the name of Zemzem when the 'Adawis began to create a tiny analogue of Mecca at Lalish.

After the death of Sheikh 'Adī in 557/1161–62, his disciples decided to construct a mausoleum in his honour on a higher floor. It is possible that this was either because the topography of the site precluded building on the sides of the *zāwiya* or to allow access to the mausoleum for the growing number of pilgrims that would be away from the secretive rituals of the disciples. In any case, the construction of an upper floor made the site of the mausoleum more visible and therefore more accessible than before. The Chilekhane and the grotto were linked to the mausoleum by stairs.

The mausoleum of Sheikh 'Adī has a square ground-plan with a fluted dome, which is a well-established form from the twelfth and the thirteenth centuries used at the Shi'ite mausoleums of the Mosul region. However, it is difficult to ascertain whether these are the original features of the mausoleum because it was destroyed rebuilt and twice in the thirteenth and the fifteenth centuries. The first time it was destroyed was in 1254–55, when Badr al-Dīn Lu'lu' sent his army against Sheikh Ḥasan. The bones of Sheikh 'Adī were exhumed and burned.[351] The second time was in 1414 when a certain Jalal al-Dīn al-Ḥulwānī declared holy war against the Yezidis and persuaded local leaders to raise forces in order to invade Sheikhan. The mausoleum of Sheikh 'Adī was ransacked by the men of Jalal al-Dīn and was immediately rebuilt by the Yezidis.[352]

It is reasonable to suppose that the mausoleum of Sheikh Ḥasan was originally an antechamber which was deliberately constructed directly above the sacred spring because the steps just inside the antechamber lead directly to the spring below. This arrangement required pilgrims to pass first through this antechamber, which would later become the mausoleum of Sheikh Ḥasan (d. 652/1254), before gaining entry to the mausoleum of Sheikh Adī and the Spring of Zemzem. This had the secondary advantage of leading the ordinary pilgrim to the spring by a route that bypassed the meditation area used by the disciples.[353]

It is more than probable that, as the number of disciples and pilgrims grew over time, the existing buildings no longer sufficed. For this reason, more structures were added to the sanctuary as and when need arose. Thus, because of the restricted space on which the original *zāwiya* was built (which could hold only a limited number of structures on the same level), the disciples were obliged to construct new buildings in response to the needs of the pilgrims.

Aligned with the mausoleum of Sheikh 'Adī and providing access to it are the three inter-connecting, rectangular, barrel-vaulted rooms, which appear to have been built as a single unit. One of these, number 17, contains the sarcophagus of Sheikh Abū Bekir, one of Sheikh Ḥasan's sons who lived in the second half of the thirteenth century. The niche in the southern wall of this room is aligned on the Meccan *qibla*. The presence of Sheikh Abū Bekir's sarcophagus may indicate that these rooms were in existence at the time of or prior to his death.

Although the hall of Sharaf al-Dīn lost its original architectural features in a recent restoration, it is still evident that, like the assembly hall, it once possessed a row of pillars running east-west down the centre of the room and a pointed vault. It is quite possible that these two halls were built at the same time for to provide separate areas for men and women in which to perform their religious rituals. An Arabic inscription on the tympanum of the Derîyê Kapî gives carries the date of 695/1295–96. But because this inscription is now located on a doorway built at the beginning of twentieth century, and so it cannot be said with certainty that this is the date this unit was constructed. Moreover, the inscriptions deciphered by Berezin[354] on the door of Derîyê Kapî do not include this inscription. While it has proved impossible to date halls 11 and 12, they were certainly constructed after rooms 13, 14 and 15 and in all probability before the fifteenth century. At that time, the Yezidis began to be persecuted because their religion was perceived as a threat to Islam. It may be that they had simultaneously evolved a characteristic form of religious architecture. Much later, between 1890 and 1907, the sanctuary was used as a Sunni religious school by the Ottomans who renovated and converted it into a madrasa in order to convert the Yezidis to Islam. Following the Yezidis' protest to the Ottoman court in Istanbul, the complex was eventually returned to them.[355]

There is no evidence for the date on which the rooms on the western and southern sides of the inner courtyard or the Suq al-Ma'rifa were constructed. However, an

inscription above the main portal in the western wall records that the door was renewed at some time during the governorship of Mayan Khatun (1913–57). The portal of the Derîyê Kapî was also renewed between 1911 and 1928.[356] The hypostyle rooms, the side courtyard and the accommodation areas, which are located in the eastern, secular part of the complex, were built around 1989.

Mausoleums

Mausoleums constitute the largest single type of the surviving monuments of Yezidi architecture. They are important for their number, their variety and for being the main places of worship in the Yezidi architectural heritage. Each Yezidi village in northern Iraq has its own venerated mausoleums. These are not only burial places but also a kind of worship place in different sizes, where the faithful, individually or in groups, come to express devotion and perform pious duties. They are venerated as tombs of saints and thus have become centres of pilgrimage, where the faithful expect their prayers to be answered. In fact, these saints are historical personages who were in the foundation and development of the Yezidi religion or who were martyred for the Yezidi cause. They are the descendants of Sheikh 'Adī and his early disciples. In this sense, these buildings are religious and constitute a part of the daily life of the Yezidi community. On every important occasion, such as marriage, festivities, illness and death, visits are made to these buildings. Commemorative meals are eaten there, and prayers are said for the souls of the dead. Moreover, there is animal sacrifice, mourning and the lighting of oil wicks in the niches of the mausoleums (during which vows are chanted).

Yezidi saints and their mausoleums are worshipped for several reasons. For instance, it is believed that these buildings serve to cure illnesses: the mausoleum of Sheikh Ḥasan is said to be effective against liver problems and rheumatism; that of Sheikh Sharaf al-Dīn is effective against jaundice and skin problems, while the mausoleum of Hajali helps to cure madness and the possession of the soul by *djins*, and so on. Some of the Yezidi saints are also considered to have a direct relationship with nature. Memê Resh is the lord of rain and protector of the harvest; Pîr Afat is associated with floods and storms. Some Yezidi saints have power over animals. For example, Sheikh Mand Pasha is believed to have influence over serpents, and his mausoleums and shrines are effective against snakebites. Thus, a vertical black snake is frequently depicted on the façades of his mausoleums and shrines. Lastly, Pîr Cerwan protects people from scorpion bites because he is associated with the scorpion.

The Yezidis call these buildings in northern Iraq *khas* (خاص), *mêr*,[357] *qubba* (قب), *marqad* (مرقد), *mazār* (مزار) and *maqām* (مقام). The terms *khas*, *mêr* and *qubba* generally refer to all mausoleums with a dome. Nevertheless, *qubba* is used only in

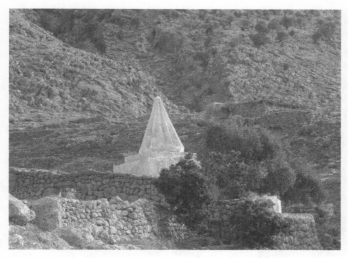

51 General view of the mausoleum of Hajali, Sinjar

the inscription in the foundation of the mausoleum of Sheikh Shams in Mem Shivan. *Marqad* (place of rest or place of sleep) is used in several inscriptions. *Mazār* (to make a pilgrimage), derived from the Arabic root *ziyara*, is the most-used term for the Yezidi mausoleums. *Maqām* (place of residence) is also used to identify mausoleums.

Yezidi mausoleums are freestanding buildings which are principally located on the top of a hill, beside sacred trees, rocks, caves or springs, and they are, in general, small, rural buildings look as though they were made from the same mould. They are usually set within the confines of an open courtyard, which also houses the private cemeteries of Yezidi saints. Nevertheless, the mausoleums of Sheikh 'Adī and of Sheikh Hasan are part of the sanctuary of Sheikh 'Adī, and mausoleums of Khetî Besî and Alū Bekir in Bozan as well as the mausoleums of Pîr Sîn and Qadî Bilban at Lalish are collateral. Yezidi mausoleums have only one floor, with the exception of the mausoleum of Hajali in Sinjar, which has two (the ground floor is reserved for the sick waiting to be cured).

These mausoleums were built in various periods, because of the lack of inscriptions and historical sources, it is difficult to date them precisely. Moreover, because of some recent bad restorations, the buildings themselves do not give us any evidence of when they were built, and there are no architectural styles that distinguish different periods of Yezidi history of that might help us to date them. The same style, derived from a particular model, has been repeatedly used over the centuries and is still in vogue.

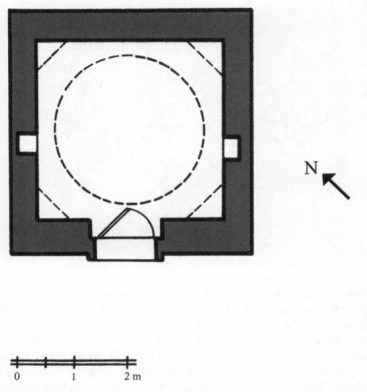

Fig. 5 Plan of the mausoleum of Melih Sheikh Sīn, Beban

The main typology of mausoleums consists of simple square and rectangular forms, and in total there are seven different plans. Astonishingly, the octagonal plan does not exist in the Yezidi architecture of northern Iraq, nor is it favoured in the Muslim architecture of Mosul. According to Uluçam,[358] the square plan with a dome is a characteristic of Mosul since all the mausoleums of Mosul represent this plan type. The octagonal form has, however, been used lavishly in Islamic mausoleums in Iraq, especially in Baghdad and Samarra,[359] as well as in Anatolia during the periods of the Seljuks and Beyliks.[360]

The square plan is the most commonly used style in the Yezidis funerary architecture. Where does this plan derive from? Should we link the Yezidis mausoleum tradition to their Zoroastrian background? Alternatively, should we seek it in their

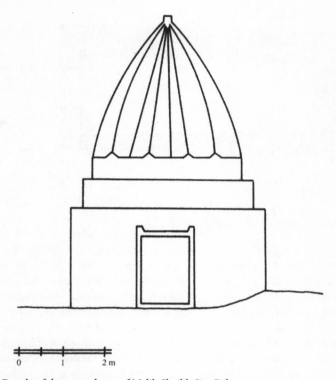

Fig. 6 Façade of the mausoleum of Melih Sheikh Sīn, Beban

Christian neighbours' inhumation tradition, in their Muslim background or in that of their Muslim neighbours?

It is obvious that the Zoroastrians did not have a tradition of building freestanding funerary monuments because they believed that human corpses pollute the earth, a belief which would have influenced the Yezidi architecture. Thus, the deceased were exposed on the Towers of Silence, *dakhmas*, in remote locations where they were eaten by scavenger birds by the Zoroastrians. However, the domed square plan may have derived from Sasanian fire temples, *char taq*.[361] Nevertheless, it would be an impetuous and inept to conclude that the Yezidi square mausoleum is the continuation of the fire temples. Late antique mausoleums, early Byzantine baptisteries and martyria can also be seen in the same plan. It is possible to suggest that this square form, which was used in the fire temples, influenced Eastern Christian architecture and then were seen in Islamic and later, in Yezidi architecture.

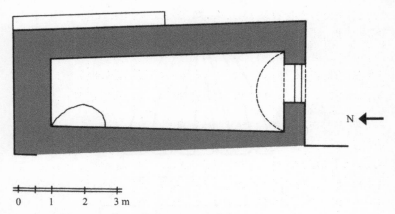

Fig. 7 Plan of the mausoleum of Pîr Cerwan, Lalish

The earliest square-plan mausoleums with domes are found in Central Asia in the tenth century. This is the Samanid mausoleum in Bukhara (943), where the last Persian dynasty of this region is buried, which is described by Hillenbrand as a fire temple in an Islamic dress.[362] Numerous other examples of the same kind of monuments exist in Iran and Central Asia from the same century. The Arab Ata mausoleum at Tim (977–78); the mausoleums of Arslan Djazeb of Sangbast (998–1030); of Ayshe Bibi (1068–80); Baladji Khatun at Taras (eleventh century); mausoleum of Ghazālī in Tus (1111), and mausoleum of Sultan Sandjar in Merv (1157) are only some examples.

It can be supposed that this square plan with a dome reached the Yezidis through the Islamic mausoleums of Mosul. Thus, the Yezidi funerary architecture cannot be studied without observing the Islamic world because its architectural heritage is part of Islamic art. The Yezidis live in an area in which Islam is the dominant faith. It is also important to evoke the Sufi Islamic background of Yezidism, particularly the 'Adawiyya epoch of the twelfth and the thirteenth centuries (from the arrival of Sheikh 'Adī in the region at around 1111 to the death of Sheikh Ḥasan in 1254), from where the ascetic and sober characteristics of Yezidism also emerged. Moreover, the excessive veneration of saints in Yezidism should be also sought in its Sufi background. Sufi characteristics influenced the construction of several tombs of the Yezidi saints, and brought the pilgrimage and worship of the Yezidi faithful to these buildings. The plans of the mausoleums of Yezidi saints were also chosen according to the existing buildings of the region.

Although the Yezidis of the era of Badr al-Dīn Lu'lu' (1211–59), known as the 'Adawis, were politically in opposed to the authority of Lu'lu' and indeed often revolted against him,[363] this political conflict did not prevent the Yezidi architecture from being

influenced by his artistic centre, Mosul. The city of Mosul housed numerous artists and artisans of this epoch. Lu'lu' ruled mainly Mosul, Sinjar and the Jazira and managed to gain the right to rule over the Kurdish forts, and by the end of 1221, most of the Kurdish regions had accepted his authority.[364] He was a great patron of the arts and architecture, and because he was Shi'ite, he especially promoted the construction of Shi'ite mausoleums, encouraging pilgrimages to these buildings instead of to Mecca and Medina.[365] The closeness of Mosul to the Yezidi settlements also meant that the city had an important influence on Yezidi architecture. Although the original plan of the mausoleum of Sheikh 'Adī is unknown to us, its current square ground plan and conical dome were also widely used in the Shi'ite mausoleums of Mosul and Sinjar in Iraq during Zangid Atabeg's period (1149–1261), particularly during the reign of Badr al-Dīn Lu'lu' (1211–59). The mausoleum of Imam Abdurrahman (1180–93) is the most ancient example of this type of Shi'ite architecture in Mosul, and it has survived to this day. The mausoleums of Imam Yahya Abū'l Qasim (1239) and Imam 'Awn al-Dīn (1248) each have an antechamber in the form of a *riwāq*, which is open on three sides. It seems that Yezidis and Muslims of Mosul simultaneously used this form, especially in the late twelfth and mid-thirteenth centuries. The Muslims, however, stopped following this plan from the end of the thirteenth century; the Yezidis appropriated it and added variations to it. These days, it is easy to distinguish a Yezidi village from its neighbours by these square-planned mausoleums covered by fluted conical domes.

One cannot deny the importance of the mausoleum architecture of eastern and central Anatolia where Mosul and Yezidi settlements interacted. Monument that are comparable to the Yezidi architecture are found throughout central and eastern Anatolia from the twelfth and fourteenth centuries. The mausoleum of Nebi Melek, which is located between Diyarbakir and Egil, is the region's first known mausoleum with a square plan. It dates to the twelfth century.[366] Mausoleums of Sheikh Necm al-Dīn of Ahlat (1222), Gök Mederese of Amasya (1266), 'Ali Tusi and Nur al-Dīn ibn Sentimur of Tokat (1314) are also examples of this plan in Anatolia.

The conical dome is the dominant element in the Yezidi funerary architecture. It is hemispheric in the interior: a semi-circle set above the squinch gallery, creating a gradual transition from the building's square body to the octagon drum. The arches of the squinches are generally round but sometimes pointed. The fluted conical exterior dome is set on multiple-sided drums which vary in number from one to three depending on the dimensions of the mausoleum and the importance of the person to whom the mausoleum is attributed. Thus, the graded drum and multiple-faced fluted cone give a feeling of movement to the monotonous square body. The fluted cone is crowned by a gilded globe (*hilêl*) to which coloured tissues are attached. There are no windows or blind arches on the façades, with the exception of small square/rectangular openings for ventilation.

This fluted conical dome is characteristic for northern Iraq, and has not been found in the rest of the country, where the *muqarnas* dome predominates. I would like to suggest that the fluted ribbed conical dome is an architectural manifestation of Badr al-Dīn Lu'lu', the ruler of Mosul, who was in opposition to Abbasid rulers of Baghdad and to the Sunnism, which is more associated with *muqarnas* domes. According to Tabbaa,[367] the *muqarnas* dome provides a formal link with the Abbasid caliphate, the

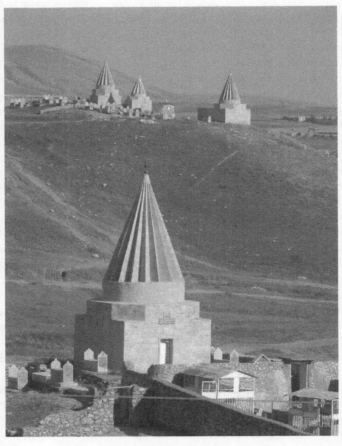

52 Mausoleum of Sheikh Sajadīn, Beḥzanê

heartland of orthodoxy and source of legitimisation; it was adopted by the rising Sunni forces of Syria and North Africa. However, al-Janabi[368] styles this fluted conical dome, without political reference, as 'mosuli', and in his opinion, this shape is more compatible with the harsh climate of the region. Tuncer[369] refers to this style of dome as a 'conical star'. According to him, the mausoleum of Baladji Khatun of Taras in Khazakhstan (beginning of the twelfth century) constructed by the Karakhânides (992–1212) is the first example of a conical star dome. Moreover, some researchers have suggested that this type of dome has its origins in the royal tents of the nomadic people of Central Asia. According to Wilber,[370] when the round tent with its conical cloth cover took on a permanent shape, it became a brick cylinder with a conical brick roof. In my opinion, these fluted conical domes are also comparable to similar domes surmounting Armenian churches and chapels in Anatolia in the tenth twelfth centuries – known as 'umbrella-shaped roof'. The Church of Kat'olikē in Amberd (1026) and the Church of Saint Serge (1029), located in the Monastery of Xckōnk in Kars, are only two of the many fluted conical domes that are seen in the Armenian architecture of Anatolia.[371]

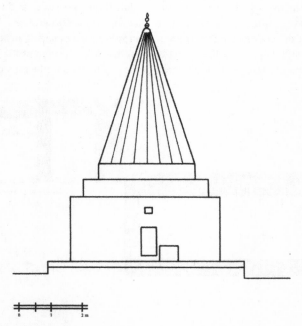

Fig. 8 Façade of Sheikh Shams, Sinjar

It is important to underline here that the fluted conical-domed buildings of Mosul and Sinjar were principally constructed in the period of Badr al-Dīn Lu'lu', a known former Armenian slave.[372] Was it a deliberate choice of Lu'lu' to cover his monuments with the very well-known Armenian-styled domes to make a reference to his origin? However, these Armenian conical-ribbed domes, the domes of Shi'ite mausoleums of Mosul and those of Yezidi mausoleums are not completely identical. Although Shi'ite and Yezidi mausoleums are similar in form, the number of ribs in Yezidi architecture is much greater and the cones are higher than in Shi'ite architecture. The number of ribs in Shi'ite mausoleums varies from 12 to 22,[373] however, in Yezidi mausoleums, they range between 16 and 48. The conical dome of the mausoleum of Sheikh 'Adī, located in the sanctuary of Sheikh 'Adī at Lalish, is the one which boasts the most number of ribs at 48, and the mausoleum of Sheikh Sharaf al-Dīn in Sinjar has 40. The number depends on the importance of the saint for the Yezidi community and the size of the mausoleum. Most Yezidi mausoleums have 28 ribs.

The choice of this form by the Yezidis to cover their most sacred places is probably not by chance. The height and the orientation of the conical domes towards the sky probably attracted Yezidi mystics from the twelfth century who felt that it represented coming nearer to God. Moreover, this form of fluted cone is regarded as the symbol of the sun, towards which the Yezidis turn to pray for their daily devotions. The cult of the sun that the Yezidis inherited from their ancestors who practised ancient Iranian religions is still observed in their practices. Another interpretation of the use of this conical dome is that in Sufism the image of the sun belongs to the men of religion,

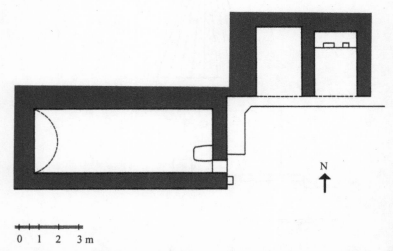

0 1 2 3 m

Fig. 9 Plan of the mausoleum of Alū Bekir, Lalish

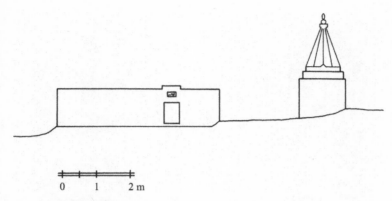

0 1 2 m

Fig. 10 Façades of Sheikh Nasr al-Dīn and Sheikh Sajadīn, Bozan

the sheikh and the pîr – an image that radiates with his kindness and illuminates his disciples in the faith. This spiritual radiance perpetuates after the death of the master who is believed to be still present with his disciples, influencing and teaching them on the level of the soul. Through its solar form, the architecture represents a place of veneration to the deceased sheikh and pîr.

Although the rectangular plan exists in Iraq and Anatolia, it is notably the main plan which was used by the Yezidis in the Sheikhan region. Thus, its use in the mausoleum seems proper to Yezidis. This plan has three variations: simple rectangular plan, rectangular separated into two bays and rectangular with an antechamber. Rectangular plan is seen in Iraqi architecture only in a Jewish shrine, Dhu'l Kifl (1316), situated between Najaf and Hillah.[374] However, buildings of this form are more in Anatolia, where the mausoleum of Behram Shah (beginning of the thirteenth century) in Kemah, mausoleum of Sancaktar (1237–46) in Kayseri and mausoleum of Torumtay (1278–79) in Amasya are in rectangular form.[375]

Even though historical sources[376] show that the roots of Yezidism go back to a time earlier than the 'Adawi epoch, the surviving examples of Yezidi patrimony date back to the arrival of the 'Adawis at Lalish in the early twelfth century. The basement of the sanctuary of Sheikh 'Adī, called Chilekhane, a zāwiya for the retirement of the 'Adawi dervishes, is the earliest known Yezidi building. It is composed of eight rectangular chambers, located next to the spring of Zemzem. Two of the chambers contain tombs of saints. Apart from this zāwiya, all the single rectangular-planned Yezidi mausoleums are located exclusively at Bozan and Lalish in the Sheikhan region, which are the most ancient places where Sheikh 'Adī and his disciples lived. Although we have no historical sources or inscriptions to date these buildings, the comparative study of the plan, their locations and the names of the saints to whom

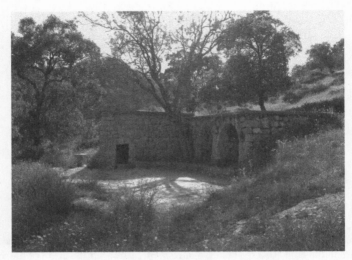

53 General view of the mausoleum of Alū Bekir, Lalish

these mausoleums are dedicated indicate that they originated in the twelfth and early thirteenth centuries.

In contrast to the Yezidis, the Muslims have not preferred this simple rectangular plan to build their mausoleums in Iraq. It is, however, the main plan of the Eastern Christian churches. According to the scholars,[377] the Yezidis gradually came to occupy the areas where Christian communities were living. Thus, I would like to suggest that the Yezidi rectangular-planned mausoleum was influenced by hall-type church architecture. When the Yezidis began to create their own religious buildings, it was the obvious plan to take as an example. The 'Adawis simply needed a humble building in which to bury and commemorate their sheikhs and pîrs. Thereafter, this plan did not continue to determine the form of Yezidi buildings, and the square plan with fluted conical domes dominated the Yezidi architecture from the second half of the thirteenth century. The mausoleums of Êzdîna Mîr (twelfth century) and Sheikh Abū Bekir (thirteenth century) are barrel-vaulted rectangular buildings of almost the same size and are the biggest buildings of this type at Lalish, which are probably from the early period. Nevertheless, the new variation of the rectangular plan, which is, in fact, a combination of dome square and rectangular plans, evokes the domed-square plan with antechamber – a plan which is represented in the mausoleum of Sheikh Mushelleh at Lalish (fourteenth century) (Fig. 11) and the mausoleum of Sheikh Amadīn (fifteenth century) (Fig. 23) in Sinjar. In this variety, the tomb chamber is rectangular in shape and covered with a polyhedral dome, while the antechamber has a flat ceiling. In some

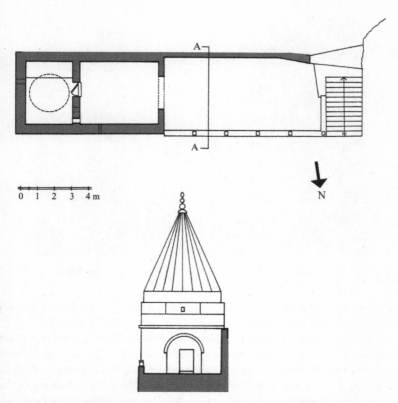

Fig. 11 Plan and section of the mausoleum of Sheikh Mushelleh, Lalish

cases, such as in the mausoleums of Sheikh Nasr al-Dīn (thirteenth century) and Khatuna Fakhran (thirteenth century) in Lalish and those of Sheikh Shams (twelfth century) and Ruale Kevînîye in Bozan (fourteenth century) who are all the members of Shamsani family, there is a rectangular tomb chamber, covered with a barrel or a pointed vault.

In Yezidi mausoleums, doors are relatively small. One has to bow one's head to enter. The door is thus designed so as to express a sense of respect for and surrender to the interred religious men. In Yezidism, it is one of the main signs of being properly faithful and of submitting to the sheikh or pîr utterly. They are rectangular or flat arched. There is usually only one door allowing access to the interior. However, the tomb chambers of the mausoleums with an antechamber have two doors, such as in the mausoleums of Sheikh Sharaf al-Dīn, Sheikh Amadīn and Khatuna Fakhran in Sinjar.

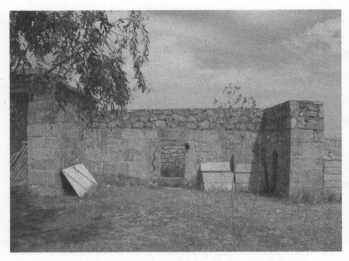

54 Façade of the mausoleum of Sheikh Abū Bekir, Mem Shivan

One of the doors communicates with the antechamber in the north, while an auxiliary door is located in the eastern wall. This is a particularity of the Sinjar region.

Unlike the Islamic mausoleums of Mosul and Anatolia, Yezidi mausoleums do not possess any window to illuminate the interior, as they prefer to have an austere ambiance in the tomb-chamber, where the pilgrims pray and burn wish wicks. There are only small raised rectangular or square openings in the walls or on the drums, which are for the purpose of ventilating the interior rather than illuminating it. However, antechambers, which are considered profane and serve pilgrims and visitors to gather and socialise after a visit to the tomb chamber, are bright because of the large windows.

The wall niches are important elements of the Yezidi funerary edifices because they were made for functional purposes. These niches are usually in small dimensions and square or rectangular in shape, and are intended as places for the pilgrim to burn oil wicks. It is a custom in Yezidi tradition to light wicks in the saint's mausoleums by making wishes. The number of niches varies according to the size of building. In the mausoleums of Sinjar, apart from the niches, there are votive columns and pillars, called *stûna mîraza* (column of prince), on which the wish-wicks are burned. It is unique to this region to have these columns in the middle of the tomb chambers, as in the mausoleums of Sheikh Amadīn and Khatuna Fakhran. They are on average a metre high.

Yezidi mausoleums are simple, almost without any decoration. Nevertheless, geometric, vegetal and zoomorphic motifs were noted in the studied Yezidi buildings.

These decorations are sculpted in low relief on marble and plaster. They are limited to an area, especially around the portal. The sole exception is the dome of the mausoleum of Sheikh Siwar at Beban, where the surface of the dome is decorated with a huge star with eleven branches covering the whole surface. Serpents, lions and birds are also represented on the façades of the edifices; however, humans are never depicted.

The serpent is depicted around the doors of the mausoleums of Sheikh Amadīn in Sinjar and Sheikh Abū Bekir in Mem Shivan. From Drower's description,[378] we learn that the doors of mausoleums of Sheikh Nasr al-Dīn and Sheikh Shams at Lalish also had an image of the serpent, but these no longer exist. Her description also allows us to see that the image of the serpent is depicted exclusively on mausoleums which belong to members of Shamsani sheikhs. Façades of all mausoleums dedicated to the Yezidi saint Sheikh Mand Pasha (who is also a descendant of Shamsani family and said to be the protector of the serpents), dated to various periods in various locations, are also ornamented with the image of the serpent (Pl. 55). Sheikh Mand Pasha was the emîr of the Kurds in Antioch and Aleppo in the second half of the twelfth century. He reconciled the internal conflict between two rival Yezidi groups, Shamsanis and Adanis, by coming to Sheikhan.

Yezidis show the serpent excessive respect because they believe that humanity survived the Flood due to his help. According to a Yezidi tradition, Noah's ark was lifted and carried by waters to the top of Mount Sinjar. There, it violently hit

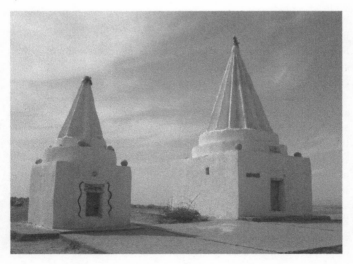

55 Mausoleums of Sheikh Mand Pasha and Baba Sheikh, Kabartu

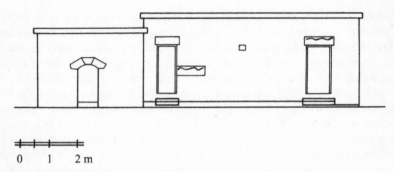

Fig. 12 Façades of the mausoleum of Pîr Sîn and Qadi Bilban, Lalish

against rocks and sprung a leak, but the serpent curled up and plugged the leak. Furthermore, the serpent is always depicted with sun god Mithra which symbolises the fertile earth in Mithraism.[379] Moreover, the serpent is considered to be a symbol of good power in popular Kurdish tradition. The image of Shahmaran (the queen of the serpents) is depicted on glass or metal work, seen hung on walls even today. Shahmaran has a woman's head and a serpent's body with six legs in the shape of serpent. In addition, it is believed that the serpent had a role in the emergence of the Kurdish race. The following is a legend written by Sharaf Khan Bidlisî in the sixteenth century.[380]

> After the death of the great Persian king Jamshid, the tyrant Zahhak usurped the throne and established a reign of terror. Besides being cruel by natural inclination, he suffered from a strange disease that made him even more of an oppressor. Two snakes grew out of his shoulders and caused him severe pain. Skilful and the most expert doctors did all in vain their efforts and deployed an untiring zeal to cure this cruel disease and to return health to him; their treatment remained without effect, and they did not obtain any result; so that Satan appeared them under the figure of a doctor and said to Zahhak: 'The only remedy for your evils consists of two brains of young teenagers, of which will be needed to anoint the surface of canker.' The chance wanted that the barbarian treatment prescribed by this cursed being was appropriate for the disease, when it had been adopted: the pains were calmed at a certain point, and Zahhak tested some relief. Consequently, two young victims were killed each day, under the sword of the iniquity of this barbarian tyrant, and employed (brain) to bandage it. This infamous system continued for a long time in the same way; but the person charged to make immolate

this was a man gifted of a generous character, of a heart sympathizing and protective of unfortunate. Thus, he was contented to sacrifice daily only one individual, of whom he mixed the brain with that of a sheep, and furtively returned freedom to the other, under the condition which he/she would flee his fatherland and would go to a residence on the peak of the most deserted and entirely uninhabited mountains. A multitude number of them gradually gathered there, which contracted marriages: their children and their descendants multiplied, and this Kurd tribe received the name of Kurds.

The serpent has an important role in the story of the Fall – a legend that exists in Jewish, Christian and Muslim traditions. In Muslim tradition, Iblis is carried into the garden by the serpent in its mouth.[381] Iblis tries to enter Paradise to seduce Adam into eating the forbidden fruit, but God prevents him. Then Iblis meets the peacock, the chief of the animals in the garden, and demands that it tell him where the tree of eternity is, lest all creatures shall die. The peacock goes and narrates to the serpent what Iblis said who then approaches Iblis and lets him into its mouth, so that Iblis enters the garden where he speaks through the serpent to Adam and Eve, and Eve eats the fruit of the forbidden tree.[382]

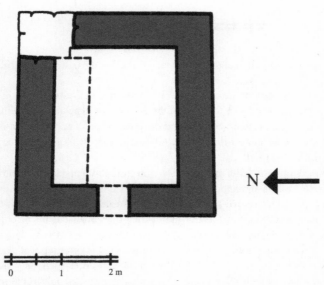

Fig. 13 Plan of Shakho Agha, Riya Teze (Armenia)

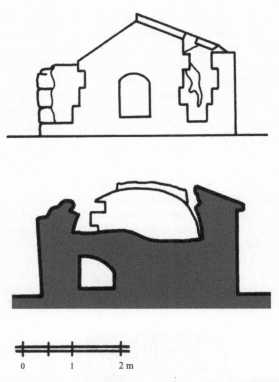

0 1 2 m

Fig. 14 Façade and section of the mausoleum of Shakho Agha, Riya Teze (Armenia)

One can assume that the serpent already had a role in the Yezidi Kurdish culture which was strengthened with the story of the Fall with the teaching of Sheikh 'Adī. For some Sufis, the Fall of Adam and Eve and the redemption of Satan was an important theme, and this may indicate how Sheikh 'Adī and his successors gave the characteristic shape to the Yezidi belief.

A few examples of Yezidi mausoleum architecture exist outside of northern Iraq. In the northern Aragatsotn region in Armenia, I studied five Yezidi mausoleums located in a group of villages known as the most ancient Yezidi villages. Although they look more ancient, according to people of the district, these mausoleums belong to their ancestries who emigrated here from their homelands in the Ottoman Empire in the end of the nineteenth century. These mausoleums represent three types of plan: square, rectangular and octagonal. Apart from the mausoleum of Shaxo Agha in Riya Teze, none of these has a door to allow people to enter. They are visited only from the exterior. Observing the half standing mausoleum of Mamo Agha in Riya Teze, I was able to note

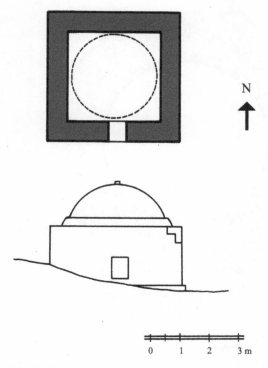

N

Fig. 15 Plan and façade of the anonymous mausoleum, Elegez (Armenia)

that the plan of the building is octagonal on the exterior and circular on the interior. The walls are extremely thick and the interior space is narrow. These mausoleums are all built of basaltic hewn stone, the same material used in Armenian religious architecture of the region and in Yezidi zoomorphic tombstones. A moulding surrounds the façades on the top of the walls. The function of these mausoleums is different from that of those in northern Iraq. They are dedicated to the nobles of the village. They are not places of religious worship but simply memorial buildings. Thus, they do not have any religious meaning. The following are some examples in northern Iraq:

Mausoleum of Sheikh Shams: It is raised on a hill at Lalish in the south-west of the baptistery of Kanîya Spî and the mausoleum of Êzdîna Mîr.

The mausoleum forms a large complex, rectangular in plan with a fore-courtyard in the west in the orientation of east-west (Fig. 17). The complex is entered through a gateway on the west side. The original components of the mausoleum consisted of a domed tomb chamber and an antechamber that occupied the northern part of the complex. An

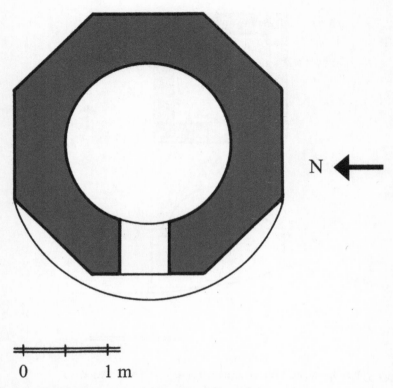

0 1 m

Fig. 16 Plan of anonymous mausoleum, Derik (Armenia)

outer lower rectangular room was added to the southern part in a later period, and the construction of the vestibule located in the western part was undertaken in the 1990s.

The rectangular chamber is entered from the vestibule by a low door. It measures 13.50 x 3.50 m and is barrel vaulted. A cenotaph is located at the far eastern end of the chamber on a platform. The northern wall of the rectangular chamber is pierced by one small and two large niches; there is a window to the tomb chamber as well as a door, surmounted with a semi-circular arch, to the antechamber, which is entered by stairs as there is a big level difference between the rectangular chamber and the tomb chamber and its antechamber.

The antechamber is rectangular in form (5.60 x 4.40 m) and barrel vaulted. It does not have a window; however, a profound niche is located in the north wall. Moreover, some basins made of mortar are displayed in front of the eastern and southern walls. Similar basins[383] are equally found in the cells of Chilekhane, the place of penitence

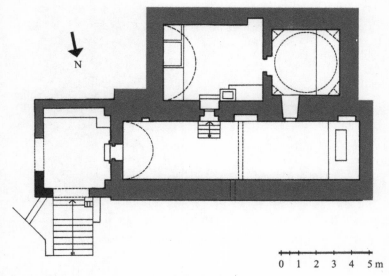

Fig. 17 Plan of the mausoleum of Sheikh Shams, Lalish

reserved for the retirement of the 'Adawi dervishes, which lies beneath the sanctuary of
Sheikh 'Adī. A small, flat, arched door connects the antechamber to the tomb chamber
in the east, which has an almost square-domed plan (3.80 x 3.40 m). In the corners
of the square, four simple squinches make the transition from the square base to
the round drum. There is a platform in front of the eastern wall where a cenotaph is
located. The dome is in the form of a fluted cone on the exterior with 32 ribs (Pl. 56).
The drum is in three levels: square, octagonal and round. It is believed that the ribs of
the conical dome are the rays of the sun, thus the style manifests the divinity of the sun,
the *shams*. In the north-east, farther from the mausoleum, on the foothills, is located a
small rectangular basin in stone where the ceremonies of bull sacrifices are performed
in the honour of the divinity of the sun.

Although there is no decoration in the building, Drower draws our attention to
some decorated stones, carved on the façade of entrance, which existed in the 1940s.[384]
These were a crescent moon, a star, a vertical serpent and a hooked stick. The hooked
stick is comparable with ones on the façade of the assembly hall in the sanctuary of
Sheikh 'Adī in the same valley.

No historical inscription exists in the mausoleum of Sheikh Shams, nor is
it mentioned in the sources. Only a recent inscription indicates the name of the
building.

56 Conic dome of the mausoleum of Sheikh Shams, Lalish

مزار الشيخ شمس عليه السلام
Mausoleum of Sheikh Shams that the salvation is on him.

Sheikh Shams is one of the most popular saints of the Yezidis. He is associated with one of the seven Yezidi angels and is considered as the divinity of the sun and the sun of the Yezidi faith. His real name is Shams al-Dīn, and he is believed to have lived in the twelfth century in Lalish, where he met Sheikh 'Adī. The two leaders influenced each other's teachings. He is the ancestor of the Shamsani family of sheikhly group in the Yezidi hierarchy. Apart from this building, four other mausoleums are dedicated to the same saint in various Yezidi locations, such as Beḥzanê, Bozan, Mem Shivan and Sinjar.

Mausoleum of Khetî Besî: It is located in the cemetery of the village of Bozan in Sheikhan Region and adjoins the mausoleum of Alū Bekir. It is composed of two rectangular units located collaterally, oriented east-west and covered by a barrel vault; only a small dome exceeds the vault in north. One reaches it by a low, rectangular door on the northern wing of the western wall. Two rectangular units are connected to each other with a ribbed arch. The room located in the south comprises a *miḥrāb* niche in the southern wall which is framed by a rectangular string course.

The masonry of the walls is made of coarse stone. Moreover, the vault and the small cupola are carried out of mortar-bound rubble stone of small and average dimensions.

Khetî Besî is the eponym of a subdivision of pîrs of Ḥasan Maman, who would have lived in the twelfth century. Moreover, the rectangular plan with a barrel vault, used abundantly during the twelfth and thirteenth centuries, is a characteristic of

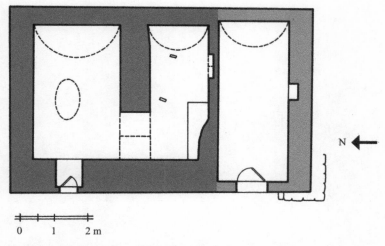

N ←

0 1 2 m

Fig. 18 Plan of the mausoleum of Khetî Besî and Alū Bekir, Bozan

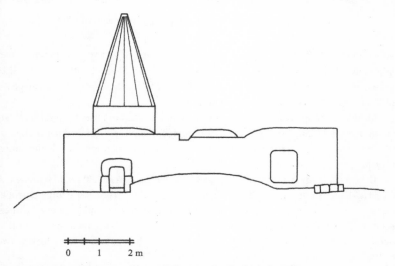

0 1 2 m

Fig. 19 Façade of the mausoleum of Khetî Besî and Alū Bekir, Bozan

Bozan and Lalish in the Sheikhan region. In addition, the *miḥrāb* niche found in the south wall of the mausoleum is in the Muslim manner and dates the building to the 'Adawi period, the twelfth century. In this period the 'Adawis turned to Mecca when they worshipped.

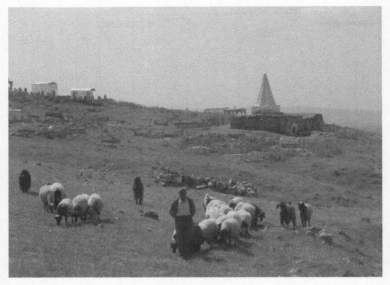

57 General view of cemetery of Bozan and the mausoleum of Khetî Besî

Mausoleum of Sheikh Siwar: It is located in the village of Beban[385] in the Sheikhan region, situated between Dohuk and Mosul. Beban is found in the south-west of Lalish, the centre of the Yezidi faith, and in the south-east of Alqosh, an important village for the Chaldean-Assyrian Christian community.

Although I noted two Arabic inscriptions in this building, they do not reveal any date of its foundation. An ancient inscription gives the door's year of construction as 1923, while another inscription gives 1985 as its year of restoration (beside the names of the people who restored it).

The mausoleum is a small cubical building that measures 3.50 by 3.50 metres. A flat, arched door in the west wall gives access to the interior. The square tomb chamber is covered by a hemispheric dome raised on a zone of transition and has ribbed conical decoration on the exterior. The drum is in two levels, one octagonal and the other circular. Northern and eastern walls are pierced with a round-arched niche. Two cenotaphs are present in front of the south wall (Fig. 20).

Mausoleum of Sheikh Siwar is the only Yezidi building that possesses a geometrical decoration on the inner surface of its dome and its drum as well as on the two superficial niches in the walls (Pl. 58). The decoration is applied on mortar. The hemisphere of the niches includes ten fine ribs radiating from the centre, which are reminiscent of a shell. The surface of the dome is decorated by eleven branches of a star. The star is formed by

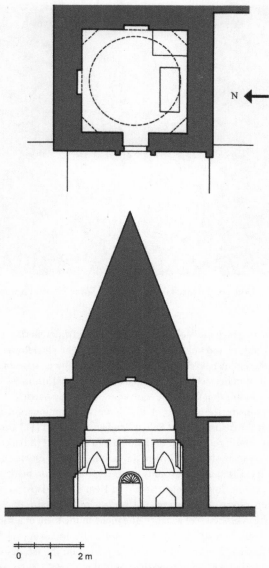

Fig. 20 Plan and section of the mausoleum of Sheikh Siwar, Beban

58 Dome of the mausoleum of Sheikh Siwar, interior, Beban

the crossing of arms which radiate from a central point in different directions. Between arms, small and large closed polygons appear with an eight-petal flower in the centre. The surface of the circular level of the drum is marked by a frieze of eleven blind-surmounted basket arches, while each side of the octagonal drum is marked with a frieze of meander motifs that frame the squinches in the round arch.

The decoration on the surface of the dome is a continuation of a tradition which starts with the mausoleum of Sultan Sandjar at Merv (1157) and continues in Anatolia on the portal of the mosque of Huant Hatun at Kayseri (thirteenth century)[386] and in Iraq on the mausoleum of Imam Yahya Abū'l Qasim of Mosul, dated to the fourteenth century. The same décor finds its correspondence on brick applied on the dome surface of the mosque of Suleimania[387] in Ḥiṣn Kayfā, dated to late fourteenth and mid-fifteenth centuries. However, the surface of the dome of this mosque is decorated by sixteen branches of a star.[388] The niche in the form of a shell is also seen in the mosque of Suleimania[389] and in the mausoleum of Imam ʿAvn al-Dīn in Mosul. Moreover, the basket arches are represented very often on the façades of fourteenth-century mausoleums at Ahlat and Gevash around the Lake of Van in Anatolia. These comparative pieces of evidence allow us to date the Mausoleum of Sheikh Siwar to the fourteenth century.

Mausoleum of Sheikh Muḥammad:[390] It is situated in the same general enclosure as the tombs of Sitt Hecici and Sitt Habibi on top of a hill in an area in Beḥzanê which is reserved exclusively for Yezidi mausoleums; there are also seven other mausoleums[391] dedicated to various Yezidi saints who are mostly from the Shamsani family. Each mausoleum is surrounded by a court where tombstones of the family members are laid.

The mausoleum represents a rectangular plan on the exterior and is oriented east-west. The antechamber is rectangular in shape and connects to the principal area by means of a large round arch in the south (Fig. 21). The antechamber is unique in the Yezidi funerary architecture for its round dome which is flat-roofed on the exterior. The tomb chamber is also square in plan but surmounted with a hemispheric dome that becomes a fluted cone on the exterior. Each unit possesses a cenotaph.

It was built with unhewn stone set in soft gypsum mortar, using a technique called *juṣṣ*, and was originally whitewashed. However, the façades, the conical dome and the drum were recently covered with *hallan*, an imitation of stone.

The mausoleum of Sheikh Muḥammad is the only building of Beḥzanê and Ba'shîqe that represents a square plan with an antechamber. The rest of the mausoleums of this twin town, which are sixteen in number, are all square in plan and roofed with a polyhedral dome. The square plan with an antechamber is especially preferred in the

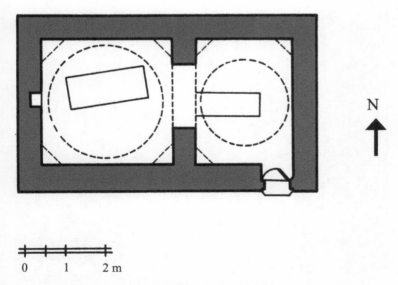

N

0 1 2 m

Fig. 21 Plan of the mausoleum of Sheikh Muḥammad, Ba'shîqe

59 Interior of the mausoleum of Sheikh Siwar, Beban

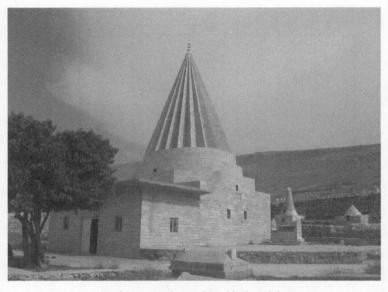

60 Façade of the mausoleum of Sheikh Sharaf al-Dīn, Sinjar

Yezidi mausoleums of Sinjar. The mausoleums of Sheikh Ḥasan (thirteenth century), Sheikh Sharaf al-Dīn (1274) and Khatuna Fakhran (thirteenth century) are well-known examples of this design in Sinjar.

Mausoleum of Sheikh Sharaf al-Dīn: Located in the village of Rashidiya, it is the most popular building in Sinjar. According to an Arabic inscription on the façade of the building, it was built in 1274. Sheikh Sharaf al-Dīn is a historical figure who was one of Sheikh Ḥasan's sons and died in 1256.

Built in a courtyard beside two shrines (*nîshan*) used for fire rituals, it presents a square-planned tomb chamber with an antechamber (Fig. 22). The tomb chamber is covered by a polyhedral dome and has two entrances: one is from the antechamber, the main door, and the other, the auxiliary door, is from the eastern wall. There is a metre-high prayer column called *stûna mîraza* located in the middle of the tomb chamber. Oil wicks are burnt on the top end of the column. These columns serve the same purpose as the Zoroastrian fire altars and are probably a trace of surviving Zoroastrian practices in the Yezidi belief. Some small windows let light in. However, windows used in the walls of the antechamber are in normal size and functions to

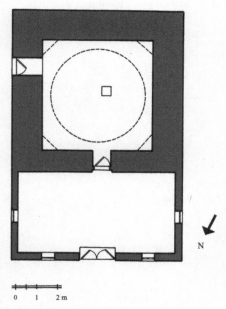

Fig. 22 Plan of the mausoleum Sheikh Sharaf al-Dīn, Sinjar

illuminate the interior of this part of the mausoleum. With forty conic slices, the drum is in three levels and high.

Mausoleum of Sheikh Amadīn ('Imād al-Dīn): This free-standing domed structure, built entirely of *jus.s.* and whitewashed, is situated on the summit of Galê Bîrîn in southern Sinjar. It is surrounded by tomb-stones on the outskirts of the hill. A square-planned, conical-roofed edifice, where the sacred breads are put for the pilgrims, is located to the east of the mausoleum (Pl. 61).

The mausoleum is a rectangle on the exterior and is separated into two distinct parts: tomb chamber and antechamber. The tomb chamber is rectangular in shape, measuring 4.30 x 3.60 m; the central area is covered with a hemispheric dome whose external form is a ribbed cone (Fig. 23). The dome rests on a transition zone of pointed arched squinches. It is entered by two doors, one is from the antechamber and the other is on the east wall. A votive column *(stûna mîraza)* is situated almost in the middle of the chamber on which oil wicks are left. The antechamber is in the north of the building, oriented east-west and rectangular in plan (4.20 x 1.90 m). Short walls possess a big rectangular niche in the middle. It is roofed with a flat ceiling.

A couple of serpents are depicted face to face on the outside border of the doors. The mausoleum contains an inscription where the year 1400 is given, and this is accepted as the year of foundation of the building.

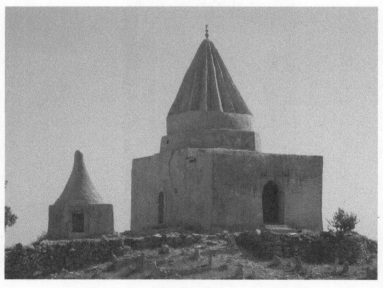

61 Façade of the mausoleum of Sheikh Amadīn, Sinjar

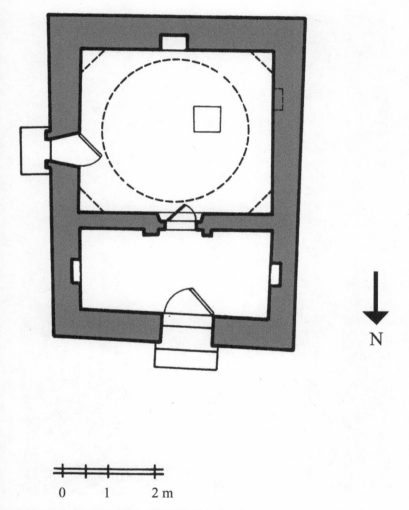

N

0 1 2 m

Fig. 23 Plan of the mausoleum of Sheikh Amadīn, Sinjar

Shrines

Shrines (*nîshans*) are numerous and serve several functions in Yezidi architecture. They are small constructions, various in shape, around which pilgrims, individually or as in groups, perform their devotions, kissing them, burning oil wicks and making wishes. Visitors may also donate money at these shrines. They are often used as

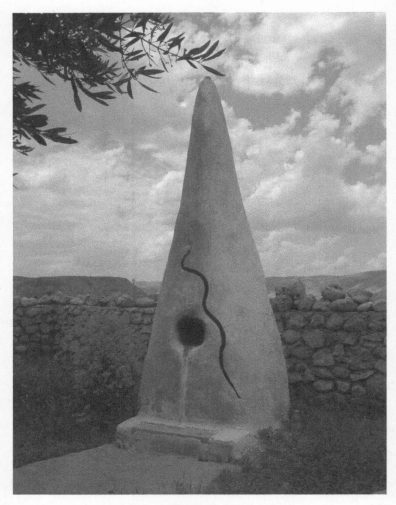

62 Shrine of Sheikh Mand Pasha, Beban

memorials for the dead saints and believed to possess the spirit of the deceased. They are usually located in the courtyards of mausoleums or in the cemeteries as freestanding edifices. No inscription or historical sources date these shrines; however, they appear only in the region of Sheikhan, with the exception of two in Sinjar.

Most shrines have a square pedestal covered with a fluted conical dome. Built of stone, Sheikh Abū Bekir, Sheikh Sajadīn, Kure Buker and Khefîre Rêye represent this form in the village of Bozan. The second type is again with a square pedestal but covered with a cylindrical dome; such shrines appear only in the courtyard of the mausoleum of Sheikh Sharaf al-Dīn in the Sinjar region. The third type has an irregular conical form resembling a stalagmite made of clay. The shrine that once existed in the middle of the fore-courtyard of the sanctuary of Sheikh ʿAdī and the shrine of Sheikh Mand Pasha in Beban (Pl. 62) are examples of this type (the former was subsequently replaced with a new one in 2003).

The main element of these shrines are the niches where the lighted oil wicks are put by pilgrims. Their numbers and forms vary according to the size of the shrine. These niches are square, rectangular or rounded in shape, small sized and just one or two.

Both their function and form have similarities with those of some Zoroastrian shrines.[392] It is possible to suggest that when the inhabitants of Sheikhan region met Muslim Sheikh ʿAdī, they were still practising their old Iranian beliefs and such shrines were still being used for their fire ritual. The fire held a sacred place in the Yezidi beliefs even under the influence of the doctrine of Sheikh ʿAdī. Moreover, fire shrines continued to be important places of worship for the Yezidis.

The Baptistery

The baptistery of Kanîya Spî (the White Spring) is the only edifice in Yezidi architecture where the baptism rite *mor kirin* is performed. This baptistery, whose water purifies and renovates, is considered extremely sacred by the Yezidis; thus, non-Yezidis are banned from entering the building. Furthermore, the baptistery of Kanîya Spî is believed to be a symbol of the Yezidi religion and has curative power as the 'Hymn of the Faith' reveals:

> The faith, what a sign it is!
> Before, there was neither earth nor heaven,
> There were neither mountains nor firm ground.
>
> There came a road to knowledge;
> Faith came (into the world) for the ṭarīqa,
> That day the water of the White Spring was made a remedy for all ills.

> *Îmane bi çi nîşane*
> *Berî ne ,erd hebû ne esmane*
> *Ne çiya nebû ne sikane*
>
> *Rê hebû me'rifetê*
> *Iman hebû ṭeîqetê*
> *Ewê rojê ava Kanîya Spî kiribû derman bi ser hemû derde.*[393]

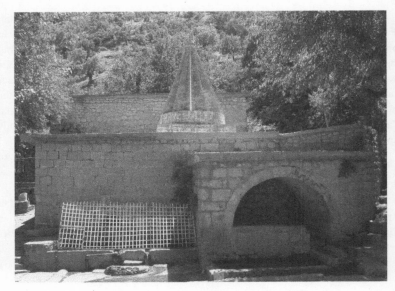

63 Northern façade of the baptistery of Kanîya Spî, Lalish

The baptistery is located to south-west of the sanctuary of Sheikh 'Adî at Lalish. Although, it is a free-standing edifice, it can be supposed that it is part of the complex of the sanctuary of Sheikh 'Adî, because of its closeness, its relation and the role that it plays takes during ceremonies and rituals performed by the pilgrims. Most religious *sama* and popular dances take place in its courtyard during annual festivals.

It has three main rooms, passageways and antechambers, which are in the form of *īwān*,[394] as well as an open courtyard to the east of the building. All the units are rectangular in shape. The rooms of *Kanîya Keçka* and *Kanîya Kurke* are designed for girls and boys respectively; *Kanîya Spî*, from where the name of the building derives, is for people who are baptised after a certain age. In the middle of each room there is a square-shaped stone basin where water from the spring gushing up from beneath the building is collected. There is a small fire shrine in the north-west corner of *Kanîya Spî*, where oil wicks are laid in its niche. All the chambers are barrel vaulted on the interior and flat roofed on the exterior, with the exception of the room of *Kanîya Spî*, which is covered by a dome with fine, deep ribbing that is characteristic of Yezidi architecture.

The door in the east wall possesses the only decoration in the building (Pl. 64). It is carved in low relief. This decoration is in a very poor state of repair today. It presents

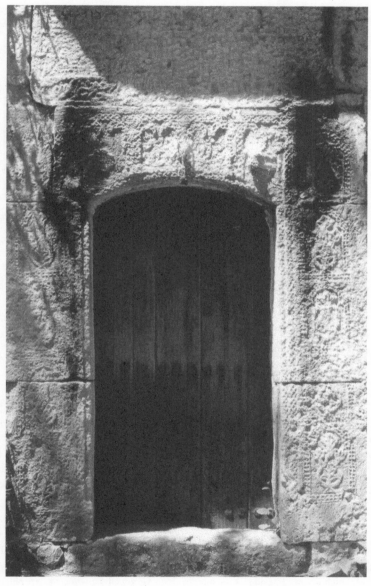

64 Decorated door of the baptistery of Kanîya Spî, Lalish

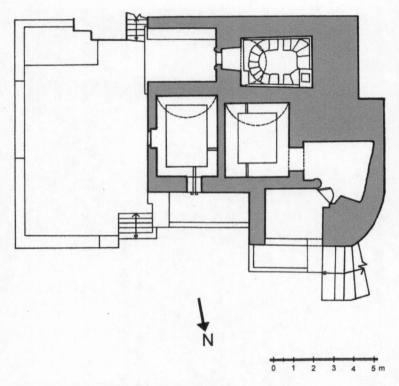

Fig. 24 Plan of the baptistery of Kanîya Spî, Lalish

a close unity of superposition and alignment. The back of these unities are filled in with different forms of vases. On the top, the vases become the palmettes. This décor has its parallel in the Mar Benham Covent in Mosul, which is dated to the beginning of the thirteenth century.[395] It is the only baptistery building in Yezidi architecture, and it is the only free-standing structure of its type, even among Christian buildings in Iraq.

Caves

Caves are considered sacred and are dedicated to Yezidi saints. They are thus visited regularly by pilgrims. Well-known caves are located in Lalish, Bozan and Dere Bûn, each of which is found beside a mausoleum. Four very well-known caves are situated in the valley of Lalish – Zemzem, Pîr Hemedî Boz, Pîr Mahmud and Pîr Memê Resh – which are all hollowed out of rocks.

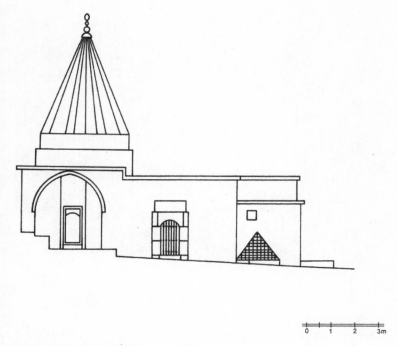

Fig. 25 Façade of the Baptistery of Kanîya Spî, Lalish

The most known cave is located underneath the sanctuary of Sheikh 'Adī where Zemzem spring emerges and runs. It is in the form of an irregular trefoil. Located in an area difficult to penetrate and off-limits to non-Yezidis, Zemzem spring is considered as the holiest place for the Yezidis. Its water is believed to have magical and medicinal properties par excellence. It is said to cure, restore and assure eternal life. Thus, Yezidis make *berats*, which are small balls formed from the earth of the sanctuary mixed with the water of Zemzem, which are extremely sacred and designated to be distributed to pilgrims during ceremonies and festivals. Pilgrims take them home and treat them with reverence. They are believed to bring good fortune to the possessor and to protect him/her from the evil eye.

The cave of Pîr Hemedî Boz has a circular plan (the biggest of its kind), whereas the caves of Pîr Mahmud and Pîr Memê Shivan are irregularly semi-circular in shape and do not possess any springs. An antechamber is built in front of these caves; it is where pilgrims rest after visiting the cave.

The column of wish, the *stûna mîraza*, is located in the middle of the cave of Pîr Hemedî Boz and against the south wall of the cave of Pîr Memê Shivan. These columns

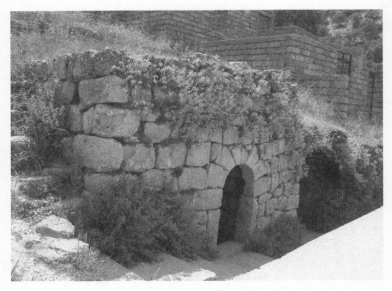

65 Façade of entrance of the cave of Pîr Hemedî Boz, Lalish

reach until the ceiling. Although they are functional in that they carry the ceiling of the building, pilgrims embrace them and make wishes.

Tombstones

The forms and styles of Yezidi tombstones considerably vary from region to region. They can diverge from simple headstoned graves to refined, cut, zoomorphic tombstones. One common particularity of this diversity in the Yezidi inhumation tradition is that the deceased is always placed with their head facing east.

Traditional Yezidi gravestones are simple. The grave is covered with an elongated mound of earth and is marked by two small-sized headstones in the short sides. Another type of gravestone is in the form of sarcophagi, which is mostly found in the villages of Riya Teze and Avshin in the Aragatsotn region of the Republic of Armenia. They are cut out of grey tuff and ornamented with niches or rosaries, a style which signifies the special piety of the deceased. The most common form of tombstone is in echelon and resembles ziggurat form. They are built of big stone blocks or whitewashed rubble. This type is preferred by the Yezidis of Turkey and Armenia Republic, who continued to follow their ancient traditions and probably wished to reference their Zoroastrian background with this form rather than that of Iraqi Yezidis, who were more under the influence of Sufi Islam. Moreover, the form of echelon is also a sign of wealth

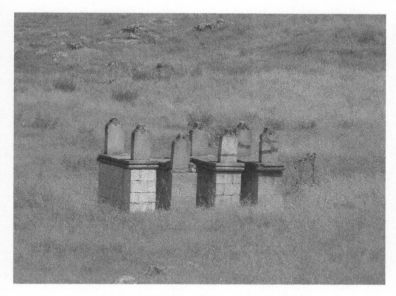

66 Tombstones, Çayırlı, Viranşehir (Turkey)

and social status of the deceased and thus special echelons were constructed for the religious or the noble class. Similar examples are found in the cemetery of Norşin Aşağı Mork village of Van in Turkey,[396] where the Yezidis used to live until their departure to the Republic of Armenia. The last level of echelon is usually topped with two vertical rectangular schists. Many examples of this type are also found in the village of Oğlakçı/ Viranşehir (a rare ancient village in Turkey still populated by the Yezidis) and in the village of Avshin in Armenia. In some tombstones, one of the schists is topped with a headgear. The headgear is represented in three-dimensional form and was probably used to indicate the rank of the deceased who come from a religious caste, sheikh or pîr. This headgear form, known commonly as *taç*, is also seen very often in the dervishes' cemeteries of the Ottoman era from the sixteenth century.[397]

A simple horizontal rectangular pedestal with two rectangular schists, triangular or semi-circular at the top, composes tombstones of Yezidi cemeteries in northern Iraq. The modern schists are depicted with floral ornaments, which are in combination with Kurdish inscriptions in Arabic letters giving the deceased's name and date of death. However, old cemeteries do not have any inscription. On recent schists, the image of peacock is also depicted very often.

Distinguished Zoomorphic tombstones, which are found almost in every Yezidi village cemetery in the Republic of Armenia, merit our special attention.[398] These

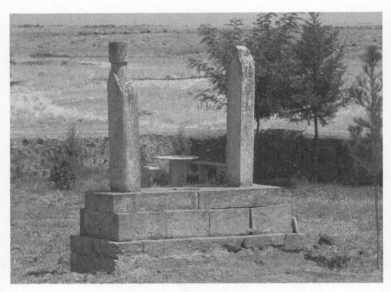

67 Tombstone, Oğlakçı, Viranşehir (Turkey)

tombstones are cut in the round, mostly in horse-shape, but also, as in recent examples, in ram, ewe and lion forms. Those located in the Aragatsotn region, although numerous and representing various styles, are horse-shaped without exception. Most of them are damaged, with the head missing or legs broken. Horse-shaped sculptures are cut sometimes in basalt and sometimes in volcanic tuff. Their dimensions vary. The average-sized sculpture is 60 cm high, 100 cm long and 30 cm wide. They are represented standing on their legs on a pedestal with heads held up. All of the sculptures carry a saddle on the back and a bridle around the neck and the mouth. These are carved in low relief. The saddle is always represented with a seat, flap, stirrup and pommel. Despite the missing heads, the existence of a bridle on the neck shows that each horse has a harness surrounding the forehead, cheek, and mouth which is attached to the bridle. Small-sized daggers are depicted on the saddle flap on two sculptures located in Derik and Sipan villages. The body of the deceased is always oriented in an east-west direction on the grave, while the sculpture, which also serves as the gravestone, is always placed with the head facing eastward.

These tombstones are represented in three distinctive types:

1. Horse with separated legs: one piece with its pedestal
2. Horse with separated legs: installed on the pedestal
3. Horse of monobloc: installed on the pedestal

Ram-shaped Tombstone

Horse-shaped Tombstone

Lion-shaped Tombstone

Map 12 Yezidi Zoomorphic tombstones in the Middle East

The first type of tombstones (Pl. 68), which are very common, are invariably cut of basalt, which is a solid and resistant material. Basalt might be the reason why most tombstones of this type survived. The profile of the horse is more or less circular or cylindrical. The horse and its low pedestal compose a unity. In most cases, the sculpture is put on a second pedestal. Four legs are perfectly visible and the fore right leg is engraved advanced. Legs are sometimes rushed forward with bended knees, which

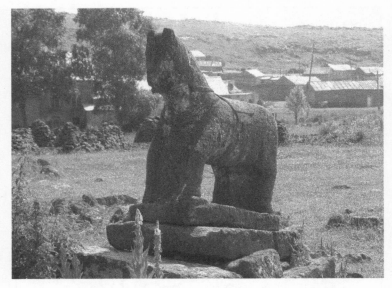

68 Horse-shaped tombstone, type I, Riya Teze, Aparan (Armenia)

give the impression of being ready to run. Hoof, fetlock and pastern are visible on the feet. Complete examples show that the heads of animals are carved in a realistic style. They are lively and expressive. The head, neck and body are lifelike in proportion. The mane of the horse is carved on the crest in low relief. The tail is thick and prolonged until the pedestal. Testicles are also depicted in some examples.

The second type of horses have a cubic body with sharp angles and have separate pedestal (Pl. 69). Fore and hind legs are carved jointly. Legs are short and penetrate into the holes on the pedestal. In some cases, four legs are separated and the pedestal bears four holes. This type is mostly carved out of red tuff, a material easy to cut but also sensitive to erosion and destruction.

The last type is represented with a few examples. It is a rectangular monolith with a head (Pl. 70). Legs are not marked. The neck is long and the head is small. They are mostly carved out of basalt and painted red, which gives it the appearance of volcanic tuff.

The presence of stylistic differences among these tombstones suggests that various workshops worked to carve these sculptures. Moreover, each type might represent a different period of production. However, it is almost impossible to precisely date these sculptures in Armenia because of the lack of inscriptions on the tombstones and of historical accounts. However, sculptures themselves appear to be either ancient or new. Nevertheless, how ancient or how new are they? A comparative study of similar

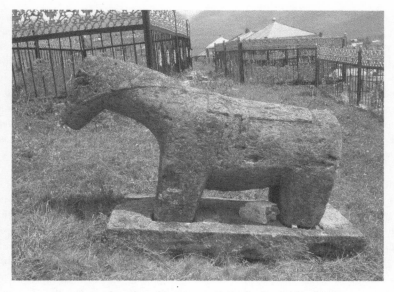

69 Horse-shaped tombstone, type II, Derik, Aparan (Armenia)

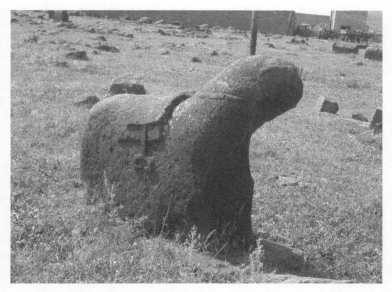

70 Horse-shaped tombstone, type III, Riya Teze, Aparan (Armenia)

horse sculptures bearing dates in Azerbaijan and those in the form of ram, ewe, horse and lion found in Turkey and Iran, and the date of arrival of Yezidis in Armenia, which is eighteenth century, helps us date these horse-shaped tombstones to the eighteenth century. It can be supposed that Yezidi tombstones in the Republic of Armenia and those in Eastern Turkey, formerly Ottoman Empire, were produced simultaneously, and that they were probably carved by the same local workshops. Yezidi tribes had a semi-nomadic lifestyle until they settled down definitely in the Republic of Armenia in the beginning of the twentieth century. They were moving in a region between Yerevan, Kars, Doğu Beyazıt, Surmeli, Iğdır, Van and the Iranian border, where most horse sculptures are found today.

Since animal-shaped tombstones are the most common type in eastern Turkey and western Azerbaijan, these two countries offer the most direct examples for a comparative study. Stylistically similar horse statues are found in the Erzurum, Kars, Van and Diyarbakir Archaeology Museums in Turkey. These are the places where the Yezidis used to live. These sculptures were all brought from neighbouring villages and towns to the museums. These gravestones are in various dimensions and with features same as those seen in the Yezidi cemeteries of Armenia. They most probably belong to the Yezidis of this region who left for Armenia in the beginning of the twentieth century because of religious oppression. These horse-shaped tombstones are far fewer than those found in the Republic of Armenia, as the Yezidis were no longer in this area to look after their cemeteries, most tombstones were probably destroyed by the population that replaced them, or perhaps the wars caused their destruction.

A horse sculpture found in Erzurum Museum composes a unity with its pedestal, which is identical with a Yezidi horse (the so-called horse 26) of Riya Teze in Armenia.[399] Feet and saddle are carved in high relief. It differs from horse 26 only in its depiction of a Maltese cross in a circle on the chest of the animal, a part which indicates its Christian origin. In the light of a comparative study of crosses used on the Armenian khachkars in the region, which are without exception Latin crosses,[400] and the lack of zoomorphic tombstones in the Armenian culture, except three ram-shaped statues of Julfa, point to a non-Armenian origin of this sculpture. Horse-shaped tombstones are favoured particularly by the Yezidis and the 'Alevi Kurds in this region. Thus, it can be suggested that this tombstone belongs to a Christian Kurd. Historical sources indicate the presence of a small number of Kurds who remained Christian, mostly Nestorian and Jacobit, while most Kurds were forcibly converted to Islam in the seventh century. In the course of time, as the majority of the Kurdish population became strict Sunni Muslim and oppressed the non-Muslim communities, most Christian Kurds were absorbed in Christian culture of the region. For instance, according to Armenian tradition, the two Armenian princes Zak'are and Ivane who were military chiefs in the service of King George in the thirteenth century were of Kurdish origin.[401] Moreover,

the presence of Christian Kurds in this region was stated by Marco Polo in the thirteenth century[402] and by missionary Campanile in the beginning of the nineteenth century.[403] Today, a very small group of Christian Kurds still exists in this region although they do not declare themselves openly.[404]

Horse sculptures from Van and Diyarbakir Museums have a cubic body and sharp angles. The heads are missing here too. The flanks of the horse in the Van Museum are adorned with three daggers and a knife as well as a scythe and a pitchfork in low-relief, which refer to the occupation of the departed, who was probably a farmer. One of the sculptures in the Kars Museum has a rifle on its back,[405] which shows that the tombstone cannot be more ancient than the seventeenth century. Other horse sculptures, found in the villages of Hespe Resh (Tekindere), Esribaş and Kubik in Çaldıran/Van, are also stated by Koşay,[406] a horse in Karaçoban/Erzurum mentioned by Bachmann[407] and a horse in Karakoyunlu/Iğdır mentioned by Sili.[408] However, the latter mistakenly describes this sculpture as a camel in his article by identifying the saddle as a hump. Furthermore, several Georgian museums such as the Tbilisi and Mtskheta Archaeological Museums also house some horse sculptures bearing Arabic inscriptions,[409] which are originally probably from Azerbaijan but were removed to Georgian and Armenian Museums, as in the examples of three zoomorphic tombstones of Julfa (Dzhulfa) in southern Azerbaijan, which were moved to Georgia in 1867. One of these sculptures found in Mtskheta has an Arabic inscription on its neck which cannot be deciphered; on its left flank is a sword, a symbol that is also depicted very often on the lion-shaped tombstones in Iran and the ram-shaped tombstones in eastern Turkey. On the right flank is depicted a human figure carrying a quiver on its belly. Moreover, horse-shaped tombstones are especially widespread in Kazakh, Lachin and Ganja in Azerbaijan.[410] A sixteenth-century horse stone is found in Lachin on which are depicted a shield, a sword and a human figure. The place of the shield and the sword are the same on the sculptures: the shield is depicted always on the shoulder of the left flank and the sword is under the stirrup. A horse sculpture with an inscription is also found in Nakhchivan, which dates back to the seventeenth century. Other horse-shaped tombstones are found in Pertek and Hozat in the Dersim region of eastern Turkey belonging to 'Alevi Kurds.[411]

Apart from tombstones that are horse-shaped, four ram-shaped ones and a lion-shaped one, carved in 1940–50, are found in Ferik, a Yezidi village in northern Echmiadzin in Armenia (Pls. 71–72). It is astonishing to encounter these ram and lion sculptures, which do not exist in the ancient Yezidi cemeteries mentioned above. The sculptures in Ferik are all represented on a pedestal in echelon. It is interesting to see that the tombstones, cut in the mid-twentieth century in Armenia, are a combination of various types. For instance, most tombstones of Ferik in Echmiadzin and of Kijla Mara in Talin are in four levels and topped with sarcophagi, cradle or zoomorphic

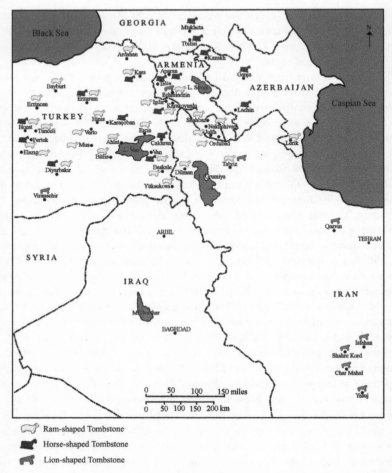

Map 13 Zoomorphic tombstones in the Middle East (Yezidi and non-Yezidi tombstones)

sculpture. They are cut out of red tuff in a naturalistic style. The production of these sculptures has been stopped.

Although the ram- and ewe-shaped tombstones are not preferred by the Yezidis of Armenia, they are widespread throughout Kurdish regions of Turkey,[412] north-western Iran and Azerbaijan.[413] In particular, 'Alevi[414] Kurds' cemeteries in Dersim region[415] are important for the variety and number of animal-shaped tombstones, which are stylistically similar to the horse statues of the Yezidis in Armenia. They are recognised

by the spiralling lines on their horns. However, the repertory of symbols carved on the flanks of the animal in Dersim has parallels to the lion sculptures of western Iran. Common symbols are weapons, such as sword, dagger, rifle, pistol, as well as a rider on his mount, horses, humans and rosettes. Nakhchivan is also important for its ram- and ewe-shaped tombstones. According to Seferli, Julfa, Ordubad and Shahbuz in Nakhchivan have more than 300 ram sculptures, which mostly possess Arabic inscriptions and date back to the second half of the fifteenth, sixteenth and seventeenth centuries.[416] A ram-shaped tombstone in the Sardarabad Ethnographic Museum in Armavir, dated 1609, is from Julfa in Nakhchivan; two other similar examples, stated by Strzygoswski,[417] which have the same pattern, dated 1578, belong to Armenians. The Armenian inscription and the fine interlaced floral and geometric decors depicted on it, which are typically Armenian, help us to identify them. However, in our opinion, zoomorphic tombstones are atypical of Armenian cemeteries as Armenian tombstones, known commonly as khachkars (cross-stones), are in general rectangular in form. The construction of these tombstones in Julfa was probably influenced by the surrounding cultures – Kurdish and Azeri cemetery tradition, which were well established in the region.

Two small ancient-looking tombstones in the form of lions are also found as spolia in the cemetery of the Yezidi village of Oğlakcı in Viranşehir/Şanlıurfa. Both of them are with missing heads. Although parallel examples from the same period in the region are unknown, similar sculptures are found at the Göbekli Tepe Höyük which is a Neolithic site from the 10th millennium BC in Şanlıurfa.[418] Moreover, lion-shaped tombstones are in great numbers in north-western Iran.[419] Many surrounding villages – three Safavid capitals namely Tabriz, Qazvin and Isfahan – possess lion sculptures dating back to the sixteenth to the nineteenth centuries.[420] According to Tanavoli, there is a revival of ancient tradition in the use of lion-shaped tombstones from the Safavid period.[421] These lions are oriented east-west, with the head to the east, but the face of the deceased is turned towards Mecca in the grave.

Turkish and Azeri scholars tend to link zoomorphic sculptures to Shamanist rites practised by Turks in Central Asia.[422] According to them, Turks had a tradition of burying people with their horses. This tradition changed with time and the real horses were replaced with a horse sculpture on the graves. Ram and ewe sculptures in Anatolia are attributed especially to members of Akkoyunlu/White Sheep (1378–1508 AD) and Karakoyunlu/Black Sheep (1375–1468 AD) Turkoman confederations[423] who would have brought this tradition from Central Asia to eastern Anatolia and influenced the local cultures where the use of animal tombstones continued afterwards. However, excavations at Göbekli Tepe in Şanlıurfa in eastern Turkey, at Tell Mozan (ancient Urkesh) in northern Syria and Giyān Tepe in north-western Iran have provided proof of the theory that the animal sculptures (whatever their shape: horse, ram or lion) have their origin in ancient Mesopotamia and ancient

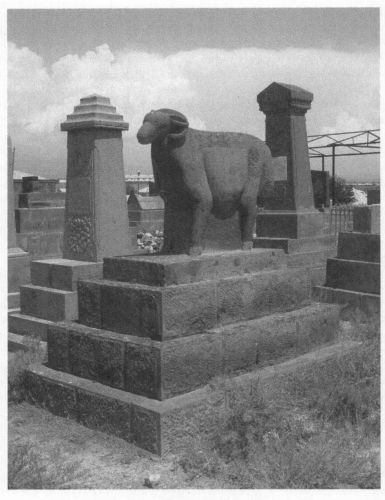

71 Ram-shaped tombstone, Ferik Echmiadzin (Armenia)

Persia. Many horse- and sheep-shaped figurines were found in ancient Urkesh, the first capital of Hurri civilisation. These figurines are dated to the middle of the third millenium.[424] Three funerary sculptures dating from 1000 BC have been excavated in Giyān Tepe. Of these, two represent rams and the third, a tiger.[425] Some others are found in Goytepe (Priship) in southern Azerbaijan in graves which also date to 1000 BC.[426]

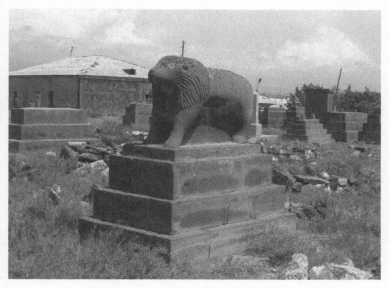

72 Lion-shaped tombstone, Ferik Echmiadzin (Armenia)

This confirms the theory that the Kurds, as an Iranian people, found their inspiration for funerary decoration in a tradition that predated them. However, this common practice lasted only as long as Islam exhibited a certain tolerance towards figurative imagery. Yezidi, Christian and 'Alevi Kurds, however, not adhering to the same prohibitions, continued with this custom. Furthermore, despite the prohibition of figural representation and sculpture in the Islamic world, this pre-Islamic ancient tradition revived with the rise of the Safavid dynasty in the sixteenth century. In this way, Shi'ites of Iran and Azerbaijan continued using this ancient tradition to form their cemeteries. These were lion sculptures, favoured especially by the Shi'ites because they were identified with Imam 'Ali. Moreover, the existence of ram-shaped tombstones in a wide area might be explained by the importance of sacrifice in Islam, which might have allowed this tradition to survive. The rite of sacrifice is especially observed among Shi'ites and Yezidis. Astonishingly, there are no zoomorphic tombstones in northern Iraq. The answer might be found again in Sunni Islam, which is strongly against idolatry. The Yezidis probably followed the rules of Islam during its 'Adawiyya period when they were under the influence of Sufi Islam and such sculptures were banned in the region. However, people who were in areas far from the religious centre, who were under the authority of the

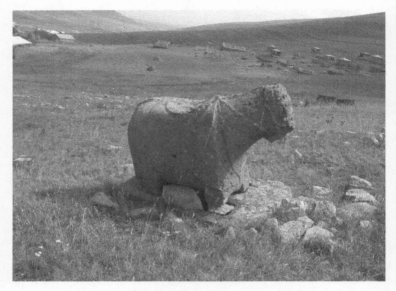

73 Horse-shaped tombstone, type II, Sipan, Aparan (Armenia)

Safavids, or under the influence of Shi'ite traditions, such as the 'Alevis of Dersim, continued to practise their ancient traditions.

One may purposefully ask the question as to why these funerary sculptures take the form of horses, rams and ewes in Yezidi culture. According to researchers, the symbols of fertility in the semi-nomad tribes who tamed animals were the horse, ram and bull.[427] Thus, it is entirely possible that the central role these animals played in the lives of these semi-nomadic people bestowed on them an importance which was given expression in the sculptures we see today. This practise is related to the roles these three animals play in the economic life of the people and to the importance of cavalry in warfare. For instance, the semi-nomad Kurds still perform two important rites concerning their pastoral life with ram and ewes. These rites are called *Serê-pez* and *Baro-dan*. People celebrate these days to mark the flock's leaving for pasture of summer in spring and its return home in autumn, which are considered the most solemn days of the year by the villagers whose lives depend on the flocks.[428] The horse was also one of the principal animals in the life of the tribes in the region. Horses were mostly reared on the Turkish-Iranian frontier, more precisely around Zagros and in the Ala Dağ region, between Van Lake and Ağrı (Ararat) Mountain – places where most horse sculptures are found today.[429]

Horse-shaped tombstones are cut for nobles and wealthy people to praise their bravery after their departure. They are made exclusively for men. According to the Yezidis, the sculptures belong to people who are known in the society for their heroism, bravery and struggle. Moreover, according to popular belief, these sculptures help deceased to go to Paradise. The horse carries its owner on its back to the door of Paradise.

5

Conclusion

Yezidis inherited several cultural and religious beliefs, and the form of each influence remained visible despite each new addition. Thus, a syncretic belief system and a new religion, with its own dogmas and rules, were established. There is no liturgical or historical writing before the twelfth century that could facilitate an examination of the periods of influence and the formation of Yezidism. However, contemporary religious practices and hymns that were transmitted orally over generations hint at various layers of development. The multicultural aspect of Yezidism can be explained in various ways. First, the areas populated by Yezidis were heterogeneous and stood at the crossroads of various religious, ethnic and linguistic communities living side by side. Second, various communities with different backgrounds gathered and constituted the Yezidi community through its early history. Adherents to Yezidism are mainly Kurds whose ancestors practiced ancient Iranian religions, but they also include Muslim Arabs who are descendants of Sheikh 'Adī, the Adanis, and some of his disciples, who were later 'Kurdified' with time. For instance, the 'Adawis (a community of both Kurds and Arabs) of the period of Sheikh Ḥasan (d. 1254) are mentioned in the medieval Arabic sources exclusively as 'Adawi Kurds (*Akrād 'Adawiyya*).

Thus, religious and ethnic differences constituted the fundamental characteristics of Yezidism, which manifest themselves today in the practices of modern-day Yezidis. For instance, the Yezidis pray to God through the banners of the Peacock Angel; consider the sun, stars, fire, water and earth as sacred; pray in the direction of the sun; use fire on every ceremonial occasion; and believe in reincarnation. They have a caste system, but it differs from the Indian system because there is no ranking. The Yezidis also perform the rite of baptism. All these rituals point to the likelihood of pre-Islamic

ancient Iranian religious roots of Yezidism. In addition to all this, Islamic practices are also observed in the Yezidi cult. The Sufi Sheikh 'Adī introduced his Islamic doctrines to the community in the twelfth century. After his death in 1162, his successors and disciples blended his doctrines with ancient Iranian traditions practised by the local people before Sheikh 'Adī, and this constituted the beginning of the Yezidi doctrine as we know it today. The Adani sheikhs are mostly loyal to Islamic practices, such as Ramadan and Sheva Berat (Laylat al-Qadr).

Yezidism was embraced by the Kurdish tribes; it spread to wherever the Kurds were living in the Middle East from the twelfth century. However, their power declined from the fifteenth century onwards because of the oppression and massacres committed by their Muslim neighbours. Paradoxically, the Yezidis suffered principally at the hands of the Muslim Kurds. However, they continued to survive as small groups dispersed amongst Kurds in a large area. Lalish continued to be the centre of Yezidism where believers from various places met. Especially because of the qewwals, the sacred musicians, the Yezidi belief system was kept alive. As the Yezidi tradition is not written but is orally transmitted to subsequent generations, the qewwals were responsible for educating Yezidi believers. Thus, it is not by chance that the Yezidi holy books, the *Mishefa Resh* (the Black Book) and the *Kitêb-i Cilwê* (the Book of the Revelation), derive their contents from the teachings transmitted by the qewwals.

Although Yezidis are considered by some modern researchers to constitute a secret and closed community, they were a dynamic community that had contact with its neighbours and close relations with the political powers of the day. However, a communal sub-conscience of protection against outsiders permeates the Yezidi communal mind. Thus, Yezidis are a self-confident group who exclude non-Yezidis as a self-protection and self-preservation mechanism. However, it is only in light of their experience and memory of persecutions, massacres, deportations and forced conversions that one can understand the vital need for community amongst the Yezidis. Even if today Yezidis seem to be tolerated by the majority populations amongst whom they live, they still encounter prejudices. Any 'outsider' showing an interest in the Yezidis community is viewed with suspicion and as potentially dangerous.

Yezidis are depicted in the medieval Arabic and late Ottoman sources as insubordinate peoples. They were against the central government of Abbasids and continued to support the Umayyad cause. They opposed the Atabeg ruler Badr al-Dīn Lu'lu' (r. 1211–59) of Mosul. They allied themselves with the Seljuks of Anatolia against the Mongols and became soldiers of the Ayyubids in Iraq, Syria and Egypt in the twelfth and thirteenth centuries. They also allied with the Black Sheep (1375–1468) and the White Sheep (1378–1508) Turkomans against Tamerlane. They first came into contact with the Ottomans in the sixteenth century. After a period of hesitation in choosing between the authorities of the Ottomans and the Safavids, they

accepted the authority of the former and lived as semi-independent unities. However, their relations with the Ottomans were tense from the beginning. They had suffered under the Ottoman military expeditions and were persecuted by the local Ottoman governors. The main pretext for the massacres was their alleged refusal to pay taxes or to be conscripted into Ottoman army, but the Ottomans also considered them former Muslims who had deviated from the right path by worshipping Satan. The Ottomans forced the Yezidis to convert to Islam, and from the eighteenth century, many *fetwas* were declared against Yezidis for their infidelity. Moreover, because they were not recognised as a 'People of the Book' (*ahl al-kitab*) protected under Islamic law, and their status was not defined by the Ottoman administration, they were relegated to the lowest rung of Ottoman society and forced to embrace Islam. It was especially at the hands of the Hamidiya Cavalry, created by the Ottoman sultan Abdülhamid II in 1891, that the Yezidis left their homelands and migrated to Caucasia en masse. After World War I and the drawing of new political boundaries, the homeland of the Yezidis was split across four countries: Turkey, Iraq, Syria and Iran. The lines of communications between the Yezidis were broken. Today it is in Europe that the Yezidis meet.

The Yezidis of Iraq are the most numerous and the most traditional Yezidis today. Since the establishment of the Kurdish Regional Government they are better protected and given their due place in Kurdish society. However, these Yezidis still feel that they are treated badly. The Yezidis of Turkey, who are concentrated in the eastern part of the country, have almost disappeared since the migrations to Europe in the face of the spiralling problems of unemployment and poverty that racked eastern Turkey in the 1960s. European attitudes towards freedom of expression and religion attracted the Yezidis of Turkey. Again, the conflicts in the 1980s between the Turkish army and the PKK (Kurdistan Workers Party) encouraged Yezidis to leave Turkey. Thus, they joined their co-religionists in Germany where the Yezidi community was growing. In the Republic of Armenia and Georgia, where Yezidis were more tolerated, economic crises and unemployment continued to encourage Yezidis to leave for the Soviet Union or European cities in search of job and a better life.

Today, the Yezidis are facing extinction. Their already small numbers are diminishing for several reasons. First of all, membership to Yezidism must be inherited by both parents, and it is not permitted for outsiders to convert into Yezidism. Moreover, if a Yezidi marries a non-Yezidi, he or she is automatically considered to have converted to the religion of the partner. This acts as a deterrent for exogamous marriage. The same de facto prohibition is observed within the different Yezidi castes. However, increasingly, the Yezidis face difficulties in applying such strict rules among the younger generation living in Europe, who sees such practices as incompatible with modern life. Today, Yezidi intellectuals living in Europe often discuss conversion. For the Yezidis, the only way to keep their numbers up is to

reproduce as much as much as possible. Secondly, Yezidis are still attacked and persecuted by Islamists in new Iraq. These are the Yezidis amongst the minorities of northern Iraq who suffered more since 2003. The most recent persecution in 2007 is forcing Yezidis to flee to Europe for safety. How they will protect themselves against extinction is an open and pertinent question, and without international protection, the survival of Yezidi culture is at risk.

Places of pilgrimage for Yezidi believers are also in their areas of origin in northern Iraq. It is there that Yezidis can develop and preserve the architectural specificity of their religious buildings. According to the surviving examples, the patrimony of the Yezidis commenced with the arrival of the 'Adawis at Lalish in the early twelfth century. The basement of the sanctuary of Sheikh 'Adī, called Chilekhane is said to have been founded by Sheikh 'Adī himself when he arrived in the valley of Lalish with his disciples. He had been in search of an idyllic spot where he could meditate and diffuse his Sufi teachings. The site became a *zāwiya* for the retreats of 'Adawi dervishes and is the earliest known Yezidi building. The sanctuary of Sheikh 'Adī was built on top and around the basement, and it is now a main pilgrimage site of the Yezidis. This monument has gained in importance not only because it is a pilgrimage site but also because it is the only existing monument that represents the characteristics of the Sufi *zāwiya* in Iraq.

In this study, it is noted that Yezidis, unlike followers of other religions, do not have temples for the performance of liturgies. However, the mausoleums of saints and the shrines fulfil the function of a place of worship. The reasons for this are diverse. First, Yezidism does not require public prayer or worship but encourages individual prayers. Formalised prayer is largely a matter of personal preference and is not obligatory. Therefore, the Yezidis do not need a large place of worship to accomplish their liturgy, which probably derives its origin from the mystical Sufi 'Adawiyya era. The mystic ancestors of the Yezidis, the 'Adawis, had a meditative and solitary lifestyle and spent much of their time in their cells praying. Moreover, from the beginning of their existence the Yezidis lived in a hostile milieu. The persecutions and massacres throughout their history have been discussed. It should also be borne in mind that Sheikh 'Adī condemned the *dhikr*[430] to his disciples.[431] As a result there was no need for the creation of large architectural structures for the conduct of worship. However, Yezidi monuments vary in type. The majority of buildings are located in the Sheikhan region, where we find forty-six examples of mausoleums, many shrines, four caves, a baptistery and a sanctuary. These buildings date back to different periods, the oldest going as far back as the twelfth century. The area of Beḥzanê/Ba'shîqe includes seventeen buildings, all of which are mausoleums: six mausoleums around Dohuk and eleven mausoleums and two shrines in the province of Sinjar were examined.

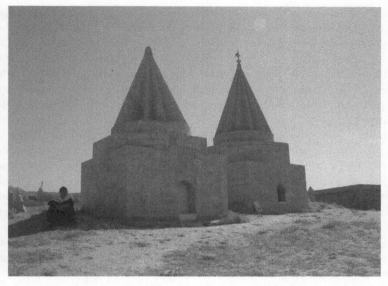

74 General view of the mausoleums of Sitt Hecici and Sitt Habibi, Ba'shîqe

Among the buildings which I studied, the mausoleums take on importance because of their number and style variation. They are considered as holy because they fulfil certain functions as places of communication with the Divinity through the performance of special ceremonies and rituals. Such sites are also places in which believers ask for divine intervention to improve their lot. The typology of the mausoleums is divided in two, the square and the rectangular, and there are seven different plans. Variations in the rectangular plan are observed mainly in the Sheikhan region. The rectangular plan has three alternatives: rectangular simple, rectangular with antechamber, and rectangular made up of two coupled parts. The barrel vault or the pointed barrel vault covers these buildings. The square plan is the most common to Yezidi architecture. It is found in four Yezidi areas in northern Iraq with two alternatives: the simple square plan and the square plan with an antechamber. It is noted that this form, a square plan covered with a ribbed conical dome, originated in Mosul in the twelfth century and was used simultaneously by both Muslims and Yezidis. Although the Muslims stopped using it in their architecture from the end of the thirteenth century, the Yezidis have continued to build mausoleums according to this form, and it has thus become characteristic of Yezidi architecture. Thus, a tomb chamber with a square plan covered by a dome raised on a square or octagonal

drum is the characteristic type found in Yezidi architecture in general. The principal architectural element of the mausoleum is the dome, and it is elevated by increasing the height and number of drums, as well as the height of the conical fluted dome. This makes it more visible and creates the impression that it rises upwards to the sky towards God; conical domes are regarded as the symbolic manifestation of Yezidi saints who even after their death continue to illuminate their followers. In addition, there is a type of plan particular to Yezidi architecture which is the round or rectangular structure without roofing.

The baptistery I studied in the Lalish valley has a complicated plan and four of its rooms have either a constructed antechamber or a side room. Furthermore, the Yezidis have a particular attachment to shrines which are used for fire rituals during ceremonies and for daily prayers. The shrines vary in form. Although I treated only a few examples of these buildings in this book, they are numerous and are mainly located in the cemeteries or beside mausoleums of the Sheikhan region. The believers make their devotions around these buildings. It is possible to suggest a Zoroastrian origin for these shrines. They were probably used by the ancestors of Yezidis who practiced the Iranian religions during the rite of fire and succeeded in surviving until our days.

The names of the buildings reveal the names of Yezidi saints and their importance in society. For example, the popularity of Sheikh Shams and Sheikh Mand becomes obvious when considering the many buildings that bear their names. The size of the mausoleums as well as the number of ribs on the conical domes which emerge on the tops of monuments demonstrate the respect that the Yezidis show their saints; the mausoleum of Sheikh 'Adī has forty eight ribs, that of Sheikh Sharaf al-Dīn has forty sections and of Sheikh Ḥasan has thirty two.

The buildings attributed to the sheikhs are found everywhere in the Yezidi regions of northern Iraq, but the mausoleums of pîrs are few and are limited to the Sheikhan and Sinjar areas. That allows us to assume that pîrs had a certain importance at the beginning but that the memory of the sheikhs continued to dominate the religion throughout its history. It is observed that the majority of the Yezidi mausoleums are particularly dedicated to the members of the family of Shamsani, from whom the baba sheikh, a predominant influence on the religious life of Yezidis today, came.

In Yezidi architecture, the concept of space has expressed itself in isolated individual buildings. Although these buildings are constructed for public use, they are set apart from habitation. Even in Beḥzanê/Ba'shîqe, where the majority of Yezidi sacred buildings are located in the centre of the town, the sites are generally built on the top of a hill to separate them from public spaces. Furthermore, each building is encircled by a high-walled courtyard.

Although small Yezidi communities reside in Iraqi cities such as Dohuk, Mosul and Baghdad, the majority of the Yezidi population lives in rural areas. It is important

to underline that apart from the buildings in Beḥzanê/Baʾshîqe, no Yezidi religious buildings exist within cities. Even Beled Sinjar, which contains the largest group of Yezidis, has no Yezidi building in its centre. One has to venture far into the remote areas to encounter Yezidi sacred buildings. Thus, Yezidi architecture is completely rural.

The monuments located in the Republic of Armenia are exclusively mausoleums that present three types of plan: square, rectangular and octagonal. The Yezidi mausoleums of northern Iraq and Armenia differ in form and function. The mausoleums in Armenia are dedicated to the notables of a given village, while in northern Iraq they commemorate religious men. Therefore, the Armenian sites are not places of worship. The building material is also different.

The Yezidis were influenced by their surrounding cultures, notably by Shi'ite Muslims of Mosul and Christians, in their choice of architectural type for their sacred places. However, they gave a new meaning to these buildings, thus unifying the followers of the Yezidi faith and differentiating them from their neighbours. The most striking feature of Yezidi sacred monuments is the depiction of the serpent and the peacock on the façades.

Another significant sign of the distinctiveness of Yezidi culture are the zoomorphic tombstones found in the cemeteries in the Republic of Armenia and Turkey. They are mainly in the shape of horses and cut in the round. There are also ram-, ewe- and lion-shaped tombstones. They are represented standing on their legs on a pedestal with their heads up. Horse-shaped tombstones are cut for nobles and wealthy people to praise their bravery. They are made exclusively for men. Although these sculptures do not date before the seventeenth century, it can be supposed that this was an ancient tradition of Mesopotamia and Persia which survived through the Yezidis. These animals had a significant role in the life of rural people, who used to bury animal sculptures with the deceased. This tradition probably continued in a slightly changed form wherein the sculptures were erected on the graves.

A final comment shall be made on the issue of restoration of Yezidi buildings. For the last fifteen years, Yezidis of northern Iraq, who receive financial support to keep alive their religious heritage, have been renovating their monuments of worship without applying any restoration principles. Rather than restoration specialists, building engineers were given these projects. Consequently, most of those 'restored' Yezidi monuments have lost their original look or constitution. In the majority of the cases, it is difficult to distinguish the old monuments from the new because of the poor restoration work. Furthermore, the mausoleums and the horse-shaped tombstones in Armenia have not been protected at all. The local inhabitants have not been sensitised to the importance and value of these tombstones for the cultural legacy of the Yezidis and the Republic of Armenia. The majority of these sculptures are dilapidated and remain abandoned to the forces of nature.

Appendices

Appendix I: Yezidi Saints[432]

'Abd Al-Qādir Al-Jīlānī (1077–1166): One of the best known mystics of his time, this Hanbalite theologian gave his name to the order of Qadiriyya. A Persian from Nayf, south of the Caspian Sea, he came to Baghdad at the age of eighteen to study and remained there for the rest of his life. He studied philology with Al-Tabrīzī (d. 1109), the Hanbalite law with Abū'l Wafā b. al-'Akīl and was directed towards Sufism by Abū'l-Khayr Hammād al-Dabbās. Moreover, he was a companion of Sheikh 'Adī, with whom he went on pilgrimage to Mecca in 1116. His *tarīqa* was embraced mainly by the Muslim Kurds. The Yezidis regard him as a Yezidi saint.

Mausoleums: (2) Lalish, Sinjar

Abī 'l-Barakāt b. Şakhr: The son of Şakhr and father of 'Adī II, he was the first successor to and nephew of Sheikh 'Adī. A pious Muslim, he was opposed to the innovations.

Mausoleums: (2) Bozan, Sinjar

Adī b. Abī 'l-Barakāt ('Adī II): Son of Abī 'l-Barakāt b. Şakhr and father of Sheikh Ḥasan, he is known to have usurped the monastery of Mar-Yuḥanan and Isho' Sabran which would later become the sanctuary of Sheikh 'Adī. He was killed by the Mongol emperor Tuman in 1221.[433]

Sarcophagus: Lalish (located in the assembly hall of the sanctuary of Sheikh 'Adī)

Mausoleums: (1) Bozan

Alū Bekir: Although there is no information about him, according to Kreyenbroek, when qewwals pronounce the words '*Ya Sheikh 'Adī, ya Alū Bekir*', it indicates that their recital is finished.[434] Moreover, in popular belief his mausoleum is effective against diseases of the mouth.

Mausoleums: (2) Bozan, Lalish

Êzdîna Mîr: The ancestor of a branch of the Shamsani sheiks and father of Shams al-Dīn, Fakhr al-Dīn, Sajadīn and Nasr al-Dīn. According to Yezidi tradition, he lived at the time of Sheikh 'Adī.

Mausoleums: (2) Bozan, Lalish

Hajali (Pîr Hec 'Elî): The eponym of a family of pîrs, he was one of Sheikh 'Adī's disciples. According to legend, when Sheikh 'Adī came from Baalbek, he stayed in Hajali's house. His mausoleum cures madness and the possession of hearts by *djins*.

Mausoleums: (1) Sinjar

Ḥasan Ferosh: Coming from the Adani lineage of a sheikh family, he is the son of Zembil Ferosh and brother of Saîd û Mesud, Sheikh Mushelleh, and Sheikh Khefir.

Mausoleums: (1) Dirawish (close to Beḥzanê)

Khatuna Fakhran: A female figure. She came from a branch of the Shamsani family and is believed to have lived in the thirteenth century. She was the daughter of Sheikh Fakhr al-Dīn, wife of Ḥasan Jelle and sister of Sheikh Mand Pasha. She is considered as the saint of births by the Yezidis.

Mausoleums: (2) Lalish, Sinjar

Khetî Besî: The eponym of a subdivision of the pîrs of Ḥasan Meman.

Mausoleums: (1) Bozan

Kure Buker: We have no information about him.

Shrines: (1) Bozan

Melekê Mîran: According to legend he was born of a virgin mother and is considered to be one of the ancestors of the Yezidis. His mausoleum in Beḥzanê is believed to be effective against rheumatism. Beneath the mausoleum is a stream from which the faithful bring earth and water to make mud which they spread on their bodies in order to cure the disease.

Mausoleums: (1) Beḥzanê

Memê Resh, Mem Reshan, Mehmed Reshan: Chief of the forty disciples of Sheikh 'Adī and the eponym of the pîrs of Pîr Afat, Pîr Buwal and Pîr Derbês. He is considered as the lord of the rain, the guard of harvests and carrier of rain. A festival is celebrated in his honour in spring.

Mausoleums: (1) Sinjar

Memê Shivan: Eponym of a pîr family from which the village of Mem Shivan borrows his name. He is the master of sheep.

Shrine: (1) Bozan

Cave: (1) Lalish

Mîr 'Ali Beg: The son of Mîr Hussein Beg, the father of Mîr Saîd Beg and husband of Mayan Khatun. When his father died in 1879, 'Ali Beg chose his brother Mîrza to take his

place as Mîr. In 1892 the Yezidi leaders were forced to convert to Islam. A group of Yezidi leaders including Mîr Mîrza Beg converted, but 'Ali Beg resisted. Consequently, he was exiled to the Turkish city of Kastamonu but was later freed. When Mîr Mîrza died in 1899 'Ali Beg was named as Mîr at the age of fifty-three. He ruled his people honestly until he was assassinated in 1913. Regarded as just, faithful and proud, he is respected by the Yezidis.

Mausoleums: (1) Ba'adrê

Mîr Sajadīn (Sejad al-Dīn): The eponym of the branch of the Shamsani family, he was one of the sons of Êzdîna Mîr and one of the seven Yezidi angels. He is identified with the angel 'Ezra'îl.

Mausoleums: (1) Behzanê

Shrines: (1) Bozan

Nabadar: We have no information about him.

Mausoleums: (1) Bozan

Pîr 'Ali: Eponym of a pîr family which is probably a subdivision of Hajali (Pîr Hec 'Elî).

Mausoleums: (1) Bozan

Pîr Būb: The son of Pîr Sîn. According to Yezidi tradition he was one of Sheikh 'Adî's close friends. His mausoleum in Behzanê is the only one belonging to the pîr class.

Mausoleums: (1) Behzanê

Pîr Buwal: He comes from the family of Hesil Meman and is a subdivision of the pîrs of Pîr Afat and Pîr Derbês.

Mausoleums: (1) Bozan

Pîr Cerwan: The eponym of a family of pîrs. Its sub-groups are Êstîye, Hecî Muḥammad, 'Omer Khalê, and Qadî Bilban. It is believed that he protects people from the bites of scorpions.

Mausoleums: (1) Lalish

Pîr Hemedî Boz: We have no information about him.

Caves: (1) Lalish

Pîr Kivane Rut: We have no information about him.

Mausoleums: (1) Lalish

Pîr Sīn al-Beḥrî: The eponym of a subdivision of the pîrs of Pîr Hajali (Hec 'Elî).

Mausoleums: (1) Lalish

Qadî Bilban (Qeḍib al-Ban): Eponym of the subdivision of Pîr Cerwan. One of the companions of Sheikh 'Adī, he was originally from Mosul. His mausoleum is effective against internal diseases.

Mausoleums: (1) Lalish

Ruale Kevînîye: We have no information about him.

Mausoleums: (1) Bozan

Said û Mesud: The son of Zembil Ferosh and brother of Ḥasan Ferosh, Sheikh Mushelleh and Sheikh Khefir, he comes from the sheikh family of Adani.

Mausoleums: (1) Beḥzanê

Shehîd ʿAbd al-Aziz: According to Yezidi tradition, he is a martyr. It is also believed that he is one of Sheikh ʿAdî's four brothers.[435]

Mausoleums: (1) Beḥzanê

Sheikh Abū Bekir: The eponym of a subdivision of the Qatani sheikhs, he is probably one of the sons of Sheikh Ḥasan ibn ʿAdī Shams al-Dīn. According to tradition, the *khirqa*, which plays a very important part in the Yezidi faith, came for him. He is also identified with the angel Jibraʾîl. His mausoleum is effective against fever.

Mausoleums: (2) Beḥzanê, Lalish

Sarcophagus: (1) Lalish (in the sanctuary of Sheikh ʿAdī)

Shrines: (1) Bozan

Sheikh Abūʾl-Qasim: According to tradition, Sheikh Abūʾl-Qasim was one of the companions and early followers of Sheikh ʿAdī. They came together to the village of Karsi in Sinjar. He was the son of Sheikh Ḥantūsh who was one of Sheikh ʿAdī's first disciples.

Mausoleums: (1) Sinjar

Sheikh ʿAdī (1078–1162): He is regarded by the Yezidis as the reformer of the Yezidi religion (See pp. 82–86).

Sanctuary: (1) Lalish

Mausoleums: (1) Lalish

Sheikh ʿAli Shamsê: We have no information about him but he may be one of the nine sons of Sheikh Shams.

Mausoleums: (1) ʿEyn Sifni

Sheikh Amadīn (ʿImad al-Dīn): The son of Khatuna Fakhran and brother of Fakhr al-Dīn, he is a descendant of the Shamsani family. His mausoleum cures stomach pains.

Mausoleums: (1) Sinjar

Sheikh Babik: One of the nine sons of Sheikh Shams of the family of Shamsani.

Mausoleums: (1) Baʾshîqe

Sheikh Bezit: He is probably Beyazid-i Bistam, an early Sufi of the ninth century.

Mausoleums: (1) Khanek

Sheikh Fakhr al-Dīn: He is one of the four sons of Êzdîna Mîr and one of the seven Yezidi angels, Nuraʾîl. The father of Sheikh Mand and Khatuna Fakhran, he is identified

with the moon, *sīn*, as his brother Sheikh Shams is identified with the sun, *shams*. Thus, he is also named as Melik Fakhr al-Dīn, Melik Sheikh Sīn, and Sheikh Sīn. His mausoleum cures children's diseases.

Mausoleums: (2) Beban, Mem Shivan

Podium: Lalish (It is located in the inner-court of the sanctuary of Sheikh ʿAdī where Baba Sheikh sits during ceremonies).

Sheikh Ḥantūsh: One of the first disciples of Sheikh ʿAdī and the father of Sheikh Abū'l Qasim.

Mausoleums: (1) Ain Sifni

Sheikh Ḥasan (Ḥasan b. ʿAdī b. Abī 'l-Barakāt): The son of ʿAdī b. Abī 'l-Barakāt who lived in 1196–1249 or 1197–1254, he is the most famous spiritual and political Yezidi chief after Sheikh ʿAdī. He was assassinated by Badr al-Dīn Luʾluʾ, who feared a Kurdish revolt against him. In the Yezidi tradition, he is identified with the Muslim Arab mystic al-Ḥasan al-Basrī (642–728). Sheikh Ḥasan is also identified with one of the seven Yezidi angels, Dardaʾīl. His mausoleum is effective against lung diseases and rheumatism.

Mausoleums: (2) Lalish, Sinjar

Sheikh Khefir: The brother of Saîd û Mesud, Sheikh Mushelleh and Ḥasan Ferosh and the son of Zembil Ferosh. He is a descendant of the Adani sheikhs.

Mausoleums: (1) Beḥzanê

Sheikh Mand: He is the eponym of the subdivision of the Shamsani sheikhs. The son of Sheikh Fakhr al-Dīn and brother of Khatuna Fakhran, he was emîr of the Kurds in Antioch and Aleppo in Syria in the service of the Ayyubids.[436] According to Yezidi tradition, Sheikh Mand resolved internal problems of the Yezidis during his rule in the thirteenth century. It is believed that he has power over snakes. Thus, his mausoleum is effective against snake bites.

Mausoleums: (4) Beḥzanê, Bozan, Kabartu, Sinjar

Shrines: (1) Beban

Sheikh Muḥammad: The son of Sheikh Nasr al-Dīn of the Shamsani family, he is famous for his combat against a powerful sheikh, which made him legendary. According to tradition, during a battle Sheikh Muḥammad's head was cut off by the partisans of the other Sheikh, but he put it under his arm and continued to fight. His wife was Sitt Hebibi.

Mausoleums: (1) Baʿshîqe

Sheikh Mushelleh: The brother of Sheikh Khefir, Ḥasan Ferosh and Saîd û Mesud, and the son of Zembil Ferosh. This family originates from one of the Adani sheikhs. Sheikh Mushelleh is considered to be the guardian of the sanctuary of Sheikh ʿAdī. His

mausoleum is, therefore, located in front of the sanctuary of Sheikh 'Adī to guard the way to the sanctuary. It is believed that Sheikh 'Adī stayed in his house for forty days when he came from Baalbek.

Mausoleums: (1) Lalish

Sheikh Nasr al-Dīn: One of the sons of Êzdîna Mîr, he is also identified with Shemna'îl, one of the seven Yezidi angels.

Mausoleums: (3) Behzanê, Bozan, Lalish

Sheikh Sīn: See Sheikh Fakhr al-Dīn.

Sheikh Siwar: He is the lord of war and horse riders.

Mausoleums: (1) Beban

Sheikh Sharaf al-Dīn: The eponym of the subdivision of the Adani sheikhs, he is the son of Sheikh Hasan. According to tradition, it is because of him that the tribe of Jiwanî of Sinjar converted to the Yezidi faith. His position in Sinjar is comparable with that of Sheikh 'Adī. When his father, Hasan b. 'Adī Shams al-Dīn, was killed by Badr al-Dīn Lu'lu', he sent messages and prepared the defence of his community, despite the fact that he was far from Lalish. His mausoleum is effective against small pox, jaundice and skin diseases.

Mausoleums: (2) Behzanê, Sinjar

Sheikh Shams: One of four sons of Êzdîna Mîr, he is identified with Israfil, one of the seven Yezidi angels, and is the divinity of the sun. He is also identified with Shams-i Tabrīzī, the friend of Mawlānā Djalāl al-Dīn. He had nine sons: Amadīn, Babik, Khidir, 'Ali, Evdal, Babadīn, Hewind, Hasan and Toqil.

Mausoleums: (5) Behzanê, Bozan, Lalish, Mem Shivan, Sinjar

Sheikh Zeyn al-Dīn: The son of Sharaf al-Dīn, he settled in Damascus after the invasion of Iraq by the Mongols when he was supported by the 'Adawiyya order. He later founded a mystical centre in Cairo, where he died in 1297. He was buried in the *zāwiya* which bears his name. His son 'Izz al-Dīn was stopped by the Mamluki sovereign al-Nasir because of fear of a Kurdish revolt. He died in prison in 1330–31.

Sitt Habibi: The wife of Sheikh Muhammad and sister of Sitt Hecici.

Mausoleums: (1) Ba'shîqe

Sitt Hecici: The sister of Sitt Habibi and the wife of a certain Sheikh Bedir.

Mausoleums: (1) Ba'shîqe

Appendix II: Genealogy of the Umayyads and Sheikh 'Adī's Family

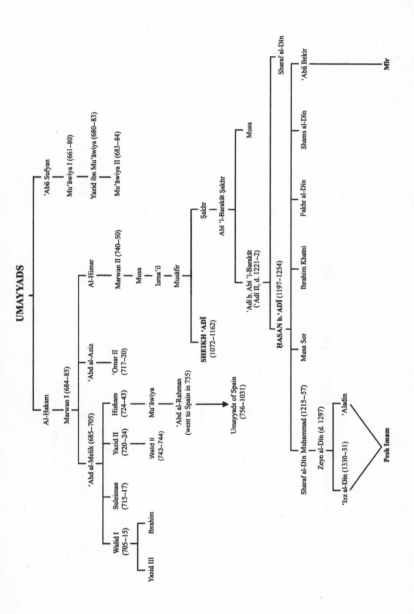

Appendix III: Genealogy of the Early Shamsani Family

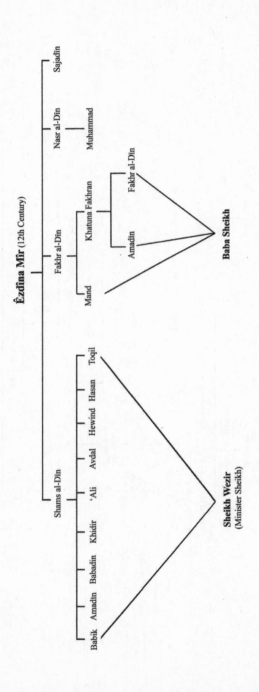

Appendix IV: Yezidi Mausoleums in Northern Iraq

No.	Name	Date	Location	Plan	Roofing	Ribs	Transition	Drum degrees	Door	Niches	Windows	Sarcophagus	Material
1	'Abd al-Qādir al-Jīlānī	XII th	Sinjar	Square	Conical dome	16	Squinch	3	Rectangular	2	–	1	W.w.
2	Alū Bekir	XII th	Bozan	Rectangular	Barrel vault	–	–	–	Rectangular	1	–	–	Rubble stone
3	Alū Bekir	XIII th	Lalish	Rectangular	Barrel vault	–	–	–	Rectangular	1	–	–	Stone
4	Baba Chawush	1450	Kabartu	Square	Conical dome	28	Squinch	2	Rectangular	1	2	1	W.w.
5	Ēzdīna Mīr	Recent	Bozan	Rectangular	Open	–	–	–	Rectangular	–	–	–	Rubble stone
6	Ēzdīna Mīr	XII th	Lalish	Rectangular	Pointed barrel vault	–	–	–	Rectangular	1	4	20	R.s./W.w.
7	Hajali	XII th	Sinjar	Square	Conical dome	24	Squinch	2	Rectangular	–	–	–	W.w.
8	Hasan Ferosh	XIV th	Dirawish	Square	Conical dome	16	Squinch	1	Rectangular	–	–	–	W.w.
9	Hecî Muḥammad		Lalish	Iwān	Barrel vault	–	–	–	–	1	–	–	Stone
10	Khatuna Fakhran	XIII th	Lalish	Rectangular + antechamber	Pointed barrel vault + flat	–	–	–	Rectangular	1	–	–	W.w.
11	Khatuna Fakhran	XIII th	Sinjar	Square + antechamber	Conical dome + flat	?	Squinch	2	Rectangular	–	3	1	W.w.
12	Kheti Besi	XII th	Bozan	Double rectangular	Barrel Vault + Conical dome	16	–	1	Rectangular	1	–	–	W.w.
13	Meleke Mîran	1919	Beḥzanê	Square	Conical dome	?	Squinch	2	Flat arched	1	–	5	Stone/W.w.
14	Melik Sh Sin	XIV th	Beban	Square	Conical dome	20	Squinch	2	Rectangular	2	–	–	W.w.
15	Memê Resh	XII th	Sinjar	Square	Conical dome	28	Squinch	2	Rectangular	2	–	1	W.w.
16	Mîr 'Ali Beg	1913	Bàádrê	Square + antechamber	Conical dome + flat	28	Squinch	2	Round arched + Rectangular	–	4	1	Stone/W.w.
17	Mîr Sajadin	XIV th	Beḥzanê	Square	Conical dome	28	Squinch	2	Rectangular	?	2	?	Stone/W.w.
18	Nabadar	Old	Bozan	Rectangular	Open	–	–	–	Rectangular	–	–	–	Stone
19	Pîr Afat	XII th	Dere Bûn	Square	Conical dome	16	Squinch	2	Rectangular	?	2	?	W.w.
20	Pîr 'Ali & Buwal		Bozan	Double rectangular	Barrel vault	–	–	–	Round arched	3	–	–	Stone
21	Pîr Bûb	XIII th	Beḥzanê	Square	Conical dome	32	Squinch	3	Flat arched	–	1	1	Stone/W.w.
22	Pîr Cerwan	XIII th	Lalish	Rectangular	Barrel vault	–	–	–	Round arched	–	–	–	Stone

Continued

Appendix IV Continued

No.	Name	Date	Location	Plan	Roofing	Ribs	Transition	Drum degrees	Door	Niches	Windows	Sarcophagus	Material
23	Pîr Kivane Rut	XIII th	Lalish	Double rectangular	Barrel vault	-	-	-	Round arched	-	-	-	Stone
24	Pîr Mand	Old	Bozan	Circular	Open	-	-	-	-	1	-	-	Stone
25	Pîr Sin	XII th	Lalish	Rectangular	Barrel vault	-	-	-	Flat arched	-	-	-	Stone
26	Qadî Bilban	XII th	Lalish	Rectangular	Flat	-	-	-	Rectangular	3	1	-	Stone
27	Ruale Kevîniye	XIV th	Bozan	Rectangular + antechamber	Barrel vault + pointed barrel vault	-	-	-	Round arched	-	5	1	Stone/W.w.
28	Saîd û Mesud	XIV th	Behzanê	Rectangular	Conical dome	20	Squinch	1	Rectangular	1	-	-	W.w.
29	Shehîd 'Abd al-Azîz	XIX th	Behzanê	Square	Conical dome	24	Squinch	1	Rectangular	-	-	1	Stone/W.w.
30	Sh Abû Bekir	XIV th	Behzanê	Square	Conical dome	28	Squinch	3	Rectangular	2	2	2	Stone/W.w.
31	Sh Abû Bekir	XIII th	Lalish	Rectangular	Barrel Vault	-	-	-	Round arched	10	2	-	Rubble stone
32	Sh Abû Bekir	XIV th	Mem Shivan	Rectangular	Open	-	-	-	Rectangular	2	-	-	Stone
33	Sh Abû'l-Qasim	1903	Sinjar	Rectangular + antechamber	Conical dome + flat	28	Squinch	2	Flat arched	6	1	-	Stone/W.w.
34	Sh 'Adî	XIII th	Bozan	Rectangular	Flat	-	-	-	Rectangular	2	-	-	Stone
35	Sh 'Adî	XII th	Lalish	Square	Conical dome	48	Squinch	3	Rectangular	-	-	1	Stone/Marble
36	Sh 'Ali Shamsê	XIV th	'Eyn Sifni	Square	Conical dome	28	Squinch	3	Rectangular	5	3	1	Stone/W.w.
37	Sh Amadîn	1400	Sinjar	Rectangular + antechamber	Conical dome + flat	32	Squinch	2	Round arched + rectangular	4	-	-	W.w.
38	Sh Babik	XIV th	Bashîqe	Square	Conical dome	28	Squinch	2	Flat arched	-	2	?	Stone/W.w.
39	Sh Barakat	1974	Bozan	Rectangular	Open	-	-	-	Rectangular	5	-	-	Stone/R.s.
40	Sh Barakat	XIII th	Sinjar	Square	Conical dome	20	Squinch	2	Rectangular	2	1	-	W.w.
41	Sh Bezit	XIV th	Khanek	Square + antechamber	Conical dome + flat	24	Squinch	2	Rectangular	2	8	1	W.w.
42	Sh Hantûsh	XII th	'Eyn Sifni	Square	Conical dome	24	Squinch	2	Rectangular	3	1	-	W.w.
43	Sh Hasan	XIII th	Lalish	Square	Conical dome	32	Squinch	2	Rectangular	-	-	1	Stone/Marble
44	Sh Hasan	XIII th	Sinjar	Square + antechamber	Conical dome + flat	24	Squinch	2	Rectangular	2	2	-	W.w.

No.	Name	Date	Place	Plan	Roof		Squinch		Arch				Material
45	Sh Mand Pasha	XIV th	Beḥzanê	Square	Conical dome	24	Squinch	2	Flat arched	–	1	–	Stone/W.w.
46	Sh Mand Pasha	XIV th	Bozan	Rectangular	Barrel vault	–	–	–	Round arched	–	2	–	Stone
47	Sh Mand Pasha	1967	Kabartu	Square	Conical dome	16	Squinch	2	Rectangular	–	2	–	W.w.
48	Sh Mand	1948	Sinjar	Square + antechamber	Conical dome + flat	28	Squinch	1	Rectangular	–	2	–	Stone/W.w.
49	Sh Muḥammad	XIV th	Bashiqe	Square + antechamber	Conical dome + dome/flat	32	Squinch	2	Flat arched	1	–	2	Stone/W.w.
50	Sh Mushelleh	XIV th	Lalish	Rectangular + antechamber	Conical dome + flat	28	Squinch	2	Round arched + Rectangular	–	3	1	Stone/W.w.
51	Sh Nasr al-Din	XIV th	Beḥzanê	Square	Conical dome	24	Squinch	2	Rectangular	–	1	?	Stone/W.w.
52	Sh Nasr al-Din	XII th	Bozan	Rectangular	Open	–	–	–	Rectangular	–	–	–	Stone
53	Sh Nasr al-Din	XIII th	Lalish	Rectangular + antechamber	Pointed barrel vault + flat	–	–	–	Rectangular	–	–	–	W.w.
54	Sheikh Shams	XIV th	Beḥzanê	Square	Conical dome	32	Squinch	2	Rectangular	–	2	1	Stone/W.w.
55	Sheikh Shams	XII th	Bozan	Rectangular + antechamber	Barrel vault + barrel vault	–	–	2	Rectangular	9	16	–	Stone/W.w.
56	Sheikh Shams	XII th	Lalish	Complex	Conical dome + barrel vault + flat	32	Squinch	2	Flat arched + Round arched	4	2	1	Stone/W.w./R.s.
57	Sheikh Shams	XIV th	Mem Shivan	Square	Conical dome	28	Squinch	2	Flat arched	2	4	1	Stone/W.w.
58	Sheikh Shams	XIV th	Sinjar	Square	Conical dome	28	Squinch	2	Rectangular	1	–	–	W.w.
59	Sh Sharaf al-Din	XIV th	Beḥzanê	Square	Conical dome	32	Squinch	2	Round arched	?	1	?	Stone/W.w.
60	Sh Sharaf al-Din	1274	Sinjar	Square + antechamber	Conical dome + flat	40	Squinch	3	Rectangular	–	10	–	Stone/W.w.
61	Sheikh Sin	XIV th	Mem Shivan	Square	Conical dome	24	Squinch	2	Rectangular	–	4	–	W.w.
62	Sheikh Siwar	XIV th	Beban	Square	Conical dome	28	Squinch	2	Flat arched	2	–	1	Stone/W.w.
63	Sheikh Khefir	XIV th	Beḥzanê	Square	Conical dome	28	Squinch	1	Rectangular	–	–	1	Stone/W.w.
64	Sh Zeyn al-Din	XIV th	Beḥzanê	Square	Conical dome	32	Squinch	2	Flat arched	?	1	?	Stone/W.w.
65	Sitt Habibi	XIV th	Bashiqe	Square	Conical dome	24	Squinch	2	Flat arched	1	–	1	Stone/W.w.
66	Sitt Hecici	XIV th	Bashiqe	Square	Conical dome	24	Squinch	2	Flat arched	1	–	–	Stone/W.w.

Appendix V: Typology of Mausoleums in Northern Iraq

Square Plan
1. 'Abd al-Qādir al-Jīlānī, Sinjar
2. Baba Chawush, Kabartu
3. Hajali, Sinjar
4. Ḥasan Ferosh, Dirawish
5. Melekê Mîran, Beḥzanê
6. Melik Sheikh Sīn, Beban
7. Memê Resh, Sinjar
8. Mîr Sajadīn (Sicad al-Dīn), Beḥzanê
9. Pîr Afat, Dere Bûn
10. Pîr Bûb, Beḥzanê
11. Shehîd 'Abd al-Aziz, Beḥzanê
12. Sheikh Abū Bekir, Beḥzanê
13. Sheikh 'Adī, Lalish
14. Sheikh 'Ali Shamsê, 'Eyn Sifni
15. Sheikh Babik, Ba'shîqe
16. Sheikh Barakāt, Sinjar
17. Sheikh Ḥantūsh, 'Eyn Sifni
18. Sheikh Ḥasan, Lalish
19. Sheikh Mand Pasha, Beḥzanê
20. Sheikh Mand Pasha, Kabartu
21. Sheikh Nasr al-Dīn, Beḥzanê
22. Sheikh Sīn, Mem Shivan
23. Sheikh Siwar, Beban
24. Sheikh Sharaf al-Dīn, Beḥzanê
25. Sheikh Shams, Beḥzanê
26. Sheikh Shams, Mem Shivan
27. Sheikh Shams, Sinjar
28. Sheikh Khefîr, Beḥzanê
29. Sheikh Zeyn al-Dīn, Beḥzanê
30. Sitt Habibi, Ba'shîqe
31. Sitt Hecici, Ba'shîqe

Square Plan + Antechamber
1. Mîr 'Ali Beg, Ba'adrê
2. Sheikh Bezit, Khanek
3. Sheikh Ḥasan, Sinjar
4. Sheikh Mand Pasha, Sinjar
5. Sheikh Muḥammad, Ba'shîqe
6. Sheikh Sharaf al-Dīn, Sinjar
7. Khatuna Fakhran, Sinjar

Rectangular Plan
1. Alū Bekir, Bozan
2. Alū Bekir, Lalish
3. Êzdîna Mîr, Lalish
4. Pîr Cerwan, Lalish
5. Pîr Sīn, Lalish
6. Qadî Bilban, Lalish
7. Saîd û Mesud, Dirawish
8. Sheikh Abū Bekir, Lalish
9. Sheikh 'Adī, Bozan
10. Sheikh Mand Pasha, Bozan

Rectangular Plan + Antechamber
1. Khatuna Fakhran, Lalish
2. Ruale Kevînîye, Bozan
3. Sheikh Abū'l Qasim, Sinjar
4. Sheikh Amadîn, Sinjar
5. Sheikh Mushelleh, Lalish
6. Sheikh Nasr al-Dīn, Lalish
7. Sheikh Shams, Bozan

Double Rectangular Plan
1. Hecî Muḥammad, Lalish
2. Khetî Besî, Bozan
3. Pîr 'Ali & Pîr Buwal, Bozan
4. Pîr Kivane Rut, Lalish

Complex Plan
1. Sheikh Shams, Lalish

Without Roofing
a) Circular
1. Pîr Mand, Bozan

b) Rectangular
1. Êzdîna Mîr, Bozan
2. Nabadar, Bozan
3. Sheikh Abū Bekir, Mem Shivan
4. Sheikh Barakāt, Bozan
5. Sheikh Nasr al-Dīn, Bozan

TOTAL: 66

Appendix VI: Typology of Mausoleums in the Republic of Armenia

Square Plan
1- Anonyme, Elegez

Rectangular Plan
1- Shaxo Agha, Riya Teze

Octogonal Plan
1- Anonyme, Derîk
2- Mamo Agha, Riya Teze
3- Emîr Beg, Sîpan

TOTAL: 5

Glossary

Abbasid	(Arabic) Arab dynasty of Caliphs which ruled Iraq between 749–1258. Abbasids' Islamic empire was centred on Iraq.
'Adawiyya	(Arabic) A mystical order founded by Sheikh 'Adī in Baghdad in the twelfth century that later became Yezidism.
Ahl-e Ḥaqq	(Arabic) 'People of the truth'. An extreme sect of Shi'ite Islam in western Iran, in the provinces of Luristan, Kurdistan, and Azerbaijan. They also live in Kerkuk and Suleimania in northern Iraq. They have a great veneration for 'Ali, whom they consider to be divine, and for his descendant imams. They also venerate Baba Yadgar whose tomb is a site of pilgrimage. They believe in the successive manifestations of the Divine seven and in the metempsychosis.
'Alevi	(Persian) Non-Sunni Muslims, also called Qizilbash (in Turkish, 'red head') or Bektashi. Like Shi'ites of the Middle-East, they revere the son-in-law of the Prophet and the fourth Caliph, 'Ali. They are, however, distinguished from other 'partisans of 'Ali', as much by their faith as for some of their practises of worship, which incorporate pre-Islamic elements and Anatolian syncretism. 'Alevis make up approximately 20 per cent of the population of Turkey.
Assyro-Chaldean	Adherents of the Chaldean Catholic Church. The majority of the members belong to the Assyrian people. They are settled mainly in Iraq, with smaller communities in Turkey and Iran, for the most part speaking the Chaldean Neo-Aramaic language.

Berat	(Kurdish) Small balls made of the earth from the sanctuary of Sheikh 'Adī and the water of the Zemzem spring. They are regarded as sacred and are distributed to pilgrims at the time of the festivals.
Cejn	(Kurdish/Persian) Religious festival, celebrated during certain days of the year.
Cherkhus	(Kurdish) A special meal made of boiled wheat.
Def	(Kurdish/Persian) A percussion instrument, made from a skin stretched on a cylindrical framework.
Dhikr	(Arabic) A process of detachment from the world in order to reach a state of ecstasy in Sufi Islam.
Emîr	(Arabic) Prince, ruler, commander.
Ferrash	(Arabic) 'Someone who extends the carpet'. In the Yezidi religion it indicates someone who is responsible for lighting and extinguishing the lamps in the sanctuary.
Feqîr	(Faqr, Arabic) 'Poor'. Mendicant Sufi. The term designates the followers of the Muslim brotherhoods (tariqā) who live by observing the vow of poverty under the control of a spiritual guide (sheikh). Through spiritual discipline and physical asceticism the feqîr tries to minimise the body functions for the better release of the soul.
Fetwa	Mufti's opinion on a matter involving the Islamic religious law.
Hallan	(Arabic) A kind of stone used to cover the Yezidi buildings in northern Iraq.
Imam	(Arabic) Term is applied to the prayer leader at public prayers, to the spiritual head of a congregation or school, and especially to the leader of the whole Islamic community.
Iwān	(Persian) Usually vaulted space, one of whose sides is entirely open to a forecourt and walled on three sides. This structure was adopted by oriental Islam from Sassanian architecture.
Juṣṣ	(Arabic) Gypsum mortar which cements the stone or brick walls.
Kanî	(Kurdish) Spring. A place where subsoil water rises and flows on the surface of the ground.
Kebane	(Kurdish) Lady of the house.
Khirqa	(Arabic) A kind of tunic worn by religious men (feqîrs). According to Sufis, the *khirqa* is the most appropriate form of religious dress, derived from the prototypical costume worn by Adam and Eve when they were placed upon the earth.
Kirîv	(Kurdish) The 'guardian of the child'. He is a kind of godfather who takes care of the child during circumcision.

Kullik	(Kurdish) Hat worn by religious men.
Kurmanji	One of the Kurdish dialects spoken by the Kurds of Turkey, Syria, the Caucasus and the septentrional part of Iran and northern Iraq. Kurmanji is also spoken by the Yezidis.
Kümbet	(Turkish) Typical mausoleum of Central Asia and Anatolia, composed of a crypt in which the body of the deceased is buried, and of a cylindrical or polygonal superstructure, generally covered by a conical or pyramidal roof.
Madrasa	(Arabic) Theological school, specialised in Islamic law. It is applied to public institutions of higher education in the Islamic world.
Manichaeism	An Iranian religion originated in Sasanian period, founded by Mani (216–76 AD, Babylon). It is a syncretic and dualistic religion combining elements of Zoroastrian, Christian, and gnostic thoughts. It extended in a large area between China and Roman Empire.
Maqâm	(Arabic) Place of the deceased, sanctuary, oratory, shrine.
Marqad	(Arabic) Place of visit, of pilgrimage.
Mazâr	(Arabic) Synonym of marqad.
Mêr	(Kurdish) Men.
Mijêwir	(Arabic) 'Neighbour'. Somebody who, for a long or short-term, remains in a sacred place in order to lead an ascetic and contemplative life. He receives offerings from pilgrims. In Yezidism, someone who is in charge of and takes care of a mausoleum.
Miḥrāb	(Arabic) The niche in a prayer hall indicating the direction of Mecca.
Mîr	(Arabic) Shortened title of emîr, indicating the military-political function of the commander and the governor. The title of mîr was given to the leaders of the independent semi-Kurdish principalities (emirates) which were created in the sixteenth century by the Ottoman Empire. In Yezidism, the mîr is the spiritual and temporal supreme authority.
Mithraism	Ancient Roman religion, established in approximately 67 AD and lasted until the fourth century AD. Mithraeas were the most sacred places of worship for members of the Mithraic cult.
Mollah	(Arabic) Title of respect for a religious and learned man.
Muqarnas	(Arabic) In Islamic and Persian architecture, a division into several levels of an arch containing a niche, realising a multitude of small pendentives or niches which creates a structure in the form of cells, with a purely decorative function. They are cut into the stucco or the stone.

Murîd	(Arabic) Somebody who receives the teaching of a master in Sufism. In Yezidism it indicates a person who does not belong to a sacerdotal caste but is of the caste of ordinary people.
Nestorianism	A Christological doctrine that Christ exists as two persons: the man Jesus and the divine Son of God. It was elaborated by Nestorius (circa 380–451), patriarch of Constantinople, according to which, the union of two natures would be at Christ. Condemned as a heretic at the Council of Ephesus in 430, Nestorius was exiled to Egypt, but the monks and especially the missionary Nestorians played a great part in the diffusion of Christianity, and its penetration as far as Transoxiana and China. Most Nestorians now live in Iraq, Syria, Turkey and Iran.
Ottomans	One of the largest and longest lasting empires in history. It replaced the Byzantine Empire and ruled from 1299 to 1922 and was succeeded by the Republic of Turkey. At the height of its power (16th–17th century), it spanned three continents, controlling much of south-eastern Europe, the Middle East and North Africa.
Perestgeh	(Kurdish) A religious building devoted to the worship of a divinity 'temple'.
Pîr	(Kurdish/Persian) A venerable old man. Moreover, it is a Sufi term which corresponds to the Arabic sheikh, which means spiritual chief.
Qaşīda	(Arabic) A form of poetry written to praise a king or a nobleman.
Qewwal	(Arabic) Orator and religious singer.
Qewl	(Arabic) Sacred hymns.
Qibla	(Arabic) Direction of prayer. Originally Jerusalem, from 624 the Kabba in Mecca, to which one turns for prayer. It is indicated in a mosque by the niche of the miḥrāb.
Qubba	(Arabic) Dome.
Riwāq	(Arabic) Portico bordering the interior of the court of the mosque, madrasa, caravanserai.
Sanjak	(Turkish) Administrative divisions of the Ottoman Empire. It also means district, banner, or flag. In Yezidism it corresponds to the banner with reference to the seven provinces of the Yezidis.
Serhad	(Kurdish) Name given to an area covering the cities of Kars, Erzurum, Ağrı, Muş, Bitlis, Van.
Serê sal	(Kurdish) New Year.

Shafi'i	Follower of al-Shafi'i (d. 820), founder of a school of law in Islam, particularly popular among the Kurds.
Shams	(Arabic) Sun.
Sheikh	(Arabic) Muslim chief with a spiritual connotation.
Shi'ite	From the Arabic shi'a, literally those who believe that the Caliphate passed to the Prophet's son-in-law 'Ali and his descendants.
Simat	(Kurdish) A special meal for religious festivals.
Squinch	An arch thrown diagonally across the corner of a room to support a circular or polygonal superstructure.
Stûna mîraza	(Kurdish) Column of prince.
Sufism	(Arabic) Mystical dimension of Islam, born in the seventh century and consisting of a search for a way to reach God. In general the Sufis regard the 'inner state' as more important than the observation of the precepts. For this reason, they were regarded sometimes as heretics or, at the very least, suspects, by the Sunnite orthodoxy.
Sunnite	Followers of orthodox Islam whose belief is based on Sunna and who recognise the first four Caliphs of Medina, and then the Umayyads and Abbasids as leaders of the Muslim community.
Sūq	(Arabic) Market, primarily applied to the commercial district of an Islamic town or city.
Takhtadji	(Turkish) Name of a nomadic Turkish group of Anatolia. They had a special status during the Ottoman period which allowed for their nomadic way of life and their religion, 'Alevism.
Tarīqa	(Arabic) It means 'way, path, method' and refers to an Islamic religious order in Sufism.
Tawûsî Melek	(Arabic) Peacock Angel.
Tawwāf	(Arabic) Circumambulation of the Ka'ba.
Turba, turbé	(Persian/Turkish) Muslim funerary building, formed of a cube surmounted by a low cupola.
Umayyads	First Islamic dynasty of Caliphs, who ruled from Damascus from 661 to 750; another branch ruled in Spain in 756–1031. They were Arabs, belonged to the Quraysh in Mecca.
Xwedê	(Kurdish/Persian) God.
Zāwiya	(Arabic) Indicates a sanctuary and, in general, a pious foundation or a small convent of dervishes.
Zemzem	(Arabic) The holy spring which is in Mecca. Yezidis also have a spring in Lalish called Zemzem.

Ziggurat Ancient Mesopotamian temple in the shape of pyramid on
 successive levels, which carried a sanctuary at its top and was
 used to observe the stars.

Zoroastrianism Religious movement reformed by Zoroaster between 1700–1000
 BC perhaps in Balkh, but taking as its base a much older Iranian
 religion as is expressed in Zend-Avesta. The name derives
 from the supreme god of the Good, Ahura Mazdā to whom
 the evil spirit Angra Manyu is opposed. This religion, marked
 by the importance of fire-worship, reigned over all Iran under
 the Achaemenids and Sassanids. It disappeared with the Arab-
 Muslim invasions. There are still Zoroastrians living in Iran and
 India.

Notes

1. Northern part of Iraq is commonly called 'Iraqi Kurdistan' and is predominantly inhabited by Kurds. This part comprises the provinces of Bahdinan, north-west of the Great Zab River and Soran in the south. Since 1991, only a part of this area came under Kurdish control to be governed by the Kurdish Regional Government. For a definition of Iraqi Kurdistan, see C. Allison, *The Yezidi Oral Tradition in Iraqi Kurdistan* (London, 2001), p. xi.
2. This is a vast region in western Asia which extends at present to eastern Turkey, northern Iraq, western Iran and northern Syria, inhabited by a Kurdish majority.
3. D. McDowall, *A Modern History of the Kurds* (London, 1996), p. 491.
4. T. Şardan, 'Iran Established Airport for Terrorism', *Milliyet* (7 April 2002).
5. This ritual is described in the third chapter.
6. All the Yezidis met in Armenia confirmed this information. According to the Yezidis of Armenia, their ancestors left their homelands and moved to the Republic of Armenia because of oppression that they had suffered under the Hamidiya Cavalries.
7. These numbers were given by the Cultural Centre of Lalish in Dohuk, the governor of Sinjar, Dexil Kasim Hason, and mayor of Ba'shîqe during my visit of the region in 2004.
8. P. G. Kreyenbroek, 'Yazīdī, Yazīdiyya', *EI* (Leiden: E.J. Brill CD-ROM Edition, 2005).
9. A. Taşğın, 'Anadolu'da Yok Olmaya Yüz Tutan Dini Topluluklardan: Yezidiler', *Anadolu İnançları Kongresi* (Ankara, 2001), pp. 737–39.
10. Kreyenbroek, 'Yazīdī, Yazīdiyya'.
11. A. Ackermann, 'Yeziden in Deutschland von der Minderheit zur Diaspora', *Paideuma* 49 (2003), p. 169.
12. These are Mishefa Resh and Kitêb-i Cilve that are considered the sacred books of the Yezidi religion.

13. These Arabic sources from the twelfth to the fourteenth centuries describe especially the famous Sheikh 'Adī, the founder of the 'Adawiyya order and his foundation of a *zāwiya* in the Hakkari region. See Al-Hafiz al-Dhahabī, *Siyar al-Alam al-Nubala'* (1983), 20: 344, 23: 223; Ibn al-'Athir, *Al-Kāmil fī al-Tarīkh*, 13 vols (Beirut, 1965); Ibn Kathīr, *Al-Bidaya wa al-Nihaya* (Beirut, 1932), 12: 243; Ibn Khallikān, *Wafiyāt al-A'yān wa-Anba' Abna' al-Zamān* (Beirut, 1978), 3: 254–55, 4: 163; Ibn Taymiyya, 'Al-Risāla al-'adawīyya' in *Majmū' al-Rasā'il al-Kubra* (Cairo, 1323), I: 262–317; Yāqūt al-Hamavī, *Mu'jam al-Buldān* (Beirut, 1814), 5: 28.

14. A Jacobit (Syrian orthodox) bishop of the thirteenth century, Gregory Bar Hebraeus (known also as Abū'l-Farac) gives important accounts of the successors of Sheikh 'Adī and their roles in the politics of the century as well as their relationship with heretic Kurds of the region. See G. Bar Hebraeus, *Gregorii Barhebraei chronicon eccelesiasticum* 3 vols (Lovanii, 1872), I: 726 and *Gregorii Barhebræi Chronicon syriacum* (Paris, 1890), pp. 497–98, 532, 535, 544. Further, the manuscript of Ramisho' written in 1451 narrates the seizure of the monastery of Mar-Yuḥanan and Isho' Sabran by Sheikh 'Adī II, discusses the arrival and establishment of the Yezidism in the area and points out the relationship among the Christians, Adawis and Mongols of the epoch. See for the translation of Tfinkdji in F. Nau and J. Tfinkdji, 'Recueil de textes et de documents sur les Yezidis', *ROC* 10 (1915–17): 185–96.

15. Asatrian and Arakelova, 'Malak-Tāwūs: The Peacock Angel of the Yezidis', *Iran and the Caucasus* 7 (2003): 2.

16. A. Mingana, 'Devil-worshippers: Their Beliefs and Their Sacred Books', *JRAS* (1916): 513.

17. A. H. Layard, *Nineveh and Its Remain*, 2 vols (London, 1849): I: 300; R. Lescot, *Enquête sur les Yézidis de Syrie et du Djebel Sindjār* (Beirut, 1938), p. 60; Kreyenbroek, *Yezidism – Its Background, Observances and Textual Tradition* (Lewiston NY, 1995), p. 95.

18. G. P. Badger, *The Nestorians and Their Rituals*, 2 vols (London, 1852), I: 112.

19. J. G. Frazer quoted by R. H. W. Empson, *The Cult of the Peacock Angel, A Short Account of the Yezîdî Tribes of Kurdistân* (London, 1928), p. 31.

20. I. Joseph, *Devil Worship: The Sacred Books and Traditions of the Yezidis* (Boston, 1919), p. 128; A. Frayha, 'New Yezīdī Texts from Beled Sinjar, Iraq', *JAOS* 66 (1946): 20.

21. This idea is supported especially by Mîr Isma'il Beg Chol. See Isma'il Beg Chol, *The Yazidis Past and Present* (Beirut, 1934), p. 77; Frayha, 'New Yezīdī Texts', p. 23.

22. Joseph, *Devil Worship*, pp. 98–99.

23. See discussion below about the origins of the sanctuary of Sheikh 'Adī, pp. 140–46.

24. Al-Sam'ānī quoted by Frayha 'New Yezīdī Texts', p. 20

25. Ḥulwān is in an area between the rivers of Tigris and Greater Zab in northern Mosul near to the Maqlūb mountain.

26. *Hal* is a plant consumed by Sufis to lighten the burdens of fasting.

27. Al-ʿAzzāwī, pp. 81–83, quoted by K. F. Al-Jabiri, *Stability and Social Change in Yezidi Society* (Oxford, 1981), p. 164.

28. See Tabarī quoted by V. Minorsky, 'Kurds, Kurdistan', *EI*, CD-ROM edition.

29. Yāqūt al-Ḥamawī mentions a castle of Qalaʾah Marwān overlooking the town of Tall Aʾfar in the thirteenth century, which was probably built by Umayyad Caliph Marwān II in the eight century AD, which shows that the memory of Marwān II was still alive among the population of the region. See Yāqūt al-Ḥamawī quoted by Reitlinger, 'Medieval Antiquities West of Mosul', *Iraq* 5 (1938): 148.

30. Kreyenbroek, *Yezidism*, p. 28.

31. See Nau and Tfinkdji, 'Recueil de textes', pp. 188–89, footnote n.2.

32. Kreyenbroek translates this religion as Magi. See Kreyenbroek, *Yezidism*, p. 28.

33. Nau and Tfinkdji, 'Recueil de Textes', pp. 188–89.

34. Ibn Kathīr, *Al-Bidaya*, 12: 243.

35. Arabic sources mention the influence of Sheikh ʿAdī on his followers. '… the People of country showed him an extreme respect that his reputation spread and people followed him at a point that their faith passed the limit and they took him as a *qibla* for their prayer and guarantee for the other world.' In Al-Hafiz al-Dhahabī, *Siyar al-Alam*, 20: 344.

36. See Kreyenbroek, *Yezidism*, p. 33.

37. Founded by Mani (216–276 CE, Babylon), Manichaeism is an Iranian religion that originated in the Sasanian period. It is a syncretic and dualistic religion combining elements of Zoroastrian, Christian and gnostic thoughts. It spread over a large area between China and Roman Empire.

38. The traveller Niebuhr confirms that some of the Shamsanis of this region joined the Yezidis in the eighteenth century, see C. Niebuhr, *Travels through Arabia and other countries in the East* (Edinburgh, 1792), p. 315. Some Shamsanis converted also to Christianity. A small group remained loyal to their own beliefs and practiced it in secret until a very recent time in Urfa (Edessa) and Mardin in Eastern Turkey. They worshipped the Sun from which their name 'Shams' derives. They worshipped three times a day in a temple where is located an idol of the sun (C. Çayır & M. C. Yıldız & İ. Gönenç, 'Kaybolmaya Yüz Tutan Bir Anadolu Dini Topluluğu: Şemsiler/Harrânîler', *Makalelerle Mardin* IV (2007), p. 169).

39. Al-Jabiri, *Stability and Social Change*, p. 146.

40. Al-Jabiri, *Stability and Social Change*, p. 101.

41. Kreyenbroek, *Yezidism*, p. 129.

42. His well-known disciples were ʿOmar b. Muhammad al-Maʾdanī, Abū Muhammad ʿAbd Allāh al-Dimashqī, Abūʾl Fatḥ Naṣr b. Ridwān b. Marwān al-Darānī, ʿAli Hamīdī Shibānī, Abūʾl Barakāt ibn Maʾdān al-Iraqī, so on. See Azzavi, quoted by Lescot, *Enquête*, p. 34.

43. See details for the seizure of monastery by Adī II and his execution by Mongols in the Syriac text, translated and published by Tfinkdji in Nau &Tfinkdji, 'Recueil de textes', pp. 190–93.

44. There is a second source, a poetic hymn composed by a Nestorian bishop of Arbil, Isho'yahb bar Mqadam, who lived in the fifteenth century, too, talks about the occupation of the monastery of Mar-Yuḥanan by 'Adī. See Nau and Tfinkdji, 'Recueil de texts', pp. 190–91; M. N. Siouffi, 'Notice sur le Cheikh Adi et sur la secte des Yézidis', *JA* 8 (1885), 5: 82; J. M. Fiey, *Assyrie Chrétienne: contribution à l'étude de l'histoire et de la géographie ecclésiastiques et monastiques du nord de l'Iraq* 2 vols (Beirut, 1965), II: 801–806.

45. Kreyenbroek, *Yezidism*, p. 31.

46. Al-Hafiz al-Dhahabī, *Siyar al-Alam*, 23: 223; Ibn Taymiyya, 'Al-Risāla al-'adawīyya', I: 300.

47. This is not the same book that is known as *Kitāb-i Cilvê*, the book of the revelation in the modern Yezidis.

48. Lescot, *Enquête*, p. 34.

49. Sharaf Khan Bidlisī, *Chèref-nâmeh ou fastes de la nation kourde*, trans. F. B. Charmoy, 4 Vols (St. Petersburg, 1868–75), II: 67–68.

50. G. Leiser, 'Zankids', *Medieval Islamic Civilisation* 2 (2006): 873.

51. Fuccaro, *The Other Kurds: Yazidis in Colonial Iraq* (London, 1999), p. 46.

52. Lescot, *Enquête*, p. 102; D. Patton, *Badr al-Din Lu'lu' Atabeg of Mosul, 1211–1259* (Seattle/London, 1991), p. 65.

53. Lescot, *Enquête*, p. 36. However, Patton gives the date of 644/1245 for his execution. See Patton, *Badr al-Din Lu'lu'*, p. 65. Sheikh Ḥasan's tomb is located next to Sheikh 'Adī's tomb in the pilgrimage centre of the Yezidis at Lalish.

54. Quoted by Kreyenbroek, *Yezidism*, p. 31.

55. Ibn Taymiyya, 'Al-Risāla al-'adawīyya', p. 300, quoted by Lescot, *Enquête*, p. 39.

56. Sharaf Khan Bidlisī, *Chèref-nâmeh*, II: 67–68.

57. Al-Jabiri, *Stability and Social Change*, p. 101.

58. See for information about this discussion Al-Jabiri, *Stability and Social Change*, p. 148.

59. Bar Hebraeus, *Chronicon Syriacum*, p. 498, quoted by Nau and Tfinkdji, 'Recueil de Textes', p. 194.

60. Bar Hebraeus, *Chronicon Syriacum*, p. 498, quoted by Nau and Tfinkdji, 'Recueil de Textes', p. 194.

61. Lescot, *Enquête*, pp. 103–104.

62. Lescot, *Enquête*, p. 104, Bois, 'Les Yézidis', p. 214.

63. For the architectural particularities of this complex see Blair, 'Sufi Saints and Shrine Architecture in the Early Fourteenth Century', *Muqarnas* 7 (1990): 36–40.

64. There is also another mausoleum attributed to Zeyn al-Dīn in Ba'shîqe. However, this is only a memorial building. See for its description, B. Açıkyıldız, *Patrimoine des Yézidis: Architecture et 'Sculptures funéraires' en Irak, en Turquie et en Arménie* (Paris, 2006), I: 159.

65. A. Taymūr, *El Yazīdiyya wa mansā' niḫlatihim* (Cairo, 1347), quoted by Lescot, *Enquête*, p. 106.

66. Fuccaro, *The Other Kurds*, p. 10.

67. Lescot, *Enquête*, pp. 110–11.

68. T. Bois, 'Les Yézidis: essai historique et sociologique sur leur origine religieuse', *Al-Machriq* 55 (1961): 217.

69. This incident was described by Al-Maqrīzī (d. 1442). See the details in his *al-Sulūk li-Ma'rifa Duwal al-Mulūk* (Cairo, 1943–72), quoted by Kreyenbroek, *Yezidism*, pp. 34–35.

70. See for other Kurdish emîrs and tribes who allied with Turcomens in this era, A. Khachatrian, 'The Kurdish Principality of Hakkariya (14th–15th centuries)', *Iran and the Caucasus* 7 (2003): 46–48, 55.

71. Sharaf Khan Bidlisī, *Chèref-nâmeh*, I/II: 135.

72. See the detailed information about the relations between Ottoman rulers and Kurdish emîrates, H. Özoğlu, 'State-Tribe Relations: Kurdish Tribalism in the 16th and 17th century Ottoman Empire', *British Journal of Middle Eastern Studies* 23 (1996), pp. 5–27.

73. Sharaf Khan Bidlisī, *Chèref-nâmeh*, II: 69.

74. See the French translation by F. B. Charmoy: Sharaf Khan Bidlisī, *Chèref-nâmeh ou fastes de la nation kourde*, 4 vols (St. Petersburg, 1868–75).

75. Sharaf Khan Bidlisī, *Chèref-nâmeh*, II/I: 168–77.

76. Sharaf Khan Bidlisī, *Chèref-nâmeh*, I/II: 28.

77. Sharaf Khan Bidlisī, *Chèref-nâmeh*, II/I: 129–33.

78. Sharaf Khan Bidlisī, *Chèref-nâmeh* II/I: 159.

79. Sharaf Khan Bidlisī, *Chèref-nâmeh*, II/I: 160–61.

80. Sharaf Khan Bidlisī, *Chèref-nâmeh*, II/I: 167.

81. Sharaf Khan Bidlisī, *Chèref-nâmeh* II/I: 165.

82. Sharaf Khan Bidlisī, *Chèref- nâmeh*, II/I: 168.

83. This manuscript is in the Ali Emiri Library in Istanbul. It is about the Ottoman attacks against the Yezidis of Van in the beginning of the eighteenth century. It was translated into modern Turkish by Faiz Demircioğlu and published on the site of Avrasya Etnografya Vakfi with the title of 'Van'da Yezidilerle Kanlı Savaşlar / Sanguinary Battles with the Yezidis in Van'. See http://www.angelfire.com/or3/etnografya/depo1/yazma.htm (consulted on 5 July 2006).

84. Sharaf Khan Bidlisī, *Chèref-nâmeh*, II/I: 169.

85. Lescot, *Enquête*, p. 114.

230 *The Yezidis*

86. Lescot, *Enquête*, p. 118.
87. Prime Ministry Ottoman Archives, Sadaret Mektubî Kalemî Muhimme Kalemî (Odası) Belgeleri (BBA, A.MKT.UM: 140/23).
88. BBA, A.MKT.MH: 351/6; BBA, A.MKT.MH: 499/2.
89. BBA, A.MKT.UM: 143/65.
90. Lescot, *Enquête*, p. 123.
91. Guest, *Survival among the Kurds*, p. 56.
92. M. Axworthy, *The Sword of Persia Nader Shah from Tribal Warrior to Conquering Tyrant* (London/New York, 2006), p. 252.
93. Lescot, *Enquête*, p. 123.
94. See http://www.angelfire.com/or3/etnografya/depol/yazma.htm for more details of the war between Yezidis and the governor of Van, the Ottoman manuscript 'Van'da Yezidilerle Kanlı Savaşlar/Sanguinary Battles with the Yezidis in Van'.
95. Lescot, *Enquête*, p. 124.
96. H. Southgate, *Narrative of a tour through Armenia, Kurdistan, Persia, and Mesopotamia* 2 vols (London, 1811), I: 220; J.S. Buckingham, *Travels in Mesopotamia* (London, 1827), I: 116–333; C. J. Rich, *Narrative of a Residence in Koordistan and on the Site of Ancient Nineveh*, 2 vols (London, 1836), II: 68–122; M. B. Poujoulat, *Voyage en l'Asie mineure, en Mésopotamie, à Palmyre, en Syrie, en Palestine et en Egypte* (Paris, 1840), pp. 355–71; Ainsworth, *Travels and Researches in Asia Minor, Mesopotamia, Chaldea and Armenia*, 2 vols (London, 1842), II: 181–94; A. H. Layard, *Nineveh and Its Remains: With an Account of a Visit to the Chaldeans Christians of Kurdistan, and the Yezidis, or Devil-worshippers, and an Enquiry into the Manners and Arts of the Ancient Assyrians*, 2 vols (London, 1854), pp. 147–325; Baron Von Haxthausen, *Transcaucasia: Sketches of the Nations and Races between the Black See and the Caspian* (London, 1854), pp. 253–63; G. L. Bell, *Amurath to Amurath* (London, 1924), pp. 269–88; E. B. Soane, *To Mesopotamia and Kurdistan in Disguise* (St Helier, 1926), pp. 101–105; W. B. Seabrook, *Adventures in Arabia Among the Bedouins, Druses, Whirling Dervishes and Yezidee Devil-worshippers* (New York, 1927), pp. 289–334.
97. G. Padre Raffaello Campanile, a Dominican missionary, was one of the first Europeans to give a detailed account about Yezidis of Sinjar. See Campanile, *Histoire du Kurdistan* (Paris, 2004); E. T. A. Wigram, *The Cradle of Mankind: Life in Eastern Kurdistan* (London, 1914), pp. 87–110.
98. Yezidis were documented in various departments of the Prime Minister Ottoman Archives (BOA): see Hatt-ı Hümayûn (HAT), Meclis-i Vükelâ Mazbataları (M.V.), Muhaberât-ı Umumiye İdaresi Belgeleri (DH.MUİ: 31–32/27), Sadaret Mektubî, Kalemî Muhimme Kalemî (Odası) Belgeleri (A.MKT.MHM), Yıldız Esas Evrakı (YEE), Yıldız Mütenevvi Mâruzat Evrâkı (YMTV).
99. Guest, *Survival among the Kurds*, p. 63.
100. Guest, *Survival among the Kurds*, p. 64.

101. Guest, *Survival among the Kurds*, p. 68.
102. Lescot, *Enquête*, p. 125.
103. Guest, *Survival among the Kurds*, pp. 108–109.
104. Kreyenbroek's English translation is used here, Kreyenbroek, Yezidism, pp. 6–7.
105. *Bamiyye* means okra.
106. Guest, *Survival among the Kurds*, p. 122.
107. Fuccaro, *The Other Kurds*, p. 33.
108. Guest, *Survival among the Kurds*, p. 132.
109. The Prime Minister Ottoman archive of Muhaberāt-ı Umumiye İdaresi Belgeleri (DH.MUİ: 31–32/27) gives the date of 1890 for this incident. However, Lescot (*Enquête*, p. 126) and Guest (*Survival among the Kurds*, p. 134) cite the date of 1892.
110. Lescot, *Enquête*, p. 127.
111. Guest, *Survival among the Kurds*, p. 135.
112. Muhaberāt-ı Umumiye İdaresi Belgeleri (DH.MUİ: 31–32/27). This document was sent by the Yezidi authorities to Ottoman court in Istanbul in order to reoccupy the sanctuary of Sheikh 'Adī from Ottomans who had converted it to a madrasa in the nineteenth century.
113. Fuccaro, *The Other Kurds*, pp. 90–91.
114. McDowall, *A Modern History*, p. 59.
115. This school was called Imperial School for Tribes (Aşiret Mekteb-i Humayun). It was a five-year boarding school that admitted boys between twelve and sixteen years old and it ran for fifteen years from 1892 to 1907. For more detailed information about this school see Eugene L. Rogan, 'Aşiret Mektebi: Abdülhamid II's School for Tribes (1892–1907), IJMES 28 (1996), p. 83.
116. McDowall, *A Modern History*, p. 59.
117. Although Milli tribe is a confederation, formed mostly by the Kurmanji speakers of Kurds, there were also various ethnical and religious background people such as Arabs, Turks, 'Alevis and Yezidis.
118. Guest, *Survival among the Kurds*, p. 140.
119. Serhat is a region that embraces the cities of Kars, Ardahan, Erzurum, Ağrı, Van, Bitlis and Muş.
120. J. Flint, *The Kurds of Azerbaijan and Armenia* (London, 1998), p. 77; Kendal, 'The Kurds in the Soviet Union' in Gerard Chaliand (ed.) *People without a Country the Kurds and Kurdistan*, trans. M. Pallis (London, 1978), p. 222; İ. Ch. Vanly, 'The Kurds under Imperial Russia' in P. Kreyenbroek & S. Sperl (eds) *The Kurds: a Contemporary Overview* (London, 1992), pp. 193–218. However, Russian sources permit us to know that still a small group of Yezidi community was living in and around Kars until the First World War. See İ. Ortaylı, *Çarlık Rusyası Döneminde Kars* (Istanbul, 1978), p. 348. The documents, found in the Prime Minister Ottoman Archives also show the presence of the Yezidis in the end of the nineteenth century in the cities of Doğu

232 *The Yezidis*

Beyazıd, Van, Muş, Siirt, Diyarbakir, Viranşehir and Midyat. See the documents A.MKT.MHM: 200/55, 281/54, 495/21; A.MKT.UM: 292/21; DH.EUM.THR: 5/29; DH.MKT: 1356/35; I.MVL: 286/11312.

121. Fuccaro, *The Other Kurds*, p. 57.
122. Guest, *Survival among the Kurds*, p. 142.
123. Guest, *Survival among the Kurds*, pp. 176–92.
124. Fuccaro, *The Other Kurds*, p. 49.
125. Guest, *Survival among the Kurds*, p. 180.
126. Fuccaro, *The Other Kurds*, p. 91.
127. Fuccaro, *The Other Kurds*, p. 92.
128. Mcdowall, *A Modern History*, pp. 178–80.
129. R. Olson, 'The Kurdish Rebellions of Sheikh Said (1925), Mt. Ararat (1930), and Dersim (1937–38): Their Impact on the Development of the Turkish Air Force and on Kurdish and Turkish Nationalism', *Die Welt des Islams* 40 (2000): 1: 67–94.
130. Hajo Agha is considered as a Yezidi also by Fuccaro and Van Bruinessen. See Fuccaro, *The Other Kurds*, pp. 128–29; M. Van Bruinessen, *Agha, Shaikh and State. The Social and Political Structure of Kurdistan* (London, 1992), p. 101.
131. Khoybun had branches in Damascus, Aleppo, Hasaka in Syria, and it was active in Mardin, Diyarbakir, Silvan and Siirt in Turkey; in Kerkuk, Suleimania, Zakho, Rowanduz and Baghdad in Iraq. See N. Fuccaro, 'Kurds and Kurdish Nationalism in Mandatory Syria: Politics, Culture and Identity' in Abbas Vali (ed.) *Essays on the Origins of Kurdish Nationalism* (California, 2003), p. 193; Vanly, 'The Kurds in Syria and Lebanon', p. 197.
132. Isma'il Beg Chol was the brother of Mayan Khatun who claimed to be the mîr of the Yezidi community after the death of Mîr Ali Beg (1913). However, Mayan Khatun gained the support of religious classes, tribal chiefs and notables and petitioned the Ottoman government in favour of his son Said Beg. Ottomans then appointed young Said as mîr under the guard of Mayan Khatun. Thus, Isma'il Beg Chol had to move to Sinjar, where he resided during the British Mandate (1920–32). However, Isma'il Beg tried to get support from local tribesman of Sinjar as well as British authorities and Yezidi community of Transcaucasia to realise his dream becoming the mîr. He was also in relationship with the members of the Kurdish nationalist organisation, Khoybun in Syria, see for more information about Isma'il Chol in Guest, *Survival among the Kurds*, pp. 176–90.
133. S. B. Yalkut, *Melek Tavus'un Halkı Yezidiler* (Istanbul, 2001), p. 27.
134. McDowall, *A Modern History*, p. 192.
135. See the details in Guest, *Survival among the Kurds*, p. 190.
136. Guest, *Survival among the Kurds*, p. 191.
137. McDowall, *A Modern History*, p. 329.
138. I. Dulz, S. Hajo, E. Savelsberg, 'Persecuted and Co-opted – The Yezidis in the New Iraq', *The Journal of Kurdish Studies* VI (2008), p. 25.

Notes 233

139. G. Black, *Genocide in Iraq: The Anfal Campaign against the Kurds* (Human Rights Watch, 1993), pp. 112–17.
140. S. Maisel, 'Social Change amidst Terror and Discrimination: Yezidis in the New Iraq', *The Middle East Institute Policy Brief* 18 (2008), p. 3.
141. Dulz, *Die Yeziden im Irak: Zwischen Musterdorf und Vertreibung* (Hamburg, 2001), p. 97.
142. Allison, *The Yezidi Oral Tradition*, p. 30.
143. McDowall, *A Modern History*, pp. 380–81.
144. Maisel, 'Social Change amidst Terror and Discrimination', p. 5.
145. I. Barir, 'The Yezidis of Iraq: An Endangered Minority', *Telaviv Notes* (30 August 2007), p. 1.
146. The main Yezidi villages of this region are Bafilûn, Erse Qibar, Cdede, Karabash, Kefir Zet, Borc al-Qas, Bosufan and Gundê Mezin.
147. McDowall, *A Modern History*, p. 466.
148. Bar Hebraeus, *Chronicon Ecclesiasticum*, pp. 220–22.
149. Sharaf Khan Bidlisī, *Chèref-nâmeh*, II: 67–68.
150. Sharaf Khan Bidlisī, *Chèref-nâmeh*, II: 67.
151. H. Lammens, 'Le Massif du Ğabal Sim'an et les Yézidis de Syrie', *Mélanges de l'Université de St. Joseph* 2 (1907): 378.
152. Sharaf Khan Bidlisī, *Chèref-nâmeh*, II: 69.
153. Lescot, *Enquête*, p. 207.
154. Sharaf Khan Bidlisī, *Chèref-nâmeh*, II: 70.
155. P. Perdrizet, 'Documents du XVIIe siècle relatifs aux Yézidis', *BSGE* (1903): 281–306, 429–45.
156. Lescot, *Enquête*, p. 212.
157. Niebuhr, *Travels through Arabia*, p. 315.
158. Fuccaro, 'Kurds and Kurdish Nationalism', p. 147.
159. Mcdowall, *A Modern History*, p. 469.
160. Fuccaro, 'Ethnicity, State Formation', p. 569.
161. Mcdowall, *A Modern History*, p. 471.
162. Mcdowall, *A Modern History*, p. 476.
163. Transcaucasia is the south part of the Caucasus region which includes whole modern Armenia, Azerbaijan and the majority of Georgia.
164. The Shaddadids are the ancestors of Saladin, the Kurd.
165. V. Minorsky, *Studies in Caucasian History* (Cambridge, 1953), p. 34; H. Kennedy, *The Prophet and the Age of the Caliphates: The Islamic Near East from the Sixth to the Eleventh Century* (London/New York, 1986), p. 251.
166. Lescot, *Enquête*, p. 117.
167. A. R. Ghassemlou, 'Kurdistan in Iran', in G. Chaliand (ed.) *A People Without a Country: The Kurds and Kurdistan* (London, 1978), p. 205.

168. There is no written source to identify its authenticity, but members of Hasanli tribe gave this account of their ancestor to Marietta Shaginian, who visited the Yezidis of Armenia in the beginning of the twentieth century, quoted by Guest, *Survival among the Kurds*, p. 198.

169. L. Pashaeva, 'Yezidi Social Life in the former USSR', paper presented at *The Workshop Integration of Trans-national Communities: Yezidi Kurds and 'Alevis in Germany* (Berlin, July 1999).

170. Kendal, 'The Kurds in the Soviet Union', p. 222.

171. McDowall, *A Modern History*, p. 492.

172. Ş. Akiner, *Islamic Peoples of the Soviet Union* (London, 1986), p. 209.

173. See Pashaeva, 'Yezidi Social Life'.

174. Guest, *Survival among the Kurds*, p. 194.

175. See his account about the Yezidi tribes of Armenia, Haxthausen, *Transcaucasia*, pp. 253–63.

176. Flint, *The Kurds of Azerbaijan and Armenia*, p. 4.

177. Pashaeva, 'Yezidi Social Life'; Flint, *The Kurds of Azerbaijan and Armenia*, p. 77; Kendal, 'The Kurds in the Soviet Union', p. 222; Vanly, 'The Kurds under Imperial Russia', pp. 193–218.

178. Most of the horse sculptures found in the Yezidi villages of this region are broken today. According to the inhabitants, they were destroyed during this war.

179. Guest, *Survival among the Kurds*, p. 197.

180. Vanly, 'The Kurds under Imperial Russia', p. 206.

181. Pashaeva, 'Yezidi Social Life'.

182. The term of *Xwedê* is a derivation from New Persian *xudây*. Other variations also designate God, such as *xudavend, rebb, ellah, êzdân* (from new Persian *yazdân-god*). See Kreyenbroek, *Yezidism*, pp. 92, 94.

183. This Heptad of seven holy beings also exists in Zoroaster's teaching. In Zoroastrian tradition, Ahura Mazdā creates six divinities of Amesha Spenta and forms a Heptad with himself. See Boyce, *Zoroastrians Their Religious Beliefs and Practices* (London/ Boston/ Melbourne/ Henley, 1979), p. 21.

184. Joseph, *Sacred Books*, p. 147.

185. Kreyenbroek, *Yezidism*, p. 226.

186. Guest, *Survival among the Kurds*, p. 210.

187. Lescot, *Enquête*, p. 47.

188. *Khas* is Arabic while *mêr* is Kurdish which indicates the incarnation of a holy being.

189. Kreyenbroek, *Yezidism*, p. 83.

190. Guest, *Survival among the Kurds*, p. 210.

191. Kreyenbroek, *Yezidism*, p. 102

192. Although each of the banners that I examined looked more like a cock than a peacock, the Yezidis call them peacock-shaped banners.

193. See whole hymn in Kreyenbroek, *Yezidism*, pp. 245–47.

194. See the whole text of *Mishefa Resh* in Guest, *Survival among the Kurds*, p. 210.

195. Guest, *Survival among the Kurds*, pp. 208–210.

196. Qur'ān: xviii. 48, quoted by E. W. Lane, *Arabian Society in the Middle Ages* (London, 1987), p. 30.

197. Joseph, *Devil Worship*, p. 149.

198. Badger, *The Nestorians*, p. 127.

199. See the Armenian source of Eznik of Kolb of fifth-century, quoted by Kreyenbroek, *Yezidism*, p. 60; n. 123.

200. Kreyenbroek, *Yezidism*, p. 60.

201. The Book of Revelation, part 4, No. 8, quoted by Guest, *Survival among the Kurds*, p. 210.

202. E.B. Soane, *To Mesopotamia and Kurdistan in Disguise* (London, 1926), f.n. 2.

203. Asatrian & Arakelova, 'Malak-Tāwūs', pp. 31–32.

204. Lescot, *Enquête*, p. 52.

205. W. Swartz, *Ibn al-Jawsi's kitāb al-quṣṣāṣ wa'l-mudhakkirin* (Beirut, 1971), p. 211, quoted by Asatrian and Arakelova, 'Malak-Tāwūs', p. 31.

206. W. Montgomery Watt, *Islam and the Integration of society* (London, 1961), p. 172.

207. Asatrian and Arakelova, 'Malak-Tāwūs', p. 31.

208. L. Jung, 'Fallen Angels in Jewish, Christian and Mohammedan Literature. A Study in Comparative Folklore', *The Jewish Quarterly Review* 16 (1925): p. 45.

209. Satan has several names in the Judaism: the angel of death, Samael and Ashmedai.

210. Ahl-e Ḥaqq is an extreme sect of Shi'ite Islam in the provinces of Luristan, Kurdistan, and Azerbaijan in western Iran. They also live in Kerkuk and Suleimania in northern Iraq. They venerate for 'Ali, whom they consider to be divine, and for his descendant Imams.

211. Asatrian and Arakelova, 'Malak-Tāwūs', pp. 23–24.

212. C. E., Jackson, *Peacock* (London, 2006), pp. 88–89.

213. J. Chevalier and A. Gheerbrant, *Dictionnaire des symboles* (Paris, 1974), pp. 352–53.

214. K. Erdmann, *Der Kunst Irans zur Zeit der Sasaniden* (Berlin, 1943), fig. 44; F. S. Kleiner & C. J. Mamiya, *Gardener's Art Through the Ages* (Orlando, 2001), p. 39; Fr. Sarre, *Die Kunst des alten Persien* (Berlin, 1922), pl. 103.

215. C. J. Brunner, 'Sasanian Seals in the Moore Collection: Motive and Meaning in Some Popular Subjects', *Metropolitan Museum Journal* 14 (1979), p. 34.

216. Jackson, *Peacock*, p. 92.

217. E. Parman, 'Bizans Sanatında Tavus Kuşu İkonografisi', *Güner İnal'a Armağan* (Ankara, 1993), p. 388.

218. The altar panel of Saint Applinare Nuovo in Ravenna, dated to the sixth century AD, a marble parapet panel dated to the sixth century found in Bode Museum in Berlin, a sarcophagus of the eight century, found in Pavia Museum, Iconostasis panel of the

Church of Santa Maria Assunta in Torcello isle in Venedik dated eleventh century are some examples for this composition in Byzantine art.

219. Jackson, *Peacock*, pp. 92–93.

220. Two peacocks drinking sacred water are depicted on the drum of the Church of T'anativank' Siounie (1273–79). Another peacock is shown in profile on the façade of the Church of Kat'olike of Surb Gelard (1215). See P. Donabédian & J. M. Thierry, *Civilisation et art arméniens* (Paris, 1987), p. 250.

221. Donabédian & Thierry, *Civilisation et art arméniens*, p. 262.

222. See for the iconography of the peacock in the Muslim tradition A. Daneshvari, *Medieval Tomb Towers of Iran: An Iconographical Study* (Lexington, 1986), p. 48; A. Daneshvari, 'A Preliminary Study of the Iconography of the Peacock in Medieval Islam', in Robert Hillenbrand (ed.) *The Art of the Saljūqs in Iran and Anatolia* (Edinburgh, 1994), p. 192; N. Green, 'Ostrich Eggs and Peacock Feathers: Sacred Objects as Cultural Exchange between Christianity and Islam', *Al-Masāq* 18 (2006), p. 56; F. Viré ane E. Baer, 'Tāwūs, Tā'ūs', *EI* (CD-ROM Edition), pp. 1–3.

223. Very well-known example for funerary architecture is the mausoleum of Kharraqan I (1067–68) in Iran.

224. Daneshvari, *Medieval Tomb Towers of Iran*, pp. 47–50.

225. The expulsion of Adam and Eve from Paradise is depicted in several sixteenth-century Ottoman miniatures. Some of them are following: Nişaburi, *Kısas-ı Enbiye*, TSMK B.250, 36a, ca. 157; Fuzuli, *Hadikatü's Süella*, TIEM 1967, 19b, ca. 159; Kalendar Pasha, *Falname*, TSMK H. 1703, 7b, 1614.

226. M.J. Yāhaqqī, *Farhang-e asātir va ešārāt-e dāstānī dar adabiyyāt-e fārsī* (Tehran, 1369/1991), pp. 292–93, quoted by Asatrian and Arakelova, 'Malak-Tāwūs', p. 27.

227. Lane, *Arabian Society*, pp. 31–32.

228. Quoted by Asatrian and Arakelova, 'Malak-Tāwūs', p. 26.

229. V. Dastgardī (ed.), *Sharaf-nāma* (Tehran, 1936), p. 256, quoted by Daneshvari, *Medieval Tomb Towers of Iran*, p. 51.

230. Takhtadji (woodcutter) is the name of a Turkish nomad group of Anatolia who are 'Alevi.

231. See Lescot, *Enquêtes*, p. 50; Bois, 'Les Yézidis Essai historique', p. 205.

232. M. Siouffi, 'Les Traditions des Yézidis' in F. Nau and J. Tfinkdji, 'Recueil de textes', p. 248.

233. This tradition is also cited by Kreyenbroek, *Yezidism*, p. 37.

234. Lescot, *Enquête*, p. 60; Al-Jabiri, *Stability and Social Change*, p. 325; Kreyenbroek, *Yezidism*, p. 95.

235. Al-Sam'ānī, quoted by Frayha, 'New Yezīdī Texts', p. 20.

236. Ibn Taymiya, 'Al-Risāla al-'adawīyya', t. I, p. 300.

237. Ibn Taymiya, 'Al-Risāla al-'adawīyya', t. I, pp. 299–302.

238. Kreyenbroek, *Yezidism*, p. 37.

239. Yāqūt al-Ḥamawī, Mu'jam al-Buldān, t. 5, p. 28.
240. Ibn al-'Athir, Al-Kāmil fi al-Tarīkh, quoted by Nau and Tfinkdji, 'Recueil de textes', p. 150.
241. Ibn Khallikān, Wafiyāt al-A'yān, t. 3, pp. 254–55; t. 4, p. 163.
242. Ibn Taymiyya, 'Al-Risāla al-'adawīyya', p. 300.
243. Al-Hafiz al-Dhahabī, Siyar al-Alam, t. 20, p. 344.
244. Ibn Kathīr, Al-Bidaya wa al-Nihaya, t. 12, p. 243.
245. Al-Hafiz al-Dhahabī, Siyar al-Alam, 20: 344; Ibn Kathīr, Al-Bidaya, 12: 243; Ibn Khallikān, Wafayat, 4: 163.
246. Lescot, Enquête, p. 22.
247. Kitab al-manaqib al-Shaikh 'Adi b. Musāfir (Berlin MS We 1743) fols: 1a–2b, quoted by Guest, Survival among the Kurds, p. 17.
248. These manuscripts were analysed and published by Rudolf Frank in his Scheikh 'Adī, der grosse Heilige der Jezîdîs (Berlin, 1911), Turkische Bibliothek, vol. 14.
249. Lescot, Enquête, pp. 25–26.
250. Lescot, Enquête, pp. 27–28.
251. See the whole text of the Hymn of Sheikh 'Adī in Guest, Survival among the Kurds, pp. 212–14.
252. Z.B. Aloine, 'Sheikh 'Adi, Sufism and the Kurds', Lêkolîn 7 (2000): 127.
253. Equally, the majority of the Sunni Kurds adhere to the Shafi'i school.
254. Sheikh 'Adī was reffered as from Hakkari (al-Hakkarî) in a letter in 1111, which is the date of al-Ghazālī's death. It means that he was already in the Kurdish region by this date. See L. Bouvat, 'A Propos des Yézidis', Revue du monde musulman 28 (1914): 344; Kreyenbroek, Yezidism, p. 40, n.13.
255. Aloine, 'Sheikh 'Adi', p. 122.
256. These Sufi Kurds listed by Lescot namely Abū Bekir Ibn 'Abd al-Hamīd es Shibānī al-Khabbāzī, Abū Muhammad es Shunbokî, Suweyd es Sinjarī, 'Ali b. Wahhāb es Sindarī, Matar al-Bādirānī, Mājid al-Kurdī, Lescot, Enquête, p. 24.
257. Aloine, 'Sheikh 'Adi', p. 122.
258. Kreyenbroek, Yezidism, p. 38.
259. Al-Jabiri, Stability and Social Change, p. 146.
260. Lescot, Enquête, pp. 28–29.
261. Guest, Survival among the Kurds, pp. 210–11.
262. Guest, Survival among the Kurds, pp. 211.
263. M.J.B. Chabot 'Notice sur les Yézidis', JA 7 (1896), p. 119.
264. Lescot, Enquête, pp. 58–59.
265. This myth of Flood is mentioned in the manuscript (with numbers of 306 and 324), found in the National Library (Bibliothèque nationale) in Paris. These Syriac manuscripts were translated and published by M.J.B. Chabot. See Chabot 'Notice sur les Yézidis', p. 119.

266. 'Eyn Sifni is a Yezidi town in Sheikhan region in northern Iraq where mîr and baba sheikh reside.

267. Mount of Sinjar is located in northern Iraq in the Syrian border.

268. This mountain is located in the south-east of modern Turkey.

269. These libraries are the Berlin Library, Library of the University of Leeds (Syr. MS. N°7); Paris National Library (BN. Syr. MS. 306); Library of Dara Attar of Kent and Library of Yildiz Palace in Istanbul.

270. Mollah Haydar was an Adani sheikh who was the only person authorised to read and write in that epoch. He was also a trainer of Yezidi religious singers, the qewwals, in Ba'shîqe. He became an informant to many researchers such as Nicolas Siouffi. Siouffi published his article on the Yezidi community in 1882 with provided information from Mollah Haydar (N. Siouffi, 'Notice sur la secte des Yézidis', *JA* 7 (1882): 20: 252–68.

271. Nau and Tfinkdji, 'Recueil de texte', p. 156.

272. Quoted by Lescot, *Enquête*, p. 122.

273. Forbes heard of the *Mishefa Resh* containing Yezidis' laws and precepts when he visited Sinjar in 1838 and he was told that Sheikh 'Adî was its author. See F. Fobes, 'A visit to the Sinjar Hills in 1838, with some Account of the Sect of Yezidis and of Various Places in the Mesopotamian Desert between the Tigris and Khabur', *JRGSL* 9 (1939): 424.

274. This manuscript was published by Samuele Giamil in 1900. See S. Giamil, *Monte Singar: Storia di un Popolo Ignoto* (Rome, 1900), pp. 72–94.

275. Guest, *Survival among the Kurds*, p. 152.

276. O.H. Parry, *Six Months in a Syrian Monastery* (London, 1885), pp. 374–80.

277. I. Joseph, 'Yezidi Texts', *The American Journal of Semitic Languages and Literatures* 25 (1909): 111–56; 218–54.

278. M.S.E. Anastase, 'La découverte récente des deux livres sacrés des Yézidis', *Anthropos* 6 (1911): 1–39.

279. A. Mingana, 'Devil-worshippers: Their Beliefs and Their Sacred Books', *JRAS* (1916), pp. 508–509; Kreyenbroek, *Yezidism*, p. 14.

280. Kreyenbroek, *Yezidism*, p. 15.

281. Mingana, 'Devil-worshippers', p. 509.

282. See for the whole text of the *Kitêb-i Cilvê* and the *Mishefa Resh* in Guest, *Survival among the Kurds*, pp. 208–210; Parry, *Six Months in a Syrian Monastery*, pp. 374–80; Frayha, 'New Yezidi Texts', pp. 23–26; R.Y. Ebied and M. Young, 'An Account of the History and Rituals of the Yazidis of Mosul', *Le Muséon* 85 (1972): 481–522.

283. These are small balls formed from the earth of the sanctuary mixed with the water of Zemzem. They are considered sacred and are distributed to pilgrims during ceremonies and festivals, including for marriage. They are believed to bring good fortune to the possessor and to protect him from the evil eye.

284. Lescot, *Enquête*, p. 70.
285. The hymn of the 'Weak Broken One' mentions Lalish:

> Afterwards, country forty years:
> The earth did not become solid,
> Until Lalish came down into (the world)
> When Lalish came,
> Plants grew on earth.
> How many things were adorned by them!
> (Kreyenbroek, *Yezidism*, p. 175)

286. 'Site of Truth'

> My King mounted his horse,
> The King and all four friends,
> Together they travelled the four corners,
> They stopped at Lalish, saying,'This is the site of Truth'
> (Kreyenbroek, *Yezidism*, p. 175)

287. Kreyenbroek, *Yezidism*, p. 56.
288. Kreyenbroek, *Yezidism*, p. 88, n. 76.
289. *Charshemiya Sor* (Red Wednesday) is still celebrated by most Kurds and Persians, in which the last Wednesday of the last month of the Iranian calendar year, which derives from Zoroastrian celebration calendar. It originally concerns a rite to drive out the demons. It is believed that the Red Wednesday is the unhappiest day of the year. See for more information about this day in Iran, H. Massé, *Croyances et coutumes persanes* (Paris, 1938), pp. 148–59. Çarşemiya Sor marks also the arrival of spring and revival of nature. The celebration usually starts in the evening. On this occasion people make bonfires on the streets and jump over them.
290. This ceremony, like others, has not been performed since 2003 for the security of Yezidi pilgrims.
291. *Oglama* means circumambulation in Kurdish and *tawaf* is in Arabic.
292. Lescot, *Enquête*, p. 103.
293. *Salât* is an Islamic prayer rituel. Therefore, some of Yezidis, in particular, the members of Shamsani lineage refuse to accomplish this Islamic ceremony.
294. Al-Jabiri, p. 92.
295. Kreyenbroek, *Yezidism*, p. 78.
296. A festival called *Cejna 'Erafat* derives its name from the celebration performed on this mountain.
297. Al-Sam'ānī quoted by Frayha,'New Yezīdī Texts', p. 20.
298. Fuccaro, *The Other Kurds*, p. 46.
299. Patton, *Badr al-Din Lu'lu'*, p. 65.
300. Lescot *Enquête*, p. 102; Patton, *Badr al-Din Lu'lu'*, p. 65.

301. There are several legends about sacred places in Sinjar. See the creation of Sinjar Mountain and its mausoleums, mentioned in Lescot, *Enquête*, p. 78.
302. Kreyenbroek, *Yezidism*, p. 122.
303. Lescot, *Enquête*, pp. 78–80.
304. Lescot, *Enquête*, p. 247.
305. Fuccaro, *The Other Kurds*, p. 10.
306. Flint, *The Kurds of Azerbaijan and Armenia*, p. 77; Kendal, 'The Kurds in the Soviet Union', p. 222; Vanly, 'The Kurds under Imperial Russia', pp. 193–218.
307. Lescot, *Enquête*, p. 250.
308. A. Taşgın, 'Yezidiler Becirmanier Karaçiler', *Makalelerde Mardin Önemli Simalar Dini Topluluklar* IV (2007): 187–88.
309. Al-Sam'ānī quoted by Frayha 'New Yezīdī Texts', p. 20.
310. The qewwals are the religious musicians who live in Beḥzanê/Ba'shîqe. They receive a strict and severe religious instruction during their childhood and adolescence. With their sacred instruments, the tambourine *'def'*, tambour and flute, as well as the banners of Tawûsî Melek *'tâwusgerrân'*, they go on missions throughout Kurdish regions in order to revive the Yezidi faith to people and recite the sacred hymns, *qewls*. They also participate to important Yezidi ceremonies with their instruments and collect donations intended for the mîr.
311. Kreyenbroek, *Yezidism*, pp. 226–27.
312. This spring takes its name from the well of Zamzam in Mecca. After the death of Sheikh 'Adī, his followers turned *qibla* from Mecca towards Lalish. Other features of the Meccan religious landscape are also found in the valley: the bridge of Sirat (*Pira Silat*), the mountain of 'Arafat (*Chiyayê 'Erafat*), and a black stone (*Kevirê resh*).
313. Badger, *The Nestorians*, p. 105.
314. Berezin was the first one to draw the ground plan of the sanctuary in 1843. According to his plan, there is a second row of five vaults located in front of the outer wall, approximately in the centre of the courtyard. He also shows another vault next to the main northern entrance, Berezin, 'A Visit to the Yezidis in 1843', p. 71. He calls these 'open rooms'. In Bachmann's plan, open vaults are shown on the northern and southern sides of the outer courtyard. He also shows a wall, with a door in its centre, closing the western side of the courtyard, Bachmann, *Kirchen und Moscheen*, p. 9.
315. Derîyê Mîr means the 'Door of the Prince'. According to Kreyenbroek Derîyê Mîr might mean 'Door of Mithra' that corresponds to the Zoroastrian term *Dar (b)-e Mehr*, a place where are celebrated important rituals, Kreyenbroek, *Yezidism*, p. 89, n. 98.
316. That is to say 'door of the door'. *Derî* means 'door' in Kurdish, and *kapi* also means 'door' in Turkish. It is known equally as *Qapîya Miraza* and *Qapîya Sheikh 'Adî*. Badger drew the ancient portal of Derîyê Kapî in 1849 and the façade of the western wall of the assembly hall which faces to the inner courtyard. According to

his details, in this epoch, the portal has a semi-circular arch. The doorjambs are decorated with a kind of simple arabesque. There is an Arabic inscription in three pieces. Two big and three small medallions are represented between the inscription and the semi-circular arch. Moreover, there are five medallions with vegetal motifs, located above the portal. A black serpent is represented on the right side of portal, which is in different shape than the actual one that we have today. On the wall next to the portal, three hooked sticks, a torch, two combs, a couple of lions and two couples of birds, one animal alike a pig and two medallions are also noticed, Badger, *The Nestorians*, p. 107. The photograph of Bell, taken in 1911, justifies, less or more, the drawing of Badger, Bell, *Amurath to Amurath*, p. 273. According to Bachmann, the frame of this door, in origin, has a decoration of tracery. On the top, there is an ornament of frieze of rings, an Arabic inscription and frieze of rosettes. In his opinion, the technique of this ornament is typically from Mosul, Bachmann, *Kirchen und Moscheen*, p. 13.

317. A couple of lion is also represented on the door of the mausoleum of Sheikh Abū Bekir in Mem Shivan.

318. The tympanum of the door is occupied by a carving in low relief consisting of two radiant sun motifs, flanking an Arabic inscription:

بسم الله الرحمن الرحيم
خالق السماوات والأرض
احفظ هذا المنزل
محل شيخ عادي الموقر
شيخ (المقام الاول) ٦٩٥

In the name of God,
the Merciful and Compassionate,
Creator of heaven and earth
Protect this house (*hādhā l-manzil*)
The place (*mahall*) of the venerable Sheikh ʿAdī, 695 (1295)

319. However, in the plans of Badger and Empson there are only five semi-circular niches, Badger, *The Nestorians*, p. 108; Empson, *The Cult of the Peacock Angel*, p. 12.

320. Bachmann, *Kirchen und Moscheen*, p. 15.

321. Layard, *Nineveh and Its Remains*, p. 283 saw the 'Ayat al-Kursī' of the Qurʾan on the sarcophagus of Sheikh Adī, but that no longer exists. Contemporary Yezidis try to erase all connections with Islam by destroying such inscriptions.

322. Abū Bekir is one of Sheikh Ḥasan's sons.

323. Chilekhane means the 'place of penitence'. This place probably was reserved for spiritual, solitary and contemplative retirement of the ʿAdawi sheikhs during the time of Sheikh ʿAdī.

324. The description of Berezin of the wall is as follows: '... The simple arabesques surrounding the door are cut relatively badly. On the right side of the entry, in

addition to two circles, is carved a serpent with some animal above it, a torch, an axe, a large comb, three Arab staffs, two saucers, and two animals resembling dogs, between which is a cross' [Berezin, 'A Visit to the Yezidis in 1843' in H. Field (ed.) *The Anthropology of Iraq* (Cambridge, 1951), p. 69]. The same wall was drawn by the British missionary and by orientalist Badger, who shows a horizontal serpent, three hooked sticks, an axe, a torch, two combs, an animal that resembles to a pig in a circle; two dogs between which is a cross, two birds, two star medallions and two other birds above the portal [Badger, *The Nestorains*, p. 107]. The British diplomat and archaeologist Layard [Layard, *Niniveh and Its Remains*, p. 283] describes: 'On the lintels of doorway are rudely carved a lion, a snake, a hatchet, a man, and a comb. The snake is particularly conspicuous....' Guérinot portrays a serpent, two dogs, two birds, a lion, two combs and a kind of broken-head [Guérinot, 'Les Yézidis', *Revue du Monde Arabe* 5 (1908): 613]. According to Bachmann, the carvings on the façade are made in low relief and depict numerous rings, daggers, hooked sticks and animals. The most striking is the black serpent [Bachmann, *Kirchen und Moscheen*, p. 13].

325. The image of serpent is also represented on the façade of several Yezidi mausoleums in northern Iraq, such as the mausoleums of Sheikh Amadīn in Sinjar, of Sheikh Mand Pasha in Beḥzanê, Kabartu and Sinjar as well as the mausoleum of Sheikh Abū Bekir in Mem Shivan. After the description of Drower [E. S. Drower, *Peacock Angel; Being Some Account of Votaries of a Secret Cult and Their Sanctuaries* (London, 1941), pp. 161–63], we also learn that the mausoleums of Sheikh Nasr al-Dīn and Sheikh Shams at Lalish were including the image of serpent next to the door which do not exist nowadays.

326. The Yezidis identify this object as *kevgîr* – skimmer.

327. There was an Arabic inscription on this stone, but it was destroyed recently by the Yezidis.

328. The monastery of Mar-Yuḥanan and of Isho' Sabran was founded in the end of seventh century by these two saints, Nau and Tfinkdji, 'Recueil de Textes', p. 188, note 1.

329. Kreyenbroek, *Yezidism*, p. 31.

330. Nau and Tfinkdji, 'Recueil de Textes', pp. 185–96.

331. Nau and Tfinkdji, 'Recueil de Textes', p. 190.

332. Nau and Tfinkdji, 'Recueil de Textes', pp. 190–91; Siouffi, 'Notice sur le Cheikh Adi', p. 82; Fiey, *Assyrie Chrétienne*, pp. 801–806.

333. Nau and Tfinkdji, 'Recueil de Textes', p. 195.

334. We can also think of the castle of the mîr in Ba'adrê occupied by the family of mîr during the centuries which is in ruin nowadays. Moreover, Fiey thinks that it is the *mazār* of Dākā Tshak which is located in Maqlūb, Fiey, *Assyrie Chrétienne*, p. 805.

335. Guest, *Survival among the Kurds*, p. 235, n. 40; Kreyenbroek, *Yezidism*, p. 31.

336. Kreyenbroek, *Yezidism*, p. 31.

Notes 243

337. Berezin, 'A Visit to the Yezidis in 1843', p. 72.
338. Bachmann, *Kirchen und Moscheen*, p. 15.
339. After having a discussion with the director of Museum of Mosul, who was doing research on the Yezidis, and who also knew the works on local Muslim history and was an expert in Sufism, they decided together that it was a mosque, Fiey, *Assyrie Chrétienne*, p. 814.
340. In fact, there are six niches and two of them in the southern wall have windows.
341. See Demeersaman, *Nouveau regard sur la voie spirituelle d'Abd al-Qâdir al Jilânî et sa tradition* (Paris, 1988), p. 22.
342. The order of Qadiriyya was found by a 'Hanbali Sufi, 'Abd al-Qādir al-Jīlānī (1077–1166) with who Sheikh 'Adī made his pilgrimage to Mecca. Al-Jīlānī is a highly respected Sufi by the Yezidis and there is a mausoleum, attributed to him among the Yezidi edifices in Sinjar.
343. N. Muhamad Amen, *Les Englises et Monastères du 'Kurdistan irakien' à la veille et au lendemain de l'Islam* (Saint-Quentin en Yvelines, 2001), p. 354.
344. Al-Dhahabī, *Siyar al-Alam*, 20: 344.
345. Ibn Kathīr, *Al-Bidaya*, 12: 243.
346. Ibn Khallikān, *Wafayat*, 3: 254.
347. Mithraism, an ancient Roman religion, was established in approximately 67 AD and lasted until the fourth century AD.
348. P. M. Edwell, *Between Rome and Persia the Middle Euphrates, Mesopotamia and Palmyra under Roman Control* (Oxford and New York, 2008), pp. 125–28.
349. See D. Ulansey, *The Origins of the Mithraic Mysteries Cosmology & Salvation in the Ancient World* (Oxford, 1989), pp. 3–7; P. Turner & Coulter, C. R., *Dictionary of Ancient Deities* (Oxford, 2001), p. 325.
350. Tritton, 'Adī b. Musāfir al-Hakkārī, Shaykh 'Adī', *EI* (CD-ROM Edition), p. 1.
351. Lescot, Enquête, p. 102. see Al-Maqrīzī, *Al-Sulūk li-Ma'rifa Duwal al-Mulūk* (Cairo, 1943–72), quoted by Kreyenbroek, *Yezidism*, pp. 34–35.
352. Al-Maqrīzī, *Al-Sulūk li-Ma'rifa Duwal al-Mulūk* (Cairo, 1943–72), quoted by Kreyenbroek, *Yezidism*, pp. 34–35.
353. The first disciples who arrived with Sheikh 'Adī, are said to have numbered about forty. It is believed that they became known as pîrs, Lescot (Lescot, *Enquête*, p. 90). Their descendants occupied the same position by traditional right, and this may well be the origin of the caste system in Yezidi society. Modern Yezidi society has three castes: sheikhs, pîrs and murîds.
354. Berezin, 'A Visit to the Yezidis in 1843', p. 69.
355. See the Prime Minister Ottoman archive of Muhaberât-ı Umumiye İdaresi Belgeleri (DH.MUİ: 31–32 /27).
356. Empson described the same doorway in 1928, Empson, *The Cult of the Peacock Angel*, p. 122. His description indicates that the doorway was reconstructed between 1911

and 1928. The pieces of the ancient portal are now located in the south façade of the mausoleum of Sheikh Ḥasan. Five medallions decorated with geometric and floral patterns, a skimmer and a poniard may be seen.

357. Mêr is a Kurdish word that signifies 'man'.

358. A. Uluçam, *Irak'taki Türk Mimarlık Eserleri* (Ankara, 1989), p. 235.

359. The mausoleum of Muntasir (d. 862), known as Qubbat al-Sulaybiyya at Samarra, is the first Islamic mausoleum which presents an octagonal plan. Zumurud Khatun (1193), Imam Hadid and Najm al-Dīn at Baghdad, Muhammad al-Sakran (1268) between Baghdad and Ba'quba, Maqam al-Shams at Hilla, Awlad Sayyid Ahmad al-Rifa'i at Haditha and Qubbat Willada at Sinjar are well known octagonal mausoleums in Iraq. For more details see T. Al-Janabi, *Studies in Medieval Iraqi Architecture* (Baghdad, 1982), p. 216.

360. Mausoleum of Emîr Saltuk (mid-twelfth century) in Erzurum, mausoleum of Han Cami (1188–89) in Kayseri, mausoleum of Sitte Melik (1196) in Divriği and mausoleum of Kalender Baba in Konya are among the many examples of Anatolian architecture with an octagonal plan. For more examples, see H. Önkal, *Anadolu Selçuklu Türbeleri* (Ankara, 1996), pp. 19–182. Mausoleum of Hüdavent Hatun (1312) in Niğde, mausoleum of Ali Cafer (fourteenth century) in Kayseri, mausoleum of Mehmed Bey (1377) in Antalya are examples of Beylik architecture. See G. Öney, *Beylikler Devri Sanatı XIV–XV. Yüzyıl (1300–1453)* (Ankara, 1989), pp. 20–21.

361. R. Hillenbrand, *Islamic Architecture Form, Function and Meaning* (Edinburgh, 1994), p. 281.

362. Hillenbrand, *Islamic Architecture*, p. 290.

363. Badr al-Dīn Lu'lu' attacked the 'Adawis because of the fear of a Kurdish revolt, killed and imprisoned many Kurds. They captured their chief, Sheikh Ḥasan and decapitated him in 1254. See Patton, *Badr al-Din Lu'lu'*, p. 65.

364. D. Patton, 'Badr al-Din Lu'lu' and the Establishment of a Mamluk Government in Mosul', *Studia Islamica* 74 (1991): 91.

365. Al-Janabi, *Studies in Medieval*, p. 53.

366. O. Arik, 'Erken Devir Anadolu-Türk Mimarisinde Türbe Biçimleri', *Anadolu* 11 (1967): 75–76; O. Aslanapa, *Türk Sanatı* II (Istanbul, 1967), pp. 133, 136–37.

367. Y. Tabbaa, 'The Muqarnas Dome: Its Origin and Meaning', *Muqarnas* 3 (1985), pp, 72.

368. Al-Janabi, *Studies in Medieval*, p. 237.

369. O. C. Tuncer, *Anadolu Kümbetleri* I (Ankara, 1986), p. 261. The starry conical dome of the mausoleum of Baladji Khatun, displaying the square plan, stands on a dram which is also in the form of a star.

370. D. N. Wilber, *The Architecture of Islamic Iran* (Princeton, 1955), p. 62.

371. Donabédian and Thierry, *Civilisation et arts arméniens*, p. 480.

372. For more information about Badr al-Dīn Lu'lu', see Patton, 'Badr al-Din Lu'lu' and the Establishment', p. 82; D. S. Rice, 'The Brasses of Badr al-Dīn Lu'lu', *BSOAS* 13 (1950): 3: 627.

Notes 245

373. The conics of the mausoleums of Abdurrahman and Imam Yayha ibn al-Qasim possess twelve, Imam Bahir sixteen and Imam 'Awn al-Dīn twenty-two ribs.
374. Al-Janabi, *Studies in Medieval*, pp. 96–105.
375. Önkal, *Anadolu Selçuklu Türbeleri*, pp. 343–55.
376. Al-Samanī quoted by Frayha, 'New Yezīdī Texts', p. 20.
377. Fuccaro, *The Other Kurds*, p. 46.
378. Drower, *Peacock Angel*, pp. 161, 163.
379. Turner & Coulter, *Dictionary of Ancient Deities*, p. 325.
380. Sharaf Khan Bidlisī, *Chèref-nâmeh*, I/2, pp. 25–27.
381. J. Pedersen, 'Adam', *EI* (CD-ROM Edition), p. 2.
382. The fruit is usually grape, fig or wheat.
383. Even though we are far from identifying these basins, it can be supposed that they were used by the 'Adawis during the ceremonies and rites.
384. Drower, *Peacock Angel*, pp. 161–62.
385. There are other two Yezidi mausoleums in this village, called Shamsa Feqra and Melik Sheikh Sīn that also present square conic domed plan.
386. S. Ögel, *Anadolu Selçukluları'nın Taş Tezyinatı* (Ankara, 1987), p. 110.
387. The origin of this building is in discussion. It is mostly considered as a mausoleum in origin, completed between the beginning of fourteenth and mid-sixteenth centuries by Ayyubid Sultan Suleiman who ruled Ḥiṣn Kayfā. See A. Uluçam, 'Eyyübi Mimarisi ve Sanat Tarihimizdeki Yeri', *Haçlı Seferlerinin 900. Yıldönümünde Uluslararası Selâhaddin-i Eyyubî Sempozyumu* (Diyarbakır, 1997), p. 257.
388. A. Gabriel, *Voyages archéologiques dans la Turquie orientale* I (Paris, 1940), p. 67; II: pl. XLIV.
389. Gabriel, *Voyages archéologiques*, II: pl. XLVI, 7.
390. Sheikhh Muhammad is the son of Sheikh Nasr al-Dīn from the lineage of Shamsani. He is known for his courageous fight against the great Sheikh (Kreyenbroek, *Yezidism*, p. 120).
391. These are the mausoleums of Pîr Bûb, Sheikh Babik, Sheikh Sicadīn, Sheikh Shams, Sheikh Zeyn al-Dīn, Sitt Hecici and Sitt Habibi.
392. See similar constructions used during the Zoroastrian rituals in Iran, M. Boyce, *A Persian Stronghold of Zoroastrianism* (Oxford, 1987), p. 89; fig. IVa.
393. In Kreyenbroek, *Yezidism*, p. 71.
394. *Iwān* is an architectural form in Mesopotamia and Iran. It is a vaulted space walled on three sides; the fourth is left entirely open. This form appeared for the first time at the Parthian Empire era (247 BC–224 AD) and was developed by the Sassanians (224 to 651 AD). Later, it was adopted by Muslim architects to their own buildings in Mesopotamia, Iran and Anatolia. In Islamic time, it was particularly used in madrasa architecture. *Iwān* is a very well-known form in Yezidi architecture as well.
395. J. Gierlichs, *Mittelalterliche Tierreliefs in Anatolie und Mesopotamien* (Tübingen, 1996), pl. 59.4.

396. For these tombstones see B. Karamağaralı, *Ahlat Mezar Taşları* (Ankara, 1992), p. 30; fig. 130.

397. H. Laqueur, 'Dervish Gravestones' in Raymond Lifchez (ed.) *The Dervish Lodge: Architecture, Art, and Sufism in Ottoman Turkey* (Berkeley, 1992), pp. 284–95.

398. I carried out research mainly in the villages of Avshin, Derik, Riya Teze, Elegez and Sipan in the region of Aragatsotn. However, according to the people of these villages, there are also in Camushlu, Mirak, Sangvar and Nigavan in the same region.

399. This sculpture is not displayed any more in the Erzurum Archaeology Museum. See for the description and photography of this tombstone B. Karamağaralı, *Ahlat Mezar Taşları* (Ankara, 1992), p. 37.

400. For Armenians crosses (*khatchkars*) see, L. Azarian, 'L'art dei khatchkar/The Art of Khatchkars', *Documents of Armenian Architecture* 2 (1969): 3–55; L. Azarian, *Armenian Khatchkars* (Ejmiatsin: Mayr At'or, 1973).

401. B. Nikitine, *Les Kurdes étude sociologique et historique* (Paris, 1956), p. 183.

402. Marco Polo, *Travels of Marco Polo* (London, 1908), p. 42.

403. Campanile, *Histoire du Kurdistan*, p. 109.

404. I met personally two Christian Kurds. The first was the sacristan of Saint Antoine Church at Beyoğlu in Istanbul, who was from Diyarbakir. It was in 1995, when I was preparing my master's thesis on the Ottoman Neo-gothic Style. The second Christian Kurd whom I met in Birmingham in 1999 was from Erzincan.

405. See Karamağaralı, *Ahlat Mezar Taşları*, p. 37.

406. H. Koşay, 'Les Statues de belier se trouvant dans les cimetières historiques en Anatolie orientale', *First International Congress of Turkish Art* 6 (1959): 217.

407. Bachmann, *Kirchen und Moscheen*, p. 8; pl. 9.

408. T. Sili, 'Iğdır Karakoyunlu İlçe Mezarlığındaki Deve-Heykel Mezartaşının Mahiyeti', *Vakiflar Dergisi* 27 (1998): 191–94.

409. See Karamağaralı, *Ahlat Mezar Taşları*, p. 36; fig. 170–71; A. Alpago-Novello, *Art and Architecture in Medieval Georgia* (Louvain-la-Neuve, 1980), p. 156.

410. H. F. Seferli, 'Nahçivan'da Taştan Yapılmış Koç ve Koyun Heykelleri', *Türkler* 8 (2002): 229.

411. See the description and the images of these tombstones in Danık who believes they are originally from the Central Asia. E. Danık, *Koç ve Koyun Şeklindeki Tunceli Mezar Taşları* (Ankara, 1993), pp. 62–65, 108–16.

412. There are numerous examples, mostly rams but also ewes in Ardahan, Kars, Iğdır, Erzurum, Erzincan, Tunceli, Hozat, Pertek, Nazmiye, Van, Çaldıran, Erciş, Ahlat, Bitlis, Muş, Başkale and Yüksekova in this region.

413. Tanavoli states the presence of ram sculptures in the villages surrounding the city of Tabriz. See P. Tanavoli, *Lion Rugs: The Lion in the Art and Culture of Iran* (New York, 1985), p. 30.

414. 'Alevis are considered as Shi'ite Muslim and called commonly as Kizilbash (Red Head) and Bektashi. Like the Shi'ite Muslims of the Middle East, they believe in Prophet Imam 'Ali and the twelve Imams. However, they distinguish themselves from the other partisants of 'Ali as certain practices and observances in their faith go back to pre-Islamic period. It is a syncretism of pre-Islamic beliefs, thirteenth-century Sufi Islam of Bektashi and Anatolian beliefs. They compose 20 per cent of the population of Turkey. Their adherents are both Kurds and Turks.

415. I visited many villages around Nazimiye, Hozat, Pertek and Tunceli in this region where I extensively studied a variety of these sculptures which were exclusively ram- and ewe-shaped.

416. Seferli, 'Nahçivan'da Taştan Yapılmış', p. 229.

417. J. Strzygowski, *Die Baukunst der Armenier und Europe* (Wien, 1918), pp. 260–61.

418. A pillar with a sculpture of a lion is found in this neolithic site. See M. Özdoğan and N. Başgelen, *Neolithic in Turkey: The Cradle of Civilisation: New Discoveries* (Istanbul, 1999), vol. II, p. 30, fig. 25.

419. See unpublished dissertation of Khosronejad, P. Khosronejad, *Les Lions en pierre sculptés chez les Bakhtiâri: description and signification de sculptures zoomorphes dans une société tribale du sud-ouest de l'Iran* (Paris, 2007); Tanavoli, *Lion Rugs*, p. 30.

420. Tanavoli, *Lion Rugs*, p. 30. Many examples from the seventeenth century are found also in Shahre Kurd, Chahar Mahal, Bakhtiâri, Shiraz, Kazerun and Yasuj.

421. Tanavoli, *Lion Rugs*, p. 29.

422. Danık, *Koç ve Koyun*, p. 49; Karamağaralı, *Ahlat Mezar Taşları*, p. 37; Seferli, 'Nahçivan'da Taştan', p. 230; M. Haseki, *Plastik Açıdan Türk Mezartaşları* (Istanbul, 1976), p. 17.

423. Karamağaralı, *Ahlat Mezar Taşları*, p. 37.

424. V. V. Ivanov, 'Horse Symbols and the Name of the Horse in Hurrian', in G. Buccellati and M. Kelly-Buccellati (eds) *Urkesh and the Hurrians* (Malibu, 1998), pp. 145–46; R. Hauser, 'The Equids of Urkesh: What the Figurines Say', in G. Buccellati and M. Kelly-Buccellati (eds) *Urkesh and the Hurrians* (Malibu, 1998), p. 63.

425. L. V. Berghe, *Archéologie de l'Iran Ancien* (Leiden, 1958), p. 118; pl. 148.

426. Seferli, 'Nahçivan'da Taştan', p. 228.

427. A. Turani, *Dünya Sanat Tarihi* (Ankara, 1983), p. 76.

428. Nikitine, *Les Kurdes*, p. 45.

429. Nikitine, *Les Kurdes*, p. 47.

430. *Dhikr* is to repeat and chant the ninety-nine names of God to praise him in Islamic mysticism.

431. Lescot, *Enquête*, p. 30; Bois, 'Les Yézidis', p. 210.

432. Yezidi saints listed here are the ones to whom mausoleums or shrines are dedicated; otherwise, Yezidi saints are more numerous.

433. Tfinkdji in Nau&Tfinkdji, 'Recueil de Textes', pp. 190–93.
434. Kreyenbroek, *Yezidism*, p. 121.
435. Kreyenbroek, *Yezidism*, p. 38.
436. Sharaf Khan Bidlisī, *Chèref-nâmeh*, II, pp. 67–68.

Interviews

Interview with the baba sheikh, religious man, Lalish, northern Iraq, 16 April 2002.

Interview with Feqîr Hecî, religious man, Ba'adrê, northern Iraq, 17 April 2002.

Interview with Mîr Kamuran Beg, Ba'adrê, northern Iraq, 17 April 2002.

Interview with Pîr Salî, religious man, Baroj/Talin, Armenia, 10 July 2003.

Interview with Çerkeze Reş, politician, Yerevan, Armenia, 13 July 2003.

Interview with Cemîlê Celîl, daugther of Kurdologist Celîlê Celîl, Yerevan, Armenia, 14 July 2003.

Interview with Feqîr Tayar Keleshî, religious man, Yerevan, Armenia, 15 July 2003.

Interview with Torîna Torîn, doctor/researcher, Gumrî, Armenia, 26 July 2003.

Interview with a group of feqîrs in the village of Karsi, Sinjar, northern Iraq, 08 May 2004.

Interview with Sheikh Hecî Samw Shamsani, religious man, Sinjar, northern Iraq, 09 May 2004.

Interview with Qewwal 'Alî, religious man, Ba'shîqe, northern Iraq, 11 May 2004.

Interview with Kheyrî Bozan, director of Lalîş Culturel Centre, Dohuk, northern Iraq, 15 May 2004.

Interview with Mahmud Kelesh, author-researcher, Afrîn/Aleppo, Syria, 04 June 2004.

Interview with Eyüp Burç, researcher, Ankara, Turkey, 05 August 2004.

Interview with Salah Şahnelî, inhabitant of the village of Burç, Viran Şehir, Turkey, 09 August 2004.

Interview with inhabitants of the village of Koçan, Midyat, Turkey, 11 August 2004.

Bibliography

(i) Archival Sources of the Presidency of the Council in Istanbul

Hatt-ı Hümayûn (HAT)
Meclis-i Vükelâ Mazbataları (M.V.)
Muhaberât-ı Umumiye İdaresi Belgeleri (DH.MUİ)
Sadaret Mektubî Kalemî Muhimme Kalemî (Odası) Belgeleri (A.MKT.MHM)
Yıldız Esas Evrakı (YEE)
Yıldız Mütenevvi Mâruzat Evrâkı (YMTV)

(ii) Historic Sources

Al-Hafiz al-Dhahabī. *Siyar al-Alam al-Nubala*, 25 vols (Beirut: Mu'assasat al-Risala, 1983).

Bar Hebraeus, G. *Chronicon eccelesiasticum*, 3 vols (Louvain: Abbeloos et Lamy, 1872–77) —— *Chronicom Syriacum* (Paris: P. Bedjan, 1890).

Hadji Khalfa. *Kashfal-zunun 'an asami 'l-kutub wa'l-funun dans Lexicon bibliographicum*, G. Fluegel (ed.) (London: 1845).

İbn al-'Athir. *Al-Kāmil fi al-Tarīkh*, 13 vols (Beirut: Tornberg, 1965).

İbn Kathīr. *Al-Bidaya wa al-Nihaya*, vol. 12 (Beirut: Maktabat al-Ma'arif, 1932).

İbn Khallikān. *Wafiyāt al-A'yān wa-Anba' Abna' al-Zamān*, 8 vols (Beirut: Daru's-Sadr, 1978).

İbn Taymiyya. 'Al-Risāla al-'adawīyya', in *Majmū' al-Rasā'il al-Kubra*, vol. 1 (Cairo, 1906), pp. 262–317.

Ramischo. *Texte Syriaque*, trans. J. Tfinkdji, Revue d'Oriental Chrétien (1915/17): 146–44; 172–242.

Sharaf Khan Bidlisī. *Chèref-nâmeh ou fastes de la nation kourde*, trans. F. B. Charmoy, 4 vols (St. Petersburg, 1868–75).

Yāqūt al-Ḥamawī. *Mu'jam al-Buldān*, vol. 5 (Beirut: Dar al-Fikr, 1814).

(iii) All Other

Açıkyıldız, Birgül, 'À la rencontre des Yézidis', *Passerelles* 30 (2005): 143–58.

—— 'Patrimoine des Yézidis: Architecture et "Sculptures Funéraires" en Iraq, en Turquie et en Arménie', unpublished thesis, University of Paris I Panthéon-Sorbonne (Paris, 2006).

—— 'Le Yézidism, son patrimoine architectural et ses stèles funéraires', *The Journal of Kurdish Studies* VI (2008): 93–103.

—— 'Yezidis', in Richard Lim (ed.) *Another Look at East and Southeast Turkey. A Traveller's Handbook* (Istanbul: GABB, 2009), pp. 324–27.

—— 'The Sanctuary of Shaykh 'Adī at Lalish: Centre of Pilgrimage of the Yezidis', *Bulletin of the School of Oriental and African Studies* 72 (2009): 2: 301–33.

—— 'Sacred Spaces in the Yezidi Religion', in C. Gates, J. Morin, and T. Zimmerman (eds) *Sacred Landscapes in Anatolia and Neighboring Regions* (Oxford: British Archaeological Reports, 2009), pp. 103–112.

Ackermann, Andreas, 'Yeziden in Deutschland von der Minderheit zur Diaspora', *Paideuma* 49 (2003): 157–77.

Ainsworth, Wiliam F., *Travels and Researches in Asia Minor, Mesopotamia, Chaldea and Armenia* (London: John W. Parker, 1842).

—— 'The Assyrian Origin of the Izedis or Yezidis – the so-called 'Devil-worshippers', *Transactions of the Ethnological Society* 1 (1861): 11–44.

—— *A Personal Narrative of the Euphrates Expedition* I (London: Kegan Paul, Trench & Co., 1888).

Akiner, Shirin, *Islamic People of the Soviet Union* (London: Kegan Paul International, 1986).

Akpınar, T., 'Yezidiler Şeytana mı Tapar?', *Tarih ve Toplum Dergisi* 131 (1994): 14–20.

Al-Azzawi, Abbas, 'Notes on the Yezidis', in Henry Field (ed.) *The Anthropology of Iraq* (Cambridge/Massachusetts: Peabody Museum of American Archaeology and Ethnology, 1951), pp. 81–93.

Al-Hadithi, 'Atta and Khaliq, Hana A., *The Conical Domes in Iraq* (Baghdad: Directorate General of Antiquities, 1974).

Al-Jabiri, K. F., *Stability and Social Change in Yezidi Society* (Oxford: Oxford University, unpublished Thesis, 1981).

Al-Janabi, Tariq J., *Studies in Medieval Iraqi Architecture* (Baghdad: Ministry of Culture and Information State Organization of Antiquities and Heritage, 1982).

Allison, Christine, 'Old and New Oral Traditions in Badinan', in Kreyenbroek and Allison (eds) *Kurdish Culture and Identity* (London/New Jersey: Centre of Near and Middle Eastern Studies, 1996), pp. 29–47.

—— *The Yezidi Oral Tradition in Iraqi Kurdistan* (London: Curzon Press, 2001).

Aloiane, Zourabi B., 'The Reconstruction of Šayh Adī B. Musāfir's Biography on the Basis of Arabic and Kurdish Sources', *The Arabist, Budabest Studies in Arabic* 18 (1996): 2, 95–104.

—— 'Al Hallaj in Kurdish Tradition', published online ‹http://www.Lalish.de/english/modules.php?name=News&file=article&sid=6› (accessed 22 February 2005).

—— 'Shaikh 'Adi, Sufism and the Kurds', *Lêkolîn* 7 (2000): 105–70.

Alpago-Novello, A., *Art and Architecture in Medieval Georgia* (Louvain-la-Neuve: l'Université catholique de Louvain, 1980).

Amirbekian, Raya, 'Contribution à la question des symboles zoomorphes dans l'art de l'orient (le serpent et le paon)', *Iran and Caucasus* 1 (1997): 147–58.

Anastase, M. S. E., 'La découverte récente des deux livres sacrés des Yézidis', *Anthropos* 6 (1911): 1–39.

Andrews, P. A., 'The Culmination of the Islamic Double Dome Form in Hindustan', in A. M. Issa and T. Ö. Tahaoğlu (eds) *Islamic Art Common Principles, Forms and Themes* (Damascus: Dar al-Fikr, 1989).

Anqosi, Kereme, 'The Yezidi Kurds' Tribes & Clans of South Caucasus', *International Journal of Kurdish Studies* 19 (2005): 1/2: 55–90.

Arakelova, Victoria, 'Sufi Saints in the Yezidi Tradition', *Iran and the Caucasus* 5 (2001): 183–92.

—— 'Healing Practices among the Yezidi Sheikhs of Armenia', *Asian Folklore Studies* 60 (2001): 2: 319–28.

Ardalan, N. and Bakhtiar, L., *The Sense of Unity: The Sufi Tradition in Persian Architecture* (Chicago: University of Chicago Press, 1973).

Arık, Oluş, 'Erken Devir Anadolu-Türk Mimarisinde Türbe Biçimleri', *Anadolu (Anatolia)* XI (1967): 57–100.

—— *Bitlis Yapılarında Selçuklu Rönesansı* (Ankara: Güven Matbaası, 1971).

Aristova, T. F., *19. Yüzyıl ve 20. Yüzyıl Birinci Yarısında Kürtlerin Maddi Kültürü*, trans. İ. Kara and A. Karabağ (İstanbul: Avesta Yayınları, 2002).

Asatrian, Garnik and Arakelova, Victoria, 'Malak-Tāwūs: The Peacock Angel of the Yezidis', *Iran and the Caucasus* 7 (2003): 1–36.

Aslanapa, Oktay, *Türk Sanatı* II (İstanbul: Milli Eğitim Basımevi, 1973).

'Attar, Farîd-ûd-dîn, *Le Langage des Oiseaux*, trans. Garcin de Tassy (Paris: Editions Albin Michel, 1996).

Auld, Sylvia, 'Birds and Blessings: A Kohl-pot from Jerusalem', in Bernard O'Kane (ed.) *The Iconography of Islamic Art, Studies in Honour of Robert Hillenbrand* (Edinburgh: Edinburgh University Press, 2005), pp. 1–19.

Avdal, Amina, *Life of Kurds in Caucasia* (Yerevan, 1957).

Awn, Peter J., *Satan's Tragedy and Redemption: Iblis in Sufi Psychology* (Leiden: E.J. Brill, 1983).

254 *The Yezidis*

Awwad, Gurgis, 'Historical and Geographical Researches in the Region East of Mosul', *Sumer* 17 (1961): 43–99.

—— 'Bibliographie Yézidi', *Al-Machriq* 63 (1969): 673–708.

Axworthy, Michael, *The Sword of Persia Nader Shah from Tribal Warrior to Conquering Tyrant* (London/New York: I.B.Tauris, 2006).

Aydın, Mehmet, 'Yezidiler ve İnanç Esaslari', *Belleten* 52 (1988): 923–53.

Azarian, Levon, 'L'art dei khatchkar/The Art of Khatchkars', *Documents of Armenian Architecture* 2 (1969): 3–55.

—— *Armenian Khatchkars* (Ejmiatsin: Mayr At'or, 1973).

Bachmann, Walter, *Kirchen und Moscheen in Armenien und Kurdistan* (Leipzig: J.C. Heinrichs'sche Buchhandlung, 1913).

Badger, George P., *The Nestorians and Their Rituals: With the Narrative of a Mission to Mesopotamia and Coordistan I* (London: Joseph Masters, 1852).

Barir, Idan, 'The Yezidis of Iraq: An Endangered Minority', *Telaviv Notes* (30 August 2007): 1–5.

Baudouin, Bernard, *Le Soufisme: l'Exigence de la perfection* (Paris: De Vecchi, 1996).

Baydaş, Özden G., *Tillo'daki Mimari Eserler* (Ankara: T.C Kültür Bakanlığı Eserleri, 2002).

Bell, Gertrude L., *Amurath to Amurath* (London: Macmillan and Co., 1924).

Bennigsen, C. A., 'Les Kurdes et la Kurdologie en Union soviétique', *Cahier du Monde Russe et Soviétique* III (1960): 513–30.

Berezin, I., 'A Visit to the Yezidis in 1843', in Henry Field (ed.) *The Anthropology of Iraq* (Cambridge/Massachusetts: Peabody Museum of American Archaeology and Ethnology 1951), pp. 67–80.

Berghe. L. Vanden, *Archéologie de l'Iran Ancien* (Leiden: E.J. Brill, 1959).

Bilge, Mahmut, *Yezidiler: Tarih – İbadet – Örf ve Adetler* (Ankara: Kalan Yayınları, 2002).

Binder, H., *Au Kurdistan, en Mésopotamie et en Perse* (Paris, 1887).

Bird, Isabella L., *Journeys in Persia and Kurdistan (1831–1904): Including a Summer in the Upper Karun Region and a Visit to the Nestorian Rayahs* (London: Muray, 1891).

Blache, P. V. and Gallois, L., *Géographie Universelle* VIII (Paris: Librairie Armand Colin, 1929).

Black, George, *Genocide in Iraq: The Anfal Campaign against the Kurds* (Human Rights Watch, 1993).

Blair, Sheila S., 'Sufi Saints and Shrine Architecture in the Early Fourteenth Century', *Muqarnas* 7 (1990): 35–49.

Blair, Sheila S. and Bloom, Jonathan M., *The Art and Architecture of Islam 1250–1800* (New Haven and London: Yale University Press, 1994).

Bois, Thomas, 'Les Yézidis et leur culte des morts', *Cahiers de l'Est* 2 (1947): 1: 52–58.

—— 'Les Yézidis: Essai historique et sociologique sur leur origine religieuse', *Al-Machriq* 55 (1961): 109–28; 190–242.

—— *Connaissance des Kurdes* (Beirut: Khayats, 1965).

—— 'Monastères chrétiens et temples yézidis dans le Kurdistan Irakien', *Al-Machriq* 61 (1967): 75–103.

Bois, Thomas and Minorsky, Vladimir, 'Kurds and Kurdistan', *Encyclopaedia of Islam* (Leiden: E.J. Brill CD-ROM Edition, 2005).

Bournoutian, George A., 'The Ethnic Composition and the Socio-economic Condition of Eastern Armenia in the first half of the nineteenth Century', in Ronald Grigor Suny (ed.) *Transcaucasia Nationalism and Social Change Essays in the History of Armenia, Azerbaijan, and Georgia* (Michigan: University of Michigan, 1983), pp. 69–86.

Bouvat, L., 'A Propos des Yézidis', *Revue du Monde Musulman* 28 (1914): 339–46.

Boyce, Mary, *A History of Zoroastrianism* I (Leiden/Köln: E.J. Brill, 1975).

—— *A Persian Stronghold of Zoroastrianism* (Oxford: Clarendon Press, 1977).

——*Zoroastrians: Their Religious Beliefs and Practices* (London/Boston/Melbourne/ Henley: Routledge & Kegan Paul, 1979).

Brown, T. Burton, *Excavations in Azarbaijan, 1948* (London: John Murray, 1951).

Bruinessen, Martin van, 'The Impact of the Dissolution of the Soviet Union on the Kurds', Paper presented at *the international conference on Islam and Ethnicity in Central Asia* (St. Petersburg, 14–18 October, 1995).

—— 'Religion in Kurdistan', *Kurdish Times* 4 (1991): 1–2, 5–27.

—— 'The Qadiriyya and the lineages of Qadiri Shaykhs in Kurdistan', *Journal of the History of Sufism* 1 (1999): 213–29.

—— 'Kurdistan in the 16th and 17th centuries, as Reflected in Evliya Çelebi's Seyahatname', *The Journal of Kurdish Studies* 3 (2000): 1–11.

—— *Agha, Shaikh and State. The Social and Political Structure of Kurdistan* (London/New Jersey: Zed Books, 1992).

Brunner, Christopher J., 'Sasanian Seals in the Moore Collection: Motive and Meaning in Some Popular Subjects', *Metropolitan Museum Journal* 14 (1979), pp. 33–50

Buckingham, J. S., *Travels in Mesopotamia* (London: H. Colburn, 1827).

Cahen, Cl., 'Lu'lu', Badr al-Dīn Abu'l Fadā'il al-Malik al-Ra īm', *Encyclopaedia of Islam* (Leiden: E.J. Brill CD-ROM Edition, 2005).

Campanile, R. P. G., *Histoire du Kurdistan*, trans. T. Bois (Paris: Institut Kurde de Paris/ L'Harmattan, 2004).

Çay, M. Abdulhaluk, *Andolu'da Türk Damgası: Koç Heykel-Mezar Taşları ve Türklerde Koç-Koyun Meselesi* (Ankara: Türk Kültürünü Araştırma Enstitüsü, 1983).

Çayır, C., Yıldız, M.C. and Gönenç, İ., 'Kaybolmaya Yüz Tutan Bir Anadolu Dini Topluluğu: Şemsiler / Harraniler', *Makalelerle Mardin* IV (2007): 162–76.

Celil, Celil, *XIX. Yüzyıl Osmanlı İmparatorlugu'nda Kürtler* (Ankara: Özge Yayınları, 1992).

Chabot, M. J. B., 'Notice sur les Yézidis, publiée d'après deux manuscrits syriaques de la Bibliothèque nationale', *Journal Asiatique* 7 (1896): 100–32.

Chaliand, Gerard, *A People without a Country: The Kurds and Kurdistan*, trans. M. Pallis (London: Zed Press, 1978).

Chevalier, J. and Gheerbrant, A., *Dictionnaire des symboles: Mythes, rêves, coutumes, gestes, formes, figures, couleurs, nombres* (Paris: Ed. Seghers et Jupiter, 1974).

Cholet, A. P., *Voyage en Turquie d'Asie: Arménie, Kurdistan et Mésopotamie* (Paris, 1892).

Christie Mallowan, Agatha, *La Romancière et l'archéologue: Mes aventures au Moyen-Orient* (Paris: Payot, 1946).

Collins, Andrew, *From the Ashes of Angels the Forbidden Legacy of a Fallen Race* (London: Signet Books, 1997).

Çoruhlu, Yaşar, 'Türk Sanatında Koyun, Koç, Keçi Figürlerinin Sembolizmi', *Türk Dünyası Tarih Dergisi* 100 (1995): 52–60.

—— 'Türk Sanatı'nda at Figürlerinin Sembolizmi', *Türk Dünyası Araştırmaları* 98 (1995): 171–219.

Crowfoot, J. W., 'A Yezidi Rite', *Man* 1 (1901): 245.

Daneshvari, Abbas, *Medieval Tomb Towers of Iran: An Iconographical Study* (Lexington: Mazdā Publishers, 1986).

—— 'A Preliminary Study of the Iconography of the Peacock in Medieval Islam', in Robert Hillenbrand (ed.) *The Art of the Saljūqs in Iran and Anatolia: Proceedings of a Symposium Held in Edinburgh in 1982* (Costa Mesa: Mazdā Publishers, 1994), pp. 192–200.

Danık, Ertuğrul, *Koç ve At Şeklindeki Tunceli Mezartaşları* (Ankara: Türk Kültürü Araştırma Yayınları, 1993).

Demeersaman, André, *Nouveau regard sur la voie spirituelle d''Abd al-Qâdir al Jilânî et sa tradition* (Paris: Librairie Philosophique J. Vrin, 1988).

Dickson, B., 'Journeys in Kurdistan', *The Geographical Journal* 35 (1910): 4: 357–78.

Diez, Ernst, *L'Art de l'Islam* (Paris: Payot, 1966).

Dodd, Erica C., 'On the Origins of Medieval Dinanderie: The Equestrian Statue in Islam', *The Art Bulletin* 51 (1969): 3: 220–32.

D'Ohsson, Mouradgea C., *Histoire des Mongols, depuis Tchinguiz-Khan jusqu'à Timour Bey ou Tamerlan*, 4 vols (La Haye/Amsterdam: Les Frères Van Cleef, 1834–35).

Donabedian, Patrick and Thierry, J. Michel, *Civilisation et arts arméniens* (Paris: Editions Mazenod, 1987).

Driver, G. R., 'An Account of the Religion of the Yezidi Kurds', *Bulletin of the School of Oriental Studies* 2 (1922): 197–213; 509–11.

Drower, E. S., 'The Peacock Angel in the spring', *Journal of the Royal Central Asian Society* 27 (1940): 391–403.

—— *Peacock Angel: Being Some Account of Votaries of a Secret Cult and Their Sanctuaries* (London: John Murray, 1941).

Dulz, Irene, *Die Yeziden im Irak: Zwischen Musterdorf und Vertreibung* (Hamburg: LIT Verlag, 2001).

Dulz, Irene & Hajo, Siamend & Savelsberg, Eva, 'Persecuted and Co-opted – The Yezidis in the New Iraq', *The Journal of Kurdish Studies* VI (2008), pp. 24–43.

Ebied, R. Y. and Young, M., 'An Account of the History and Rituals of the Yazidis of Mosul', *Le Muséon* 85 (1972): 481–522.

Eddé, Anne-Marie, *Saladin* (Paris: Flammarion, 2008).

Edmonds, Cecil J., *A Pilgrimage to Lalish* (London: Royal Asiatic Society, 1967).

Edwell, Peter M., *Between Rome and Persia the Middle Euphrates, Mesopotamia and Palmyra under Roman Control* (Oxford/New York: Routledge, 2008).

Efendi, Rasim, *Decorative and Applied Arts of Azerbaijan (middle aged)* (Baku: Ishyg, 1976).

—— *Stone Plastic Arts of Azerbaijan* (Baku: Ishyg, 1986).

Empson, R. H. W., *The Cult of the Peacock Angel, A Short Account of the Yezîdî Tribes of Kurdistân* (London: H.F. & G. Witherby, 1928).

Erbek, Mine, *Çatalhöyük'ten Günümüze Anadolu Motifleri / Anatolian Motifs from Çatalhöyük to the Present* (Ankara: T.C. Kültür Bakanlığı Yayınları, 2002).

Erdmann, Kurt, *Der Kunst Irans zur Zeit der Sasaniden* (Berlin: F. Kupferberg, 1943).

Esin, Emel, *Turkish Miniature Painting* (Vermont/Tokyo: Rutland, 1960).

Ettinghausen, Richard, '"The Snake-Eating Stag" in the East', in R. Ettinghausen (ed.) *Islamic Art and Archaeology: Collected Papers* (Berlin: Gebr. Mann Verlag, 1984), pp. 272–86.

Ettinghausen, Richard and Grabar, Oleg, *The Art and Architecture of Islam, 650–1250* (Harmondsworth: Penguin, 1987).

Evliya Çelebi, *Gördüklerim* II (İstanbul: İnkılâp ve Aka Kitabevleri, 1977).

Eyüboglu, İ. Zeki, *Anadolu İnançları Anadolu Mitolojisi* (Istanbul: Geçit Kitabevi, 1987).

Fahd, T. and Rippan, A., 'Shaytān', *Encyclopaedia of Islam* (Leiden: E.J. Brill CD-ROM Edition, 2005).

Febvre, M., *Théâtre de la Turquie* (Paris, 1682).

Feqîr Hecî, Bedelê, *Baweri û Mîtolojiya Êzidîyan Çendeha Têkist û Vekolîn* (Dihok: Çapxana Hawar, 2002).

Fergusson, James, *Tree and Serpent Worship or Illustration of Mythology and Art in India* (London: India Museum, 1873).

Field, Henry, *The Anthropology of Iraq* II (Cambridge/Massachusetts: Peabody Museum of American Archaeology and Ethnology, 1951).

Fiey, Jean M., *Mossoul Chrétienne: Essai sur l'histoire, l'archéologie et l'état actuel des monuments chrétiens da la ville de Mossoul* (Beirut: Imprimerie Catholique, 1959).

—— 'A la Recherche des Anciens Monastères du Nord de l'Irak', *Proche-Orient Chrétien* IX (1959): 97–108.

—— 'Le Temple Yezidi de Cheikh Adi', *Proche-Orient Chrétien* X (1960): 205–10.

—— *Assyrie Chrétienne: Contribution à l'étude de l'histoire et de la géographie ecclésiastiques et monastiques du nord de l'Iraq II* (Beirut: Imprimerie Catholique, 1965).

Flint, Julie, *The Kurds of Azerbaijan and Armenia* (London: Kurdish Human Rights Project, 1998).

Forbes, Frederick, 'A visit to the Sinjar Hills in 1838, with some Account of the Sect of Yezidis and of various Places in the Mesopotamian Desert between the Tigris and Khabur', *Journal of the Royal Geographical Society of London* 9 (1939): 409–30.

Frank, R., *Scheikh 'Adī, der grosse Heilige der Jezîdîs* (Berlin: Turkische Bibliothek, 1911), vol. 14.

Frankfort, H., 'A Tammuz Ritual in Kurdistan', *Iraq* 1 (1934): 137–45.

—— 'Two Acquisitions from the Simkhovitch Collection', *Journal of Near Eastern Studies* 5 (1946): 2: 153–56.

Frayha, Anis, 'New Yezīdī Texts from Beled Sinjār, 'Iraq', *Journal of the American Oriental Society* 66 (1946): 18–43.

Fuccaro, Nelida, *The Other Kurds: Yazidis in Colonial Iraq* (London/New York: I.B.Tauris, 1999).

—— 'Ethnicity, State Formation, and Conscription in Postcolonial Iraq: The Case of the Yazidi Kurds of Jabal Sinjar', *International Journal of Middle East Studies* 29 (1997): 559–80.

—— 'Kurds and Kurdish Nationalism in Mandatory Syria: Politics, Culture and Identity', in Abbas Vali (ed.) *Essays on the Origins of Kurdish Nationalism* (Costa Mesa: Mazda Publishers, 2003), pp. 191–217.

Furlani, Giuseppe, 'The Yezidi Villages in Northern Iraq', *The Journal of the Royal Asiatic Society* 15 (1937): 483–91.

—— *The Religion of the Yezidis, Religious Texts of the Yezidis Translation, Introduction and Notes*, trans. J. M. Unvala (Bombay: Jamshedji Maneckji Unvala, 1940).

Gabriel, Albert, *Voyages archéologiques dans la Turquie orientale* (Paris: Boccard, 1940).

Ghassemlou, A. R., 'Kurdistan in Iran', in G. Chaliand (ed.) *A People Without a Country: The Kurds and Kurdistan* (London: Zed Press, 1978).

Giamil, S., *Monte Singar: Storia di un Popolo Ignoto* (Rome, 1900).

Gibb, H. A. R., *The Travels of Ibn B.at.tu.ta A.D. 1325-1354* (Cambridge: Cambridge University Press, 1962).

Gibbs, Josiah W., '*Melek Taus of the Yezidis*', *Journal of the American Oriental Society* 3 (1853): 502–503.

Gierlichs, Joachim, *Mittelalterliche Tierreliefs in Anatolien und Mesopotamien* (Tübingen: E. Wasmuth, 1996).

Gilbert, T., 'Note sur les Sectes dans le Kurdistan', *Journal Asiatique* 7 (1873): 393–95.

Godard, A., 'Les Monuments du Feu', *Athār-é Iran* 3 (1938): 7–80.

—— *L'art de l'Iran* (Paris: Arthaud, 1962).

Golombek, Lisa and Wilber, Donald, *The Timurid Architecture of Iran and Turan* (Princeton: Princeton University Press, 1988).

Grabar, Oleg, 'The Earliest Commemorative Structures, Notes and Documents', *Art Orientalis* IV (1966): 7–46.

Green, Nile, 'Ostrich Eggs and Peacock Feathers: Sacred Objects as Cultural Exchange between Christianity and Islam', *Al-Masāq* 18 (2006): 27–66.

Grégoire, M., *Histoire des sectes religieuse* (Paris: Baudouin Frères Editeurs, 1829).

Guérionot, A., 'Les Yézidis', *Revue du Monde Arabe* 5 (1908): 581–630.

Guest, John S., *Survival among the Kurds: A History of Yezidis* (London/New York: Kegan Paul International, 1993).

Guillemin, J. Duchesne, *Ormazd et Ahriman: L'Aventure dualiste dans l'Antiquité* (Paris: Presses Universitaires de France, 1953).

Haseki, Metin, *Plastik Açıdan Türk Mezar Taşları* (İstanbul: Istanbul Devlet Güzel Sanatlar Akademisi, 1976).

Hasluck, F. W., 'Heterodox Tribes of Asia Minor', *The Journal of the Royal Anthropological Institute of Great Britain and Ireland* 51 (1921): 310–42.

Hauser, Rick, 'The Equids of Urkesh: What the Figurines Say', in G. Buccellati and M. Kelly-Buccellati (eds) *Urkesh and the Hurrians* (Malibu: Undena Publications, 1998), pp. 63–74.

Haxthausen, Baron Von, *Transcaucasia: Sketches of the Nations and Races between the Black Sea and the Caspian* (London: Chapman and Hall, 1854).

Heard, W. B., 'Notes on the Yezidis', *The Journal of the Royal Anthropological Institute of Great Britain and Ireland* 41 (1911): 200–19.

Hillenbrand, Robert, *Islamic Architecture Form, Function and Meaning* (Edinburgh: Edinburgh University Press, 1994).

—— *Islamic Art and Architecture* (London: Thames and Hudson, 1999).

Hoag, John D., *Islamic Architecture* (London: Faber, 1987).

Howey, M. Oldfield, *The Encircled Serpent: A Study of Serpent Symbolism in all Countries and Ages* (London: Rider & Co., 1926).

Huart, C., 'Adī b. Musafir', *Encyclopaedia of Islam* I (1913): 139.

Humphreys, R. Stephen, *From Saladin to the Mongols: The Ayyubids of Damascus, 1193–1260* (Albany: State University of New York Press, 1977).

Hurmî, Heso, *Perêsgeha Lališ* (Bilzen: Drukkerij Eragco N.V., 2002).

İbrahimzade, Kemal and Güzel, Eylem, 'Şahmeran Efsanesi', *Bakü Slavyan Üniversitesi 2. Uluslararası Filoloji Konferansı* (Bakü: Slavyan Üniversitesi, 2007), pp. 400–403.

Ivanov, Vyacheslav, V., 'Horse Symbols and the Name of the Horse in Hurrian', in G. Buccellati and M. Kelly-Buccellati (eds) *Urkesh and the Hurrians* (Malibu: Undena Publications, 1998).

Izady, Mehrdad R., *The Kurds: A Concise Handbook* (Washington: Taylor/Francis, 1984).

Jaba, M. A., *Recueil de notices et récits kourdes servant à la connaissance de la langue, de la littérature et des tribus du Kourdistan* (St. Petersburg, 1860).

Jackson, Christine E., *Peacock* (London: Reaktion Books, 2006).

Jackson. A. V. Williams., *Persia Past and Present* (New York: Macmillan, 1906).

James, Boris, *Saladin et les Kurdes: Perception d'un groupe au temps des Croisades* (Paris: Institut Kurde de Paris/L'Harmattan, 2006).

James, E. O., 'The Tree of Life', *Folklore* 79 (1968): 241–49.

Jarry, Jacques, 'La Yazidiyya: Un vernis d'Islam sur une hérésie gnostique', *Annales islamologiques* VII (1967): 1–20.

Jastrow, Morris, 'Adam and Eve in Babylonian Literature', *The American Journal of Semitic Languages and Literatures* XV (1899): 4: 193–214.

Jaubert, P. Amédée, *Voyage en Arménie et en Perse* (Paris: Pélicier et Nepveu, 1821).

Jettmar, Karl, 'The Slab with a Ram's Head in the Rietberg Museum', *Artibus Asiae* 27 (1964–65): 291–300.

Jobes, Gertrude, 'Peacock', *Dictionary of Mythology, Folklore and Symbols* 2 (1961): 1246–47.

Joseph, Isya, 'Yezidi Texts', *The American Journal of Semitic Languages and Literatures* 25 (1909): 111–56; 218–54.

—— *Devil Worship: The Sacred Books and Traditions of the Yezidis* (Boston: Gorham Press, 1919).

Jung, L., 'Fallen Angels in Jewish, Christian and Mohammedan Literature. A Study in Comparative Folklore', *The Jewish Quarterly Review* 16 (1925): 45–88.

Karamağaralı, Beyhan, *Ahlat Mezar Taşları* (Ankara: Kültür Bakanlığı Yayınları, 1992).

Kelly, Henry A., *Satan: A Biography* (Cambridge: Cambridge University Press, 2006).

Kendal, 'The Kurds in the Soviet Union', in Gerard Chaliand (ed.) *A People without a Country the Kurds and Kurdistan*, trans. M. Pallis (London: Zed Press, 1978), pp. 220–28.

Kennedy, Hugh, *The Prophet and the Age of the Caliphates: The Islamic Near East from the Sixth to the Eleventh Century* (London/New York: Longman, 1986).

Khachatrian, Alexander, 'The Kurdish Principality of Hakkariya (14th–15th centuries)', *Iran and the Caucasus* 7 (2003): 37–58.

Khalid, Sultan, 'Les Monuments islamiques de Mossoul aux XIIe et XIIIe siècles', unpublished thesis, Université de Paris IV (Paris, 1987).

Khosronejad, Pedram, 'Les Lions en pierre sculptés chez les Bakhtiâri: Description et significations de sculptures zoomorphes dans une société tribale du sud-ouest de l'Iran', unpublished thesis, Ecole des Hautes Etudes en Science Social (Paris, 2007).

Kleiner, Fred, S. & Mamiya, Christin J., *Gardener's Art Through the Ages* (Orlando: Harcourt Brace College Publishers, 2001).

Koşay, Hamit Z., 'Les statues de bélier se trouvant dans les cimetières historiques en Anatolie orientale', *First International Congress of Turkish Art* 6 (1959): 215–18.

Kreyenbroek, Philip G., *Yezidism – Its Background, Observances and Textual Tradition* (Lewiston/Queenston/Lampeter: Edwin Mellen Press, 1995).

—— 'On the Study of Some Heterodox Sects in Kurdistan', *Les Annales de l'Autre Islam*, 5 (1998): 163–84.

—— *Living Zoroastrisme: Urban Parsis speak about their religion*, (Richmond: Curzon Press, 2000).

—— 'Yazīdī, Yazīdiyya', *Encyclopaedia of Islam* (Leiden: E.J. Brill CD-ROM Edition, 2005).

Lammens, Henri, 'Le Massif du Ğabal Sim'an et les Yézidis de Syrie', *Mélanges de l'Université de St. Joseph* 2 (1907): 366–94.

Lane, E. W., *Arabian Society in the Middle Ages* (London: Curzon Press, 1987).

Langer, Robert, 'From Private Shrine to Pilgrimage Centre: The Spectrum of Zoroastrian Shrines in Iran', in M. Stausberg (ed.) *Zoroastrian Rituals in Context* (Leiden/Boston: E.J. Brill, 2004), pp. 563–92.

Laqueur, Hans-Peter, 'Dervish Gravestones', in Raymond Lifchez (ed.) *The Dervish Lodge: Architecture, Art, and Sufism in Ottoman Turkey* (Berkeley: University of California Press, 1992), pp. 284–95.

Layard, Austin Henry, *Nineveh and Its Remains: With an Account of a Visit to the Chaldeans Christians of Kurdistan, and the Yezidis, or Devil-worshippers, and an Enquiry into the Manners and Arts of the Ancient Assyrians* (London: John Murray, 1849).

Leeming David Adams, *A Dictionary of Creation Myths* (Oxford/New York: Oxford University Press, 1994).

Leiser, G., 'Zankids', *Medieval Islamic Civilisation* 2 (2006): 873.

Leisten, Thomas, *Architektur für Tote* (Berlin: Reimer, 1998).

Leroy, Jules, *Monks and Monasteries of the Near East* (London: George G. Harrap, 1963).

Lescot, Roger, *Enquête sur les Yézidis de Syrie et du Djebel Sindjār* (Beirut: Mémoire de l'Institut Français de Damas, 1938).

Long. P. W., 'A Visit to Sheikh Adi: The Shrine of the Peacock-Angel', *Journal of the Royal Central Asian Society* 23 (1936): 632–38.

Luke, Harry C., 'The Yezidis or Devil-worshippers of Mosul', *The Indian Antiquity* 54 (1925): 94–98.

—— *Mosul and its Minorities* (London: Martin Hopkinson, 1925).

Lycklama à Nijeholt, T. M., *Voyage en Russie, au Caucase et en Perse, dans la Mésopotamie, le Kurdistan, la Syrie, la Palestine et la Turquie* (Paris: Arthus Bertrand/Amsterdam: C. L. Van Langenhuysen, 1877).

Lynch, H. F. B., *Armenia: Travels and Studies* II (London: Longmans, Green, and Co., 1901).

Maisel, Sebastian, 'Social Change amidst Terror and Discrimination: Yezidis in the New Iraq', *The Middle East Institute Policy Brief* 18 (2008): 1–9.

Marco Polo, *Travels of Marco Polo*, trans. W. Marsden (London: Dent, 1908).

Mason, Robert, 'Feast of the Devil-worshippers', *Parade* 159 (1943): 10–12.

Massé, Henri, *Croyances et Coutumes Persans* (Paris: Librarie Orientale et Americains, 1938).

Massignon, Louis, 'Al-Hallāj le phantasme crucifié des docètes et Satan selon les Yézidis', *Revue Histoire des Religions* 63 (1911): 195–207.

McDowal, David, *A Modern History of the Kurds* (London/New York: I.B.Tauris, 1994).

Meiselas, Susan, *Kurdistan: In the Shadow of History* (New York: Random House, 1997).

Menant, M. Joachim, *Les Yézidis: Épisode de l'Histoire des Adorateurs du Diable* (Paris: Ernest Leroux, 1892).

Menzel, Th., 'Kitāb al-Djilwa', *Encyclopaedia of Islam* (Leiden: E.J. Brill CD-ROM Edition, 2005).

Mingana, Alphonse, 'Devil-worshippers: Their Beliefs and Their Sacred Books', *The Journal of the Royal Asiatic Society* (1916): 505–26.

—— 'Sacred Books of Yezidis', *The Journal of the Royal Asiatic Society* (1921): 117–19.

Minorsky, Vladimir, *Studies in Caucasian History, I. New Light on the Shaddâdids of Ganja, II. Shaddâdids of Ani* (Cambridge: Oriental Series of the University of Cambridge, 1953).

Mir-Hosseini, Ziba, 'Inner Truth and Outer History: The Two Worlds of the Ahl-I Haqq of Kurdistan', *International Journal of Middle East Studies* 26 (1994): 267–85.

Mokri, M., 'Les rites magique dans les fêtes du 'Dernier Mercredi de l'année' en Perse', *Mélanges d'Orientalisme offerts à Henri Massé* (1963): 303–16.

Montgomery, Harriet, *The Kurds of Syria: An Existence Denied* (Berlin: Europäisches Zentrum für Kurdische Studien, 2005).

Montgomery, W. W., *Islam and the Integration of Society* (London: Routledge & Kegan Paul, 1961).

Moorhead, W. G., 'Universality of Serpent-worship', *The Old Testament Student* 4 (1885): 5: 205–10.

Morgan, J., *Mission scientifique en Perse* (Paris: Ernest Leroux, 1894).

Mozzati, Luca, *L'Art de l'Islam*, trans. D. A. Canal (Paris: Editions Mengès, 2003).

Muhammad Amen, Nermin, 'Les Églises et Monastères du 'Kurdistan irakien' à la veille et au lendemain de l'Islam', unpublished thesis, University of Versailles (Saint-Quentin en Yvelines, 2001).

Müller, Daniel, 'The Kurds of Soviet Azerbaijan', *Central Asian Survey* 19 (2000): 1: 41–77.

Mundkur, Balaji, *The Cult of the Serpent* (New York: State University of New York Press, 1893).

Nair, P. Thankappan, *The Peacock: The National Bird of India* (Calcutta: Firma K.L.M., 1977).

Nalbantoğlu, İlhami, *Anadolu'da Türk Mühürü Ahlat* (Ankara: Ahlat Kültür Vakfı, 1993).

Nau, F. and Tfinkdji, Joseph, 'Recueil de textes et de documents sur les Yézidis', *Revue de l'Orient Chrétien* XX (1915–1917): 142–200; 225–75.

Nazdar, M., 'The Kurds in Syria', in Gerard Chaliand (ed.) *A People without a Country the Kurds and Kurdistan* (London: Zed Press, 1993), pp. 211–19.

Newall, Venetia, 'Easter Eggs', *The Journal of American Folklore* 80 (1967): 315: 3–32.

—— 'Easter Eggs: Symbols of Life and Renewal', *Folklore* 95 (1984): 21–29.

Niebuhr, Carsten, *Travels through Arabia, and Other Countries in the East* II, trans. R. Heron (Edinburgh: R. Morison and Son, 1792).

Nikitine, Bazil, *Les Kurdes: Étude sociologique et historique* (Paris: Imprimerie nationale, 1956).

Northedge, Alastair, *Historical Topography of Samarra – Samarra Studies* I (London: British School of Archaeology in Iraq, 2006).

Ögel, Semra, *Anadolu Selçuklularının Taş Tezyinatı* (Ankara: Türk Tarih Kurumu, 1987).

Okçu, Davut, *Yezidilik ve Yezidiler* (Van: Bileşik Yayın, 1993).

Olson, Robert, 'The Kurdish Rebellions of Sheikh Said (1925), Mt. Ararat (1930), and Dersim (1937–8): Their Impact on the Development of the Turkish Air Force and on Kurdish and Turkish Nationalism', *Die Welt des Islams* 40 (2000): 1: 67–84.

Öney, Gönül, *Beylikler Devri Sanatı: XIX–XV Yüzyıl (1300–1453)* (Ankara: Türk Tarih Kurumu, 1989).

Önkal, Hakkı, *Osmanlı Hanedan Türbeleri* (Ankara: Kültür Bakanlığı Yayınları, 1992).

—— *Anadolu Selçuklu Türbeleri* (Ankara: Atatürk Kültür Merkezi Yayını, 1996).

Othman, Mamo F., 'The Yezidi Religion as a Microcosm of Kurdish Culture: Similarities and Differences', published online ‹http://www.lalish.de/english/modules.php?name=News&file=article&sid=32› (accessed 16 February 2008).

Otter, Jean, *Voyage en Turquie et en Perse, en relation avec les expéditions de Thomas Koulikhan* (Paris: Frères Guerin, 1748).

Özbek, Yıldıray, 'The Peacock Figure and Its Iconography in Medieval Anatolian Turkish Art', *the 10ᵉ Congrès International d'arc turc* (Genève: Fondation Max Van Berchem, 1998), pp. 537–34.

Özdemir, B. Murat, *Yezidiler ve Süryaniler* (İstanbul: Ekin Yayınları, 1988).

Özdoğan, M. and Başgelen, N., *Neolithic in Turkey: The Cradle of Civilization: New Discoveries* II vols (İstanbul: Arkeoloji ve Sanat Yayınları, 1999).

Özoğlu, Hakan, 'State-Tribe Relations: Kurdish Tribalism in the 16th- and 17th-Century Ottoman Empire', *British Journal of Middle Eastern Studies* 23 (1996): 1: 5–27.

Parman, Ebru, 'Bizans Sanatında Tavus Kuşu İkonografisi', *Sanat Tarihinde İkonografik Araştırmalar Güner İnal'a Armağan* (Ankara: Hacettepe Üniversitesi, 1993), pp. 387–412.

Parry, Oswald H., *Six Months in a Syrian Monastery Being the Record of a Visit to the Head Quarters of the Syrian Church in Mesopotamia: With Some Account of the Yazidis or Devil Worshippers of Mosul and El Jilwah, Their Sacred Book* (London: H. Cox, 1895).

Pashaeva, Lamara, 'Yézidi Social Life in the former USSR', paper presented at *The Workshop Integration of Trans-national Communities: Yezidi Kurds and 'Alevis in Germany* (Berlin, July 1999).

Patton, Douglas, 'Badr al-Din Lu'lu' and the Establishment of a Mamluk Government in Mosul', *Studia Islamica* 74 (1991): 79–103.

—— *Badr al-Din Lu'lu' Atabeg of Mosul, 1211–1259* (Seattle: University of Washington Press, 1991).

Paujoulat, M. Baptistin, *Voyage dans l'Asie Mineure et, en Mésopotamie, à Palmyre, en Syrie, en Palestine et en Egypte* I (Paris: Ducollet, Libraire-Editeur, 1840).

Pedersen, J., 'Adam', *Encyclopaedia of Islam* (Leiden: E.J. Brill CD-ROM Edition, 2005).

Pognon, H., 'Sur les Yézidis du Sindjar', *Revue d'Orient Chrétien* XX (1917–1919): 325–28.

Pope, Arthur Upham, *Persian Architecture* (London: Thames and Hudson, 1965).

Pushkin, Aleksandr S., *A journey to Arzrum*, trans. Brigitta Ingemanson and Ann Arbor (Michigan: Ardis, 1974).

Raghib, Yusuf, 'Les Premiers monuments funéraires de l'Islam', *Annales islamologiques* 9 (1970): 21–36.

Rashow, Khalil Jindy, *An Approach to the Essence of Yezidian Religion* (Uppsala: Rabun, 1998).

Reitlinger, Gerald, 'Mediaeval Antiquities West of Mosul', *Iraq* V (1938): 143–56.

Reld, James J., 'Mahmûdî Order and Clan 1500–1606', *Lêkolîn* 7 (2000): 41–65.

Remonnay, Jean, 'Chez les Adorateurs du Diable', *Jésuites Missionnaires* 9 (1938): 4–11.

Rice, D. S., 'The Brasses of Badr al-Dīn Lu'lu', *Bulletin of the School of Oriental and African Studies* 13 (1950): 3: 627–34.

Rice, Tamara T., *The Seljuks in Asia Minor* (London: Thames and Hudson, 1961).

Rich, Claudius J., *Narrative of a Residence in Koordistan, and on the Site of Ancient Nineveh* (London, 1836).

Rogan, Eugene L., 'Aşiret Mektebi: Abdülhamid II's School for Tribes (1892–1907)', *International Journal of Middle East Studies* 28 (1996): 83–107.

Rondot, Pierre, 'Les Kurdes de Syrie', *La France méditerranéenne et africaine* 1 (1939): 81–126.

—— 'Les Kurdes d'Irak: Les Yézidis', *Bulletin Mensuel de Centre d'Etudes Kurdes* 12 (1950): 11–13.

Rousseau, J. Baptiste Louis, *Description du Pachalik de Bagdad* (Paris, 1809).

Roxburgh, David J., *Turks a Journey of a Thousand Years, 600–1600* (London: Royal Academy of Arts, 2005).

Russo, Deborah and Yıldız, Kerim, *Azerbaijan & Armenia: An Update on Ethnic Minorities and Human Rights* (London: Kurdish Human Rights Project, 2000).

Sachau, Eduard, *Reise in Syrien und Mesopotamien* (Leipzig: F. A. Brockhaus, 1883).

——*Am Euphrat und Tigris: Reisenotizen aus dem Winter 1897–1898* (Leipzig: J.C. Hinrichs, 1990).

Şardan, Tolga, 'Iran Established Airport for Terrorism', *Milliyet* (7 April 2002).

Sarre, Fr. and Herzfeld, E., *Archäologische Reise im Euphrat- und Tigris-Gebiet* (Berlin: D. Reimer, 1911).

Sarre, Friedrich, *Die Kunst des alten Persien* (Berlin: B. Cassirer, 1922).

Scheherezade, Q. H., 'Les Instruments de musique chez les Yézidis de l'Irak', *Yearbook of the International Folk Music Council* 8 (1976): 53–72.

Seabrook, W. B., *Adventures in Arabia among the Bedouins, Druses, Whirling Dervishes & Yezidee Devil-worshipers* (New York: Blue Ribbon Books, 1935).

Sebri, Osman and Wikander, Stig, 'Un témoignage kurde sur les Yézidis du Sindjar', *Orientali Suecana*, II (1953): 112–18.

Seferli, Haci Fahrettin, 'Nahçivan'da Taştan Yapılmış Koç ve Koyun Heykelleri', *Türkler* 8 (2002): 227–32.

Sestini, Domenico, *Voyage de Constantinople à Bassora en 1781 par le Tigre et l'Euphrate, et Retour à Constantinople en 1782, par le Désert et Alexandrie*, trans. Comte de Fleury (Paris, 1797).

Sever, Erol, *Yezidilik ve Yezidilerin Kökeni* (Istanbul: Berfîn Yayınları, 1993).

Silêman, Xidir and Cindî, Xelîl, *Êzidiyatî li ber ronahiya hindek têkistên ola Êzidiyan* (Duhok: Ararat, 1995).

Sılı, Timur, 'Iğdır-Karakoyunlu İlçe Mezarlığındaki Deve-Heykel Mezartaşının Mahiyeti', *Vakıflar Dergisi* XXVII (1998): 191–94.

Sinclair, T. A., *Eastern Turkey: An Architectural and Archaeological Survey* (London: Pindar Press, 1987).

Sinha, Binod C., *Serpent Worship in Ancient India* (New Delhi: Books Today, 1979).

Siouffi, M. N., 'Une courte conversation avec le chef de la secte des Yézidis ou les Adorateurs du Diable', *Journal Asiatique* 7 (1880): 18: 78–83.

—— 'Notice sur la Secte des Yezidis', *Journal Asiatique* 7 (1882): 20: 252–68.

—— 'Notice sur le Cheikh Adi et sur la secte des Yézidis', *Journal Asiatique* 8 (1885): 5: 78–98.

—— 'Les Traditions des Yézidis', in F. Nau (ed.) 'Recueil de textes et de documents sur les Yézidis', *Revue de l'Orient* XX (1915–17): 243–52.

Soane, Ely Bannister, *To Mesopotamia and Kurdistan in Disguise Narrative of a Journey from Constantinople through Kurdistan to Baghdad, 1907–1909* (St Helier: Armorica Book Co.; Amsterdam: Apa-Philo Press, 1926).

Sourdel-Thomine, Janine, *Les Monuments Ayyoubides de Damas* (Paris: E. de Boccard, 1950).

Southgate, Rev. Horatio, *Narrative of a Tour through Armenia, Kurdistan, Persia, and Mesopotamia* (London: Tilt and Bogue, 1811).

Spät, Eszter, *The Yezidis* (London: Saqi, 2005).

Spottiswoode, W., 'Tribes of Northern Kurdistan', *Transactions of the Ethnological Society of* London 2 (1863): 244–48.

Stevens, E. S., *By Tigris and Euphrates* (London: Hurst and Blackett, 1923).

Stoyanov, Yuri, 'Islamic and Christian Heterodox Water Cosmogonies from the Ottoman Period – Parallels and Contrasts', *Bulletin of the School of Oriental and African Studies* 64 (2001): 1: 19–33.

Stronach, D. and Young, T. C. J., 'Three Seljuq Tomb Towers', *Iran* 4 (1966): 1–20.

Strzygowski, Joseph, *Die Baukunst der Armenier und Europa* (Wien: Kunstverlag Anton Schroll, 1918).

Suny, R. G., *Transcaucasia Nationalism and Social Change* (Michigan: Slavic Publications, 1983).

Süslü, Özden, 'Le Motif du paon dans la céramique ottomane du XVIᵉ siècle', *IVᵉᵐᵉ Congrès International d'Art Turc* (Aix-en-Provence: Université Provence, 1971), pp. 237–41.

Suvari, Ç. Ceyhan, 'Yezidilik Örneğinde Etnisite, Din ve Kimlik İlişkisi', in Ç.C. Suvari, A. Yıldırım, T. Bozkurt and İ.M. İşoğlu (eds) *Artakalanlar: Anadolu'dan Etnik Manzaralar* (Istanbul: E Yayınları, 2006), pp. 39–133.

Sykes, Mark, 'The Kurdish Tribes of Ottoman Empire', *Journal of the Royal Anthropological Institute of Great Britain and Ireland* 38 (1908): 451–86.

Tabbaa, Yasser, 'The Muqarnas Dome: Its Origin and Meaning', *Muqarnas* 3 (1985): 61–74.

Tanavoli, Parviz, *Lion Rugs: The Lion in the Art and Culture of Iran* (Basel and New York: Transbooks, 1985).

Taşğın, Ahmet, 'Anadolu'da Yok Olmaya Yüz Tutan Dini Topluluklardan: Yezidiler', *Anadolu İnançları Kongresi* (Ankara: Ervak Yayınları, 2001), pp. 731–52.

——'Yezidiler, Becirmanier, Karaçiler', *Makalelerde Mardin Önemli Simalar Dini Topluluklar* IV (2007): 177–98.

Thompson, Jon and Canby, Sheila R., *Hunt for Paradise: Court Arts of Safavid Iran 1501–1576* (Milan: Skira; London: Thames and Hudson, 2003).

Topcu, Mümin, 'Yaşar Kemal'in Romanlarında Yezidilikle İlgili İnançlar', in İbrahim Özcoşar (ed.) *Makalelerde Mardin Önemli Simalar Dini Topluluklar* IV (2007): 299–307.

Trimingham, J. S., *The Sufi Orders in Islam* (Oxford: Clarendon Press, 1971).

Tritton, A. S., ''Adī b. Musāfir al-Hakkārī, Shaykh 'Adī', *Encyclopaedia of Islam* (Leiden: E.J. Brill CD-ROM Edition, 2005).

Tuncer, Orhan Cezmi, *Anadolu Kümbetleri* I (Ankara: Güven Matbaası, 1986).

Turani, Adnan, *Dünya Sanat Tarihi* (Ankara: Türkiye İş Bankası Kültür Yayınları, 1983).

Turner, Patricia & Coulter, Charles R., *Dictionary of Ancient Deities* (Oxford: Oxford University Press, 2001).

Ulansey, David, *The Origins of the Mithraic Mysteries Cosmology & Salvation in the Ancient World* (Oxford: Oxford University Press, 1989).

Uluçam, Abdüsselam, *Irak'taki Türk Mimari Eserleri* (Ankara: Kültür Bakanlığı Yayınları, 1989).

—— 'Eyyübi Mimarisi ve Sanat Tarihimizdeki Yeri', *Haçlı Seferlerinin 900. Yıldönümünde Uluslararası Selâhaddin-i Eyyubî Sempozyumu* (Diyarbakır: Diyarbakır Büyük Şehir Belediyesi, 1997), pp. 255–81.

Ünsal, Behçet, *Turkish Islamic Architecture in Seljuk and Ottoman Times: 1071–1923* (London: Academy Editions, 1973).

Utudjian, Edouard, *Armenian Architecture 4th to 17th Century*, trans. G. Capner (Paris: Editions Albert Morancé, 1968).

Vafadari, Kasra, *Iranian Zoroastrians* I (Tehran: Mahriz Publication, 2002).

Vanly, Ismet Cheriff, 'The Kurds Under Imperial Russia', in P.G. Kreyenbroek and S. Sperl (eds) *The Kurds: A Contemporary Overview* (London/New York: Routledge, 1992), pp. 193–218.

—— 'The Kurds in Syria and Lebanon', in P.G. Kreyenbroek and S. Sperl (eds) *The Kurds: A Contemporary Overview* (London/New York: Routledge, 1992), pp. 143–66.

—— *Batılı Eski Seyyahların Gözüyle Kürtler ve Kürdistan* (İstanbul: Avesta Yayınları, 1997).

Vassilieva, Eugenia, 'The Bokhty Principality of Jazira', *Lêkolin* 7 (2000): 66–73.

Viré, F. and Baer, E., 'Tāwūs, Tā'ūs', *Encyclopaedia of Islam* (Leiden: E.J. Brill CD-ROM Edition, 2005).

Wahby, Tawfiq, *The Remnant of the Mithraism in Hatra and Iraqi Kurdistan and its Traces in Yazidism: The Yazidis are not Devil-worshippers* (London, 1962).

Watt, W. Montgomery, *Islam and the Integration of Society* (London: Routledge & Kegan Paul, 1961).

Wigram, R. W. A. *The Cradle of Mankind Life in Eastern Kurdistan* (London: Adam and Charles Black, 1914).

Wilber, Donald N., *The Architecture of Islamic Iran: The Ilkhanid Period* (Princeton: Princeton University Press, 1955).

Yalkut, Sabiha Banu, *Melek Tavus'un Halki Yezidiler* (İstanbul: Siyahbeyaz Metis Güncel, 2001).

Yaltkaya, Mehmed Şerefeddin, 'Küçük Asya Yezidileri'nin Şeytan'a Tapmaları', in Mehmet Bayrak (ed.) *Açık-Gizli/Resmi-Gayrıresmi Kürdoloji Belgeleri* I (Ankara: Özge Yayınları, 1994).

Index